COLLINS
COMPLETE GUIDE TO
BRITISH
GARDEN WILDLIFE

Paul Sterry

Collins

HarperCollinsPublishers Ltd.
77–85 Fulham Palace Road
London W6 8JB

www.harpercollins.co.uk

Collins is a registered trademark of HarperCollinsPublishers Ltd.

First published in 2010

Text © 2010 Paul Sterry
Photographs © Individual photographers as indicated in the picture credits

14 13 12 11

10 9 8 7 6 5 4 3 2

A catalogue record for this book is available from the British Library.

ISBN 978-0-00-736394-0

Collins uses papers that are natural, renewable and recyclable products made
from wood grown in sustainable forests. The manufacturing processes
conform to the environmental regulations of the country of origin.

Acknowledgement
The author would like to thank Andrew Cleave, Andrew Merrick and Bill
Helyar for their help and encouragement in the creation of this book.

Colour reproduction by Nature Photographers Ltd

Edited and designed by D & N Publishing, Baydon, Wiltshire

Printed and bound in Hong Kong by Printing Express

CONTENTS

HOW TO USE THIS BOOK

The identification section of this book (the species descriptions) has been designed so that the text and main photographs for each species face each other on the left and right pages, respectively; special features, relevant to identification, have sometimes been added as insets in the text pages. The main photographs are labelled so that the identity of the species is clear. The text has been written to complement the information conveyed by the photographs. By and large, the order in which the species appear in the main section of the book follows standard classification.

SPECIES DESCRIPTIONS

At the start of each species description, the most commonly used and current English name is given. This is followed by the scientific name of the species in question, which comprises the species' genus name first, followed by its specific name. In a few instances, reference is made, either in the species heading or the main body of the text, to a further subdivision – subspecies – where this is pertinent.

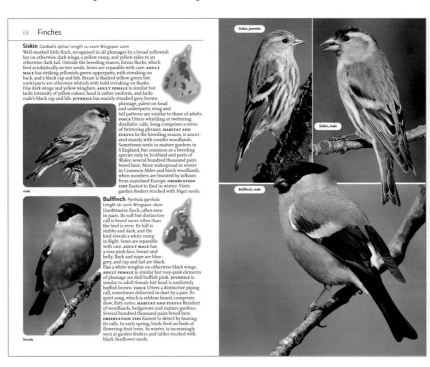

The text has been written in as concise a manner as possible. Each description begins with a summary of the species in question. To avoid potential ambiguities, sub-headings break up the rest of each species description. Different sub-headings are used for different divisions within the natural world: for the section covering birds, typical sub-headings would be **ADULT MALE**, **ADULT FEMALE**, **JUVENILE**, **VOICE**, **HABITAT AND STATUS**, and **OBSERVATION TIPS**; for the sections on mammals, reptiles and amphibians, they might include **ADULT**, **JUVENILE**, **VOICE**, **HABITAT AND STATUS**, **HABITS**, and **OBSERVATION TIPS**; for the section on invertebrates, typical sub-headings would be **ADULT**, **EGG**, **LARVA**, **PUPA**, and **STATUS**; for the section covering trees, they might include **BARK**, **BRANCHES**, **LEAVES**, **REPRODUCTIVE PARTS**, and **STATUS**; and for the section covering wildflowers, typical sub-headings would be **FLOWERS**, **FRUITS**, **LEAVES**, and **STATUS**.

INTRODUCTORY SPREADS

Throughout the book, each significant division within the natural world has two pages devoted to its introduction. These pages are lavishly illustrated and have straightforward text that helps the reader understand the group's natural history and significance to garden ecology.

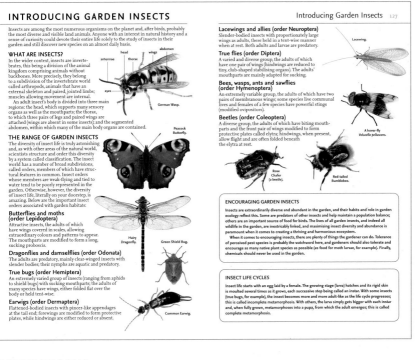

INTRODUCING GARDEN INSECTS

Introducing Garden Insects 127

Insects are among the most numerous organisms on the planet and, after birds, probably the most diverse and visible land animals. Anyone with an interest in natural history and a sense of curiosity could devote their entire life solely to the study of insects in their garden and still discover new species on an almost daily basis.

WHAT ARE INSECTS?
In the wider context, insects are invertebrates, this being a division of the animal kingdom comprising animals without backbones. More precisely, they belong to a subdivision of the invertebrate world called arthropods, animals that have an external skeleton and paired, jointed limbs; muscles allowing movement are internal.

An adult insect's body is divided into three main regions: the head, which supports many sensory organs as well as the mouthparts; the thorax, to which three pairs of legs and paired wings are attached (wings are absent in some insects); and the segmented abdomen, within which many of the main body organs are contained.

THE RANGE OF INSECT INSECTS
The diversity of insect life is truly astonishing and, as with other areas of the natural world, scientists structure and order this diversity by a system called classification. The insect world has a number of broad subdivisions, called orders, members of which have structural features in common. Insect orders whose members are weak-flying and tied to water tend to be poorly represented in the garden. Otherwise, however, the diversity of insect life, literally on your doorstep, is amazing. Below are the important insect orders associated with garden habitats:

Butterflies and moths (order Lepidoptera)
Attractive insects, the adults of which have wings covered in scales, allowing extraordinary colours and patterns to appear. The mouthparts are modified to form a long, sucking proboscis.

Dragonflies and damselflies (order Odonata)
The adults are predatory, mainly clear-winged insects with slender bodies; their nymphs are aquatic and predatory.

True bugs (order Hemiptera)
An extremely varied group of insects (ranging from aphids to shield bugs) with sucking mouthparts; the adults of many species have wings, either folded flat over the body or held tent-wise.

Earwigs (order Dermaptera)
Flattened-bodied insects with pincer-like appendages at the tail end; forewings are modified to form protective plates, while hindwings are either reduced or absent.

head, antennae, thorax, wings, abdomen, eyes, German Wasp.
Peacock Butterfly.
Hairy Dragonfly.
Green Shield Bug.
Common Earwig.

Lacewings and allies (order Neuroptera)
Slender-bodied insects with proportionally large wings as adults, these held in a tent-wise manner when at rest. Both adults and larvae are predatory.

True flies (order Diptera)
A varied and diverse group, the adults of which have one pair of wings (hindwings are reduced to tiny, club-shaped stabilising organs). The adults' mouthparts are mainly adapted for sucking.

Bees, wasps, ants and sawflies (order Hymenoptera)
An extremely variable group, the adults of which have two pairs of membranous wings; some species live communal lives and females of a few species have powerful stings (modified ovipositors).

Beetles (order Coleoptera)
A diverse group, the adults of which have biting mouthparts and the front pair of wings modified to form protective plates called elytra; hindwings, when present, allow flight and are often folded beneath the elytra at rest.

Lacewing.
A hover-fly Volucella pellucens.
Rose Chafer (a beetle).
Red-tailed Bumblebee.

ENCOURAGING GARDEN INSECTS
Insects are extraordinarily diverse and abundant in the garden, and their habits and role in garden ecology reflect this. Some are predators of other insects and help maintain a population balance; others are an important source of food for birds. The lives of all garden insects, and indeed all wildlife in the garden, are inextricably linked, and maximising insect diversity and abundance is paramount when it comes to creating a thriving and harmonious ecosystem.

When it comes to encouraging insects, there are plenty of things the gardener can do. Tolerance of perceived pest species is probably the watchword here, and gardeners should also tolerate and encourage as many native plant species as possible (as food for moth larvae, for example). Finally, chemicals should never be used in the garden.

INSECT LIFE CYCLES
Insect life starts with an egg laid by a female. The growing stage (larva) hatches and its rigid skin is moulted several times as it grows, each successive step being called an instar. With some insects (true bugs, for example), the insect becomes more and more adult-like as the life cycle progresses; this is called incomplete metamorphosis. With others, the larva simply gets bigger with each instar and, when fully grown, metamorphoses into a pupa, from which the adult emerges; this is called complete metamorphosis.

PHOTOGRAPHS

Great care has gone into the selection of photographs for this book, and in many cases the images have been taken specifically for the project. Preference was given to photographs that serve both to illustrate key identification features of a given species and to emphasise its beauty. In many instances, smaller inset photographs illustrate features useful for identification that are not shown clearly in the main image.

MAPS

Maps have been used for species descriptions covering birds, mammals, amphibians and reptiles. In the case of birds, these help illustrate and explain the seasonally different ranges seen in certain species. Different colours represent different seasons:

■ – present year-round;
■ – present in summer;
■ – present in winter.

With the other animal groups, each species' year-round range is shown. Maps have not been used for remaining groups in the natural world, either because their ranges can be explained easily in words, or because their natural ranges in the garden context have been so altered by man as to make maps irrelevant.

INTRODUCING GARDEN WILDLIFE

As a nation, the British are fanatical about their gardens, and quite probably there are more committed gardeners per head of the population here than in any other country. Most have at least a passing interest in wildlife, and for many people their garden's natural history is a source of delight and pleasure, and a driving force for their activities.

THE ROLE OF GARDENS

Gardens mean different things to different people. For some, they are merely another room, an outdoor extension to the house. For others, they are places of relaxation that provide an escape from the outside world. But for most garden owners, their relationship with their plot of land is much more than simply passive: passionate and committed, they enjoy gardening for its own sake. The pleasure derived from growing and tending your own plants is irresistible for many, and the reward of creating a thing of beauty, or growing food for the table, is priceless.

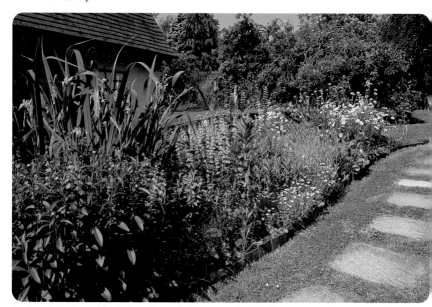

A well-tended herbaceous border is much more than just a pretty floral display. Many of the flowers provide nectar for insects, and the leaves of many plantsmen's favourites are food for the larvae of moths in particular.

THE ROLE OF GARDENS FOR WILDLIFE

Part of the fun of gardening is that it brings people into intimate contact with nature, whether it be the plants they cultivate and nurture, or the native wildlife that finds our gardens so attractive. Observant gardeners cannot fail to be impressed by the native plants and animals that soon colonise and take up residence. And most people – presumably all those who have bought this book – find their garden's natural history an endless source of interest. Many have a real sense of pride when it comes to garden wildlife, and their plots of land become unofficial nature reserves – as far as they are concerned, the more wildlife diversity the better.

From a conservation point of view, British gardens in the 21st century are more than just novelties or curiosities. Because so much of lowland Britain has been swallowed up by intensive farming, and by sprawling towns and cities with their hectares of concrete and tarmac, gardens are truly significant in the grand scheme of things as sanctuaries or oases for wildlife. And yes, it is slightly ironic that urban sprawl is one of the main problems that beset our wildlife yet the gardens that result redress the balance in a small way. If tended sympathetically, gardens really do become important for wildlife and as their owners' private nature reserves; *Complete Garden Wildlife* aims to help in this regard.

A slightly chaotic approach to garden maintenance is often best for wildlife and suits the temperament of many gardeners, the author included.

GARDEN WILDLIFE DIVERSITY AND CONSERVATION

The primary aim of *Complete Garden Wildlife* is to allow gardeners to identify the native plants and animals they come across in the garden, be they welcome or otherwise. Being able to put a name to a mystery species is a significant part of the pleasure derived from working in the garden, for me at least. But learning about any given species' requirements and its role in garden ecology can also be enlightening. It allows gardeners to adapt their approach to gardening in order to encourage certain species while discouraging others. Maximising the biodiversity in the garden does not have to be at the expense of having a pretty or productive piece of land. And it really does make a difference to do your bit for wildlife. Individual gardens may seem like a drop in the ocean in conservation terms, but their real significance is apparent when they are seen as part a countrywide network of unofficial nature reserves. Value your garden's wildlife and not only will it repay you with endless hours of fascinating study but you will also be doing your bit for conservation.

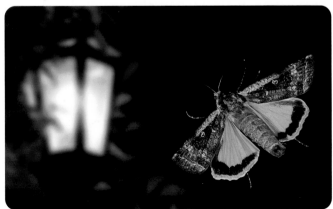

Not all the wildlife action in the garden takes place during the hours of daylight: this Large Yellow Underwing, attracted to an outside light, is just one of hundreds of moth species that can be found in most mature gardens over the course of a year.

INTRODUCING GARDEN BIRDS

Birds are the most visible members of the garden wildlife community and, generally speaking, they are also the most popular. Indeed, there is a good chance that every person who buys *Complete Garden Wildlife* already encourages birds in one way or another, perhaps by feeding them or providing nest boxes. The fact that most garden birds are relatively bold and easy to see adds to their appeal, and in gardens where they are encouraged many individuals become remarkably tame.

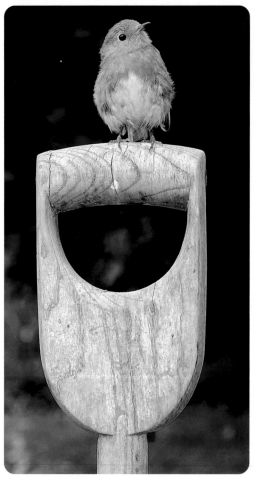

Garden Robins often show little or no fear of people. Take a well-earned break from digging the potato patch, for example, and you may find one perched on the handle of your fork! Ever alert, a bold Robin will be quick to spot a wriggling earthworm on the ground below. Interestingly, Britain appears to be best place in the world for tame Robins; elsewhere in their range they are usually shy and secretive.

BTO GARDEN BIRDWATCH

Most of the current facts, figures and detailed information about garden bird populations and numbers comes from the British Trust for Ornithology (BTO), the pivotal birding organisation when it comes to understanding the complexities and trends in British birdlife. Apart from the BTO's nationwide monitoring and recording programmes, and its ringing activities, the organisation runs the BTO Garden Birdwatch. Like most BTO projects, data and information for this scheme are provided by an army of enthusiastic amateur garden naturalists. If you want to find out more about BTO Garden Birdwatch and are keen to contribute information, visit www.bto.org. You could also consider joining the BTO and becoming a paid-up citizen scientist.

THE CHARM OF BIRDS

Anyone with an interest in wildlife will derive a huge amount of pleasure from watching birds at close quarters in the garden. Many people get a real sense of privilege when their feeders are frequented by good numbers of birds, or when birds choose to nest nearby. But with this privilege comes responsibility: birds can, to a degree, become dependent on garden handouts, and as guardian to your birds you need to be prepared to accept the duty (not to mention significant cost) of maintaining food stocks. The rewards are, however, worth it. A huge amount of pleasure can be had simply from watching garden birds go about their daily business, and for the serious-minded the relationships between species and within flocks is an endless source of study. On occasions, watching birds in the garden can also be plain fun: the antics of many species are undeniably comical.

RIGHT: **What better way to start the day than to wake up to your very own dawn chorus? By encouraging the birds in your garden, not only with food but also by providing plenty of potential nesting sites, you could have a dozen or more species in full song on a spring morning.**

BELOW: **Starlings have a well-deserved reputation for being pugnacious and, at times, aggressive birds. While much of their bullying behaviour is concerned with feeding, and reserved for smaller species, they will not hesitate to 'have a go' at members of their own kind. With patience, keen-eyed observers who can discern subtle differences between individual members of a garden Starling flock will usually be able to work out their pecking order.**

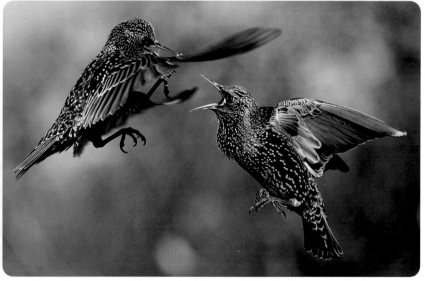

THE SIGNIFICANCE OF GARDENS TO BIRDS

Although many garden birds are also found in the countryside at large, the significance of man-made habitats should not be underestimated. The sheer number of gardens in Britain, and the land area that they occupy, makes them particularly important, and many species occur at higher densities in mature gardens than they do, for example, in deciduous woodland. A few species, such as Swift and House Martin, have even made the house and garden their primary locations.

BIRD FOOD AND FEEDING

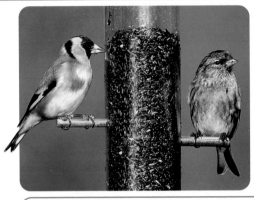

One sure way of increasing the numbers and diversity of birds in the garden is to provide them with food. Species with a preference for nuts, seeds and grains are the easiest to cater for, and a range of subtly different food sources maximises the number of species that can be attracted. All sorts of feeders are available on the market, allowing access to the food to be controlled.

Goldfinches and Redpolls find Niger seeds irresistible, and a narrow delivery port on the feeder means that most other species are excluded from this food source.

FOOD TYPES

Feeding birds is big business – gone are the days when, in most gardens, leftover scraps were all their birds could expect. A wide range of foodstuffs can now be bought, each attracting and feeding its own range of species.

Niger seeds are tiny and have to be contained in a specially designed feeder to prevent them from spilling everywhere. They are extremely popular with Goldfinches, Siskins and Redpolls.

Black Sunflower seeds are a good source of energy for birds and are relished by tits and Greenfinches in particular. The downside is that the empty husks accumulate on the ground below the feeders and make a bit of a mess.

Fresh Coconut halves are a good source of food for species such as Long-tailed Tit and Starling. However, desiccated Coconut should never be fed to birds since it causes dehydration.

BELOW: **Sunflower hearts have had the outer husks removed and, unsurprisingly, are more expensive than black Sunflower seeds. They allow birds to feed more quickly and efficiently, and you don't get an unsightly accumulation of husks below the feeder.**

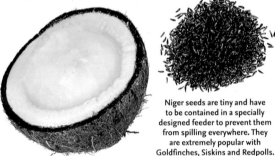

ABOVE: **Mixed seeds and grain are designed to attract buntings and finches in particular, birds that would once have fed on spilt grain among stubble when fields were left fallow. Avoid brands that contain a high proportion of cereal grains (a cheap ingredient for manufacturers).**

ABOVE: **Peanuts are the old favourite of most garden bird enthusiasts and, being rich in oils and proteins, they are a great source of food. They are best presented in mesh feeders, as these prevent birds from being able to remove whole peanuts in one go.**

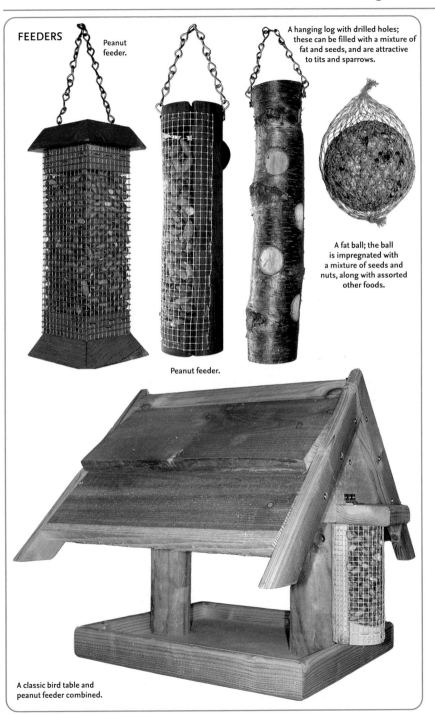

FEEDERS

Peanut feeder.

A hanging log with drilled holes; these can be filled with a mixture of fat and seeds, and are attractive to tits and sparrows.

A fat ball; the ball is impregnated with a mixture of seeds and nuts, along with assorted other foods.

Peanut feeder.

A classic bird table and peanut feeder combined.

BIRD NESTING AND NEST BOXES

Gardens are not only refuges for birds seeking a meal. In spring, several species also nest here if the structure of the garden is suitable; some birds even nest at higher densities than in the countryside at large. The provision of nest boxes as well as suitable natural sites can greatly increase both the numbers and diversity of breeding birds in the garden.

UNDERCOVER NESTERS

In the countryside, many species of songbird nest in dense cover, typically using tangled or spiny bushes and scrub plants such as Bramble to conceal their whereabouts from predatory eyes. If suitable cover is provided in the garden, then species such as Dunnock, Chaffinch, Song Thrush and Blackbird will all nest.

NEST BOXES

Many of the birds that use gardens are mainly associated with wooded habitats in the countryside, and of these a fair number – tits in particular – use tree-holes and crevices for nesting. Of course, most modern gardens lack mature, gnarled trees and offer little potential for hole-nesting species. Instead, a sure way to encourage these species is by providing nest boxes. Tits and Nuthatches favour hole-fronted nest boxes, while Robins, Chaffinches, Blackbirds and Spotted Flycatchers will sometimes use open-fronted designs. Wrens, on the other hand, will use boxes only where the gap at the front is no larger than 4cm. Nest boxes are readily available from suppliers but are easy to make yourself if you are fond of DIY. Use untreated native hardwood boards to construct the boxes if possible, and fix them in a shady position at least 2m off the ground.

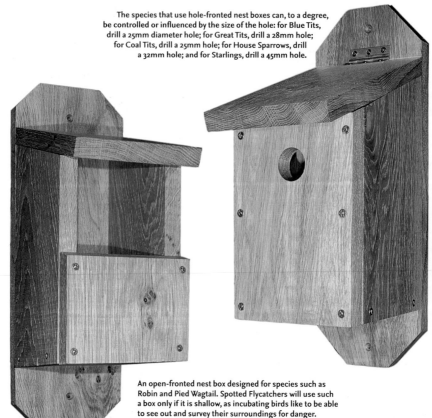

The species that use hole-fronted nest boxes can, to a degree, be controlled or influenced by the size of the hole: for Blue Tits, drill a 25mm diameter hole; for Great Tits, drill a 28mm hole; for Coal Tits, drill a 25mm hole; for House Sparrows, drill a 32mm hole; and for Starlings, drill a 45mm hole.

An open-fronted nest box designed for species such as Robin and Pied Wagtail. Spotted Flycatchers will use such a box only if it is shallow, as incubating birds like to be able to see out and survey their surroundings for danger.

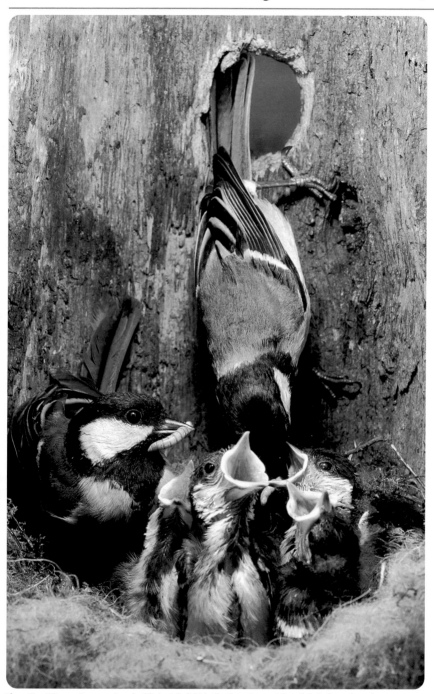

These Great Tit parents are rearing a healthy brood of chicks thanks to the provision of a hole-fronted nest box by thoughtful garden owners.

BIRDS' NESTS AND EGGS

For a long time, the topic of birds' eggs was taboo, as it was felt that the mere mention of the subject might encourage people to start collecting. But things are changing and it is now recognised that an awareness of nesting behaviour and an ability to identify eggs is not a bad thing in itself, so long as people act in a responsible manner.

EGGS OF GARDEN-NESTING BIRDS

The precise markings on any given egg are unique and those of some species are much more variable in appearance than others. However, sufficient similarity exists between eggs laid by any given species for a combination of size, colour and pattern to be used for accurate identification. Below is a selection of eggs laid by some of the most typical garden nesters.

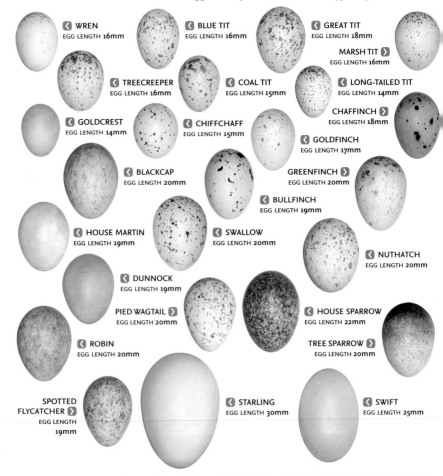

◖ WREN
EGG LENGTH **16mm**

◖ BLUE TIT
EGG LENGTH **16mm**

◖ GREAT TIT
EGG LENGTH **18mm**

MARSH TIT ▶
EGG LENGTH **16mm**

◖ TREECREEPER
EGG LENGTH **16mm**

◖ COAL TIT
EGG LENGTH **15mm**

◖ LONG-TAILED TIT
EGG LENGTH **14mm**

CHAFFINCH ▶
EGG LENGTH **18mm**

◖ GOLDCREST
EGG LENGTH **14mm**

◖ CHIFFCHAFF
EGG LENGTH **15mm**

◖ GOLDFINCH
EGG LENGTH **17mm**

◖ BLACKCAP
EGG LENGTH **20mm**

GREENFINCH ▶
EGG LENGTH **20mm**

◖ BULLFINCH
EGG LENGTH **19mm**

◖ HOUSE MARTIN
EGG LENGTH **19mm**

◖ SWALLOW
EGG LENGTH **20mm**

◖ NUTHATCH
EGG LENGTH **20mm**

◖ DUNNOCK
EGG LENGTH **19mm**

PIED WAGTAIL ▶
EGG LENGTH **20mm**

◖ HOUSE SPARROW
EGG LENGTH **22mm**

◖ ROBIN
EGG LENGTH **20mm**

TREE SPARROW ▶
EGG LENGTH **20mm**

SPOTTED FLYCATCHER ▶
EGG LENGTH **19mm**

◖ STARLING
EGG LENGTH **30mm**

◖ SWIFT
EGG LENGTH **25mm**

EGGS AND THE LAW

Egg-collecting is a crime and it is illegal to possess the egg of any wild bird. Of course, you are perfectly entitled to inspect nests that you find in the garden, and nobody could object to keeping an empty egg that you find on the lawn, for example. But the law exists to punish those whose obsessional collecting behaviour causes the wanton and pointless destruction of our breeding birds.

BTO NEST RECORD SCHEME

Being able to identify eggs and nests of garden birds will allow you to satisfy your own curiosity about what is nesting in your garden. But more importantly, you can contribute your records to an important national project, the BTO's Nest Record Scheme. The information gathered allows the BTO's researchers to chart the fortunes of breeding birds both in the garden and in the wider countryside. The Nest Records Starter Pack is available from the Nest Records Unit at the BTO (email: nest.records@bto.org).

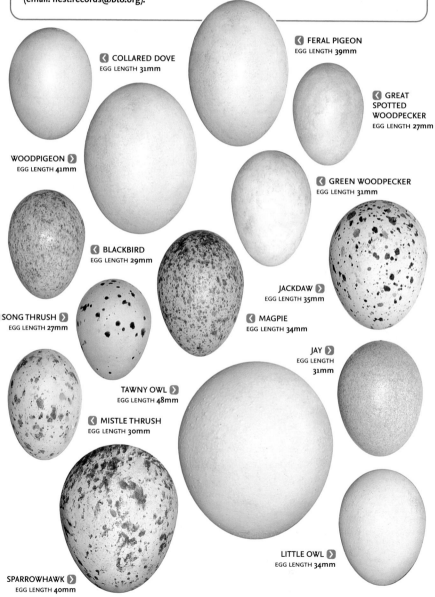

◄ COLLARED DOVE
EGG LENGTH 31mm

◄ FERAL PIGEON
EGG LENGTH 39mm

◄ GREAT SPOTTED WOODPECKER
EGG LENGTH 27mm

WOODPIGEON ❯
EGG LENGTH 41mm

◄ GREEN WOODPECKER
EGG LENGTH 31mm

◄ BLACKBIRD
EGG LENGTH 29mm

JACKDAW ❯
EGG LENGTH 35mm

SONG THRUSH ❯
EGG LENGTH 27mm

◄ MAGPIE
EGG LENGTH 34mm

JAY ❯
EGG LENGTH 31mm

TAWNY OWL ❯
EGG LENGTH 48mm

◄ MISTLE THRUSH
EGG LENGTH 30mm

LITTLE OWL ❯
EGG LENGTH 34mm

SPARROWHAWK ❯
EGG LENGTH 40mm

GARDENING AND GARDEN PLANTS FOR BIRDS

Even if you don't garden with birds specifically in mind, a wide range of species is sure to visit you. But with a bit of planning and insight into birds' requirements – notably shelter for nesting and roosting, and natural food sources – numbers and species diversity can be increased dramatically.

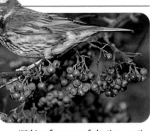

Within a few years of planting, a native Hawthorn hedge will produce a heavy crop of berries in most years; migrant Redwings feast on this food source in autumn.

NATURAL FOOD

Although some birds have very specific diets, with bill shape and behaviour to match, most species found in the garden eat a range of foodstuffs. In terms of their natural diet, some are omnivorous and, to a degree, opportunistic throughout the year. Blackbirds, for example, will feed on invertebrates in any month, but when fruits are in season these will be feasted upon. Other birds show marked seasonal differences. Tits and finches, for example, will seek out invertebrates in spring and summer, particularly to feed their young, but seeds and nuts feature heavily in their diet in autumn and winter when invertebrates are hard to find. A knowledge of each species' preferences can help allow us to maximise the opportunities for birds to feed in the garden.

BELOW: Holly trees have separate sexes, with only the female trees producing berries. These are eagerly consumed by thrushes in winter, and particularly good trees will become 'owned' by a territorial Mistle Thrush that will do its best to drive away all-comers.

Encouraging a wide range of invertebrates in the garden may seem anathema to some diehard traditional gardeners, but it is the way forward for the enlightened majority who are environmentally aware. Not only is this approach good for insect-eating birds, but it also helps wildlife in general, and maximising biodiversity is something that every responsible gardener should strive for. By growing as many native plant species as possible and tolerating as many native 'weed' species, you will have gone a long way to achieving this goal; Brambles and nettles are particularly important in this regard. But perhaps the single most important thing you can do is to avoid using chemicals in the garden, in any shape or form. Put simply, if you learn to love aphids your garden Blue Tits and their broods will be eternally grateful!

RIGHT: Alder cones are food for Siskins, Redpolls and Goldfinches in winter.

Similarly, by growing as many berry-bearing and seed-rich plants, shrubs and trees as possible, you will be doing something really positive for the bird species that depend on these food sources in the winter months. Suitable shrubs and trees include Rowan, Dogwood, Holly, Blackthorn and Hawthorn.

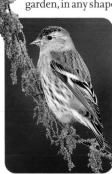

ABOVE: The value of Common Nettle as a food plant for the caterpillars of certain butterfly species is well known. But the plant also produces a good crop of seeds and, in times of hardship in particular, finches such as Siskins (seen here) value them as a source of food.

Grow a few Teasel plants in the garden and you are more than likely to be visited by Goldfinches in late winter. Males have narrower bills than females and are the most adept sex when it comes to extracting the seeds. Gardeners beware though: teasels can be invasive if left unchecked so you might want to keep an eye on the number of rosettes of these biennial plants you allow to mature.

NATURAL NEST SITES

Many of the plants that bird-friendly gardeners encourage as sources of food for birds are also good for nesting. A dense hedge of spiny shrubs provides a safe haven for many breeding species, as does the cover created by patches of Brambles and Common Nettles. During the winter months in particular, dense shrubs are important as roosting sites for many species and the value of Ivy in this regard cannot be overstated.

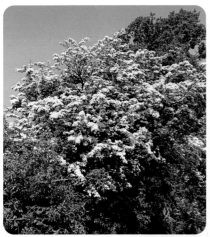

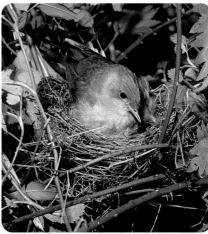

ABOVE: **In spring, the leaves and spiny shoots of Hawthorn combine to create a near-impenetrable refuge for nesting birds such as finches, while the flowers are alive with pollinating insects.**

ABOVE RIGHT: **A thicket of Brambles and nettles is perfect for nesting Blackcaps.**

RIGHT: **Gardeners need do little to assist the breeding success of Woodpigeons in the garden: they construct what appears to be the flimsiest of twig nests, often in surprisingly open settings.**

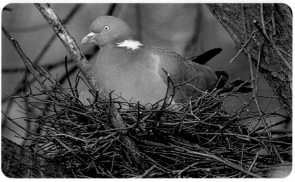

KEEP BRITAIN UNTIDY!

Growing suitable flowers, shrubs and trees is an important first step when it comes to encouraging birds in the garden. But gardeners should also be aware of how critical the timing of garden activities can be for birds. Take the pruning of shrubs and hedges, for example, a task that most gardeners have to face on a regular basis. If you prune and cut things back in the autumn, you will probably remove seeds, fruits and berries that would otherwise provide a natural source of food for birds in winter, and you will also destroy hibernating insect eggs and larvae attached to the twigs and buds. And if you leave the task until late winter or early spring, you run the risk of disturbing early-nesting birds. Herbaceous borders are also important. There is an understandable and natural tendency to want to cut back dead plants in the autumn, but many of these species harbour seeds that are food for birds in winter. So if you can bear to, leave tidying up the herbaceous border until late winter. And never burn fallen leaves: either compost them or, better still, spread them on garden borders and beds, as the invertebrates they harbour are food for birds as well.

Sparrowhawk *Accipiter nisus* Length 33cm Wingspan 60–75cm

Widespread and common raptor that catches small birds in flight in surprise, low-level attacks. Has relatively short, rounded wings, a proportionately long, barred tail, long legs and staring yellow eyes. Male is appreciably smaller than female and separable by plumage as well as size. **ADULT MALE** has blue-grey upperparts and pale underparts, strongly barred and reddish brown on body and wing coverts. **ADULT FEMALE** has grey-brown upperparts and pale underparts with fine, dark barring. **JUVENILE** has brownish upperparts and pale underparts, strongly marked with broad brown barring. **VOICE** Utters a shrill *kew-kew-kew* in alarm. **HABITAT AND STATUS** Associated with wooded habitats, both rural and suburban; the commonest raptor seen in gardens. As many as 30,000 pairs breed in Britain while, in autumn, young birds more than double the number present.

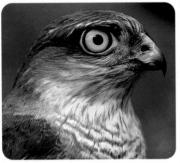

OBSERVATION TIPS A twig nest is constructed in a tree (conifers are favoured), and the nest site is the focal point for breeding pair's territory. Established birds are typically resident, while juveniles tend to wander in autumn and winter. When breeding, Sparrowhawks are notoriously secretive. Look for piles of feathers at a regular 'plucking post' or listen for the sound of alarm calls uttered by unseen birds. In early spring, males circle high above territories in display. At other times of year, sightings are really a matter of chance. Hunting birds are most active at dawn and dusk. With experience, specific Sparrowhawk-inspired alarm calls uttered by tits and other garden birds can be detected.

male

Kestrel *Falco tinnunculus* Length 34cm Wingspan 65–80cm

Widespread falcon that habitually hovers where lookout perches are not available, scanning the ground below for small mammal prey; also takes small birds and insects. Sexes are dissimilar. **ADULT MALE** has a dark-spotted orange-brown back, blue-grey head, and blue-grey tail with black terminal band. Underparts are creamy buff with bold black spots on body. In flight and from above, dark outerwing contrasts with orange-brown innerwing and back. **ADULT FEMALE** has barred brown upperparts; underparts are pale creamy buff with dark spots. In flight and from above, contrast between brown innerwing and dark outerwing is less distinct than with male and tail is barred. **JUVENILE** resembles adult female but upperparts are more reddish brown. **VOICE** Utters a shrill and insistent *kee-kee-kee...* **HABITAT AND STATUS** Found in all kinds of open grassy places and an occasional visitor to gardens; sometimes nests in abandoned buildings. 50,000 or so pairs nest in Britain. **OBSERVATION TIPS** Unlikely to be confused with other raptors in a garden setting. Hard to encourage to visit small gardens, but pairs may use suitable nest boxes in rural locations.

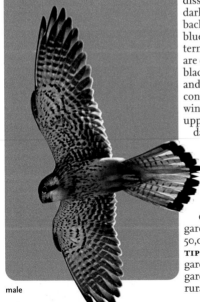

male

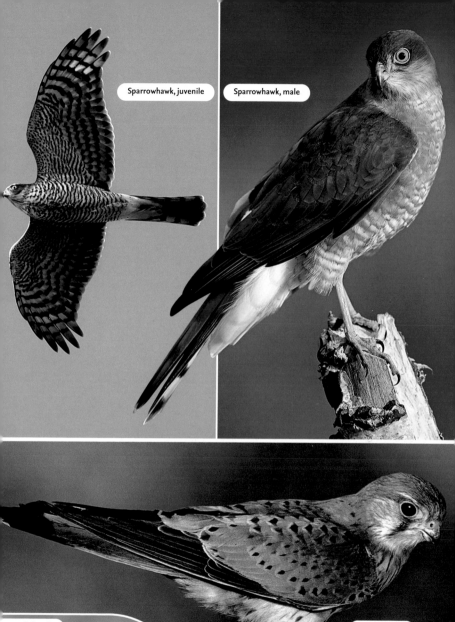

Sparrowhawk, juvenile

Sparrowhawk, male

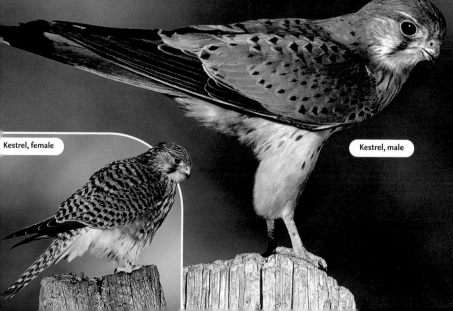

Kestrel, female

Kestrel, male

Pheasant *Phasianus colchicus* Length (including tail) 65–90cm (male), 55–70cm (female) Wingspan 70–90cm (both sexes)

Male is colourful and unmistakable; female is also hard to confuse with other species. Takes flight noisily and explosively when flushed. Sexes are dissimilar. **ADULT MALE** has orange-brown body plumage, blue-green sheen on head, red wattle and long, barred orange tail; some birds have a white collar. **ADULT FEMALE** is mottled buffish brown with a shorter tail than male. **JUVENILE** resembles small, short-tailed adult female. **VOICE** Territorial male utters shrieking call followed by bout of vigorous wingbeating. In alarm, a loud *ke-tuk, ke-tuk, ke-tuk* is uttered as bird flies away. **HABITAT AND STATUS** An alien species, established here since the 11th century. Mostly associated with farmland and wooded habitats but often visits rural gardens, especially where birds are fed. **OBSERVATION TIPS** Hard to miss. Often becomes tame in gardens where it is fed.

male

Black-headed Gull *Larus ridibundus* Length 35–38cm Wingspan 94–105cm

Our most numerous medium-sized gull and the one most likely to visit gardens. Plumage varies with age and time of year, but species can be distinguished at all times by white leading edge to outerwings. Sexes are similar. **SUMMER ADULT** has grey back and upperwings, white underparts and chocolate-brown hood. Legs and bill are red. Note subtle white eye-ring. In flight, trailing edge of outerwing is black. **WINTER ADULT** loses dark hood; white head has dark smudges above and behind eye; in other respects plumage is similar to summer adult. **JUVENILE** has orange-brown flush to upperparts, some dark feathering on back, dark smudges on head, and dark tip to tail. Acquires adult plumage by 2nd winter through successive moults. 1st-winter bird retains many juvenile features but loses rufous feathering and gains uniform grey back. 1st-summer bird still has juvenile-type pattern on wings but gains a dark hood. **VOICE** Utters raucous calls that include a nasal *kaurrr*. **HABITAT AND STATUS** At least 200,000 pairs probably nest in Britain. Numbers are boosted in winter by birds from mainland Europe; several million may be present outside the breeding season. This opportunistic feeder sometimes visits bird tables, mainly in coastal and urban districts, where numbers are highest. **OBSERVATION TIPS** If you live in an area where the species is common and want to attract it to your garden, then a large, open bird table stocked with bread and scraps will probably do the trick.

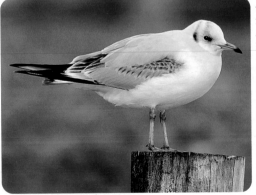

1st-winter

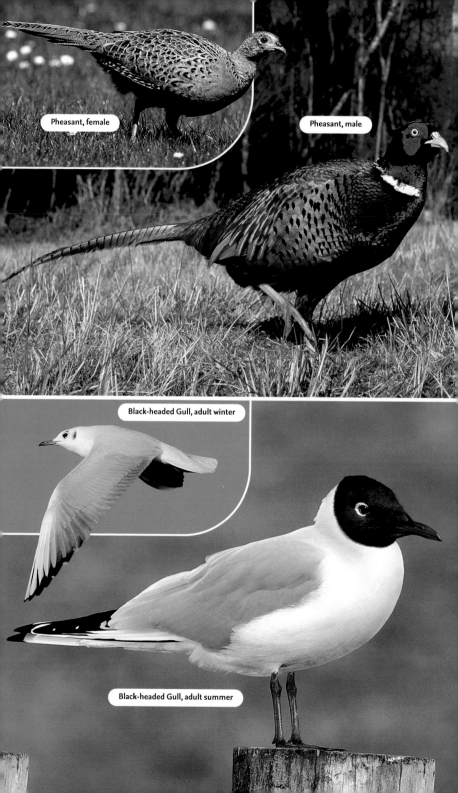

Pheasant, female

Pheasant, male

Black-headed Gull, adult winter

Black-headed Gull, adult summer

Feral Pigeon *Columba livia* Length 33cm Wingspan 66cm

Domesticated descendant, and urban counterpart, of the Rock Dove. Occurs in a wide variety of colour forms, some of which resemble the ancestral Rock Dove. Often forms flocks. Sexes are similar. **ADULT AND JUVENILE (ANCESTRAL FORM)** has blue-grey plumage, palest on upper-wings and back, and flushed pinkish maroon on breast. Note 2 dark wingbars, seen in standing birds, and dark-tipped tail. In flight, note small white rump patch; upperwings reveal a dark trailing edge, plus a narrow wingbar, while underwings are white. Also seen as a spectrum of colour forms from almost black to pure white. **VOICE** Utters a range of cooing calls. **HABITAT AND STATUS** Ancestral Rock Dove is restricted to coasts and cliffs in the N and W, where it is scarce. Feral Pigeon is widespread and common elsewhere in Britain, and particularly abundant in urban areas; many have also returned to ancestral-type habitats. Feral Pigeons are often abundant (to the point of becoming a nuisance) in most towns and cities. Smaller numbers are also found near farms, sometimes feeding alongside Woodpigeons (below) in arable fields. **OBSERVATION TIPS** You will have no problem seeing this species, or in attracting it to your garden with food, if you live in a town or city.

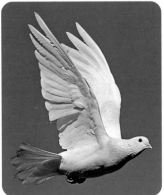

Woodpigeon *Columba palumbus* Length 41cm Wingspan 78cm

Plump, familiar bird of lightly wooded, open country. Often visits rural gardens and also occurs in leafy suburbs of towns and cities. Its 'song' is a familiar countryside sound, as is the loud clatter of wings heard as a bird flies off in alarm, or when aerial displays are performed in spring. Forms flocks outside the breeding season. Sexes are similar. **ADULT** has mainly blue-grey plumage with pinkish maroon on breast. Note the striking white patch on side of neck and, in flight, prominent, transverse white wingbars, accentuated by dark wingtips; tail has a dark terminal band. **JUVENILE** is similar to adult but white mark on neck is missing. **VOICE** Sings a series of *oo-OO-oo, oo-oo* phrases. **HABITAT AND STATUS** The most numerous of its kind on farmland and in the countryside at large; has benefited from the cultivation of oilseed rape. Found increasingly in urban settings where, in contrast to their rural cousins, birds often become tolerant of people, sometimes even tame. **OBSERVATION TIPS** You should have no difficulty in seeing this species almost anywhere in mainland Britain and Ireland throughout the year. Can be attracted to the garden by supplying grain as a feed and, if you have a mature oak tree, birds will gather in autumn to feed on fallen acorns. Often nests in surprisingly spindly garden trees and shrubs.

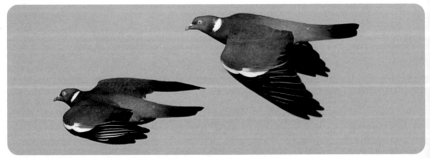

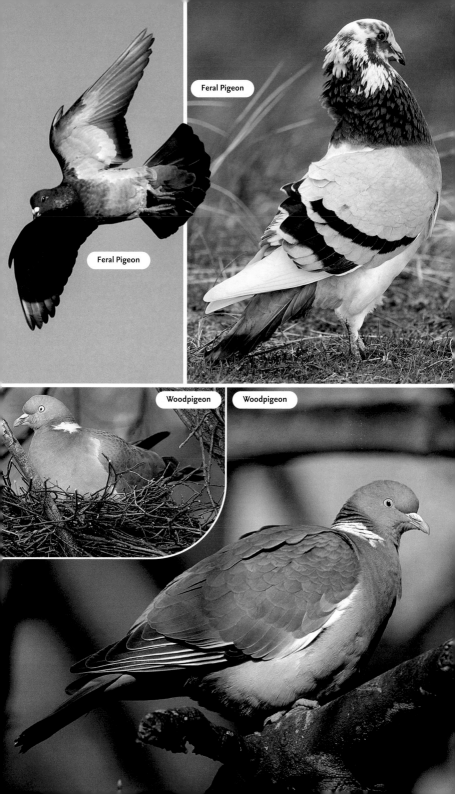

Feral Pigeon

Feral Pigeon

Woodpigeon

Woodpigeon

Collared Dove *Streptopelia decaocto* Length 32cm Wingspan 51cm
Comparatively recent arrival to Britain but now a familiar sight. Its
distinctive call is also well known, particularly in urban areas, as is its
gliding display flight, performed on bowed, outstretched wings. Sexes
are similar. **ADULT** has mainly sandy-brown plumage with pinkish
flush to head and underparts. Note dark half-collar on nape. Black
wingtips and white outer-tail feathers are most noticeable in flight.
Bill is dark and legs are reddish. **JUVENILE** is similar but duller and
black half-collar is absent. **VOICE** Utters a repetitive (and, for many
people, mildly irritating) song that comprises a much-repeated *oo-
oo-oo* phrase. **HABITAT AND STATUS** Spread NW across Europe during
the first half of the 20th century; first recorded here in the 1950s. Since

then it has prospered and now
the population probably numbers more than
100,000. Often associated with urban areas
and a frequent visitor to many gardens. Also
fairly common on arable farmland, usually
near farm buildings and grain spills.
OBSERVATION TIPS A familiar garden bird
and usually easy to see. Birds are often rather
tame and usually travel around in pairs, even
in winter.

Swift *Apus apus* Length 16–17cm Wingspan 45cm
Familiar summer visitor that is invariably seen in flight. Indeed, apart from
when nesting, Swifts spends their entire life in the air, eating, sleeping
and mating on the wing. The large gape allows it to capture flying insects.
Easily recognised by its anchor-shaped outline in flight and mainly
dark plumage. Sexes are similar. **ADULT** has overall blackish-brown
plumage, although in good light its pale throat can be discerned.
Tail is forked but often held closed in active flight. **JUVENILE** is
similar, but plumage is darker overall while throat is whiter and
forehead can look rather pale. **VOICE** Loud, shrill, screaming calls
are often heard from parties of birds as they chase one another over-
head, or at breakneck speed through narrow streets. **HABITAT AND
STATUS** Nesting Swifts are typically associated with man-made structures and
churches; loft spaces in houses are favoured sites. At other times, birds are seen in the air,
and usually congregate where insects are numerous. Common breeding bird in S Britain
but decidedly scarce in far N; many tens of thousands of pairs breed in the region as a
whole. **OBSERVATION TIPS** Easy to see in late spring and early summer in most low-lying
villages and towns. Typically, adult birds will have vacated nesting sites by early Aug.

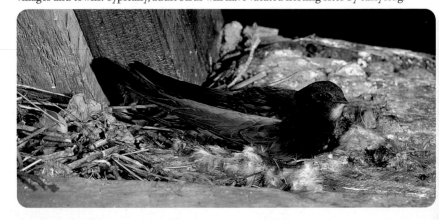

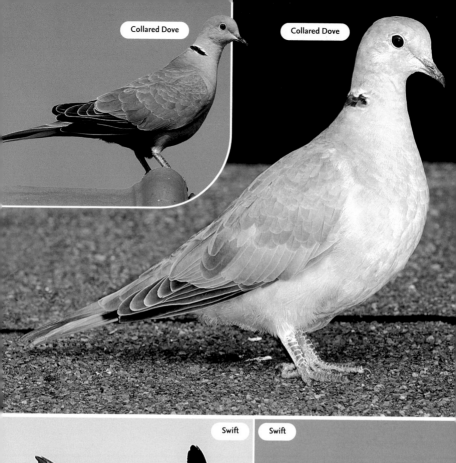

Collared Dove

Collared Dove

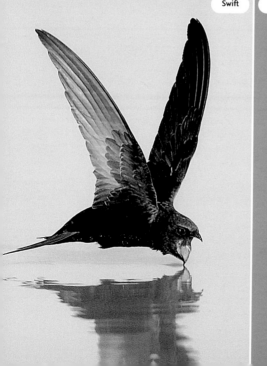

Swift

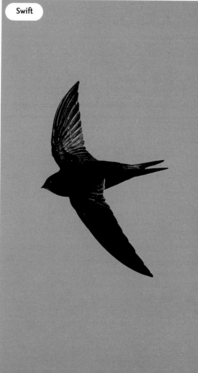

Swift

Tawny Owl *Strix aluco* Length 38–40cm Wingspan 99cm

Our commonest garden owl, usually easier to hear than see. Roosts unobtrusively in the daytime among branches and foliage of trees; sometimes discovered and mobbed by small songbirds. Flight is leisurely on broad, rounded wings. Sexes are similar. **ADULT** has variably chestnut-brown or grey-brown plumage. Streaked underparts can look rather pale (especially when seen in artificial light after dark); dark streaks on well-marked upperparts. Eyes are dark. In flight, underwings look rather pale. **JUVENILE** typically leaves nest while downy and white; adult-like plumage is acquired within a few weeks. **VOICE** Utters a sharp *kew-wick* and well-known hooting calls; most vocal in late winter and early spring when territorial boundaries are under dispute. **HABITAT AND STATUS** A resident species that is associated predominantly with woodland habitats where small mammal prey – mainly mice and voles – are common. Also occurs in gardens and suburban parks with mature trees, and will even use nest boxes if these are placed in a quiet corner of the garden high off the ground. Because the Tawny Owl is nocturnal and unobtrusive, its precise status is difficult to gauge, but several tens of thousands of birds probably live in Britain. **OBSERVATION TIPS** Listen out for calling Tawny Owls in Jan–Mar. If you can imitate their calls, this will sometimes elicit a response. In the daytime, listen for telltale alarm calls of mobbing songbirds – Blackbirds are particularly vocal – and you might spot the source of their aggravation.

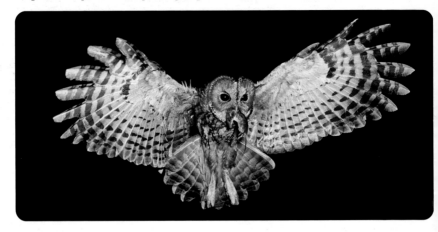

Little Owl *Athene noctua* Length 22cm Wingspan 56cm

Our smallest owl, recognised even in silhouette by its dumpy outline and short tail. Also one of the easiest owls to see since it is often active in daylight. When perched and curious, it often bobs its head and body. Sexes are similar. **ADULT** has brown upperparts that are adorned with whitish spots, and pale underparts that have dark streaks. Note the staring yellow eyes. **JUVENILE** is similar but less well marked and lacks spotting on head. **VOICE** Calls include a strange, cat-like *kiu*, uttered repeatedly and agitatedly in early evening. **HABITAT AND STATUS** Introduced to Britain from mainland Europe in the 19th century and now widespread and fairly common as far N as S Scotland; absent from Ireland. Around 10,000 pairs are probably resident. Favours open country habitats, typically comprising a mosaic of fields and hedgerows. Sometimes visits rural gardens and nests in tree-holes and cavities in stone walls and old buildings. **OBSERVATION TIPS** Listen for distinctive calls at dusk to discover whether Little Owls are present in a given area. They often perch on fenceposts and dead branches in daytime, and will take to the provision of nest boxes.

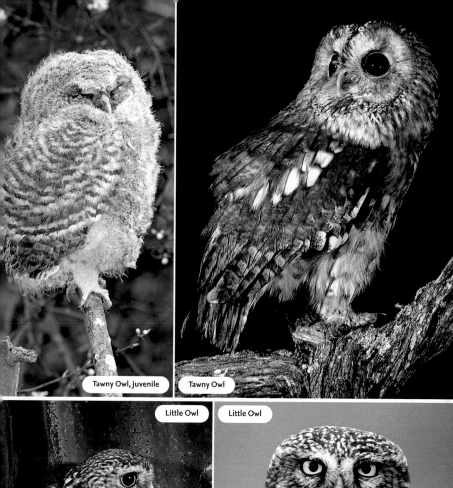

Tawny Owl, juvenile

Tawny Owl

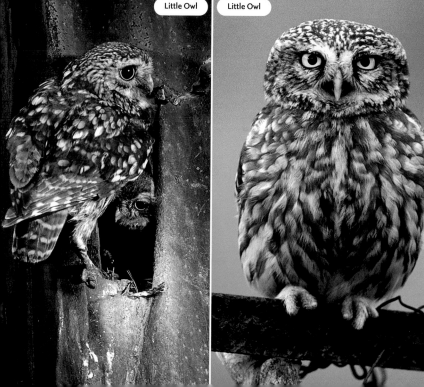

Little Owl

Little Owl

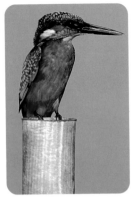

Kingfisher *Alcedo atthis* Length 16–17cm
Wingspan 25cm

Dazzlingly attractive bird with a dagger-like bill. Colours can look muted in shade. Tied to water because of its fish-based diet and often perches on overhanging branches. Occasionally attracted to large, fish-stocked garden ponds. Sexes are separable with care. **ADULT** has orange-red underparts and mainly blue upperparts; electric-blue back is seen to best effect in flight. Legs and feet are red. Bill is all dark in male; base of lower mandible is red in female. **JUVENILE** is similar but colours are duller and tip of bill is pale. **VOICE** Utters a distinctive, thin, high-pitched call in flight. **HABITAT AND STATUS** Widespread resident of rivers, streams and lakes. Occasionally visits garden ponds, especially in the summer months, when birds tend to wander as streams dry up. **OBSERVATION TIPS** If you create a large pond and stock it with sticklebacks, you might attract a Kingfisher to the garden; remember to provide a suitable fishing perch.

Ring-necked Parakeet *Psittacula krameri* Length 40–42cm Wingspan 45cm

Established alien species and a rather out-of-place British resident. Colourful, with a distinctive long-tailed outline in flight. Sexes are similar. **ADULT MALE** has mainly green plumage but dark flight feathers are noticeable on wing. Note the red bill and eye-ring, and pinkish neck-ring that is dark-bordered towards lower margin; this links to black throat. **ADULT FEMALE** is similar but lacks any markings on neck or throat. **VOICE** Often announces its presence (including in flight) with loud, squawking calls. **JUVENILE** is similar to adult female but duller and with shorter tail. **HABITAT AND STATUS** A feral population (escapees from captivity and their progeny) is now established in parts of Britain and as many as 7,000 individuals may be present in winter in the region as a whole. Suburban W fringes of London are a stronghold for the Ring-necked Parakeet, which looks particularly incongruous when seen flying over the M4 or against the bleak backdrop of industrial complexes that fringe Heathrow Airport. **OBSERVATION TIPS** Often first detected by its raucous calls. If you live along the Thames/M4 corridor between London and Windsor, you are certain to encounter the species sooner or later by chance. Nests in tree-holes (often out-competing and excluding native species). Sometimes visits bird tables; has an eclectic diet that includes seeds, fruits and nuts.

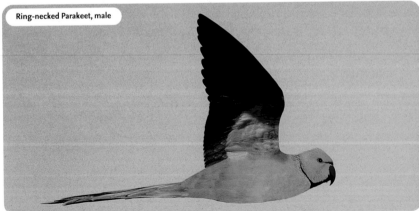

Ring-necked Parakeet, male

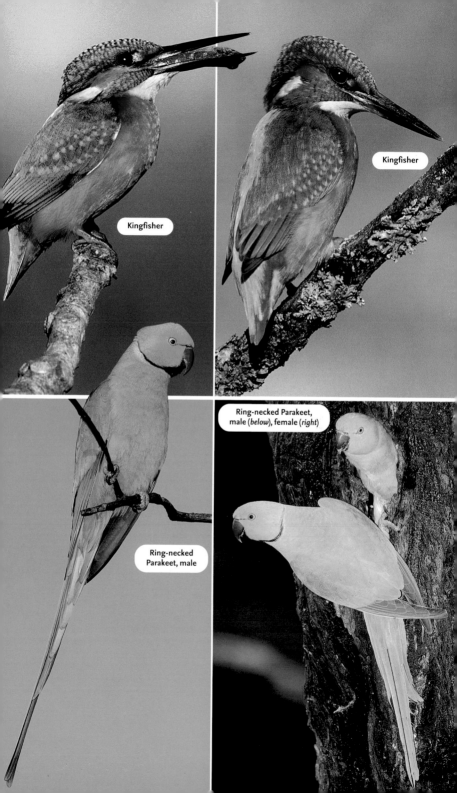

Kingfisher

Kingfisher

Ring-necked Parakeet, male

Ring-necked Parakeet, male (*below*), female (*right*)

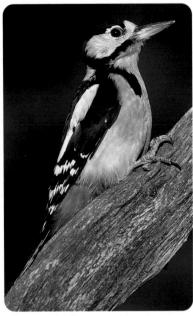

male

Great Spotted Woodpecker
Dendrocopus major
Length 23–24cm Wingspan 36cm
The most familiar woodpecker species in the garden. Often seen climbing tree trunks or in undulating flight. Excavates timber by drilling with its bill. Sexes are similar but separable with care. **ADULT MALE** is mainly black on back, wings and tail, with white 'shoulder' patches and narrow white barring; underparts are mainly grubby white. Head pattern is distinctive: face and throat are white, while cap and nape are black and connect via a black line to a black stripe running from base of bill. Note also red patch on nape and red vent. In flight, white barring and shoulder patches are striking. **ADULT FEMALE** is similar but lacks the red nape patch. **JUVENILE** recalls an adult male but note the red crown and subdued red vent colour. **VOICE** All birds utter a loud *tchick* alarm call. In spring, males 'drum' loudly (by hammering bill against tree trunk) to proclaim territorial ownership. **HABITAT AND STATUS** Widespread and generally common in wooded habitats throughout S and central England and Wales; becomes less numerous further N in its range. A frequent garden visitor to peanut feeders. **OBSERVATION TIPS** Easily detected by its loud alarm call and most vocal in spring. Also easy to attract to the garden with feeders.

Green Woodpecker *Picus viridis* Length 32–34cm Wingspan 41cm
Despite its size and colourful plumage, this woodpecker can be tricky to observe well. Climbs trees and excavates timber but also feeds on the ground, using its long tongue to extract ants from subterranean nests. Flight is undulating. Sexes are similar but separable with care. **ADULT MALE** has greenish-olive upperparts and whitish underparts. Head is adorned with a red crown, black 'mask' and red-centred black 'moustache'. In flight, yellowish rump is striking. **ADULT FEMALE** is similar but 'moustache' is all black. **JUVENILE** recalls an adult male but is heavily spotted. **VOICE** Its *yaffling* call is distinctive and its song comprises a dozen or so yelping, call-like notes. **HABITAT AND STATUS** Found in open woodland, parks and gardens. Relatively common in central and S England and Wales; becomes scarcer further N in its range. **OBSERVATION TIPS** Easily overlooked during the summer months when leaves are on trees; best located by becoming familiar with its distinctive call. Typically rather wary and often actively hides by shuffling around the other side of a tree trunk from an observer. Easiest to observe when 'anting' on the lawn, and sometimes becomes so preoccupied with feeding that a fairly close approach is permitted.

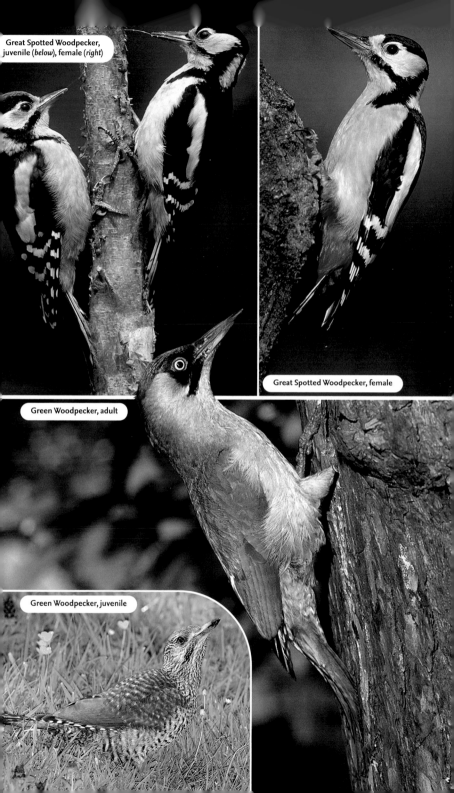

Great Spotted Woodpecker, juvenile (*below*), female (*right*)

Great Spotted Woodpecker, female

Green Woodpecker, adult

Green Woodpecker, juvenile

House Martin *Delichon urbica* Length 12–13cm Wingspan 28cm

Familiar and welcome summer visitor that is easily recognised in flight by its rather black and white appearance and conspicuous white rump. Sexes are similar. **ADULT** has mainly blue-black upperparts with a striking and contrasting white rump; underparts are white. **JUVENILE** is similar but underparts are rather grubby white and upperparts are duller. **VOICE** Utters a distinctive *prrrt* call in flight. Its twittering song is often delivered from overhead wires in the vicinity of the nest. **HABITAT AND STATUS** Summer visitor to the region and generally widespread, although decidedly scarce in the far N. As its name suggests, is typically associated with houses during the breeding season. Its rather spherical mud nest is constructed under eaves and

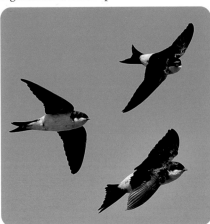

overhangs in loose colonies; in more natural settings, birds sometimes breed on cliffs and near cave entrances. Several hundred thousand pairs are probably present in the region as a whole in summer. During the breeding season, feeding (on insects, caught in flight) often takes place in the vicinity of the nesting site. **OBSERVATION TIPS** House Martins are invariably associated with houses, and most towns and villages can boast small colonies. Soon after their arrival in spring, birds can be seen gathering sticky mud from puddles, which is mixed with saliva and used to build the nest. Keep muddy puddles topped up with water to aid the birds. Artificial nests, placed under the eaves of a house, will sometimes attract breeding pairs and may even start a colony.

Swallow *Hirundo rustica* Length 19cm Wingspan 34cm

Familiar migrant visitor, recognised in flight by its pointed wings and long tail streamers. The appearance of the first Swallows in early Apr is considered by many people to herald the arrival of spring. Sexes are similar, although on average males have longer tail streamers than females. **ADULT** has blue-black upperparts and white underparts except for dark chest band and brick-red throat and forecrown. **JUVENILE** is similar but has shorter tail streamers and a pale buffish-red throat. **VOICE** Utters a sharp *vit* call in flight; male sings a

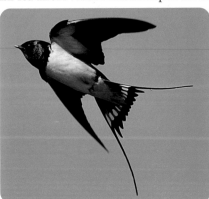

twittering song, often while sitting on overhead wires near the nest site. **HABITAT AND STATUS** Common and widespread during the summer months; more than 500,000 pairs are probably present in the region at this time. Nesting Swallows are usually associated with margins of rural villages and farmyards; they typically nest under eaves or in barns or sheds, attaching a half-cup-shaped nest of mud to a wall or rafter. On migration, in spring and autumn, birds often congregate near water. **OBSERVATION TIPS** Easy to see during the breeding season since nesting pairs often perch conspicuously and are comparatively unafraid of people.

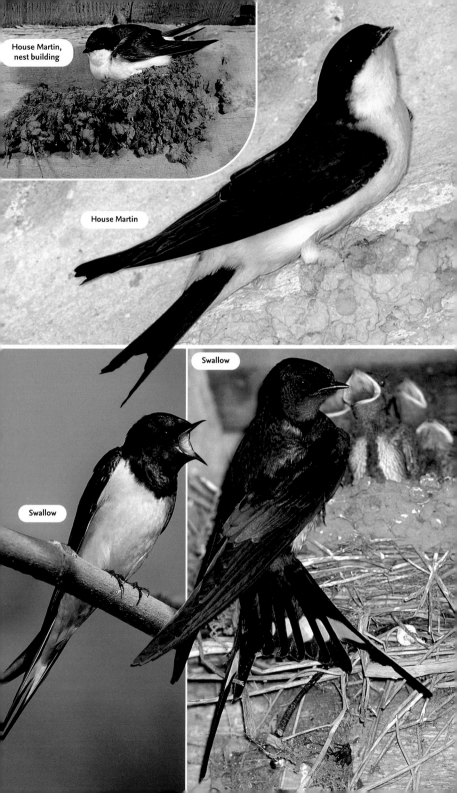

House Martin, nest building

House Martin

Swallow

Swallow

Pied Wagtail *Motacilla alba yarrellii* Length 18cm Wingspan 28cm

Familiar black, grey and white bird. Has a distinctive habit of pumping its tail up and down; flight is bounding. Sexes are dissimilar. **SUMMER ADULT MALE** has mainly white underparts and black upperparts, but note the white face and striking white wingbars. Legs and bill are dark and outer-tail feathers are white. **WINTER ADULT MALE** is similar but throat is white, and black on breast is less extensive. **ADULT FEMALE** recalls adult male in appropriate seasonal plumage but back is dark grey, not black. **JUVENILE AND FIRST-WINTER BIRDS** have greyish upperparts (note, however, black rump) and whitish

underparts; whitish wingbars are striking, and face sometimes reveals faint yellowish wash. **VOICE** Utters a loud *chissick* call. **HABITAT AND STATUS** Associated with areas of bare ground and short grassland, and often found in urban locations such as playing fields and car parks. Sometimes nests in garden sheds and outbuildings. Several hundred thousand pairs breed in the region as a whole. Usually most numerous in S towns in winter: birds from upland regions and the far N move S to lowland areas outside the breeding season. **OBSERVATION TIPS** You should have little difficulty in finding this species. Most school playing fields and supermarket car parks have their own resident pair. In winter, birds sometimes visit gardens that have extensive lawns.

juvenile

Waxwing *Bombycilla garrulus* Length 18cm Wingspan 34cm

Distinctive and much-admired bird. Often remarkably indifferent to human observers, allowing superb views to be obtained. In flight, its silhouette is rather Starling-like. Sexes are similar but separable. **ADULT** has mainly pinkish-buff plumage, palest on belly. Note the black crest,

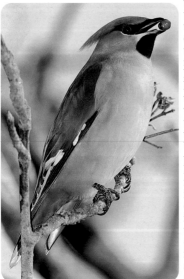

throat and black mask through eye. Rump is grey, undertail is chestnut and dark tail has a broad yellow tip (narrower in female than male). Wings have red, wax-like projections. Flight feathers have yellow edges in female; note white margins and yellow edges in male. **FIRST-WINTER BIRD** is similar to respective sex adult but the red wax-like wing projections are absent. **VOICE** Utters a trilling call. **HABITAT AND STATUS** Winter visitor from N mainland Europe. Numbers vary from year to year. In most seasons, several hundred probably spend the winter here, with most records from E Britain. However, if the berry crop fails in NE Europe influxes may involve thousands of birds and Waxwings can occur almost anywhere in Britain. **OBSERVATION TIPS** Could turn up wherever berry-bearing bushes flourish. By the end of winter, when most berries have been consumed in the countryside, Waxwings move to urban areas and often feed on Rowan and pyracantha berries in gardens and car parks, typically remaining until the food supply has been exhausted.

male

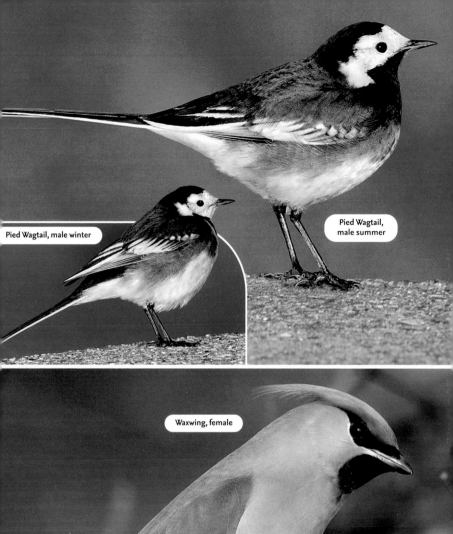

Pied Wagtail, male winter

Pied Wagtail, male summer

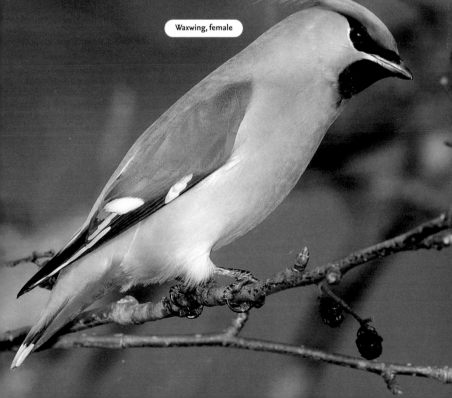

Waxwing, female

Wren *Troglodytes troglodytes* Length 9–10cm Wingspan 15cm
Tiny bird, recognised by its dumpy proportions, mainly dark brown
plumage and habit of frequently cocking its tail upright. Rather unob-
trusive as it creeps through low vegetation in search of insects, making
it appear mouse-like. Very vocal; the presence of unseen birds is often
detected by hearing the distinctive call. Sexes are similar. **ADULT AND
JUVENILE** have dark reddish-brown upperparts with barring on wings
and tail. Underparts are greyish white with a buff wash to flanks;
note also the striking pale supercilium. Bill is needle-like and legs
are reddish. **VOICE** Utters a loud, rattling alarm call. Song is loud and
warbling, ending in a trill. **HABITAT AND STATUS** Widespread resident,
found in a range of habitats, from woodlands and hedgerows to scrub
patches and coastal cliffs, the common factor being dense undergrowth.
Common in most mature gardens; nests in Ivy thickets, dense bushes and outbuildings.
Population fluctuates from year to year, suffering badly in severe winters. In a good season
there may be a minimum of 10 million birds in Britain as a whole. **OBSERVATION TIPS** Listen
for the species' distinctive call to indicate whether it is present in any given area. In severe
winters, Wrens sometimes visit bird tables or forage for scraps on the ground below.

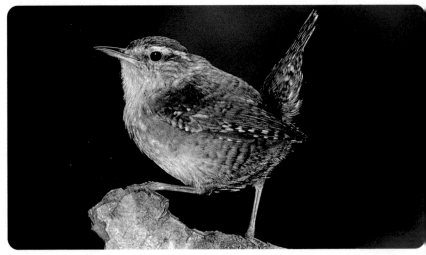

Dunnock *Prunella modularis* Length 13–14cm Wingspan 20cm
Vaguely House Sparrow-like bird but with a thin, warbler-like bill. Gener-
ally skulking, although males are comparatively bold and conspicuous
in spring. Sexes are similar. **ADULT** has heavy streaking on chestnut-brown
back. Underparts are mostly bluish grey but flanks are boldly streaked
with brown and chestnut. Face is bluish grey with brown streaking on
ear coverts and crown. Note the faint, pale wingbar. Bill is needle-thin
and dark, and legs are reddish pink. **JUVENILE** is similar but with
bolder streaking. **VOICE** Song is energetic and warbler-like; usually
delivered from a prominent perch or highest tangle in a Bramble
patch. Alarm call is a thin, piping *tseer*. **HABITAT AND STATUS** Wide-
spread and rather common resident of woodlands, hedgerows, gardens
and similar habitats – in fact, almost anywhere that harbours low, dense cover
such as Bramble patches. **OBSERVATION TIPS** Feeds quietly and unobtrusively, mainly on
the ground and generally close to cover. If a partial view is obtained, it can look almost
mouse-like. Consequently, despite the species' relative abundance, it can be difficult to locate
unless you are familiar with its alarm call. Easiest to see in spring, when males in particular
exhibit a reversal in the species' typically retiring behaviour and frequently sit out in the open

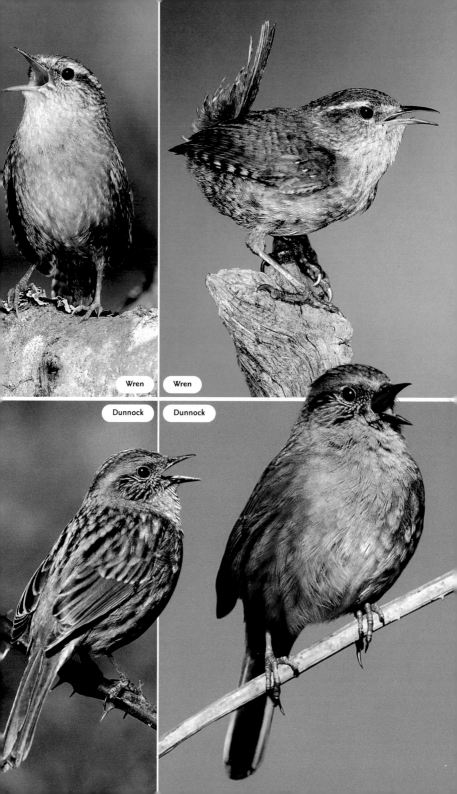

Wren

Wren

Dunnock

Dunnock

Robin *Erithacus rubecula* Length 13–14cm Wingspan 21cm

Familiar bird and one of the nation's favourites. Often bold and inquisitive in garden settings but usually much less so in the countryside. Strongly and conspicuously territorial. Sexes are similar. **ADULT** is unmistakable with its striking orange-red face, throat and breast; this is bordered by blue-grey to sides with a sharp demarcation from white belly. Upperparts are buffish brown; note the faint buff wing-bar. **JUVENILE** has brown upperparts, marked with pale buff spots and teardrop-shaped streaks. Pale buff underparts are adorned with darker spots and crescent-shaped markings. **VOICE** The rather plaintive, melancholy song can be heard in almost any month

although the species is most vocal in spring. Alarm call is a sharp *tic*. **HABITAT AND STATUS** Widespread and common resident in most of England, Wales and Ireland; its distribution is rather more patchy in Scotland, and it is scarce in the far N. Passage migrants from mainland Europe pass through Britain in autumn. **OBSERVATION TIPS** Usually one of the easiest songbirds to find, and to observe well. In many gardens Robins will actively seek out people in the hope of picking up scraps of food or disturbed invertebrates. Often nests in garden sheds and outbuildings.

Blackbird *Turdus merula* Length 25–28cm Wingspan 36cm

Ground-dwelling bird with thrush-like proportions. Familiar across much of Britain and Ireland, partly because of its liking for gardens and suburban locations, but also because it is so numerous. Sexes are dissimilar. **ADULT MALE** has uniformly blackish plumage. Legs are dark but bill and eye-ring are yellow. **FIRST-WINTER MALE** is similar but bill is dark and eye-ring is dull. **ADULT AND FIRST-WINTER FEMALE** have brown plumage that is darkest on wings and tail, and palest on throat and breast; breast is streaked. **JUVENILE** is similar to adult female but back and underparts are marked with pale spots. **VOICE** Utters a harsh and repeated *tchak* alarm call, often at dusk or if a prowling cat is discovered. Male is an excellent songster with a rich and varied repertoire.

Female at nest.

HABITAT AND STATUS In addition to gardens and parks, occurs in areas of woodland and scrub, as well as on farmland, moors and coasts. Resident species, with several million pairs nesting here. Outside the breeding season, birds from N and upland districts tend to move to lower-lying areas, and the population may treble in winter months owing to influxes of birds from N mainland Europe. **OBSERVATION TIPS** You should have no difficulty in seeing and hearing Blackbirds in gardens throughout the region. Often nests in garden sheds and outbuildings.

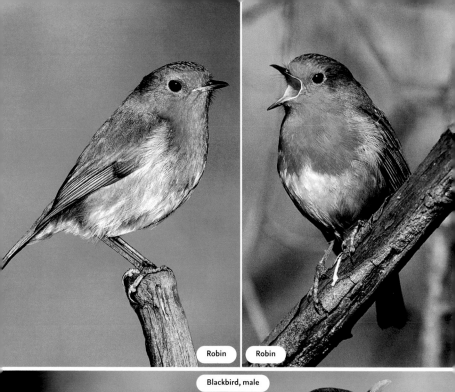

Robin

Robin

Blackbird, male

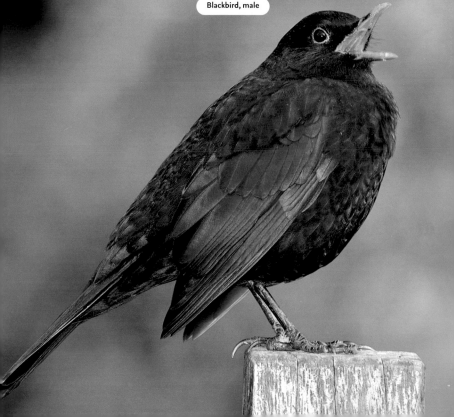

Fieldfare *Turdus pilaris* Length 24–26cm Wingspan 40cm

Large, plump thrush, usually encountered in sizeable winter flocks, often
with Redwings (below). Sexes are similar. **ADULT** has a blue-grey head and
chestnut back; note the pale supercilium. Breast and flanks are washed
with orange-yellow and heavily spotted, while rest of underparts are
whitish. In flight, note the pale grey rump and white underwings.
JUVENILE is similar but note the pale spots on wing coverts. **VOICE**
Utters a harsh *chack-chack-chack* call; night-migrating flocks can
sometimes be detected by these calls. Song (seldom heard in Britain)
comprises short bursts of subdued fluty phrases. **HABITAT AND
STATUS** Common winter visitor from N mainland Europe, with
perhaps a million or more birds present Oct–Mar. Numbers vary from
year to year and the

species is nomadic. Initially, flocks
congregate where berries and fallen
fruit are in good supply, moving on
when food sources are depleted. In
later winter, it is usually found on
farmland and roosts in hedgerows and
adjacent woodland. Small numbers of
Fieldfares nest here, mainly in N
Britain. **OBSERVATION TIPS** Flocks
roam the countryside in midwinter;
usually only visits gardens if condi-
tions are harsh. If snow blankets the
ground, put out apples on your garden
lawn and you may be lucky.

Redwing *Turdus iliacus* Length 20–22cm Wingspan 34cm

Small, well-marked thrush. Winter visitor that forms flocks and often
associates with Fieldfares (above). Sexes are similar. **ADULT** has grey-brown
upperparts and pale underparts, neatly dark-spotted and flushed with
orange-red on flanks and underwings. Has prominent white stripes
above eye and below cheeks. **JUVENILE** is similar but with pale spots
on upperparts and subdued colours on flanks. **VOICE** Utters a thin,

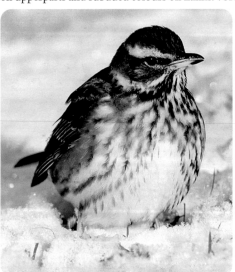

high-pitched
tseerp in flight;
often heard on
autumn nights as
migrating flocks pass
overhead. Song (seldom
heard in region) comprises short
bursts of whistling and fluty phrases.
HABITAT AND STATUS Common
winter visitor, with a million or so
birds present in most years. Usually
associated with farmland, but also
found in open woodland, where birds
forage among leaf litter for earth-
worms. Berries and fallen fruit are
eaten; when food supplies dwindle in
the countryside, nomadic flocks some-
times visits urban parks and gardens.
OBSERVATION TIPS Watch berry-bear-
ing bushes in the garden for this
species. In harsh weather, birds may
be attracted if you put apples out on
the lawn.

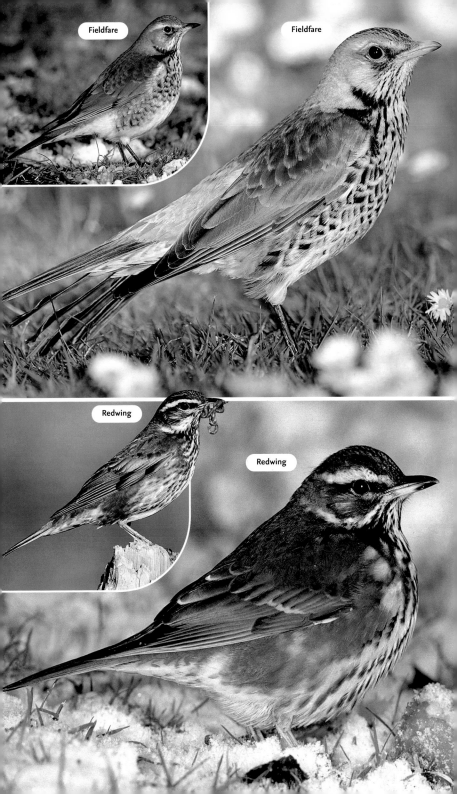

Fieldfare

Fieldfare

Redwing

Redwing

Song Thrush *Turdus philomelos* Length 23cm Wingspan 34cm

Dainty, well-marked thrush. Its attractive appearance and beautiful and
distinctive song contribute to its appeal. Sexes are similar. **ADULT** has
warm brown upperparts with a subtle orange-buff wingbar. Underparts
are pale but well marked with dark spots; note yellowish-buff wash to
breast. In flight, orange-buff underwing coverts aid identification.
JUVENILE is similar but markings and colours are less intense. **VOICE**
Utters a thin *tik* call in flight. Song is loud and musical; phrases are
repeated 2 or 3 times. **HABITAT AND STATUS** Found in woodland,
parks and mature gardens. Perhaps a million or so pairs breed here;
it is least common in N and upland districts. Outside the breeding
season, many Song Thrushes from N Britain move S and some migrate
to mainland Europe. However, the overall population is boosted by influxes
from N mainland Europe. The species has declined in recent decades, with changes in
farming practices contributing to its plight. **OBSERVATION TIPS** Rather secretive in the
breeding season and more easily observed in winter. To encourage Song Thrushes in the
garden, avoid using pesticides and discourage cats by whatever means you deem appropriate.

Mistle Thrush *Turdus viscivorus* Length 27cm Wingspan 45cm

Bulky bird that is appreciably larger than a Song Thrush (above). Often
rather unobtrusive; were it not for its distinctive call and song, it could
easily be overlooked. Sexes are similar. **ADULT** has grey-brown upper-
parts with a suggestion of a white wingbar. Underparts are pale but
marked with large, dark spots; flanks are washed orange-buff. In flight,
note the white underwings and white tips to outer-tail feathers.
JUVENILE recalls an adult but back is adorned with teardrop-shaped
white spots. **VOICE** Utters a loud and distinctive rattling alarm call.
Loud song contains brief phrases and long pauses; it is often sung
in dull weather, even when it is raining. **HABITAT AND STATUS** Wide-
spread throughout much of the region during the breeding season, with
several hundred thousand pairs probably nesting here. Outside the breeding
season, many N and upland regions are vacated and a proportion of the British population
migrates to mainland Europe. However, the overall population is probably boosted in
winter by influxes of birds from N mainland Europe. Mistle Thrushes are found in
areas of open woodland, parks and mature gardens. **OBSERVATION TIPS** Listen for the
distinctive song during the breeding season; it is often the only species that sings with
vigour on rainy days. Its rattling alarm call and white underwings are diagnostic. In
winter, individuals will often establish a territory centred on fruit- and berry-bearing
bushes and trees. Feeds on lawns in large, mature gardens.

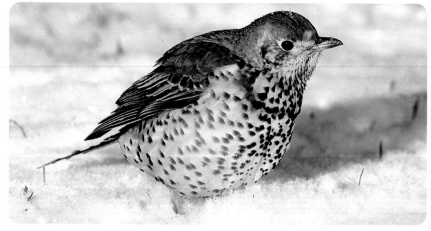

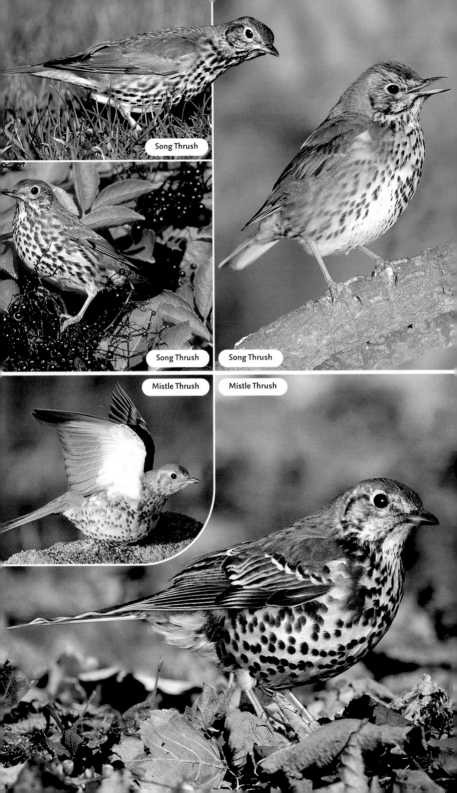

Song Thrush

Song Thrush

Song Thrush

Mistle Thrush

Mistle Thrush

Whitethroat *Sylvia communis* Length 13–15cm Wingspan 20cm

Familiar warbler of open country that sometimes visits gardens. Male often perches conspicuously, allowing good views to be obtained. Sexes

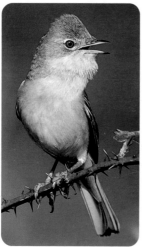

are separable with care. **ADULT MALE** has a blue-grey cap and face, grey-brown back and rufous-brown edges to wing feathers. Throat is strikingly white, while remaining underparts are pale but suffused with pinkish buff, especially on breast. Legs are yellowish brown and bill is yellowish with dark tip. Dark tail has white outer feathers. **ADULT FEMALE AND JUVENILE** are similar to adult male but cap and face are brownish and pale underparts (apart from white throat) are suffused with pale buff. **VOICE** Utters a harsh *check* alarm call. Song, sung from an exposed perch or in flight, is a rapid and scratchy warble. **HABITAT AND STATUS** Widespread summer visitor, present mainly May–Aug. Favours scrub, Bramble patches, overgrown hedgerows and heaths; more than 500,000 pairs probably breed here. **OBSERVATION TIPS** Easy to see in the countryside in spring. Sometimes nests in mature or overgrown garden hedges in rural settings, so leave 'wild' areas and Bramble patches in the garden if you want to encourage this species.

male

Blackcap *Sylvia atricapilla* Length 14–15cm Wingspan 22cm

Well-marked, distinctive warbler. Has an engaging, musical song and is easy to identify in all plumages. Sexes are dissimilar. **ADULT MALE** has grey-brown upperparts and paler, dusky-grey underparts, palest on throat and undertail. Note the pale eye-ring and diagnostic black cap. **ADULT FEMALE AND JUVENILE** have grey-brown upperparts, pale buffish-grey underparts (palest on throat and undertail) and a reddish-chestnut cap; note the pale eye-ring. **VOICE** Utters a sharp *tchek* alarm call. Song is a rich and musical warble. **HABITAT AND STATUS** Found in a range of habitats, from deciduous woodland with dense undergrowth, to areas of scrub and mature gardens and parks. Several hundred thousand pairs probably nest here and most breeders are summer visitors. Their departure

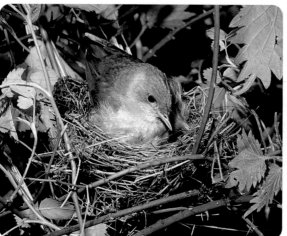

in autumn often overlaps with the arrival of migrants from N mainland Europe, and more than 1,000 of these birds probably winter in Britain and Ireland. **OBSERVATION TIPS** Easy to find in the breeding season and often nests in mature gardens with thick hedges. Overwintering birds are encountered mainly by chance but some visit garden bird-feeders.

female

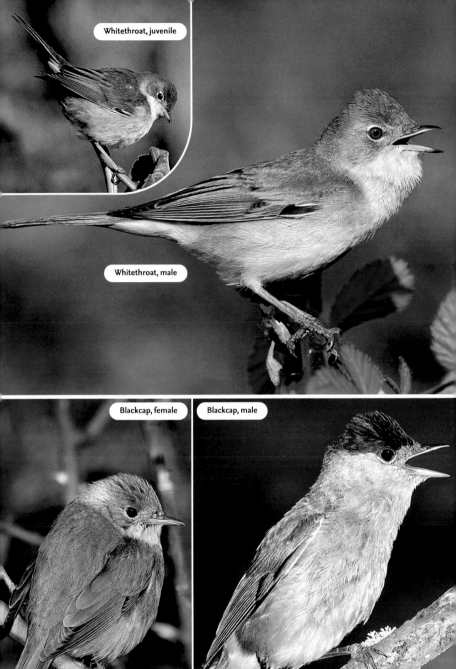

Whitethroat, juvenile

Whitethroat, male

Blackcap, female

Blackcap, male

Chiffchaff *Phylloscopus collybita* Length 11cm Wingspan 18cm

Tiny warbler with an onomatopoeic song. A restless feeder, constantly searching foliage for invertebrates. Sexes are similar. **ADULT AND JUVENILE** have grey-brown upperparts and pale greyish underparts washed with yellow-buff, especially on the throat and breast. Bill is thin and needle-like; legs are black. **VOICE** Call is a soft *hueet*. Song is a continually repeated *chiff-chaff* or *tsip-tsap*, heard most frequently in

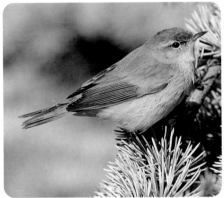

early spring although migrants sometimes sing snatches of song in late summer. **HABITAT AND STATUS** Mainly a summer visitor; several hundred thousand pairs probably breed here, and the species is commonest in the S. Breeding birds favour deciduous woodland with a dense understorey of shrubs; mature gardens are sometimes also used. Most Chiffchaffs winter around the Mediterranean but several hundred remain in Britain, the majority in S and SW England. **OBSERVATION TIPS** Easy to see and hear in spring.

Goldcrest *Regulus regulus* Length 9cm Wingspan 14cm

Our smallest bird. Has a passing resemblance to a warbler but note the large, white-ringed, dark eye, thick neck and colourful crown stripe. Often forages high in the tree canopy for invertebrates, sometimes hanging from twigs or hovering. Sexes are dissimilar. **ADULT MALE** has greenish upperparts with 2 pale wingbars, and yellow-buff underparts. Note the black-bordered orange crown and needle-like bill. **ADULT FEMALE** is similar but crown-stripe colour is yellow. **JUVENILE** is similar to

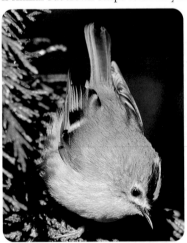

adults but crown-stripe markings and colours are absent. **VOICE** Utters a thin, high-pitched *tsee-tsee-tsee*. Song is a series of high-pitched phrases that ends in a flourish. **HABITAT AND STATUS** Widespread and common woodland resident, also found in mature gardens. Favours conifers but also found in deciduous woodland and scrub, especially in winter. More than a million birds are present in the breeding season; influxes from N mainland Europe may almost double the population in winter. **OBSERVATION TIPS** Listen for the high-pitched call to detect its presence. Most numerous in conifer woodlands but usually easier to observe in deciduous woodlands in winter, when leaves have fallen. At this time of year, Goldcrests often consort with mixed flocks of tits and other woodland birds. A large, mature conifer in the garden will often support a breeding pair.

female

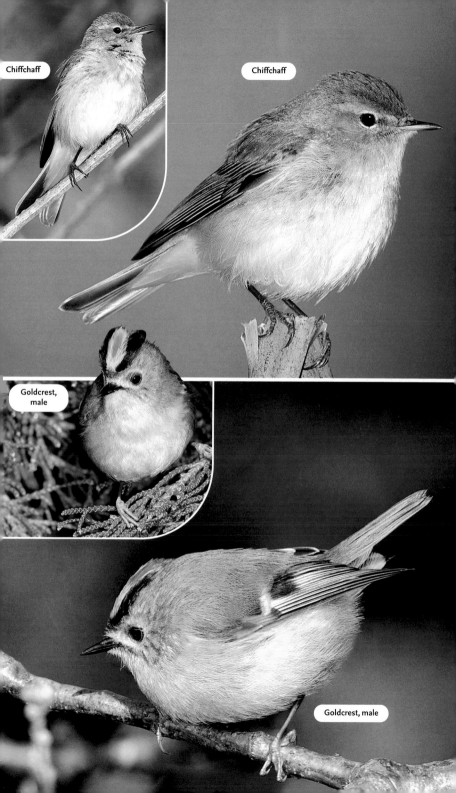

Chiffchaff

Chiffchaff

Goldcrest, male

Goldcrest, male

Spotted Flycatcher *Muscicapa striata* Length 14cm Wingspan 24cm

Perky little bird with undistinguished plumage. Recognised by its upright posture and habit of using regular perches from which to make insect-catching aerial sorties. Sexes are similar. **ADULT** has grey-brown upperparts, streaked on crown, and pale greyish-white underparts that are heavily streaked on breast. **JUVENILE** is similar but has pale spots on back and dark spotting on throat and breast. **VOICE** Utters a thin *tsee* call. Song is simple and includes thin, call-like notes. **HABITAT AND STATUS** Widespread but declining summer visitor; more than 100,000 pairs probably breed here, often nesting around habitation. Favours open woodland with sunny clearings, and parks and gardens. **OBSERVATION TIPS** The species' thin call is easy to miss and consequently it is often overlooked until insect-catching aerial sorties are observed. It will sometimes use an open-fronted nest box but also nests among climbing shrubs trained against house walls – take care not to disturb birds when pruning in spring and summer.

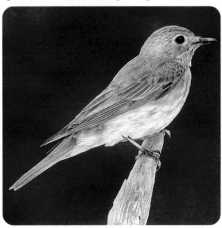

Blue Tit *Cyanistes caeruleus* Length 11–12cm Wingspan 18cm

Familiar and colourful little bird. Widespread in woodland and scrub, but also found in most British gardens and a frequent visitor to bird-feeders. Sexes are similar although males are slightly more colourful than females. **ADULT** has a greenish back, blue wings and yellow underparts. Mainly white head is demarcated by a dark blue collar, which connects to a dark eye-stripe and dark bib; cap is blue. Note the pale wingbar. Bill is short and stubby, and legs are bluish. **JUVENILE** is similar but colours are subdued, particularly blue elements of the plumage. **VOICE** Call is a familiar, chattering *tser err-err-err*. Song contains whistling and trilling elements. **HABITAT AND STATUS** Common resident and widespread everywhere except on N and smaller offshore islands; several million pairs are present overall. Favours deciduous woodland but also frequents parks and gardens. Nests in natural tree-holes and readily takes to nest boxes where the hole is a suitable size (*see* p. 12). **OBSERVATION TIPS** Easy to observe because it is common in gardens and readily comes to food.

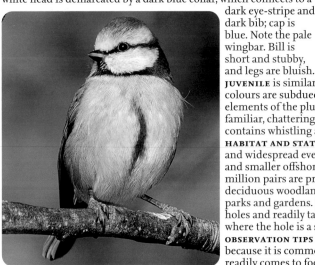

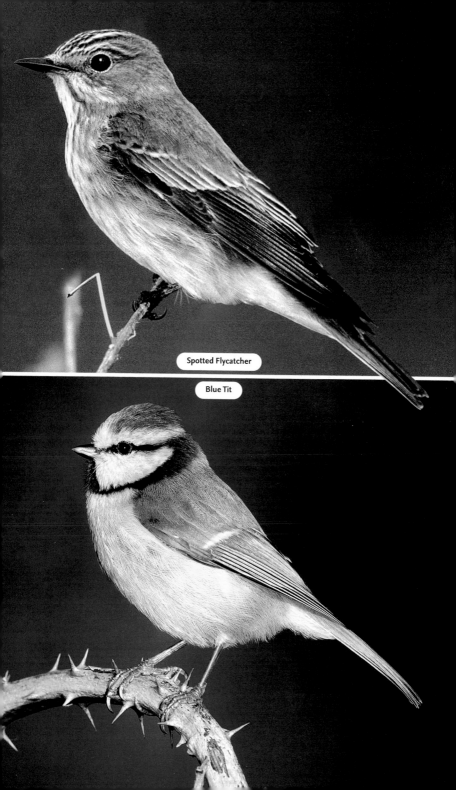

Spotted Flycatcher

Blue Tit

Great Tit *Parus major* Length 14–15cm Wingspan 24cm

Familiar, bold woodland bird, and a frequent garden visitor. Well marked and colourful, with a distinctive song. Sexes are separable with care. **ADULT MALE** has striking white cheeks that contrast markedly with otherwise black head; black throat continues as a thick black line down centre of breast on otherwise yellow underparts. Upperparts are greenish and blue with white wingbar. **ADULT FEMALE** is similar but with a narrower black line on breast. **JUVENILE** has plumage pattern that recalls that of adult, but colours are much duller and paler overall. **VOICE** Utters a harsh *tche-tche-tche* alarm call. Song is a striking variation on a *teecha-teecha-teecha* theme. **HABITAT AND STATUS** Widespread throughout, but absent from most N Scottish islands and scarce in upland districts. Commonest in lowland wooded habitats, with an overall population probably numbering several million pairs. A frequent garden resident, helped through the winter by stocked peanut feeders and bird tables. Nests in natural tree-holes and takes readily to nest boxes where the entrance hole is a suitable size (*see* p. 12). **OBSERVATION TIPS** Easy to find in most gardens. Often remarkably bold at bird-feeders.

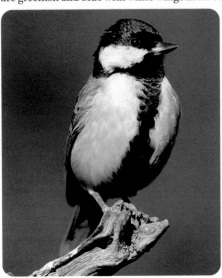

Marsh Tit *Poecile palustris* Length 12–13cm Wingspan 19cm

Pugnacious woodland bird that is often found in rural gardens, especially at winter feeders. Sexes are similar. **ADULT AND JUVENILE** have a black cap and bib; cap is glossy and bib is relatively small. Cheeks are whitish, upperparts are uniform grey-brown and underparts are pale grey-buff. Bill is short and legs are bluish. **VOICE** Utters a loud *pitchoo* call. Song is a loud and repeated *chip-chip-chip…* **HABITAT AND STATUS** A resident bird that is associated with deciduous woodland; also found in parks and gardens with mature trees and shrubs. Commonest in S Britain; several tens of thousands of pairs are probably present. Nests in natural tree-holes and will occasionally use a nest box if it is placed in a shady, out-of-the-way place. **OBSERVATION TIPS** A regular visitor to bird tables and feeders, where it is particularly fond of Sunflower seeds; often forages on the ground below feeders for fallen leftovers.

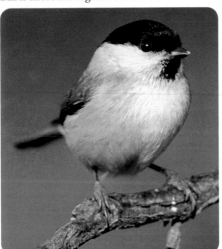

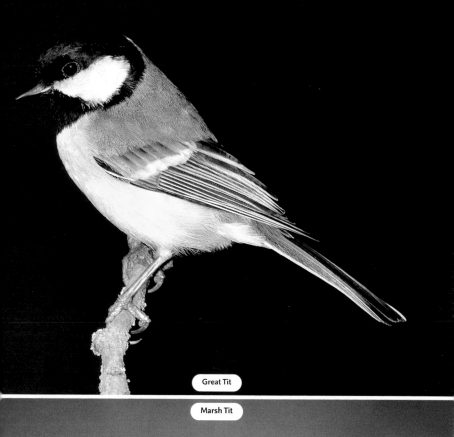

Great Tit

Marsh Tit

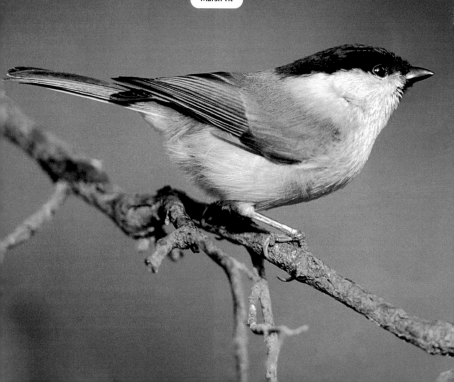

Coal Tit *Periparus ater* Length 10–11cm Wingspan 19cm

Tiny, well-marked bird with warbler-like proportions; feeds in an energetic and acrobatic manner. Sexes are similar. **ADULT** has white cheeks and a white nape patch on an otherwise black head. Back and wings are bluish grey and underparts are pale pinkish buff. Has 2 white wing-bars and a dark, needle-like bill. **JUVENILE** is similar but plumage colours and pattern are less striking. **VOICE** Utters a thin call. Song is a repeated *teechu-teechu-teechu…*, higher-pitched, more rapid and weaker than that of Great Tit (p. 50). **HABITAT AND STATUS** Widespread resident throughout most of the region except N islands; a million or more pairs are probably present. Most numerous in conifer forests and plantations, but also common in mixed and decidu-

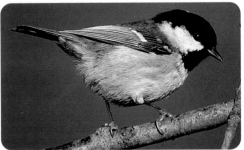

ous woodland. Nests in tree-holes and will occasionally use a nest box. Although largely sedentary, birds are sometimes nomadic in winter in search of food; at such times, they often join mixed feeding flocks of other small woodland birds. **OBSERVATION TIPS** Singing Coal Tits are easy to locate in the breeding season. In winter, look for them among roving mixed-species flocks of woodland birds. Also visits garden bird-feeders in rural areas.

Long-tailed Tit *Aegithalos caudatus* Length 14cm Wingspan 18cm

Delightful, often confiding bird with a very long tail and seemingly almost spherical body. Often seen in animated flocks; moves in a rather jerky fashion and has acrobatic feeding habits. Flight is undulating. Sexes are similar. **ADULT** can look rather black and white at a distance. At close range, note pinkish-chestnut patch on scapulars and whitish wing-

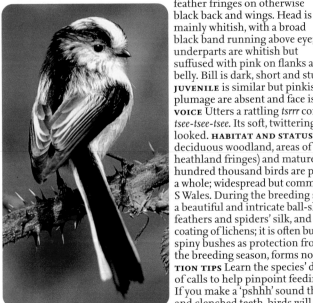

feather fringes on otherwise black back and wings. Head is mainly whitish, with a broad black band running above eye; underparts are whitish but suffused with pink on flanks and belly. Bill is dark, short and stubby. **JUVENILE** is similar but pinkish elements of plumage are absent and face is more uniformly dark. **VOICE** Utters a rattling *tsrrr* contact call and a thin *tsee-tsee-tsee*. Its soft, twittering song is easily overlooked. **HABITAT AND STATUS** Favours mainly deciduous woodland, areas of scrub (particularly on heathland fringes) and mature hedgerows. Several hundred thousand birds are present in the region as a whole; widespread but commonest in S England and S Wales. During the breeding season, birds construct a beautiful and intricate ball-shaped nest, made from feathers and spiders' silk, and camouflaged with a coating of lichens; it is often built in the cover of dense, spiny bushes as protection from predators. Outside the breeding season, forms nomadic flocks. **OBSERVATION TIPS** Learn the species' distinctive repertoire of calls to help pinpoint feeding flocks in winter. If you make a 'pshhh' sound through pursed lips and clenched teeth, birds will sometimes come close.

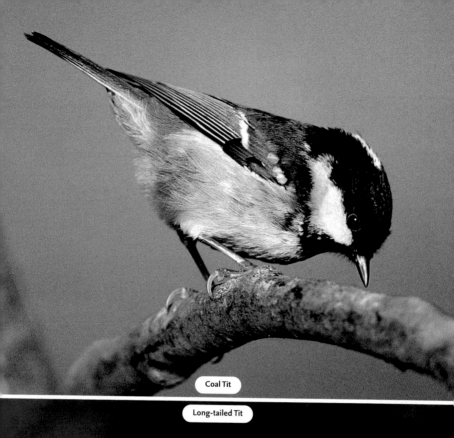

Coal Tit

Long-tailed Tit

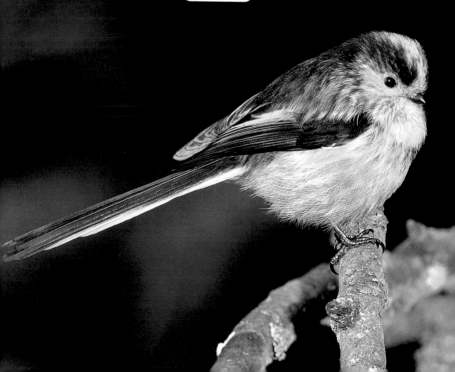

Nuthatch *Sitta europaea* Length 14cm Wingspan 24cm

Dumpy, short-tailed woodland bird that often visits garden feeders. Uniquely among British birds, it can descend tree trunks head-downwards, doing so in a jerky manner. Its chisel-like bill is used to prise insects from tree bark and hammer open acorns wedged into bark crevices. Sexes are similar. **ADULT** has blue-grey upperparts, a black eye-stripe, white cheeks and orange-buff underparts; on average, males have a more intense reddish-buff flush to rear of flanks than females. **JUVENILE** is similar but colours and eye-stripe are less intense. **VOICE** Utters a loud, insistent *zwiit*, repeated regularly if bird is agitated. Song typically comprises a series of whistling notes. **HABITAT AND STATUS** Associated with deciduous and mixed woodland, but also occurs in gardens and parks where mature trees are present. More than 100,000 pairs probably breed in the region as a whole, although the species is

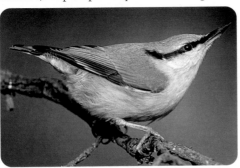

commonest in S and central England, and in Wales; its range only just extends to S Scotland and it is absent from Ireland. **OBSERVATION TIPS** A vocal species whose distinctive call announces its presence. Within its range, it occurs in most suitable woodlands. A frequent visitor to garden bird-feeders in rural areas. Nests are made in tree-holes, typically with mud plastered around the entrance to reduce the hole size; it will sometimes occupy nest boxes and undertake similar construction work.

Treecreeper *Certhia familiaris* Length 12–13cm Wingspan 19cm

Unobtrusive woodland bird, easily overlooked as it creeps up tree trunks, probing bark for insects and spiders with its needle-like bill. Its spiky tail

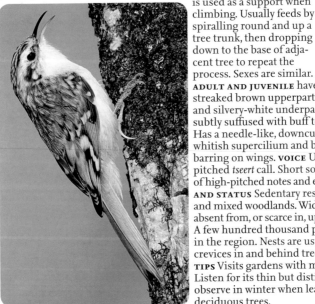

is used as a support when climbing. Usually feeds by spiralling round and up a tree trunk, then dropping down to the base of adjacent tree to repeat the process. Sexes are similar. **ADULT AND JUVENILE** have streaked brown upperparts and silvery-white underparts subtly suffused with buff towards rear of flanks. Has a needle-like, downcurved bill, grubby whitish supercilium and broad, zigzag buffish barring on wings. **VOICE** Utters a thin, high-pitched *tseert* call. Short song comprises a series of high-pitched notes and ends in a trill. **HABITAT AND STATUS** Sedentary resident of deciduous and mixed woodlands. Widespread generally, but absent from, or scarce in, upland and N districts. A few hundred thousand pairs probably breed in the region. Nests are usually constructed in crevices in and behind tree bark. **OBSERVATION TIPS** Visits gardens with mature, large trees. Listen for its thin but distinctive call. Easiest to observe in winter when leaves have fallen from deciduous trees.

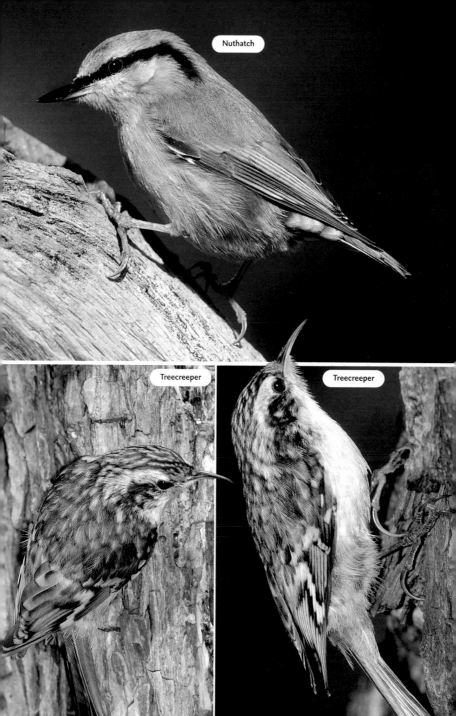

Nuthatch

Treecreeper

Treecreeper

Jay *Garrulus glandarius* Length 33–35cm Wingspan 55cm

Colourful, distinctive bird but wary, hence its colours are seldom seen to best effect and its raucous calls are heard more often than the bird is seen. A typical view is of the white rump, emphasised by the black tail, seen as a bird flies away. Each Jay buries thousands of acorns every

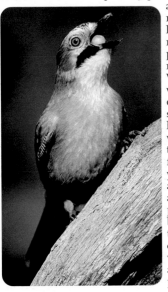

autumn as food cache for the rest of the year. Sexes are similar. **ADULT AND JUVENILE** have mainly pinkish-buff body plumage except for a white rump, undertail and lower belly. Wings are marked with black and white pattern and a chequerboard patch of blue, black and white. Has a black 'moustache', streaked pale forecrown, and pale eye. **VOICE** Utters a loud, harsh scream. **HABITAT AND STATUS** Typically a woodland bird whose precise distribution is linked to the occurrence of mature oak trees. Acorns (both freshly ripened and stored) are important in its diet year-round, but in summer it is more opportunistic and omnivorous, taking invertebrates as well as eggs and young of other birds. Probably more than 150,000 pairs of Jays breed in the region. Generally sedentary, but if the acorn crop fails then widespread dispersal takes place and influxes from mainland Europe occur. **OBSERVATION TIPS** Shy and usually hard to observe well. Often easiest to see in Oct when birds search for acorns. Visits garden feeders, especially in winter, and prefers whole peanuts.

Magpie *Pica pica* Length 45–50cm Wingspan 56cm

Unmistakable long-tailed black and white bird. Outside the breeding season, it is often seen in small groups. An opportunistic omnivore, taking fruit, insects, animal road-kills, and eggs and young of birds; it will also scavenge discarded leftover food scraps in towns and gardens.

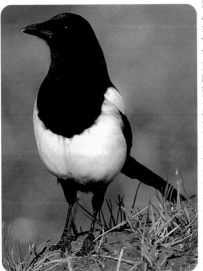

Sexes are similar. **ADULT AND JUVENILE** have mainly black plumage with a contrasting white belly and white patch on closed wing. In good light, a bluish-green sheen is seen on wings and tail. In flight, outer half of short, rounded wings appears strikingly white. **VOICE** Utters a loud, rattling alarm call. **HABITAT AND STATUS** Widespread resident but scarce in, or absent from, upland and N districts. Favours a wide variety of wooded and lightly wooded habitats, including mature gardens, and is common in urban areas. Several hundred thousand pairs are present in the region. **OBSERVATION TIPS** Easy to find in most lowland districts. Probably easiest to observe beside roads, scavenging at corpses of animal road-kills. Also visits garden feeders where large scraps are provided. Nest is large and twiggy, and is built among dense branches, often in garden trees and shrubs.

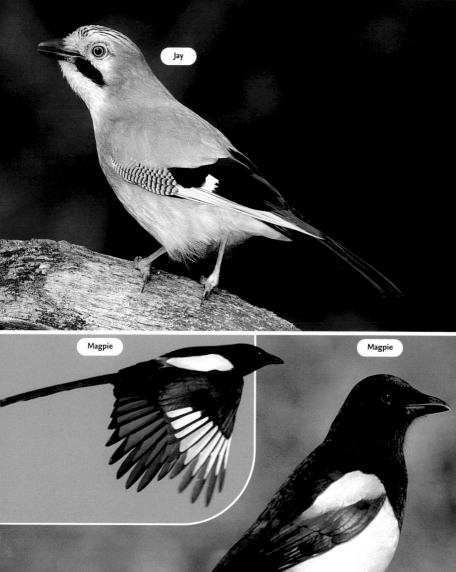

Jay

Magpie

Magpie

Jackdaw *Corvus monedula* Length 31–34cm Wingspan 70cm

Our most widespread small corvid. An opportunistic feeder, quick to exploit any new food source. Walks with a swagger and is aerobatic in flight. Forms flocks outside the breeding season. Sexes are similar. **ADULT** has mainly smoky-grey plumage, darkest on wings and crown; note the pale blue-grey eye and grey nape. **JUVENILE** is similar but plumage has a brownish tinge and eye is darker and duller. **VOICE** Utters a characteristic *chack* call. **HABITAT AND STATUS** Widespread and common resident, equally at home on farmland and sea cliffs, and in towns and villages. Nests in rock crevices, old buildings and chimneys. Several hundred thousand pairs breed here. Outside the breeding season, influxes of birds from mainland Europe boost numbers and more than a million are probably present in winter. **OBSERVATION TIPS** Easy to find. In some urban areas where food scraps are in plentiful supply, Jackdaws are remarkably bold and inquisitive. Sometimes visits garden bird-feeders.

Carrion Crow *Corvus corone* and Hooded Crow *Corvus cornix*
Length 43–50cm Wingspan 98cm

Now treated as separate species but formerly considered to be subspecies of a single crow species. Their plumage differs but their habits are identical. Both are extremely wary and are opportunistic feeders, taking both carrion and live prey. Less gregarious than either Jackdaws (above) or Rooks (p. 60), and usually seen singly or in pairs, not in flocks. Sexes are similar. **CARRION CROW ADULT AND JUVENILE** have all-black glossy plumage and a stout bill. **HOODED CROW ADULT AND JUVENILE** have mainly grubby grey body plumage with black wings and tail; head is black, and black throat and centre of upper breast form a bib. **VOICE** Utters a harsh, slightly slurred *creeaa-creeaa-creeaa* call. **HABITAT AND STATUS** The Carrion Crow is found throughout England and Wales, but in Scotland it occurs mainly S and E of an imaginary line drawn roughly from the Firth of Clyde to Dornoch Firth. N and W of this line, and throughout Ireland and on the Isle of Man, the Hooded Crow either predominates or replaces the Carrion Crow entirely. A zone of hybridisation occurs along, and either side of, the Scottish transition line. Both species occur in a wide variety of habitats, from farmland to seashores, moorland and urban locations. Nest is usually constructed in a tree – even an isolated specimen will suffice. Several hundred thousand pairs of both Carrion and Hooded crows occur in Britain. **OBSERVATION TIPS** Usually easy to find. The Hooded Crow presents few identification problems but the Carrion Crow could be confused with a juvenile Rook: bill is longer in Rook than in Carrion Crow and the latter lacks the adult Rook's bare whitish skin at base of bill. Both crow species occasionally visit garden bird tables and eat eggs and chicks of nesting garden birds.

Carrion Crow

Hooded Crow

Carrion Crow

Hooded Crow

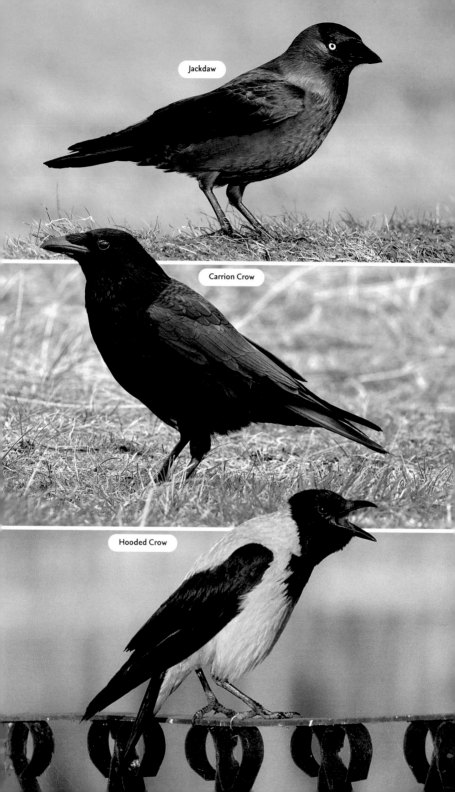

Rook *Corvus frugilegus* Length 43–48cm Wingspan 90cm

Familiar farmland bird that visits rural gardens. Often seen in flocks feeding in fields or gathering at colonial tree nest sites, which are noisy and active from early Mar to May. The bulk of its diet comprises invertebrates, notably earthworms and leatherjackets, and seeds and roots, probed from the ground. Sexes are similar. **ADULT** has all-black plumage with reddish-purple iridescence at certain angles. Bill is long, narrow and pointed; note also bare patch of whitish skin at base. **JUVENILE** is similar but patch of bare white skin at bill base is absent. **VOICE** Utters a grating *craah-craah-craah…* call. **HABITAT AND STATUS** Associated mainly with farmland; flocks forage in grassland and ploughed fields. Nests colonially, building large twig nests in clumps of tall trees. In winter, these sites, and other isolated copses and woodlands, are used for communal roosting. More than a million pairs probably breed here and the winter population is boosted by influxes from mainland Europe. **OBSERVATION TIPS** Easy to find in lowland Britain and Ireland. Most memorable (and noisy) at the start of the breeding season in early Mar, when nests are being repaired and courtship is underway. Will visit garden bird tables for scraps of bread and nuts.

Starling *Sturnus vulgaris* Length 20–22cm Wingspan 40cm

Familiar urban bird. Extremely vocal and a proficient mimic. Forms sizeable flocks outside the breeding season. Walks with a swagger. Flight is rather undulating and wings look pointed and triangular in outline. Sexes are separable with care in summer. **ADULT SUMMER MALE** has mostly dark plumage with green and violet iridescence discernible in good light. Legs are reddish and bill is yellow with blue base to lower mandible. **ADULT SUMMER FEMALE** is similar but has a few pale spots on underparts; base of lower mandible is pale yellow. **WINTER ADULT (BOTH SEXES)** has numerous white spots adorning dark plumage. Bill is dark. **JUVENILE** is grey-brown, palest on throat; bill is dark. 1st-winter bird retains grey-brown head and neck but acquires white-spotted dark plumage elsewhere. **VOICE** Has a varied repertoire of clicks and whistles. Song includes elements of mimicry of other birds, as well as man-made sounds such as car alarms and phone tones. **HABITAT AND STATUS** The breeding population has declined recently but the species is still widespread and abundant. Nests in holes and cavities, including roofs, as well as more natural locations such as tree-holes. Feeds in areas of short grass. Winter flocks roost in woodlands or on urban buildings. A million or more pairs nest in the region but outside the breeding season influxes from mainland Europe boost numbers so that tens of millions of birds may be present midwinter. **OBSERVATION TIPS** You should have no difficulty finding and identifying the species. It needs little encouragement in the garden.

adult winter

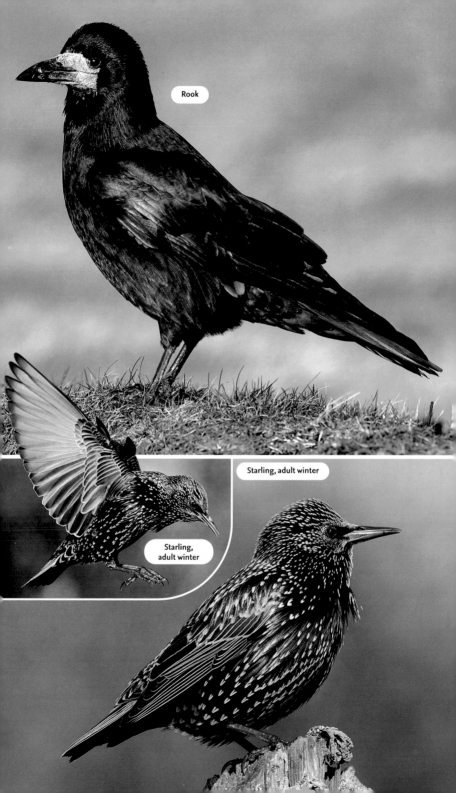

House Sparrow *Passer domesticus* Length 14–15cm Wingspan 24cm

Familiar species with an affinity for human habitation. Often dust-bathes, and small groups are often seen sitting on roofs, uttering familiar sparrow chirps. Where it is fed, it is often remarkably tame, sometimes even taking food from the hand. Sexes are dissimilar. **ADULT MALE** has grey crown, cheeks and rump. Nape, sides of crown, back and wings are chestnut-brown, underparts are pale grey, and throat and breast are black. Bill is dark and legs are reddish. In winter, chestnut colour is less intense and bill is paler. **ADULT FEMALE** has mainly brown upperparts, including crown. Back is streaked with buff and underparts are pale grey; note the pale buff supercilium behind eye. **JUVENILE** is similar to adult female but plumage pattern is less distinct. **VOICE** Utters a range of chirping calls. **HABITAT AND STATUS** Widespread, although scarce in, or absent from, many upland and N districts. Often nests in roof spaces and holes in walls, and takes advantage of food supplies around houses and farms, hence the species is clustered around villages, towns and farm buildings. Has declined markedly in last few decades, perhaps by as much as 50%, but there are still several million pairs in the region. **OBSERVATION TIPS** You should have no difficulty finding or identifying House Sparrows, no matter where you live in the region. Probably easiest to see well in urban parks where people feed the birds.

male

Tree Sparrow *Passer montanus* Length 13–14cm Wingspan 21cm

Distinctive and well-marked rural counterpart of the House Sparrow (above) that sometimes occurs alongside that species, especially around untidy farms. Outside the breeding season, forms flocks and sometimes feeds alongside buntings and finches in fields. Sexes are similar. **ADULT** has a chestnut cap and striking black patch on otherwise whitish cheeks and side of head; note the black bib. Underparts are otherwise greyish white, and back and wings are streaked brown; has white wingbars. **JUVENILE** is similar but facial markings are duller, darker and less distinct. **VOICE** Utters House Sparrow-like chirps but also a sharp *tik-tik* in flight. **HABITAT AND STATUS** Sometimes found on outskirts of villages, visiting bird-feeders, but more usually associated with untidy arable farms, taking advantage of grain spills. Absent from, or scarce in, W England and Wales, and N and upland districts elsewhere. Usually nests in tree-holes but takes to nest boxes. Population has declined by more than 90% in recent decades and disappeared from many former haunts. Changes in farming practices are behind its demise. **OBSERVATION TIPS** Consider yourself lucky if you come across a winter flock of Tree Sparrows, so scarce has the species become. East Midlands and parts of East Anglia are the species' strongholds. If you live in its range, put up nest boxes.

House Sparrow, female

House Sparrow, male

Tree Sparrow

Chaffinch *Fringilla coelebs* Length 15cm Wingspan 26cm

Common garden bird whose song is familiar in spring. Forms flocks outside the breeding season. Its diet includes insects in spring and summer, and mainly seeds at other times. Sexes are dissimilar. **ADULT MALE** has reddish pink on face and underparts, blue crown and nape, and chestnut back. Dark wings have whitish wingbars; note white undertail and vent. White outer-tail feathers are obvious in flight. Colours are brightest in spring and early summer. **ADULT FEMALE AND JUVENILE** have mainly buffish-brown plumage, palest on face and underparts, and pale wingbars (pattern similar to male) on otherwise dark wings. **VOICE** Utters a distinct *pink pink* call. Song

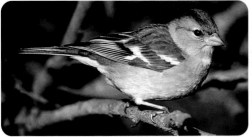

comprises a descending trill with a final flourish. **HABITAT AND STATUS** Year-round resident of gardens, parks and woodlands. Several million pairs probably nest here. Outside the breeding season, influxes from N mainland Europe probably more than double the winter population. **OBSERVATION TIPS** Easy to find and identify. Can be attracted to the garden by scattering seed. Nests in dense bushes.

female

Brambling *Fringilla montifringilla* Length 14–15cm Wingspan 26cm

Well-marked finch. Winter visitor to Britain that often mixes with Chaffinch flocks. Recognised in flight by its white rump; the absence of white outer-tail feathers helps distinguish it from Chaffinch (above). Sexes are dissimilar. **SUMMER ADULT MALE** (sometimes seen before departure in early spring) has an orange throat, breast and lesser wing coverts; underparts are otherwise white with dark spots on flanks. Head and back are blackish. Wings are dark, but note the pale feather margins and striking whitish-orange wingbars. Bill is black. **WINTER ADULT MALE** (typical plumage seen here) is similar, but black elements of plumage are obscured by pale buff and grey-buff fringes. Bill is yellow with a dark tip. **ADULT FEMALE** recalls winter male but colours are less intense. Pale fringes obscure dark feathers on back; head is pale grey-brown with dark lines on sides of crown and nape. Bill is yellow with a dark tip. **JUVENILE** is similar to respective sex winter adult but colours are less

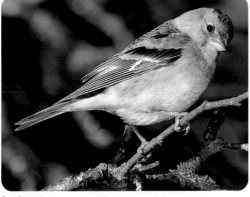

intense. **VOICE** Calls include a harsh *eeerrp*. Song (seldom heard here) comprises a series of buzzing notes. **HABITAT AND STATUS** Very rare breeder in the region and known mainly as a common winter visitor. Several hundred thousand are present in most winters. Forages for seeds on the ground in woodland; Beech seeds are a favourite. **OBSERVATION TIPS** Easiest to find in mature Beech woodland. Feeds unobtrusively, so listen for distinctive calls to detect its presence. If good numbers of Chaffinches visit your garden in winter, Bramblings may join them from midwinter onwards.

female winter

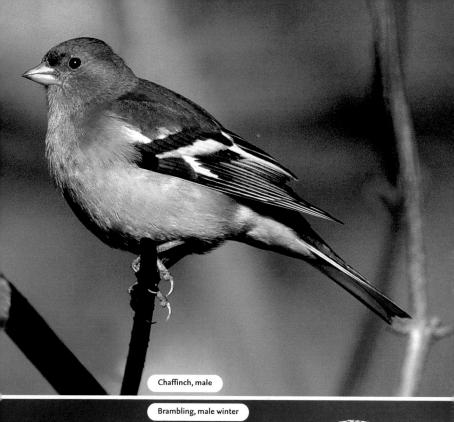

Chaffinch, male

Brambling, male winter

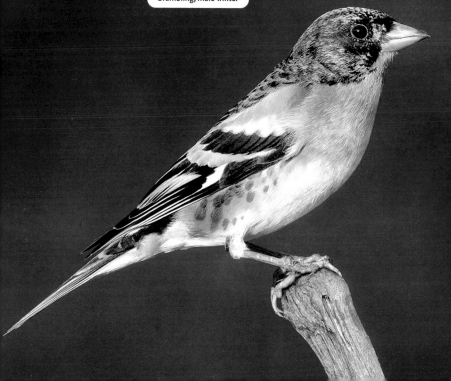

Greenfinch *Carduelis chloris* Length 14–15cm Wingspan 26cm

Familiar garden resident with a relatively large, conical pinkish bill. In all plumages, the yellowish wing patch (seen as a yellow bar on closed wing) and yellow sides to the base of the tail are useful identification clues. Sexes are dissimilar. ADULT MALE looks overall mainly yellowish green, darkest on back, with grey on face, sides of neck and on wings. Colour intensity increases throughout winter as pale feather fringes wear. ADULT FEMALE is similar but colours are duller and it has faint streaking on back. JUVENILE recalls adult female but back and pale underparts are obviously streaked. VOICE Utters a sharp

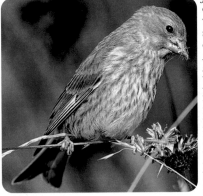

jrrrup call in flight. Song either comprises well-spaced wheezy *weeeish* phrases or a series of rapid, trilling whistles (sometimes delivered in flight, on slow wingbeats). HABITAT AND STATUS In the breeding season, it is associated with parks, gardens and hedgerows. Widespread and fairly common, with several hundred thousand pairs breeding here. In winter, many N and upland districts are abandoned and the species is most numerous in lowland S Britain; influxes from mainland Europe boost the population. OBSERVATION TIPS Often nests in gardens, sometimes using thick conifer hedges, so listen out for the male's breezy, call-like song in spring. Also visits garden bird-feeders, where it is often the dominant species.

juvenile

Goldfinch *Carduelis carduelis* Length 12cm Wingspan 24cm

Colourful favourite among birdwatchers. Forms flocks outside the breeding season and the sound of its tinkling flight calls is a delight. In flight, the combination of yellow wingbars and white rump is diagnostic. Sexes are similar. ADULT has a striking black and white pattern on head, with a red face. Back is buffish brown, and underparts are mainly whitish but suffused with pale buff on flanks and sides of breast. Wings are black with yellow wingbar and white tips to flight feathers; has white tips to black tail feathers. Bill is relatively long, narrow, conical and pale pinkish buff. JUVENILE has mainly pale buffish-white plumage, streaked brown on flanks and back. Wings are black with a yellow wingbar. VOICE Utters a tinkling, trisyllabic call. Song is

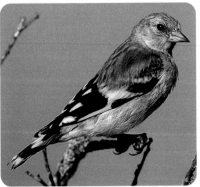

twittering and rapid, containing call-like elements. HABITAT AND STATUS Widespread year-round. In the breeding season, favours scrub, deciduous woodland and mature gardens; several hundred thousand pairs nest here. Outside the breeding season, forms flocks that are associated with wayside ground and field margins where seed-producing plants such as thistles and teasels grow. Most of our Goldfinches move S in autumn and winter in mainland Europe. They return in Feb and Mar and often visit gardens in search of seeds. OBSERVATION TIPS To watch the species with minimal effort and at close range, grow teasels in your garden. Increasingly, Goldfinches visit garden feeders stocked with Niger seeds in winter.

juvenile

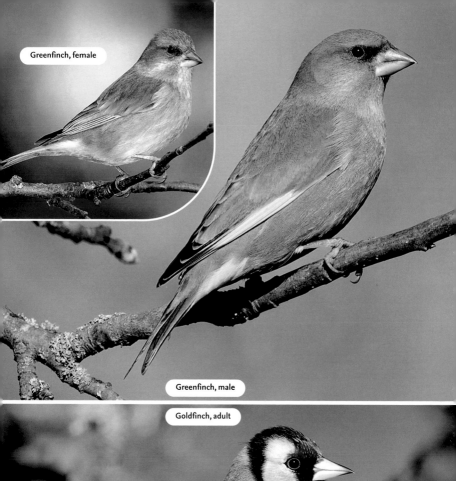

Greenfinch, female

Greenfinch, male

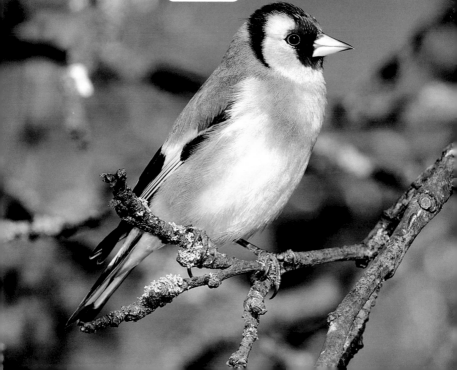

Goldfinch, adult

Siskin *Carduelis spinus* Length 11–12cm Wingspan 22cm

Well-marked little finch, recognised in all plumages by a broad yellowish bar on otherwise dark wings, a yellow rump, and yellow sides to an otherwise dark tail. Outside the breeding season, forms flocks, which feed acrobatically on tree seeds. Sexes are separable with care. **ADULT MALE** has striking yellowish-green upperparts, with streaking on back, and a black cap and bib. Breast is flushed yellow-green but underparts are otherwise whitish with bold streaking on flanks. Has dark wings and yellow wingbars. **ADULT FEMALE** is similar but lacks intensity of yellow colour; head is rather uniform, and lacks male's black cap and bib. **JUVENILE** has mainly streaked grey-brown plumage, palest on head and underparts; wing and tail patterns are similar to those of adults. **VOICE** Utters whistling or twittering disyllabic calls. Song comprises a series of twittering phrases. **HABITAT AND STATUS** In the breeding season, is associated mainly with conifer woodlands. Sometimes nests in mature gardens in S England, but common as a breeding species only in Scotland and parts of Wales; several hundred thousand pairs breed here. More widespread in winter in Common Alder and birch woodlands, when numbers are boosted by influxes from mainland Europe. **OBSERVATION TIPS** Easiest to find in winter. Visits garden feeders stocked with Niger seeds.

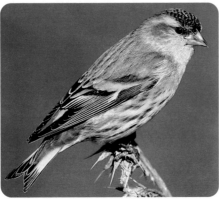

male

Bullfinch *Pyrrhula pyrrhula*

Length 16–17cm Wingspan 26cm
Unobtrusive finch, often seen in pairs. Its soft but distinctive call is heard more often than the bird is seen. Its bill is stubby and dark, and the bird reveals a white rump in flight. Sexes are separable with care. **ADULT MALE** has a rosy-pink face, breast and belly. Back and nape are blue-grey, and cap and tail are black. Has a white wingbar on otherwise black wings. **ADULT FEMALE** is similar but rosy-pink elements of plumage are dull buffish pink. **JUVENILE** is similar to adult female but head is uniformly buffish brown. **VOICE** Utters a distinctive piping call, sometimes delivered in duet by a pair. Its quiet song, which is seldom heard, comprises slow, fluty notes. **HABITAT AND STATUS** Resident of woodlands, hedgerows and mature gardens. Several hundred thousand pairs breed here. **OBSERVATION TIPS** Easiest to detect by hearing its calls. In early spring, birds feed on buds of flowering fruit trees. In winter, is increasingly seen at garden feeders and tables stocked with black Sunflower seeds.

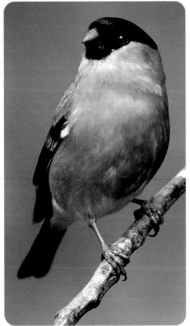

female

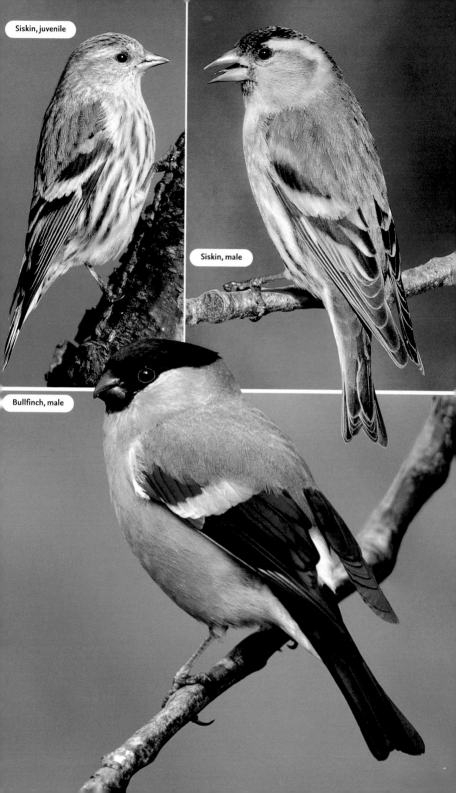

Siskin, juvenile

Siskin, male

Bullfinch, male

Lesser Redpoll *Carduelis cabaret* Length 12–14cm Wingspan 23cm
Well-marked finch. Outside the breeding season, forms restless flocks that
feed in tree tops, sometimes with Siskins. Sexes are similar. **ADULT MALE**
has heavily streaked grey-brown upperparts, darkest on back. Under-
parts are pale but heavily streaked. Has a red forecrown, black bib and
lores, white wingbar, and pale, streaked rump; usually shows pinkish-
red flush to breast. **ADULT FEMALE AND JUVENILE** are similar but
lack pinkish flush to breast. **VOICE** Utters a rattling *chek-chek-chek*
call in flight. Song comprises a series of wheezing and rattling notes.
HABITAT AND STATUS Occurs here throughout the year and is asso-

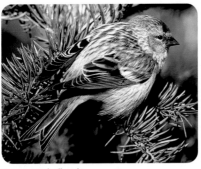

ciated with woodland. In
the breeding season, favours
birch woodland; more than
100,000 pairs probably nest here. At other
times of year, occurs in birch and Common
Alder woodlands (seeds of these are important
in its diet). **OBSERVATION TIPS** Easiest to find
in winter when flocks have formed and leaves
have fallen from the trees where they feed.
Listen for its distinctive flight call. Sometimes
visits garden feeders stocked with Niger seeds.
SIMILAR SPECIES Common Redpoll
C. flammea, a winter visitor from mainland
Europe, is paler in all plumages; it is common-
est in E England.

Common Redpoll, male

Reed Bunting *Emberiza schoeniclus* Length 14–15cm Wingspan 24cm
Well-marked bunting. Usually associated with wetlands but outside the
breeding season it sometimes consorts with other ground-feeding birds
and visits gardens. Sexes are dissimilar. **SUMMER ADULT MALE** has a
black head, throat and bib, and white collar and sub-moustachial
stripe. Underparts are otherwise whitish with faint streaking, back

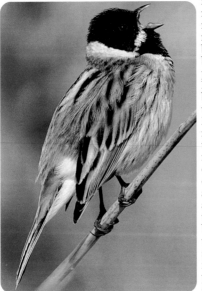

is dark and wings have
reddish-brown feather
margins. **ALL OTHER
PLUMAGES** have dark
brown and buffish-
brown stripes on head and a
pale sub-moustachial stripe.
Back has dark brown and buff stripes, reddish-
brown margins to wing feathers, and pale
underparts, streaked on flanks and breast.
Males show a hint of summer head pattern,
notably dark on throat and bib. **VOICE** Utters a
thin *seeu* call. Song is simple, chinking and
repetitive. **HABITAT AND STATUS** Favours areas
of scrub on wetland margins but also occurs
on farmland. Several hundred thousand birds
are present in the breeding season and British
and Irish birds are typically residents. Outside
the breeding season, the population is boosted
by influxes from N mainland Europe. **OBSER-
VATION TIPS** Easiest to see in the breeding
season when males sing their repetitive songs
from prominent perches. At other times of
year, it is rather unobtrusive and usually feeds
on the ground. Sometimes visits gardens
where seed is scattered for birds.

male

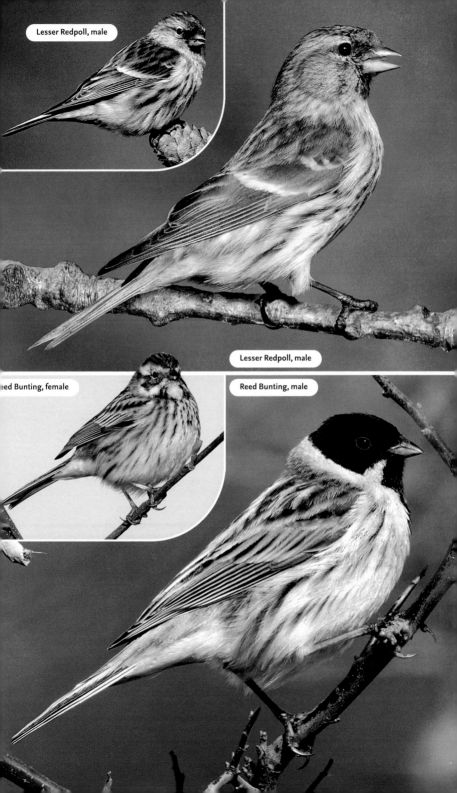

Lesser Redpoll, male

Lesser Redpoll, male

Reed Bunting, female

Reed Bunting, male

Mallard
Anas platyrhynchos Length 50–65cm Wingspan 90cm

Our most familiar duck. In flight, shows a white-bordered blue speculum. Sexes are dissimilar. **ADULT MALE** has a yellow bill and shiny green head and upper neck, this separated from chestnut breast by white collar. Underparts are grey-brown with black stern and white tail. Back is grey-brown, grading to reddish brown. Legs and feet are orange. In eclipse, male resembles adult female but with yellow bill. **ADULT FEMALE AND JUVENILE** have orange-brown bill and mottled

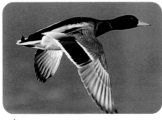

brown plumage. Legs and feet are dull orange-yellow. **VOICE** Male utters whistles and nasal calls. Female utters familiar quacks. **HABITAT AND STATUS** Common on almost all types of waterbody, including urban lakes and ponds. Sometimes visits gardens and will occasionally nest there. **OBSERVATION TIPS** Easy to find and recognise. Probably best discouraged from visiting garden ponds – it causes considerable disturbance to water plants.

male

Red Kite
Milvus milvus Length 63cm Wingspan 145–165cm

Elegant raptor, identified in flight by its forked tail and long, bowed wings. Sexes are similar. **ADULT** has a pale grey head but plumage is otherwise reddish brown. Seen from below in flight, reddish-brown body and underwing coverts contrast with silvery-grey tail and pale patch on primaries. From above, note the red tail, reddish-brown back and wing coverts, and contrasting dark flight feathers. **JUVENILE** resembles adult but with subdued colours and pale tips to wing coverts. **VOICE** Utters shrill calls in flight, like somebody whistling for their dog. **HABITAT AND STATUS** Formerly restricted to central Wales, but reintroduced to England and Scotland and now locally common there in open country and farmland. **OBSERVATION TIPS** Easy to see in many areas; very occasionally visits gardens where meat scraps are provided.

Buzzard
Buteo buteo Length 54cm Wingspan 115–130cm

Large raptor that soars on broad, rounded wings held in shallow 'V'. Plumage is variable but most birds are brown overall. Sexes are similar but females are larger than males. **ADULT** has brown upperparts. Breast is finely barred and typically paler than throat or belly. In flight and from below, flight feathers and tail are grey and barred; has dark trailing edge to wings, and tail has dark terminal band. Note the

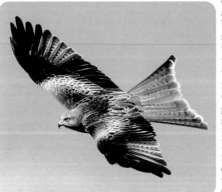

dark carpal patch and pale breast band. **JUVENILE** is similar but lacks the terminal dark band on tail and dark trailing edge to wings. **VOICE** Utters a distinctive mewing *pee-ay*. **HABITAT AND STATUS** Once mainly a W species, persecuted by gamekeepers, the Buzzard is now widespread and common in many parts. Favours open country (including farmland) with scattered woodland for nesting; sometimes soars over gardens. **OBSERVATION TIPS** Most vocal and easiest to observe in spring and late summer (when young are flying).

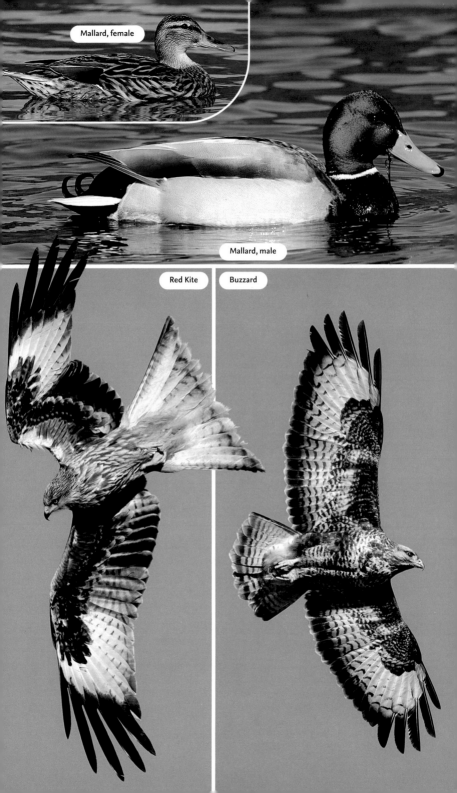

Mallard, female

Mallard, male

Red Kite

Buzzard

Grey Heron *Ardea cinerea* Length 90–98cm Wingspan 185cm

Familiar wetland bird. Fish and amphibians are its main prey and it sometimes visits garden ponds to feed. In flight, has broad wings and slow, flapping wingbeats; its neck is held in a hunched 'S' and its legs and feet trail behind. Sexes are similar. **ADULT** has a whitish-grey head, neck and underparts with dark streaks on front of neck and breast; note pure white forecrown and black sides to crown leading to black nape feathers. Back and upperwings are blue-grey with contrasting black flight feathers. Dagger-like bill is yellowish and legs are yellowish grey.

JUVENILE is similar but has a uniformly dark grey crown and forehead, and dull bill colour. **VOICE** Utters a harsh and distinctive *krrarnk*. **HABITAT AND STATUS** Widespread and common resident; more than 10,000 pairs breed in the region. Favours river margins, lakes and marshes, but also seen on coasts in winter. **OBSERVATION TIPS** Easy to find at most wetland reserves. Will sometimes feed on fish-stocked ornamental lakes, and even garden ponds.

Water Rail *Rallus aquaticus* Length 23–28cm Wingspan 42cm

Secretive wetland bird with a distinctive call, which is heard far more often than the bird itself is seen. In profile, note the dumpy body, short tail and long, slightly downcurved bill. Seen head on, the body is laterally compressed. Sexes are similar. **ADULT** has mainly blue-grey underparts and reddish-brown upperparts; black and white barring on flanks,

and long reddish bill and legs. **JUVENILE** is similar but bluish-grey elements of underparts are pale. **VOICE** Utters a piercing pig-like squeal and various choking calls. **HABITAT AND STATUS** Favours wetlands with emergent vegetation. On migration and in winter, sometimes turns up along well-vegetated stream margins and even ventures into nearby gardens. **OBSERVATION TIPS** Easiest to observe in winter. Hard to attract to the garden, and most observations are chance encounters.

Moorhen *Gallinula chloropus* Length 32–35cm Wingspan 52cm

Widespread wetland bird. Swims with jerky movements and constantly flicks tail. Wary in natural surroundings but often bold in urban areas. Sexes are similar. **ADULT** has a dark blue-grey head, neck and underparts, and brownish back, wings and tail. Note the yellow-tipped red bill and frontal shield on head; legs and long toes are yellow. Has white on sides of undertail and white line on flanks. **JUVENILE** is greyish brown with white on throat, sides of undertail coverts, and along flanks. **VOICE** Utters a loud, far-carrying *kurrrk*. **HABITAT AND STATUS** Found on all sorts of wetlands, from village ponds and overgrown streams to gravel pits and sizeable natural lakes. 300,000 or so pairs may breed here. **OBSERVATION TIPS** Easy to see at most wetlands. In suitable areas, it is easily attracted to gardens where food is scattered on the lawn.

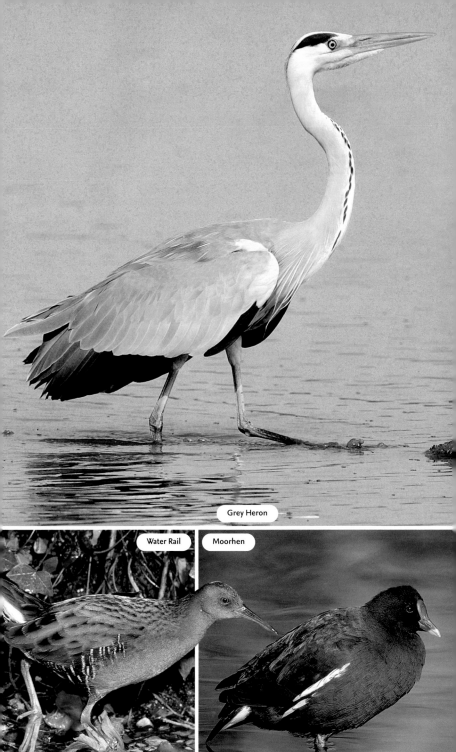

Grey Heron

Water Rail

Moorhen

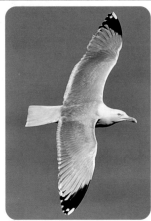

adult summer

Herring Gull *Larus argentatus* Length
56–62cm Wingspan 144cm
Our most numerous and familiar large
gull. Often bold when it is fed regularly.
Sexes are similar. **SUMMER ADULT**
has a blue-grey back and upper-
wings, with white-spotted black
wingtips; plumage is otherwise
white. Legs are pink, bill is yellow
with orange spot near tip, and eye
is yellow with orange-yellow orbital
ring. **WINTER ADULT** is similar but has
dark streaks on head and nape. **JUVENILE
AND FIRST-WINTER BIRDS** are mottled grey-brown with
streaked underparts. Legs are dull pink, bill is dark, and
pale, spotted tail has dark tip. Adult plumage is acquired
over 3 years. **VOICE** Utters a raucous *kyaoo* and an anxious
ga-ka-ka. **HABITAT AND STATUS** Mainly coastal in
summer; more than 100,000 pairs breed here. Typically nests
on sea cliffs but seaside rooftops are increasingly used. In
winter especially, sometimes visits coastal gardens to scavenge food. **OBSERVATION TIPS**
Easy to find; not always welcome in the garden.

Stock Dove *Columba oenas* Length 33cm Wingspan 66cm
Similar to the Woodpigeon (p. 22) but slimmer and with subtly different
plumage. Forms flocks outside the breeding season. In direct flight, its
wings are flicked. Sexes are similar.

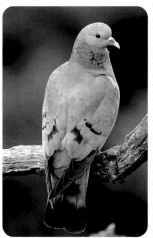

ADULT has blue-grey upperparts and
paler grey underparts; note pink-
ish-maroon flush to breast and
iridescent green patch on side of
neck. Has 2 narrow black bars on
upper surface of innerwing and
broad, dark trailing edge. **JUVENILE**
is similar but wingbars are faint. **VOICE**
Utters a repetitive *oo-u-look* call in the
breeding season. **HABITAT AND STATUS** In the breeding
season, favours areas of wooded farmland, mainly in
lowland England and Wales; nests in tree-holes. At other
times of year, found on arable fields. The British popula-
tion probably exceeds 200,000 individuals. **OBSERVATION
TIPS** Unobtrusive during the breeding season, when its
'song' is often the best way of determining the species'
presence. At other times, search weedy margins of arable
fields. Sometimes attracted to rural gardens when seed is
scattered on the ground.

Turtle Dove *Streptopelia turtur* Length 27cm Wingspan 50cm
Attractive species with the proportions of a Collared Dove (p. 24). Has a
fast, direct flight with rather jerky wingbeats. Its song is distinctive.
Sexes are similar. **ADULT** has a blue-grey head, neck and underparts
with a pinkish-buff flush on breast. Back and wing coverts are chest-
nut with dark feather centres. Long, mainly black tail appears
wedge-shaped in flight owing to white corners. Has black and
white barring on neck. **JUVENILE** is similar but colours are duller
and neck markings are absent. **VOICE** Song is a diagnostic, purring
coo. **HABITAT AND STATUS** Summer visitor associated with lowland
arable farmland, scrub and downland. **OBSERVATION TIPS** Can some-
times be attracted into rural gardens if seeds and water are provided.

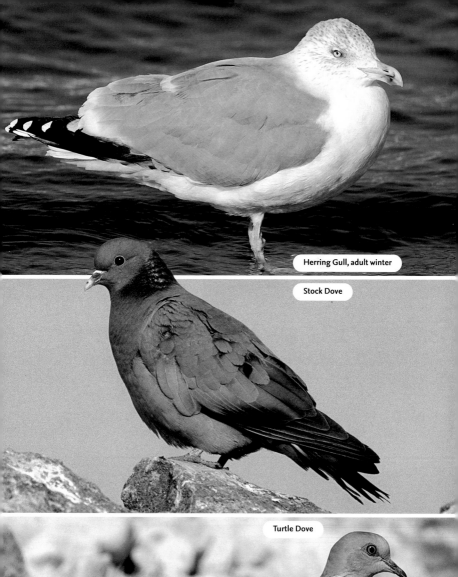

Herring Gull, adult winter

Stock Dove

Turtle Dove

Cuckoo *Cuculus canorus* Length 33–35cm Wingspan 58cm
Secretive summer visitor. The male's familiar onomatopoeic call is heard
more often than the bird is seen. Recalls a Sparrowhawk (p. 18) in flight.
Renowned for its unusual parasitic breeding behaviour: the female lays
an egg in a songbird's nest and, having evicted the companion eggs or
chicks, the young Cuckoo is fed by its hosts until it fledges. Sexes are
separable in some birds. **ADULT MALE AND MOST FEMALES** have a
blue-grey head, neck and upperparts, barred white underparts and

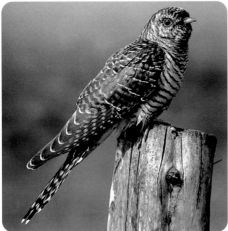

juvenile

a yellow eye. **SOME
ADULT FEMALES**
are brown and
barred on head, neck
and upperparts, under-
parts being white with dark bars.
JUVENILE is similar to brown adult
female but with white nape patch. **VOICE**
Male utters a distinctive *cuck-oo* song;
female has a bubbling call. **HABITAT
AND STATUS** Declining seasonal visitor
(present Apr–Jul). Its distribution and
habitat is dictated by that of songbirds
used for nest parasitism; classic host
species include the Meadow Pipit
Anthus pratensis, Dunnock (p. 36) and
Reed Warbler (p. 82). **OBSERVATION TIPS**
Listen for the species in late Apr and
early May; mostly silent from Jun
onwards. Garden-nesting Dunnocks are
sometimes used as nest-parasite hosts.

Barn Owl *Tyto alba* Length 34–38cm Wingspan 90cm
Beautiful owl that can appear ghostly white when caught in car headlights.
Usually crepuscular or nocturnal, but in winter sometimes hunts in the
late afternoon. Flight is leisurely and slow on rounded wings. Sexes are
similar. **ADULT AND JUVENILE** have orange-buff upperparts speckled
with tiny black and white dots. Facial disc is heart-shaped and white.
In flight, underwings are white. **VOICE** Utters a blood-curdling call.
HABITAT AND STATUS Widespread and fairly common resident;
several thousand pairs are present. Feeds mainly on small mammals
and favours undisturbed grassland. **OBSERVATION TIPS** Sometimes
hunts over roadside verges and visits rural gardens with large grassy
areas; will use suitable nest boxes.

Lesser Spotted Woodpecker *Dendrocopus minor*
Length 14–15cm Wingspan 26cm
Britain's smallest woodpecker. Unobtrusive and easily overlooked. Sexes
are separable with care. **ADULT MALE** has a black back and wings with
white barring. Underparts are grubby white with dark streaking. Face
is white, nape is black and black stripe runs from bill base to sides
of breast. Note white-flecked red crown (cf. juvenile Great Spotted
Woodpecker, p. 30). **ADULT FEMALE AND JUVENILE** are similar but
have a black crown. **VOICE** Male utters a raptor-like piping call in
spring. Drumming is rapid but faint. **HABITAT AND STATUS** Favours
deciduous woodland and parkland. Local and may be declining.
OBSERVATION TIPS Easiest to find in spring when males are calling.
Sometimes nests in rural gardens with mature trees. Seldom visits
bird-feeders.

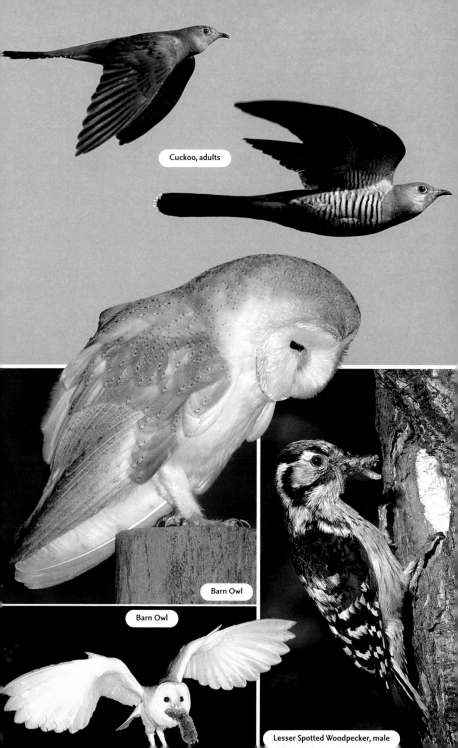

Cuckoo, adults

Barn Owl

Barn Owl

Lesser Spotted Woodpecker, male

Sand Martin *Riparia riparia* Length 12cm Wingspan 28cm
Our smallest hirundine, typically seen hawking for insects over water. Sexes
are similar. **ADULT** has sandy-brown upperparts and mainly white under-
parts with a brown breast band. Tail is short and forked. **JUVENILE**
is similar but has pale margins to back feathers that create a scaly
appearance. **VOICE** Utters a range of rasping twitters. **HABITAT AND
STATUS** Widespread summer visitor that nests colonially, excavating
burrows in sandy banks beside rivers and in sand and gravel quar-
ries. Several hundred thousand pairs probably breed here. Often
feeds over water. **OBSERVATION TIPS** Usually easy to find near water.
Hard to attract to the garden but occasionally seen hawking for
insects overhead.

Grey Wagtail *Motacilla cinerea* Length 18cm Wingspan 26cm
Elegant bird that continually pumps its long tail up and down. Usually
associated with flowing fresh water. Sexes are dissimilar. **SUMMER
ADULT MALE** has blue-grey upperparts and lemon-yellow underparts.
Has a black bib, contrasting white sub-moustachial stripe and white
supercilium. Bill is dark, legs are reddish and outer-tail feathers are
white. **SUMMER ADULT FEMALE** is similar but bib is whitish and
variably marked with grey; underparts are paler and yellow colour
is striking only on vent. **WINTER ADULTS** are similar to respective

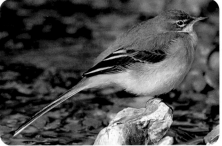

sex summer
plumages but with
white throats. **JUVENILE
AND FIRST-WINTER BIRDS**
resemble winter adult female. **VOICE**
Utters a sharp *chsee-tsit* call in flight.
HABITAT AND STATUS In the breeding
season, is usually associated with fast-
flowing stony streams and rivers.
Sometimes visits gardens if freshwater
habitats occur nearby. **OBSERVATION TIPS**
If you are lucky enough to have a stream
or pond in your garden, you may attract
this species.

female winter

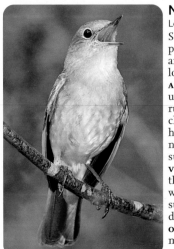

Nightingale *Luscinia megarhynchos*
Length 16–17cm Wingspan 24cm
Secretive bird, best known for its
powerful, musical song. Silent birds
are unobtrusive and easily over-
looked. Sexes are similar. **ADULT
AND JUVENILE** have rich brown
upperparts overall; tail and
rump are warmer reddish
chestnut than back, and shows
hint of grey on face and sides of
neck. Underparts are greyish white,
suffused pale buffish brown on breast.
VOICE Song is rich and varied, and includes fluty whis-
tles and clicking sounds, usually starting with a rich,
whistling *tu-tu-tu-tu.* **HABITAT AND STATUS** Migrant
summer visitor that favours coppiced woodland with
dense undergrowth; a few thousand pairs breed here.
OBSERVATION TIPS Easier to hear than to see; usually
most vocal at dusk. Mature rural gardens within the

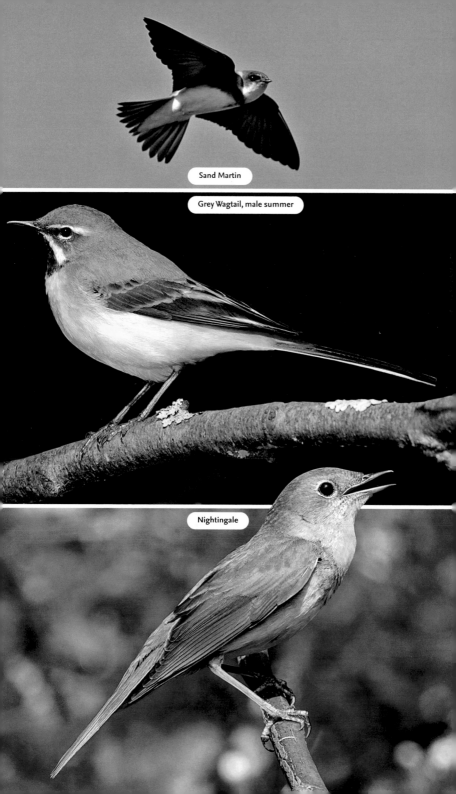

Sand Martin

Grey Wagtail, male summer

Nightingale

Redstart *Phoenicurus phoenicurus* Length 14cm Wingspan 22cm
Robin-sized bird with a dark-centred red tail that is pumped up and down when the bird perches. Sexes are dissimilar. **ADULT MALE** has a grey back, nape and crown, black face and throat, and orange-red underparts. Note the white forehead and supercilium. Legs and bill are dark. **ADULT**

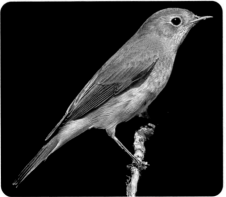

FEMALE has grey-brown upperparts and head, and an orange wash to pale underparts. 1st-winter birds recall respective sex adults, but pale feather fringes obscure colours and patterns. **VOICE** Utters a soft *huiit* call and sharp ticking when alarmed. Song is tuneful but melancholy. **HABITAT AND STATUS** Migrant visitor that favours open woodland and will nest in mature gardens within its range; around 100,000 pairs may breed here. **OBSERVATION TIPS** Usually nests in holes in trees or stone walls, but will use nest boxes.

female

Black Redstart *Phoenicurus ochruros* Length 14cm Wingspan 24cm
Perky bird that often perches conspicuously, quivering its red tail. Some individuals are very tame. Sexes are dissimilar. **ADULT MALE** has mainly slate-grey body plumage, darkest on face and breast. Has a white wing patch and whitish lower belly. Legs and bill are dark. **ADULT FEMALE AND IMMATURE** have grey-brown body plumage, darkest on wings and palest on lower belly. Pale eye-ring emphasises dark eye. **VOICE** Utters a whistling call. Song comprises whistles and curious crackling, static-like phrases. **HABITAT AND STATUS** Scarce breeding species that favours industrial and urban locations when nesting; uses buildings, both occupied and derelict. At other times, most records are coastal. **OBSERVATION TIPS** Occasionally seen in gardens on migration; most urban breeding records are from industrial sites rather than gardens.

Reed Warbler *Acrocephalus scirpaceus* Length 13–14cm Wingspan 19cm
Wetland warbler that occasionally occurs in mature gardens on migration. Spring passage migrants sometimes sing, and the species' song is distinctive enough to allow identification when the bird cannot be seen. Sexes are similar. **ADULT** has sandy-brown upperparts with a reddish-brown flush to rump. Underparts are pale with a buffish flush to flanks. Legs are dark and bill is thin and needle-like. Has hint of a pale supercilium and eye-ring. **JUVENILE** is similar but upperparts are warmer brown and underparts are more intensely flushed buff. **VOICE** Utters a sharp *tche* call. Song contains grating and chattering phrases, some of which are repeated 2 or 3 times, plus some elements of mimicry. **HABITAT AND STATUS** Locally common summer visitor to wetlands, breeding mainly in reedbeds. **OBSERVATION TIPS** Garden sightings typically relate to chance observations of migrants that pause for a day or so to feed.

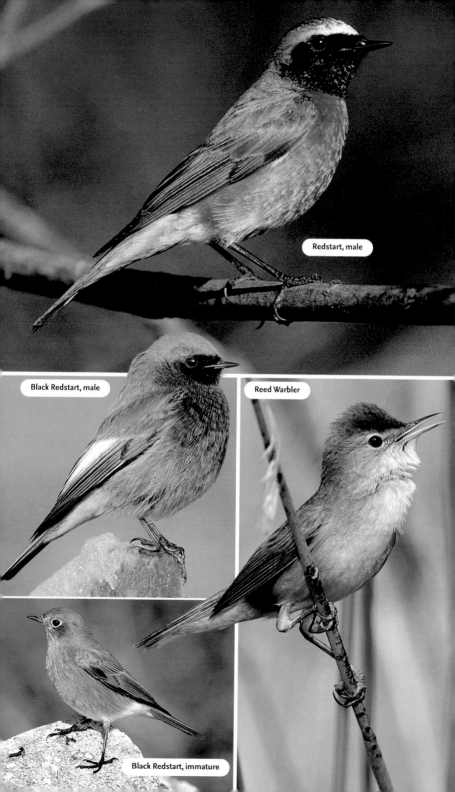

Redstart, male

Black Redstart, male

Reed Warbler

Black Redstart, immature

Sedge Warbler *Acrocephalus schoenobaenus* Length 12–13cm Wingspan 19cm
Well-marked wetland warbler whose lively song aids identification. Sexes
are similar. **ADULT** has dark-streaked sandy-brown upperparts, and pale
underparts flushed orange-buff on breast and flanks. Head has a
dark-streaked crown, striking pale supercilium and dark eye-stripe.
JUVENILE is similar but with faint streaking on breast. **VOICE** Utters
a sharp *chek* alarm call. Song comprises a series of rasping and grat-
ing phrases mixed with trills and whistles. **HABITAT AND STATUS**
Widespread summer visitor, with several hundred thousand pairs
breeding here; favours rank marshy vegetation and scrub. **OBSERVA-
TION TIPS** Sometimes stops off in gardens on migration and, in
spring, sometimes sings, aiding identification.

Lesser Whitethroat *Sylvia curruca* Length 12–13cm Wingspan 18cm
Small, short-tailed warbler. Rather shy but has a distinctive song that is
easily learned. Sexes are similar. **ADULT AND JUVENILE** have a blue-grey
crown, dark mask, and grey-brown on back and wings. Underparts are
pale, whitish on throat but washed with pale buff on flanks. Legs are
dark, grey bill is dark-tipped, and pale iris can sometimes be discerned.
VOICE Utters a harsh *tchek* alarm call. Song comprises a tuneless
rattle, sung on 1 note, preceded by short warbling phrase. **HABITAT
AND STATUS** Summer visitor that is commonest in S and SE England;
more than 50,000 pairs probably breed here. Favours mature scrub
and hedgerows, and sometimes breeds in rural gardens. **OBSERVATION
TIPS** Its distinctive song is the best clue to the species' presence in a given
area. If you have dense hedges and shrubs in the garden, then it may nest.

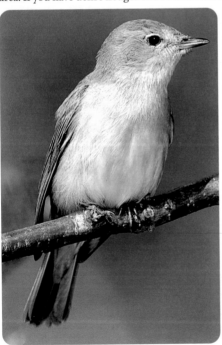

Garden Warbler
Sylvia borin Length
14–15cm Wingspan 22cm
Nondescript warbler
with an attractive
song. Sexes are
similar. **ADULT
AND JUVENILE**
have rather
uniform grey-
brown upperparts
and pale underparts
with a buffish wash, partic-
ularly on breast and flanks. Legs are grey,
grey bill is relatively short and stubby, and
note the subtle grey patch on side of neck.
VOICE Call is a sharp *chek-chek*. Song is
rich and warbling, similar to that of a
Blackcap (p. 44) but even more musical,
some phrases having a thrush-like quali-
ty. **HABITAT AND STATUS** Fairly common
summer visitor to England and Wales; a
couple of hundred thousand pairs proba-
bly breed here. Favours deciduous
woodland and mature scrub. **OBSERVA-
TION TIPS** Sometimes nests in mature
rural gardens that have plenty of cover
and dense hedges and shrubs for nesting.

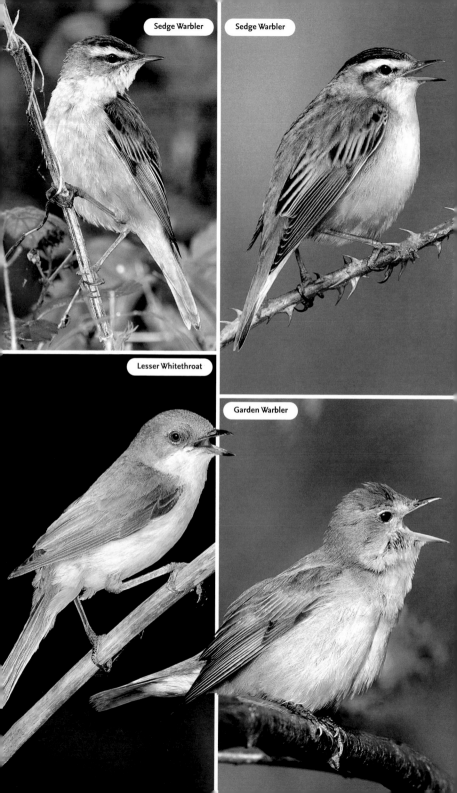

Willow Warbler *Phylloscopus trochilus* Length 11cm Wingspan 19cm
Similar to Chiffchaff (p. 46) but separable using plumage and song. Sexes are
similar. **ADULT** has olive-green upperparts, yellow throat and whitish
underparts; note the pale supercilium. Overall, plumage is brighter
than that of Chiffchaff and primary feathers project further, relative

to tertials. Has a pale supercilium and
pinkish legs (black in Chiffchaff).
JUVENILE is similar but plumage is
yellower. **VOICE** Utters a *hueet* call,
similar to that of Chiffchaff. Song is a
tinkling, descending phrase that ends
in a flourish. **HABITAT AND STATUS**
Common summer visitor, with several million
birds present here. Favours open woodlands. **OBSERVATION
TIPS** Listen for the species' song to detect its presence in
spring. Focus on leg colour to separate silent birds from
Chiffchaffs. Sometimes nests in large rural gardens;
otherwise known as a passage migrant.

Firecrest *Regulus ignicapillus* Length 9–10cm Wingspan 14cm
Tiny, active bird. Similar to Goldcrest (p. 46) but with distinctive markings
and colours. Sexes are dissimilar. **ADULT MALE** has yellow-green upper-
parts with 2 pale wingbars. Underparts are buffish white, flushed golden
yellow on sides of neck. Has a dark eye-stripe, broad white supercilium
and orange-centred black crown stripe. **ADULT FEMALE** is similar but
crown centre is yellow. **JUVENILE** is similar to adults but lacks crown
markings and colours. **VOICE** Utters a thin *tsuu-tsee-tsee* call. Song is a
series of thin, high-pitched notes, ending in a short trill. **HABITAT**

AND STATUS Rare breeding
bird with perhaps 100 pairs
present in most summers,
mainly in S England. Favours
large, mature conifers. Several hundred
also winter here and good numbers pass
through on migration. **OBSERVATION TIPS** Very
occasionally seen in gardens with mature
conifers, mainly in winter.

male, displaying

Pied Flycatcher *Ficedula hypoleuca* Length 12–13cm Wingspan 22cm
Well-marked insect-catching bird. Sexes are dissimilar. **SUMMER ADULT
MALE** has black upperparts, white underparts and a white band on

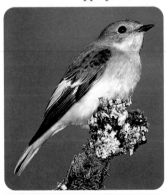

otherwise black wings; has a small
white patch at base of bill. **ALL
OTHER PLUMAGES** have a similar
pattern to summer adult male
but black elements of plumage
are brown. **VOICE** Utters a sharp
tik call. Song is sweet and ring-
ing. **HABITAT AND STATUS**
Summer visitor; several tens of
thousands of birds are present each
year. Favours W oak woodlands and is commonest
in Devon, Wales and the Lake District. **OBSERVATION
TIPS** Easiest to locate in spring, when the males are
singing. Thereafter, is mostly silent and hard to locate.
This tree-hole-nester takes readily to nest boxes. If
you live in the species' range, try putting up a few
hole-fronted boxes (see pp. 12–13).

female

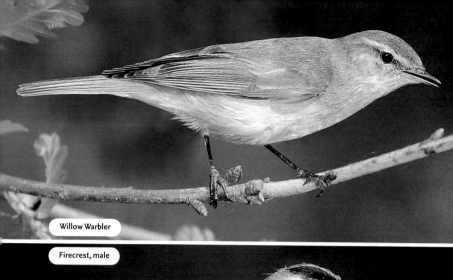

Willow Warbler

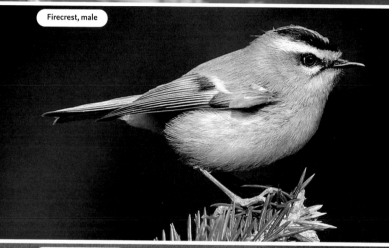

Firecrest, male

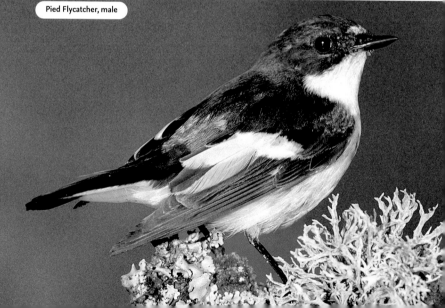

Pied Flycatcher, male

Crested Tit *Lophophanes cristatus* Length 11–12cm Wingspan 17–20cm
Distinctive little bird with a conspicuous crest. Sexes are similar. **ADULT**
has a striking black and white barred crest. Note the black line through

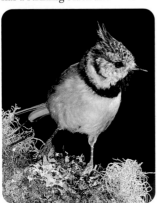

eye and bordering ear coverts on
otherwise whitish face; throat is
black, and black collar demarcates
head. Upperparts are otherwise
brown and underparts are buffish
white. Bill is narrow and warbler-
like. **JUVENILE** is similar but
colours and markings are less strik-
ing. **VOICE** Utters a high, trilling call.
Song is a rapid, warbler-like series of call-
like notes and whistles. **HABITAT AND STATUS** Resident
of native pine forests and mature, open Scots Pine plan-
tations in the Scottish Highlands. Nests in standing dead
tree stumps. Feeds mainly on invertebrates in summer,
but seeds are eaten in winter. **OBSERVATION TIPS** If you
live within the species' range, you may attract it to the
garden with seed feeders.

Hawfinch *Coccothraustes coccothraustes* Length 17–18cm Wingspan 29–33cm
Large and impressive finch, recognised by its relatively massive bill. Its
large head and thick neck match the proportions of its bill. Sexes are
separable with care. **ADULT MALE** has mainly pinkish-buff plumage
with grey on neck and a brown back. Note broad whitish wingbar,
blue-black flight feathers, and broad white tip to tail. Bill is dark
grey in summer but buffish brown in winter. **ADULT FEMALE** is
similar but colours are muted and an additional pale wing panel is
sometimes seen. **JUVENILE** is similar to adult female but colours are
even duller. **VOICE** Utters a sharp, almost Robin-like *tsic* call. Song is
quiet and seldom heard. **HABITAT AND STATUS** Favours mature
deciduous woodland but also visits orchards and large gardens if suitable
seed-bearing trees (notably Hornbeam and cherries) are present. **OBSERVA-
TION TIPS** Scatter seed on the lawn in winter and, if you attract Chaffinch flocks, you may
be lucky and have the odd Hawfinch visit.

Linnet *Carduelis cannabina* Length 13–14cm Wingspan 21–25cm
Active little finch, the males of which are colourful in spring. Outside the
breeding season, it forms flocks. Sexes are dissimilar. **SUMMER ADULT**

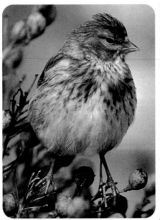

MALE has a grey head with a rosy-
pink patch on forecrown, and a
chestnut back. Pale underparts are
flushed rosy pink on breast. Note
the whitish patch on wings, pale
sides to tail, and streaked throat.
WINTER ADULT MALE is similar
but rosy-pink elements of
plumage are dull. **ADULT FEMALE** has
a brown back, grey-brown head and
streaked pale underparts. **JUVENILE** is similar to adult
female but duller and more streaked. **VOICE** Utters a
distinctive *tetter-tett* call. Song is a twittering warble.
HABITAT AND STATUS Common resident of scrub and
hedgerows. **OBSERVATION TIPS** Hard to attract to the
garden with food, but may nest there in dense hedges
and shrubs.

juvenile

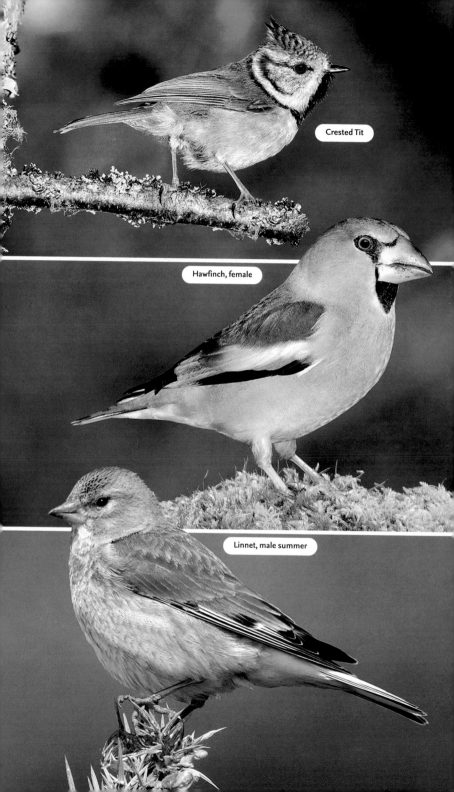

Crested Tit

Hawfinch, female

Linnet, male summer

Common Crossbill

Common Crossbill *Loxia curvirostra* Length 15–17cm Wingspan 27–30cm
Distinctive finch with crossed-tipped mandibles, used to extract seeds
from conifer cones. Forms flocks outside the breeding season. Sexes are
dissimilar. **ADULT MALE** has reddish plumage with brownish wings.
ADULT FEMALE has greenish plumage with brownish wings. **IMMA-
TURES** are similar to respective sex adults but duller. **JUVENILE** is
grey-brown and heavily streaked. **VOICE** Utters a sharp *kip-kip-kip*
flight call. **HABITAT AND DISTRIBUTION** Found in conifer woodland
with trees of cone-bearing age. Dependent on the cone crop; if it fails
in a given area, then birds wander nomadically. **OBSERVATION TIPS**
Hard to attract to the garden unless you have mature larch or spruce
trees. If you live near conifer woodland, birds may visit drinking pools
in your garden.

Yellowhammer

Yellowhammer *Emberiza citrinella* Length 15–17cm Wingspan 23–29cm
Colourful bunting with an easily recognised song. Sexes are dissimilar.
SUMMER ADULT MALE has a mainly bright yellow head and underparts,
and reddish-brown back and wings. Note the faint dark lines on head,
chestnut flush to breast and streaking on flanks; rump is reddish brown
and bill is greyish. **WINTER ADULT MALE** is similar but yellow elements
of plumage are subdued, and dark streaking on head and underparts

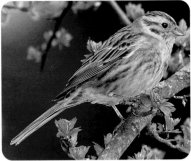

is more extensive. **ADULT
FEMALE** has a streaked
greenish-grey head and
breast, streaked pale yellow
underparts and brown back;
note the reddish-brown rump.
JUVENILE is similar to adult female but more
streaked. **VOICE** Utters a rasping call. Song is
often rendered as *'a little bit of bread and no
cheese'*. **HABITAT AND STATUS** Widespread in
open countryside with grassland, arable fields,
scrub and hedgerows. Outside the breeding
season, forms flocks and feeds in fields. **OBSER-
VATION TIPS** Sometimes feeds in rural gardens
where seed is provided.

female

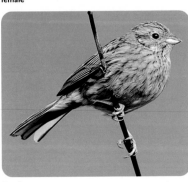

female

Cirl Bunting

Cirl Bunting *Emberiza cirlus*
Length 16–17cm
Wingspan 22–25cm
Well-marked bunting. Sexes
are dissimilar. **ADULT MALE**
has a head pattern
comprising a black
throat and eye-stripe,
separated and defined by
yellow. Breast, nape and
crown are greenish grey
and underparts are yellow,
flushed and streaked chestnut on
flanks; back is reddish brown. Colours are less
distinct in winter than in summer. **ADULT
FEMALE** has dark and yellowish stripes on head, a streaked greenish-grey crown, nape and
breast, and streaked yellowish underparts. Back is reddish brown. **JUVENILE** is similar to
adult female but yellow elements of plumage are pale. **VOICE** Utters a sharp *tziip* call. Song
is a tuneless rattle, recalling that of Lesser Whitethroat (p. 84). **HABITAT AND STATUS**
Confined mainly to coastal districts of S Devon, but reintroduced to Cornwall and hopefully
spreading. Favours a mosaic of weedy fields, mature hedgerows and scrub. **OBSERVATION
TIPS** If you live within the species' range you may attract it in winter with seed.

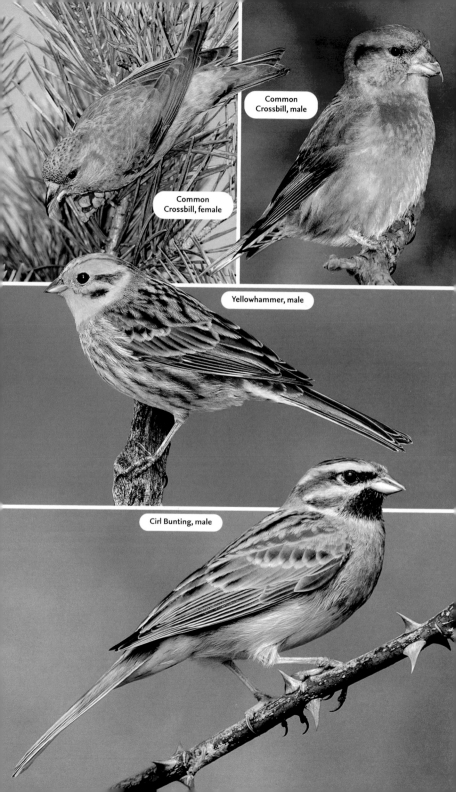

Common Crossbill, female

Common Crossbill, male

Yellowhammer, male

Cirl Bunting, male

INTRODUCING GARDEN MAMMALS

In terms of popularity, mammals are the poor relations to birds. In part, this is because they are less numerous in the garden, but the main reason is that they can be quite hard to study. Birds' ability to fly as a means of escape confers on them a bold presence in the garden. But many of our garden mammals lead unobtrusive, often nocturnal lives, and some are positively shy and furtive. For the garden naturalist, however, this challenge just makes the reward of studying mammals all the greater.

GARDEN RESIDENTS

Unless you have a large rural plot, the species resident in your garden are likely to be mainly relatively small mammals. Wood Mice, Bank Voles and both Pygmy and Common shrews are widespread, and many urban and suburban gardens will usually support a Hedgehog. To encourage these species, leave wild areas in the garden and piles of brush and logs as places for daytime retreats, along with locations for hibernation in the case of Hedgehogs.

ABOVE: **Hedgehogs form part of the nightshift in the garden and forage on lawns and in borders for invertebrates. They are also partial to a saucer of milk and, with patience, can become completely accustomed to people.**
LEFT: **If you live within the Red Squirrel's range in Scotland and northern England, then the species may visit your garden feeders; peanuts in their shells seem to be a particular favourite food. Unlike their Grey cousin, which is the typical garden squirrel of the south, Reds are a welcome addition to any garden list.**

ATTRACTED TO FOOD

Feeding birds in the garden has a proven track record for increasing not only the numbers of visitors but also their diversity. The same approach works with some mammal species and it has the added advantage that it can make them much easier to see. Foxes and Badgers will sometimes visit gardens after dark if appropriate food is provided. Peanuts and peanut-butter sandwiches are particularly good in this regard, and the visitors will often become accustomed to outside lights, allowing great views to be obtained.

Bird-feeders and tables attract not only the avian visitors for which they are intended, but also a few mammals. Squirrels – Grey and even Red in northern Britain – are bold and often appear in the daytime. Wood Mice and Bank Voles are more wary and often visit after dark.

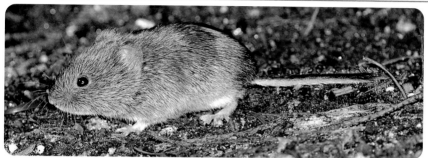

ABOVE: **This Bank Vole is venturing out under cover of darkness to forage for scraps of food that have fallen from a bird-feeder. Typically, voles gather food quickly and then make a hasty retreat to a nearby burrow or hidey-hole.**

RIGHT: **Within the species' range in Britain, Roe Deer are surprisingly frequent visitors to rural gardens. To the dismay of some gardeners, they love to browse shrubs and nibble shoots. But most enlightened homeowners, who garden with wildlife in mind, tolerate the minor damage they cause and view their presence as a privilege.**

UNDETECTED PRESENCE

The distinction between house and garden is often blurred when it comes to mammals. Many people know only too well about winter-visiting Wood and Yellow-necked mice, which take up residence in the home as the weather deteriorates. But many houses are also home to bats, whose presence often goes unnoticed. During the summer months they roost and have their young in loft spaces and outbuildings, and in winter some species use the same locations for hibernation. If your garden is produc-

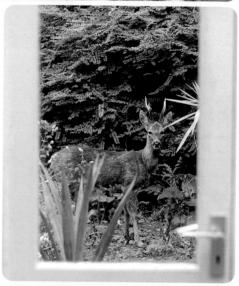

tive for insects, then bats will also feed there after dark, hunting on silent wings for flying moths, flies and beetles.

LEFT: **Bats can be encouraged in the garden by siting wooden bat boxes in strategic places such as the shady side of a tree trunk or house wall.**

RIGHT: **A bat detector is a great asset if you want to monitor the bats in your garden. It converts the inaudible high-pitched sounds the bats emit for echolocation into audible clicks and squeaks. With experience, different species can be identified with a fair degree of certainty using this method.**

MAMMAL TRACKS, TRAILS AND SIGNS

You will be amazed at how much information can be gleaned about the mammals present in your garden simply by looking for tracks, trails and signs. With larger tracks and trails, it is usually possible to determine the identity of the mammal that made them. Other signs of life, such as hair or droppings, can also help identification and sometimes reveal traits of intriguing animal behaviour.

TRACKS AND PRINTS

Soft mud and sand are usually the best media for the formation and preservation of good-quality tracks. In the garden, damp – not waterlogged – soil is best. Unsurprisingly, the autumn and winter months usually offer the best opportunities for finding tracks.

DOG tracks – note the four toes and the presence of visible claw marks in clean prints.

FOX tracks are more oval than those of a dog. Note the four toes and the presence of claw marks. Typically, tracks follow a straight line.

DOMESTIC CAT prints are rounded in overall appearance, with four toes. Because the claws are retractable, no marks are visible.

BADGER prints are broad, with five toes and conspicuous claw marks.

ROE DEER make rather dainty tracks, which comprise slots that are broad-based but distinctly pointed at the tip.

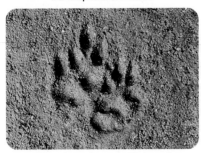

RABBIT tracks are characterised by long prints left by the hind feet and smaller, rounded ones formed by the front feet; these often appear on top of one another in slow-moving animals.

MUNTJAC make tiny prints with slots that are proportionately narrower than those of the Roe Deer.

MAMMAL DROPPINGS

The study of mammal faeces is, understandably, not a subject that attracts armies of enthusiasts and there is no getting away from the fact that, at times, it can be distinctly unpleasant. But mammal droppings are useful for identifying the presence of secretive or nocturnal animals, and many species use them to define territories.

ROE DEER LENGTH 17mm Usually scattered on the ground.
MUNTJAC LENGTH 12mm – Small and cylindrical.
RABBIT LENGTH 12mm – Spherical and fibrous.
BROWN RAT LENGTH 18mm – Ovoid, but usually distinctly pointed at one end.
GREY SQUIRREL LENGTH 18mm– Ovoid and fibrous.
DOG LENGTH 120mm – Cylindrical, tapering at the ends and often appearing almost segmented.
FOX LENGTH 60mm – Dog-like. However, prey remains are often visible.

HOUSE MOUSE LENGTH 3mm – Small, irregularly cylindrical to ovoid, and friable.
WOOD MOUSE LENGTH 5mm – Irregularly ovoid to cylindrical.
YELLOW-NECKED MOUSE LENGTH 6mm Larger than those of Wood Mouse.
HEDGEHOG LENGTH 40mm – Contain insect remains.
BANK VOLE LENGTH 5mm – Irregularly cylindrical to sausage-shaped.
COMMON PIPISTRELLE LENGTH 4mm – Small, friable and superficially similar to mouse droppings.

ⓘ **APPROX. SCALE: LIFESIZE**

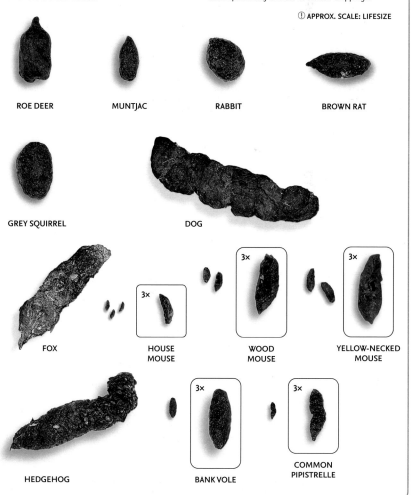

ROE DEER MUNTJAC RABBIT BROWN RAT

GREY SQUIRREL DOG

FOX HOUSE MOUSE 3× WOOD MOUSE 3× YELLOW-NECKED MOUSE 3×

HEDGEHOG BANK VOLE 3× COMMON PIPISTRELLE 3×

Hedgehog *Erinaceus europaeus* Length 23–27cm

Distinctive mammal with a body coating of protective spines. Familiar resident of many gardens. Often seen as a road casualty. **ADULT** has a coating of several thousand spines (modified hairs) on its back, sleeked back when animal is foraging but erectile and effective as a deterrent when animal rolls into a defensive ball. Head and underparts are covered in coarse hairs. Has relatively short ears and a muzzle-shaped head that ends in a sensitive nose. Legs are relatively short but can transport animal at surprising speed. **JUVENILE** is born blind and naked but soon acquires a coating of stout whitish spines. Resembles a miniature adult after 3 weeks. **VOICE** Utters a piercing pig-like squeal when distressed. Various grunts and snorts are heard from courting or feeding animals. **HABITAT AND STATUS** Widespread but its precise range is patchy. Favours a mosaic of grassy areas and scrub; highest densities occur in suburban gardens and parks. **HABITS** Strictly nocturnal and forages on the ground for

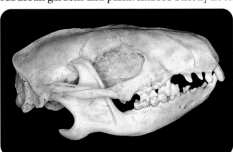

invertebrates. When alarmed, rolls into a defensive ball. Hibernates, typically from late Oct to early Apr. Mating occurs in spring, and litters of 4 or 5 young are born from spring to early autumn. **OBSERVATION TIPS** Found in most lowland towns and villages in Britain. Look for sausage-shaped droppings on your lawn (*see* p. 95). Cat food or bread and milk will often attract Hedgehogs, as will the construction of protected nesting and hibernation sites.

Mole *Talpa europaea* Length 14–18cm

Unmistakable subterranean mammal, the signs of which (molehills and surface runs) are seen more frequently than the animal itself. **ADULT** has a cylindrical, sausage-shaped body that is covered in blackish-grey velvety fur; hairs can lie in any direction, allowing animal to move backwards and forwards in tunnels with ease. Head is pointed and tapering, and jaws are armed with sharp teeth. Eyes are small, beady and covered with fur. Front limbs are broad, spade-like, armed with claws and amazingly powerful; they are used for digging. **JUVENILE** is born blind and naked. Acquires fur within a week or so. **VOICE** Mostly silent. **HABITAT AND STATUS** Widespread and common, but possibly declining. Favours undisturbed soils of grassland and woodland habitats, but also occurs in rural gardens. **HABITS** Lives in a network of underground tunnels; molehills are created when a Mole pushes excavated soil above ground. Its metabolic rate is high and it needs to feed almost constantly. It eats mainly earthworms that fall into the tunnels, these captured by the patrolling Mole; excess worms are disabled and stored in a larder for later consumption. Litters of 4 or 5 young are born

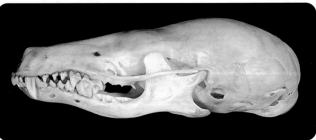

in spring. **OBSERVATION TIPS** Signs of Mole activity are easy to observe. Wandering animals are sometimes seen above ground in spring. Molehill soil makes superb potting compost.

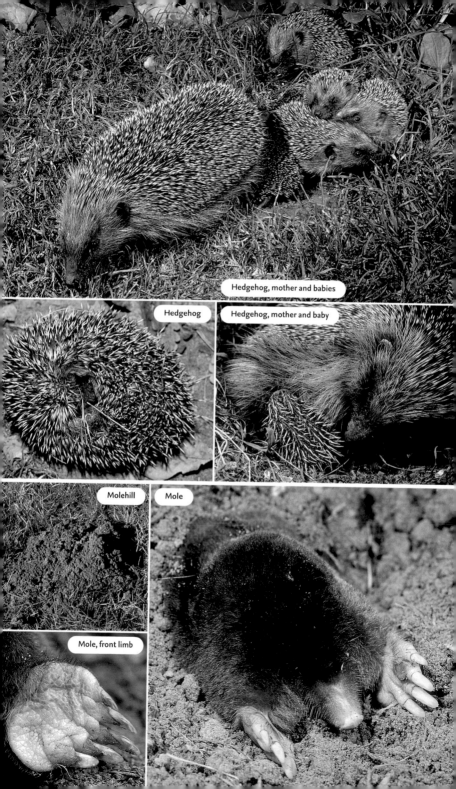

Hedgehog, mother and babies

Hedgehog

Hedgehog, mother and baby

Molehill

Mole

Mole, front limb

Common Shrew *Sorex araneus* Body length 5.5–8.5cm Tail length 3.5–5.5cm
Widespread shrew that leads a frenetic life in its search for invertebrate
food. **ADULT** has dense, velvety fur; upperparts are dark brown, flanks
are paler buffish brown, grading to greyish white on underparts. Head
has a pointed snout with bristly whiskers. Has tiny, beady eyes and
rather small external ears. Teeth have reddish tips. Tail is almost
naked and, relative to body length, is shorter than that of Pygmy
Shrew (below). **JUVENILE** is similar but smaller; tail is covered with
short hairs. **VOICE** Utters high-pitched twittering squeaks when
feeding and shrill screams during aggressive encounters; easiest to
pick up using a bat detector. **HABITAT AND STATUS** Widespread and
common in mainland Britain; absent from Ireland, the Isles of Scilly
and most Scottish islands. Favours hedgerows, grassland, woodland
margins and mature gardens with plenty of ground cover. **HABITS** Active throughout the
24-hour period apart from brief rest periods, foraging for invertebrates both at ground

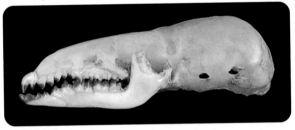

level and in burrows. 1 or
2 litters containing an
average of 6 young are
born in spring and
summer. **OBSERVATION
TIPS** Hard to observe other
than by chance. Sometimes
discovered by turning over
boards or sheets of corru-
gated iron lying on the
ground in grassland.

Pygmy Shrew *Sorex minutus* Body length 4–6cm Tail length 3–4.5cm
Our smallest land mammal. Constantly active in search of food. **ADULT**
has dense fur. Uniformly dark brown on upperparts and flanks; under-
parts are contrastingly pale greyish white. Head is elongated into a
pointed snout with long, sensitive bristles; eyes are small and beady,
and external ears are partly hidden by fur. Tail is relatively long
compared to body length and covered with fine hairs. Tips of teeth
are red. **JUVENILE** resembles a miniature adult. **VOICE** Utters high-
pitched squeaks when foraging for food; these are inaudible to
most people but can be picked up by a bat detector. **HABITAT AND
STATUS** Widespread species in most of mainland Britain and Ireland;
also occurs on many islands, although absent from the Isles of Scilly,
Channel Islands and Shetland. Favours a wide range of habitats, including
deciduous woodland margins, hedgerows, meadows, heathland and moors. **HABITS** Active
day and night, and throughout the year. Forages in leaf litter and at ground level in vegeta-
tion, and less inclined than the Common Shrew (above) to venture underground. Adept at
climbing. Feeds on invertebrates, including snails, slugs, spiders, woodlice and beetles.
Females give birth in spring and early summer. There can be 2 litters a year, each contain-
ing 5–7 young. **OBSERVATION TIPS** Hard to observe in the wild. Use a bat detector to pick

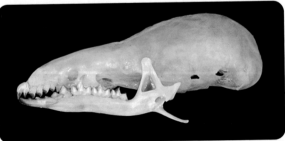

up its high-pitched calls.
The provision of boards
and other hiding places
may encourage this species
in the garden.

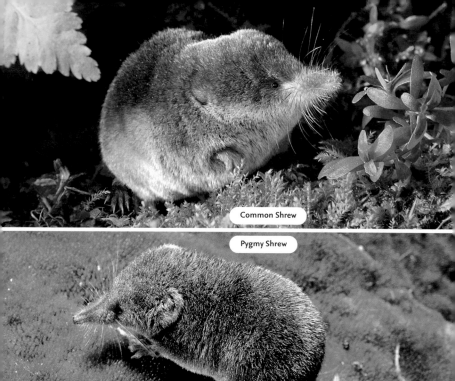

Common Shrew

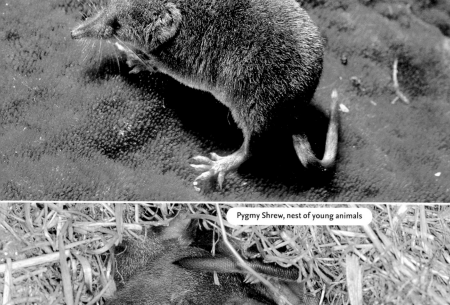

Pygmy Shrew

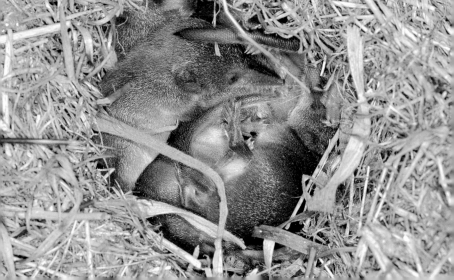

Pygmy Shrew, nest of young animals

Bank Vole *Clethrionomys glareolus* Body length 9.5–10.5cm Tail length 3.5–7cm
Plump, richly coloured vole that is sometimes seen in broad daylight.
ADULT has a compact body and mostly reddish-brown fur, grading to
greyish brown on flanks and paler still on chest and belly. Has relatively
large (by vole standards) ears and a long tail. **JUVENILE** is similar but
greyer. **VOICE** Squeaks if alarmed or distressed. **HABITAT AND STATUS**
Found in a variety of wooded and scrub habitats, including decidu-
ous woodland, mature hedgerows and field margins. Widespread

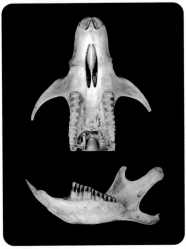

and common but popula-
tions fluctuate seasonally,
and in response to climate.
HABITS Home range centres on
a nest, woven from plant fibres
(typically grass); usually sited underground in a
burrow but sometimes under a piece of corrugat-
ed iron or log. Shallow burrows and surface
tunnels radiate from the nest and are used for
feeding. Diet includes plant shoots and leaves,
and berries, nuts and fungi in season. Active
throughout the 24-hour period. Feeds mainly on
the ground but climbs well. Breeding season
extends from early spring to late autumn, and
females have the potential to produce up to 5
litters a year, each with 3–5 young. **OBSERVATION**
TIPS If you sit quietly beside a blackberry-covered
Bramble patch in the garden, you may see a feed-
ing vole. Also visits bird-feeding stations in
winter, typically foraging on the ground for fallen
scraps after dark.

House Mouse *Mus domesticus* Body length 7–10cm Tail length 7–9cm
Archetypal mouse and ancestor of domesticated pet mice. **ADULT** has a
compact head and body that is of similar length to tail. Coat is variable, but
usually grey-brown and slightly darker above than below. Has beady eyes
and relatively large ears. **JUVENILE** is similar but smaller. **VOICE** Utters
high-pitched squeaks, barely audible to the human ear. **HABITAT**
AND STATUS Probably introduced. Present at low densities in the

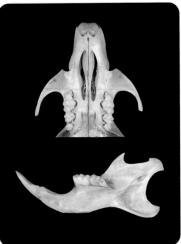

countryside but thrives
where humans live and
work, especially where
food is stored, processed or
distributed. In towns and cities,
it is found in buildings where
food is stored, processed or cooked, and to a much
lesser degree in houses. **HABITS** Behaviour is
extremely flexible and adaptable. At low densities,
the home ranges overlap and there is little terri-
toriality. As densities increase, signs of aggressive
behaviour appear. Diet includes a wide range of
food materials, particularly stored grains, but
strange items with little nutritional value (e.g. soap)
are also nibbled. Reproductive rate is prodigious
– can produce as many as 10 litters per year, each
with 5–7 babies. **OBSERVATION TIPS** Changes in
building construction and increased domestic
hygiene mean that it is a rare visitor to the modern
home and garden. Easiest to see in older suburbs
of large cities.

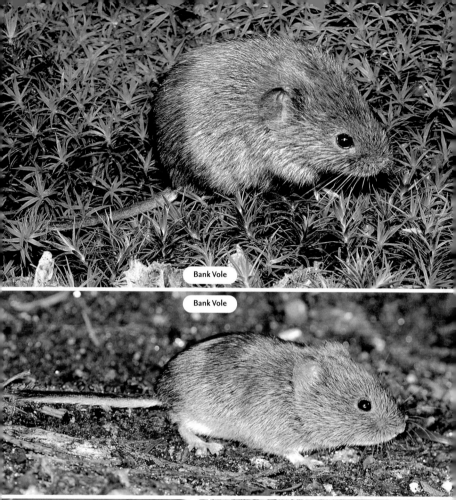
Bank Vole

Bank Vole

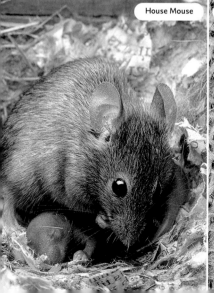
House Mouse

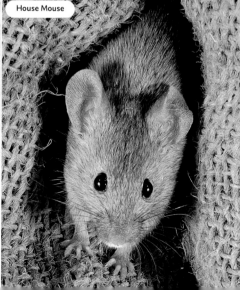
House Mouse

Wood Mouse *Apodemus sylvaticus* Body length 9–11cm Tail length 7–11cm

The most familiar mouse in rural houses and gardens. **ADULT** has a classic mouse shape, with a pointed head, compact body and long tail. Compared to the House Mouse (p. 100), note the large eyes, ears, hind legs and tail. Coat colour is mainly yellowish brown on upperparts, with a dark vertebral band along dorsal surface of head and body.

Yellowish colour on flanks grades to whitish underparts, with a less clear demarcation than in Yellow-necked Mouse (below). Some animals have a small yellowish spot on throat. **JUVENILE** is similar but smaller; greyish brown and lacks adult's yellowish hue. **VOICE** Mainly silent but utters frantic squeals in distress. **HABITAT AND STATUS** Widespread and most numerous in deciduous woodland. Also found in hedgerows, scrub and mature gardens. Frequent visitor to garden sheds, greenhouses and loft spaces in winter. **HABITS** Mainly nocturnal; forages on the ground and climbs well. Varied diet includes seeds, nuts, fruits, fungi and invertebrates. Breeding season extends from early spring to autumn, and female can produce 4–6 litters a year, each with 3–8 young. **OBSERVATION TIPS** Sometimes visits bird tables in winter, especially after dark.

Yellow-necked Mouse *Apodemus flavicollis* Body length 9–13cm
Tail length 9–13cm

Impressive mouse and the largest of its kind in Britain. **ADULT** is similar to the Wood Mouse (above) but larger and with proportionately larger ears, eyes and feet, and a longer tail; coat colour is richer on upperparts, and there is a clearer demarcation between this and white underparts. Has a broad, prominent, richly coloured yellow band on throat linking to brown fur on upperparts (in Wood Mouse, yellow on throat is, at most, restricted

to a discrete spot). **JUVENILE** is similar but smaller, often with a less well-developed yellow throat and duller coat colour. **VOICE** Mainly silent but squeals loudly in distress. **HABITAT AND STATUS** Occurs patchily in S England and Wales. Associated mainly with ancient deciduous woodlands. **HABITS** Mainly solitary but home ranges may overlap in winter, especially where it occupies human habitation. Usually nocturnal; daytime is spent in its nest in a burrow or tree hollow. Forages after dark on the ground or by climbing. Diet includes nuts, fruits, berries, fungi and invertebrates. Breeding season extends from early spring to autumn, and female is capable of producing 2 to 3 litters a year, each containing 4–7 babies. **OBSERVATION TIPS** Visits human habitation in autumn. If you live within the species' range and near woodland, then one or more may take up residence in your house, garage or garden shed from Sep to Mar.

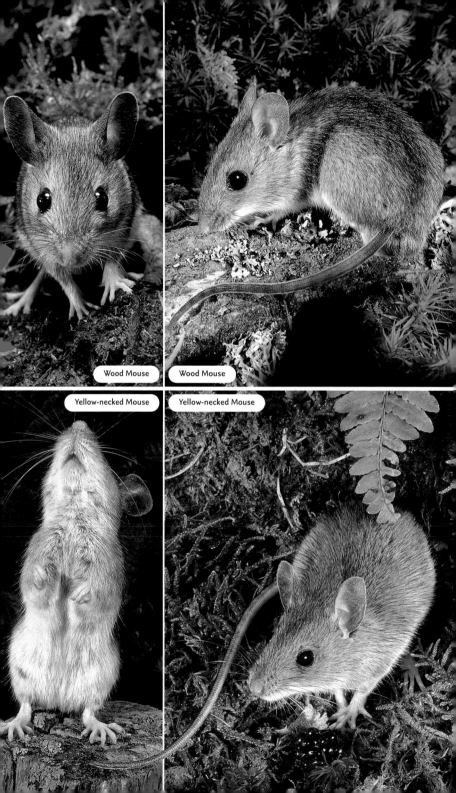

Wood Mouse

Wood Mouse

Yellow-necked Mouse

Yellow-necked Mouse

Red Squirrel *Sciurus vulgaris* Body length 20–25cm Tail length 15–20cm
Endearing mammal and our only native squirrel. **ADULT** has a compact
body, large head and tufted ears, and a bushy tail. In summer, coat is
reddish brown above with creamy-white underparts. Tail bleaches pale
with time. In winter, has a thicker coat; back is usually greyish brown
while legs and head are reddish brown; ear tufts are long. Animals
introduced from mainland Europe are noticeably darker than
native ones. **JUVENILE** is similar to adult but smaller. **VOICE** Utters
a variety of chattering calls. **HABITAT AND STATUS** Widespread
prior to the introduction of the Grey Squirrel (below) in 1876. Now
restricted to conifer forests (usually Scots Pine) in Scotland,
Northumberland and Cumbria. Isolated populations are also found in
Wales and England. **HABITS** Usually solitary but with some territorial over-
lap, especially when feeding. Sometimes forages on the ground, but mainly arboreal,
feeding on pine nuts, acorns, fungi, berries, buds and shoots, in season. Front paws help

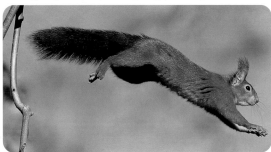

manipulate food. Sleeps in a
nest (drey) made from twigs
and lined with grasses and
mosses. Young (usually 3–5 per
litter) are born in early spring.
OBSERVATION TIPS Easy to see
in conifer forests in the Scot-
tish Highlands or Lake
District. If you live in these
regions, and near suitable
habitat, Red Squirrels can
easily be attracted to garden
feeders; peanuts are popular.

Grey Squirrel *Sciurus carolinensis* Body length 25–30cm Tail length 20–25cm
Widespread and abundant alien. The familiar squirrel of urban parks
and gardens. **ADULT** has a plump, elongated body and long, bushy tail.
Ears are rounded and lack ear tufts. Coat and tail are grizzled grey with
a whitish chest and belly. Some animals are tinged brown on back,
flanks and legs. In winter, coat is thick and uniformly grizzled grey,
lacking brown tinge. **JUVENILE** is similar to summer adult but tail
is scrawny. **VOICE** Utters a teeth-smacking *tchack* when alarmed and
various chattering calls. **HABITAT AND STATUS** Introduced from
North America in 1876, since when its range and numbers have
increased dramatically. Its presence causes untold damage to native
wildlife. **HABITS** Usually solitary, but territories may overlap where feed-
ing is good. Diurnal and mainly arboreal, but will feed on the ground,

especially in winter. Often visits
bird-feeders and takes eggs and
young of birds, sometimes even
raiding nest boxes. Sleeps in a
nest (drey) made from twigs,
lined with leaves and placed
high in a tree. Young (2 or 3 per
litter) are born in early spring.
OBSERVATION TIPS Easy to see in
most gardens and often bold
and inquisitive. On balance, it is
probably best discouraged
because of the impact it has on
native wildlife.

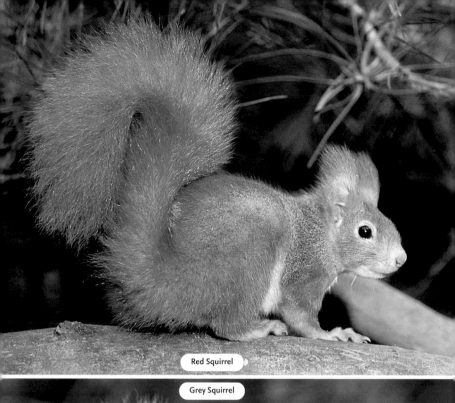
Red Squirrel

Grey Squirrel

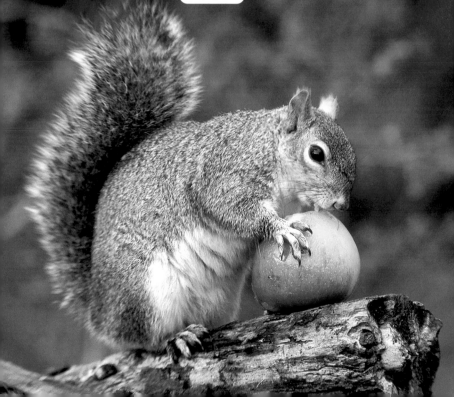

Brown Rat *Rattus norvegicus* Body length 20–27cm Tail length 16–23cm
All-too familiar rodent. An adaptable animal, usually reviled on account of its habits. **ADULT** recalls an outsized mouse but note the much larger, plumper body and shorter ears; also has relatively shorter legs (but larger feet) and a thicker tail. Fur is coarse and mainly brown, grading to grey on underparts. Tail looks scaly and is sparsely armed with bristles. **JUVENILE** is similar but with a slimmer body and proportionately larger head. **VOICE** Utters various screams and whistles in distress. **HABITAT AND STATUS** Introduced and first recorded here in 1720. Now widespread and common, and usually associated with people: highest densities are found in sewers, rubbish dumps, urban locations where food is discarded, and farm buildings. **HABITS** Forms

colonies where feeding is good and shelter is available. Omnivorous, its diet including stored foodstuffs, fruit, berries, insects and other invertebrates, birds' eggs and amphibians, and discarded food and rubbish generally. A female is capable of producing 5–10 litters per year (each containing 6–9 babies). **OBSERVATION TIPS** Few tips are needed to see Brown Rats. Often attracted to garden feeding stations where large quantities of food are put out for the birds.

Rabbit *Oryctolagus cuniculus* Body length 30–40cm Tail length 5–6cm
Distinctive mammal with a plump body, relatively short tail and long, broad-tipped ears. Unrelated to rodents. **ADULT** has mostly greyish-brown fur, palest and whitish on underparts and showing a reddish-brown patch between ears. Note the white underside to the fluffy tail, mostly obvious when animal is alarmed and running. Ears are reddish brown. **JUVENILE** is similar but with proportionately shorter ears. **VOICE** Mostly silent but screams loudly when distressed. **HABITAT AND STATUS** Introduced to Britain but now widely established and common. Found in a wide variety of habitats, from farmland and open grassland to heaths and rural gardens. **HABITS** Mostly nocturnal, especially where persecuted, and spends hours of daylight in a network of burrows called a 'warren'. Feeds on plant material, which is nibbled. Has a prodigious breeding rate: litters are born anytime between late winter and early autumn, each containing 4–12 young. **OBSERVATION TIPS** Usually easiest to observe feeding on roadside verges, often in surprisingly urban areas.

Frequent visitor to rural gardens and can cause considerable damage to trees, shrubs and vegetable patches.

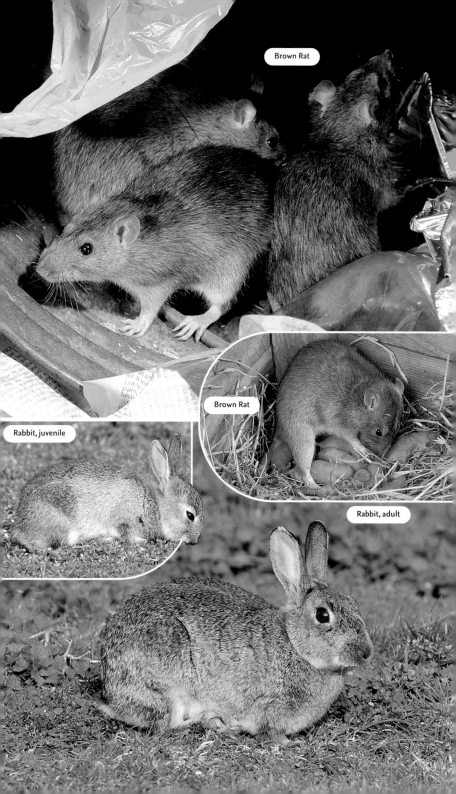

Brown Rat

Brown Rat

Rabbit, juvenile

Rabbit, adult

Roe Deer *Capreolus capreolus* Shoulder height 65–70cm

Attractive native species. Familiar to people who walk in the countryside. **ADULT** has a reddish-brown coat in summer; moulted in autumn to produce a thick, dense greyish-brown winter coat. At all times, note the striking black and white markings on muzzle (black nose and 'moustache', contrasting with white 'chin'). Male (buck) develops short, branch-like antlers in late winter and early spring. Initial coating of velvet is shed in spring and antlers are lost in early winter. Antlers increase in size and complexity with age, to a maximum length of 25cm and 3 points. Has a whitish mark on rump that is oval to kidney-shaped, and lacks a tail. Female (doe) is similar but less stocky. Antlers are missing and whitish marking on rump is shaped like an inverted heart. In winter, has a white tuft of anal hairs (tush) that resembles a tail. **JUVENILE** (fawn) is reddish brown with white spots on back and flanks. **VOICE** Has a barking alarm call. In rutting season, females attract males with high-pitched

antler

cries. **HABITAT AND STATUS** Locally common, favouring a mosaic of woodland copses, arable farmland and grassland. **HABITS** Browses leaves and grazes grassland. Crepuscular and nocturnal in areas of disturbance. Territorial for much of the year, but in winter is sometimes encountered in small groups. Rutting season lasts from Jun to Aug. Implantation is delayed until midwinter, hence young are born in May or Jun. **OBSERVATION TIPS** Easiest to observe in winter when leaves have fallen. Whitish rump is striking. Signs include tufts of hair and hoof prints (3–4cm across; *see* p. 94). Droppings are scattered liberally and 1.6–1.8cm long (*see* p. 95).

Muntjac *Muntiacus reevesi* Shoulder height 43–45cm (male), 38–40cm (female)

Introduced deer, barely the size of a Labrador dog. **ADULT** has a mainly reddish-brown coat with whitish chest and belly. Head is relatively large and legs are short. Tail is long, reddish brown above and whitish below, and striking when raised in alarm. Adult male (buck) develops tusk-like upper canine teeth (to 2cm long) that project outside closed mouth. Antlers are grown in late summer and shed in early summer the following year; they are borne on permanent skin-covered pedicles. Adult female (doe) is similar but smaller, and lacks antlers. **JUVENILE** (fawn) is reddish brown with white spots on back and flanks. **VOICE** Utters a piercing, coughing bark. **HABITAT AND STATUS** Native to Far East. Escaped from captivity here in the 20th century. Now widespread in dense scrub, woodland undergrowth and mature gardens. **HABITS** Browses low-growing vegetation, including Brambles and shrubs, strips tree bark and shoots, eats grasses and forages for fallen fruit. Young are born at any time of year. **OBSERVATION TIPS** Unobtrusive; easiest to see at dawn and dusk. Causes damage to garden plants.

antler

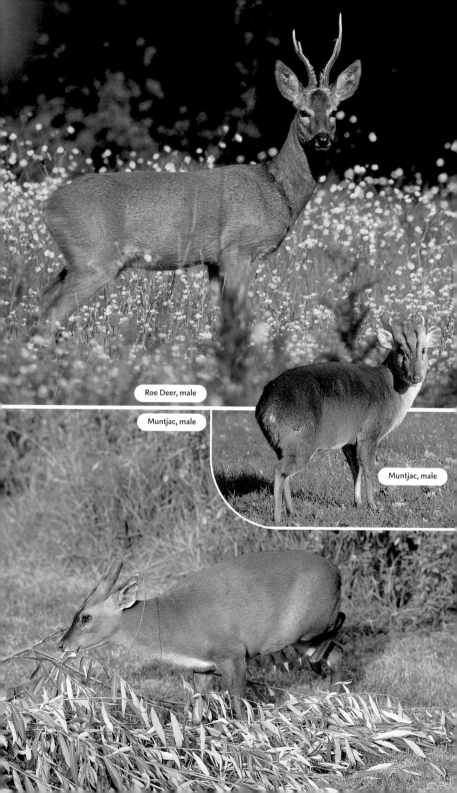

Roe Deer, male

Muntjac, male

Muntjac, male

Fox *Vulpes vulpes* Body length 60–90cm Tail length 35–45cm
Adaptable dog-like mammal whose appearance and colour are familiar
to most people. **ADULT** has a thick coat of orange- or reddish-brown fur
on most of its body and tail. Jaws and underparts are white, and has a
white tip to tail. Feet and backs of ears are blackish. Male (dog) is
slightly larger than female (vixen). **JUVENILE** (cub) has dark fur and a
relatively larger head than adult. **VOICE** Vixen utters high-pitched
yelping screams in midwinter, to mark breeding season. Adults
bark near den to warn cubs of danger. **HABITAT AND STATUS** Wide-
spread and common in woodland, farmland and on moors. Has
also adapted well to towns and cities, benefiting from discarded
food and boosted small mammal populations. **HABITS** Kills and eats
mammals, birds, amphibians and invertebrates, but also takes carrion, fruits
and berries. Will raid dustbins. Mainly nocturnal, spending much of the day in an excavat-

ed den (earth). Territorial;
boundaries are marked
with urine-scent and
conspicuously placed drop-
pings. Mating occurs in
midwinter (females are
fertile for 3 days) and young
are born in early spring.
OBSERVATION TIPS Easiest
to see in urban areas and
fairly easy to attract to the
garden (after dark) with
food.

Badger *Meles meles* Body length 65–70cm Tail length 15–20cm
Familiar stout-bodied mammal with iconic black and white markings on
its face. **ADULT** has a thickset body that often looks rather flattened as it
shuffles along on relatively short legs. Body is covered in greyish fur.
Broad, pointed head is marked with black and white stripes, and ears
are white-tipped. **JUVENILE** is similar but with a relatively larger
head. **VOICE** Mostly silent but sometimes utters grunts and squeals
during playful interactions. **HABITAT AND STATUS** Widespread and
locally common (except where deliberately exterminated or perse-
cuted), favouring countryside with a mosaic of woodland (where
sett is typically built) and grassland (where most feeding occurs). Also
found in and around many rural villages, and even towns, sometimes
venturing into gardens. **HABITS** Almost exclusively nocturnal, spending
daytime in communal, underground excavated burrows and chambers (the sett). A socia-
ble animal – between 3 and 10 animals typically share a sett. Has an omnivorous diet:
earthworms are important, but also other invertebrates, small mammals, fruits, berries

and carrion. Dung is
deposited in frequently
used latrines. **OBSERVATION
TIPS** With preparation and
a knowledge of fieldcraft,
can sometimes be watched
emerging from sett at
twilight. Otherwise, some-
times seen crossing the road
(and, indeed, is a frequent
road casualty). In rural
areas, can be attracted to
the garden by the provision
of peanuts and other food.

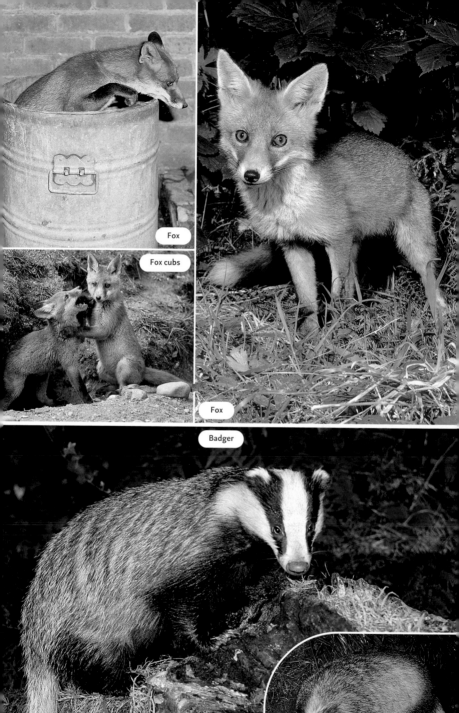

Fox

Fox cubs

Fox

Badger

Badger

Stoat *Mustela erminea* Body length 18–30cm Tail length 10–14cm
Active animal with a long, sinuous body. Voracious predator of rodents and Rabbits. Male is larger and heavier than female. **SUMMER ADULT** has rich orange-brown fur on upperparts (and outer sides of legs), with a clear demarcation from white underparts. Tail is mostly rich orange-brown but tip is black. **WINTER ADULT** has a thicker coat. In S Britain, colour remains same as in summer. Further N, has a variably complete white winter coat; tip of tail remains black. **JUVENILE** is similar but smaller. **VOICE** High-pitched calls are uttered in alarm. **HABITAT AND STATUS** Widespread in mainland Britain; also occurs in Ireland, where it is sometimes referred to as a 'weasel'. Favours varied habitats, including farmland, woodlands, marshes and moors. **HABITS** Unobtrusive; views are typically fleeting. Stoats have an exclusively carnivorous diet. Males catch Rabbits and hares; females favour small mammals and birds. Their sinuous body form allows them to hunt underground and in dense vegetation. Hunting is often concentrated along hedgerows and walls. Prey is typi-

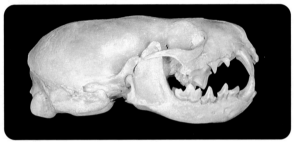

cally killed by a bite to back of neck. Active by day or night. Has 1 litter per year, born in spring, usually with 6–12 young. **OBSERVATION TIPS** Hard to observe except by chance. If you live in the country and have Rabbit warrens nearby, then a Stoat may visit your garden if you are lucky.

Weasel *Mustela nivalis* Body length 18–30cm Tail length 5–10cm
Long, sinuous body recalls a small Stoat (above). Note the relatively shorter, uniform-coloured tail. **ADULT** has orange-brown fur on upperparts and sides of body and legs, and on entire tail. Underparts are white with a clear demarcation between 2 zones of colour. Coat colour is the same in summer and winter. Male is larger than female. **JUVENILE** is similar to adult. **VOICE** Utters high-pitched hissing sounds in alarm. **HABITAT AND STATUS** Widespread in mainland Britain but absent from most islands and Ireland. Favours woodlands, hedgerows, meadows, farmland and moors. Sometimes seen in rural gardens. **HABITS** Voracious predator of small mammals, notably voles and mice, young rats, baby Rabbits. Its sinuous body form allows it to hunt underground in rodent burrows and to follow small mammal runs. Climbs well and

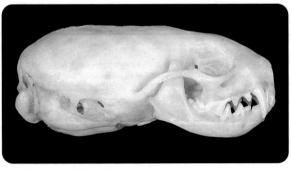

sometimes raids nest boxes for young birds. Active day and night. Young are born in spring and female alone cares for them. **OBSERVATION TIPS** Unobtrusive; most encounters occur by chance. Hard to attract to the garden. If you have a log pile or similar area where small mammals find sanctuary, then a hunting Weasel may visit occasionally.

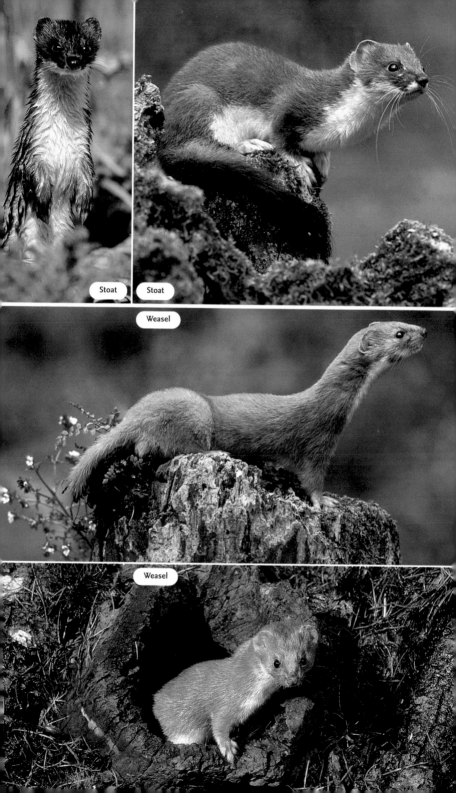

Stoat

Stoat

Weasel

Weasel

Brown Long-eared Bat *Plecotus auritus*
Wingspan 24–28cm Body and tail length 7–10.5cm

Widespread bat that can sometimes be identified in flight by its distinctive long-eared silhouette. **ADULT** has fluffy, long fur that is buffish brown above and buffish white below. Ears are very long and pinkish brown, with numerous transverse folds; long, pointed tragus is narrow (less than 5mm at its widest) and mostly translucent pink. Wings are brown and thumb is longer than 6.5mm. Face is rather uniformly pinkish brown. **JUVENILE** is similar but appears greyer overall, leading to potential for confusion with Grey Long-eared Bat (below). **VOICE** Utters various chirping squeaks when alarmed. Echolocation peaks in 30–40kHz range. **HABITAT AND STATUS** Found in a wide range of wooded habitats, including parks, mature gardens and hedgerows, as well as deciduous and mixed woodland. **HABITS** Typically emerges from roost after dark and feeds, off and on, for much of the night. Summer roost sites include tree-holes and roof spaces; bat boxes are often occupied. Hibernation takes place from Nov to Apr; roof spaces, cellars and caves are preferred locations. Flight is rather slow, on fluttering wingbeats. Feeds mainly on moths, mostly caught on the wing but sometimes gleaned from foliage. **OBSERVATION TIPS** On a mild night, shine a torch beam up into a tree canopy and you may see one feeding. Can be encouraged by the provision of bat boxes.

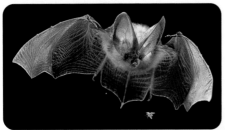

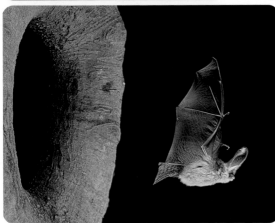

Grey Long-eared Bat *Plecotus austriacus*
Wingspan 26–30cm Body and tail length 8–11cm

Very similar to Brown Long-eared (above) but separable using colour of fur and other features. **ADULT** has long, fluffy fur that is dark grey above and greyish white below. Face is dark grey, creating a 'highwayman's mask' effect. Ears are very long, and grey tragus is greater than 5mm wide at its maximum. Wings are dark grey-brown and thumb is less than 6.5mm long. **JUVENILE** is similar. **VOICE** Utters various chirping squeaks when alarmed. Echolocation occurs mainly in the 35–40kHz range. **HABITAT AND STATUS** Intolerant of cold temperatures, and in our region found only in S England. Usually associated with mature gardens in towns and villages. **HABITS** Seldom emerges from roost before darkness has fallen and forages, off and on, throughout the night. Flight is slow and fluttering. Feeds mainly on moths. Roosts in roof spaces in summer, when females form communal nurseries. Hibernates Oct–Apr in cellars and caves. **OBSERVATION TIPS** Sometimes hawks for insects around street lamps or outside lights to which moths are attracted. Almost impossible to separate from Brown Long-eared with just a fleeting glimpse in flight.

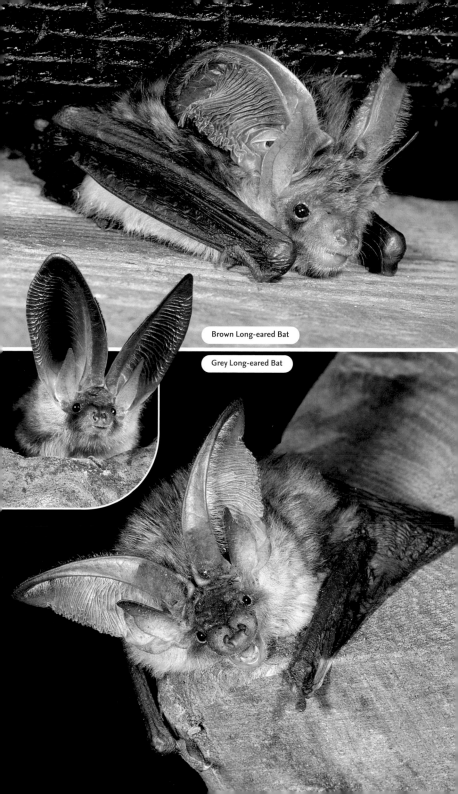

Brown Long-eared Bat

Grey Long-eared Bat

Common Pipistrelle *Pipistrellus pipistrellus*

Wingspan 18–24cm Body and tail length 6–8.5cm

Smallest and commonest bat in urban and suburban areas. **ADULT** has sleek, fluffy fur, rich grey-brown above and buffish brown below. Face shows a blackish 'bandit' mask; blackish ears are broadly oval to triangular with 4–5 transverse folds on outer edge. Wings are dark brown. **JUVENILE** is darker and less rufous than adult. **VOICE** High-pitched contact calls can be detected by those with good hearing. Echolocation calls peak at around 45kHz. **HABITAT AND STATUS** Favours mature gardens and parks in towns and villages. **HABITS** Emerges half an hour or so after sunset and feeds throughout night. Flight is fluttery, constantly changing direction to catch midges and moths. Roosts in roof spaces in modern houses. **OBSERVATION TIPS** Sometimes feeds around street lamps and outside lights. Often use bat boxes.

Soprano Pipistrelle *Pipistrellus pygmaeus*

Wingspan 18–24cm Body and tail length 6–8.5cm

Almost identical to Common Pipistrelle (above). **ADULT** has browner fur than the Common Pipistrelle and lacks 'bandit' mask. **JUVENILE** is very similar to juvenile Common Pipistrelle. **VOICE** People with good hearing can detect high-pitched contact calls. Echolocation peaks at around 55kHz. **HABITAT AND STATUS** Poorly known but probably similar to Common Pipistrelle, although seems to favour more rural habitats. **HABITS** Probably similar to Common Pipistrelle. **OBSERVATION TIPS** Impossible to separate from Common Pipistrelle in the field without a bat detector (the 2 species echolocate at different frequencies). Even in the hand, identification is tricky.

Noctule *Nyctalus noctula*

Wingspan 35–45cm Body and tail length 10–14cm

The most likely large bat species to be seen in gardens; often flies at dawn and dusk. **ADULT** has shortish golden-brown fur, darkest on back and paler below. Face is blackish brown; dark brown ears are relatively large and broadly oval to triangular. Wings are long and rather narrow.

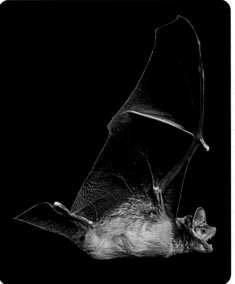

JUVENILE is similar but darker. **VOICE** Flying bats utter loud clicks; noisy yickering calls are sometimes heard at daytime roosts. **HABITAT AND STATUS** Feeds over open, lightly wooded terrain including mature suburban gardens and parks. **HABITS** Starts flying at dusk and sometimes feeds until dawn; flying insects as large as Cockchafers and hawk-moths are taken. Roosts in tree-holes; bat boxes are sometimes used during the summer months. Hibernates in tree-holes and crevices. **OBSERVATION TIPS** Its size and liking for parks and gardens mean the Noctule is relatively easy to see and identify in the field.

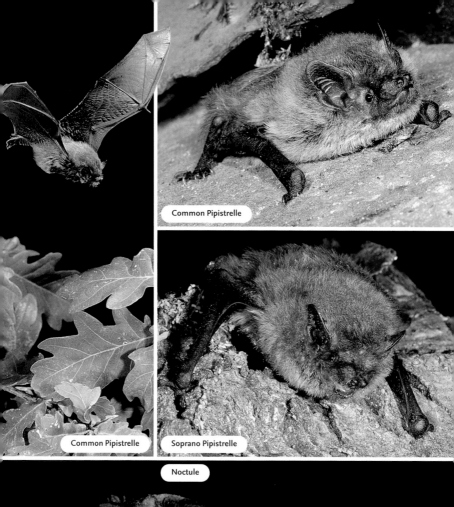

Common Pipistrelle

Common Pipistrelle

Soprano Pipistrelle

Noctule

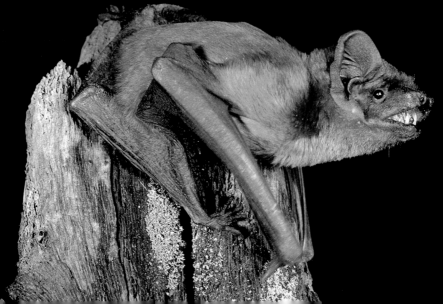

INTRODUCING GARDEN REPTILES AND AMPHIBIANS

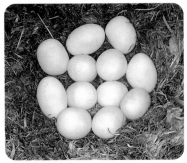

A clutch of Grass Snake eggs incubating in a compost heap.

Although the number of species of reptiles and amphibians found in the garden is tiny, their welfare and conservation attracts a disproportionately significant level of interest among members of the gardening community. By understanding the needs of these charming animals, you can make a real difference to their success.

THE LIVES OF REPTILES

British reptiles are essentially terrestrial animals – only the Grass Snake makes occasional forays into water to hunt. Our snakes and lizards have a tough outer skin layer comprising scales. These overlap and are embedded in soft skin below, allowing flexibility and speedy movement. The Common Lizard (p. 120) has legs, while the Slow-worm (a legless lizard; p. 120) and Grass Snake (p. 120) achieve propulsion by means of S-shaped movements of the body.

A reptile's layer of scales provides a degree of protection from damage and predators, and from desiccation. As a result, Common Lizards and Grass Snakes in particular are often seen in the daytime and even sunbathe quite happily: being unable to generate internal body heat, the warmth of the sun allows them to speed up their metabolism. But reptiles are still wary creatures and basking is usually done close to, or amongst, cover – as with amphibians, if you provide them with a log pile you will be doing them a favour. These sites may also be used by reptiles as safe refuges for winter hibernation.

Unlike amphibians, the developmental stages of reptiles take place inside an egg. In the case of Slow-worms and Common Lizards, the eggs develop inside the body of the mother and she gives birth to live young. In contrast, the Grass Snake lays eggs and, in the context of the garden, compost heaps are extremely important in this respect.

Like others of their kind, Grass Snakes slough their skins regularly, the remains of which are often more easily discovered than the snakes themselves.

If you place a corrugated sheet in an out-of-the-way place in the garden, both reptiles and amphibians may bask underneath it.

THE LIVES OF AMPHIBIANS

British amphibians spend only part of their lives in water – during the breeding season – and for much of the rest of the year are terrestrial. They have soft skins, which makes them vulnerable to attack from predators and can create problems with desiccation. Consequently, at times of the year when they are found on land they tend to be nocturnal – water loss is less of a problem after dark and they avoid the attentions of diurnal predators, notably birds. During the daytime, they typically seek refuge in sheltered spots. If you leave convenient log piles or areas of cut brush, or provide wooden boards under which they can hide, then they are sure to use them (along with reptiles of course).

Amphibians cannot generate internal body heat and consequently go into a state of torpor in the depths of winter. The same refuges used as daytime retreats in summer will provide safe havens for amphibians to see out the coldest months of the year.

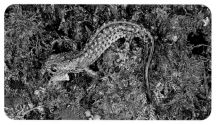

Newly metamorphosed from a tadpole, this juvenile Great Crested Newt has left the water and begun a terrestrial life that will last until the following spring.

This Palmate Newt has entered a state of torpor and was discovered underneath a garden paving slab.

AMPHIBIAN REPRODUCTION

All British amphibians reproduce in water. The process is broadly similar in all species but is most familiar and easiest to observe in the Common Frog (p. 124). This species produces large masses of spawn comprising eggs (1) protected in a bubble of jelly. The embryo (2) develops inside, nourished by a yolk sac; it finally emerges as a comma-shaped tadpole (3). Gills soon develop (4), followed by hind legs (5), then front legs (6); finally, the gills and tail resorb, and metamorphosis into a miniature frog occurs (7).

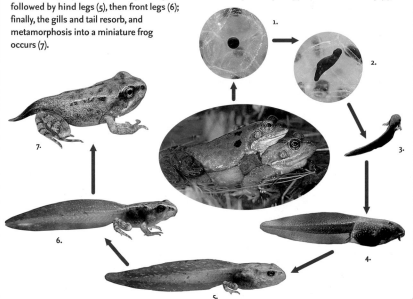

Common Lizard *Lacerta vivipara* Length 10–15cm

The only lizard likely to occur in the garden. **ADULT** has a slender body and angular, pointed snout. Usually brown overall with dark spots down back, and rows of dark markings on flanks bordered above by pale spots. Some have a green or reddish flush to head and neck. Mature male has yellow or orange underparts with dark spots; female's underparts are usually dull yellow and unspotted. **JUVENILE** is black at first, soon becoming dark golden brown. **VOICE** Silent. **HABITAT AND STATUS** Widespread but local in open habitats with plenty of invertebrate food. Found in gardens near heathlands, open scrub and railway embankments. **HABITS** Likes sunbathing, especially in early spring or autumn, often near or on a log pile. Hibernates Oct–early Apr. Courtship and mating occur in spring. Female does not lay eggs but gives birth to live young in early summer. Can shed tail as a defence against predators; regrows stumpy replacement in time. **OBSERVATION TIPS** Leave piles of twiggy brush on sunny banks to encourage Common Lizards; they can retreat into these if danger threatens, and sunbathe in relative safety.

Slow-worm *Anguis fragilis* Length 30–40cm

Legless lizard. **ADULT** has an elongated, shiny body (50–60% tail). Body tapers smoothly, with no discernible 'neck'. Male is usually unmarked coppery brown. Female is similar but often with a thin, dark stripe down back; anterior end of stripe often ends in a faint 'V' on head. Belly of all animals is bluish and marbled. **JUVENILE** is golden or silvery with a thin, dark vertebral stripe. **VOICE** Silent. **HABITAT AND STATUS** Favours open habitats with plenty of invertebrate prey. Found in mature gardens but only where domestic cats are absent (these kill Slow-worms). **HABITS** Secretive, but easy to find under discarded objects such as corrugated sheets. Feeds mainly on invertebrates and hibernates Oct–Mar. Can shed tail if alarmed; stumpy replacement grows back in time. **OBSERVATION TIPS** Place planks or corrugated sheets on the ground to discover whether Slow-worms are present.

Slow-worm

Grass Snake *Natrix natrix* Length 60–80cm

Large, non-venomous snake. **ADULT** has a slender body, thickest towards the middle and tapering evenly towards tail. Ground colour is usually olive-green; has vertical stripes on flanks and indistinct dark spots down vertebral line. Neck is defined by black and yellow crescent-shaped markings. Scales on underbody are pale. **JUVENILE** resembles a miniature adult. **VOICE** Hisses if distressed.

Grass Snake feigning death

HABITAT AND STATUS Favours grassland and scrub, often near water; common resident of rural gardens. **HABITS** Hibernates mainly Oct–Apr. Prey includes amphibians, fish, small mammals and invertebrates. Lays 5–20 eggs in a mound of decaying vegetation (compost heaps are ideal). If distressed, produces a vile smell. **OBSERVATION TIPS** Sunbathes in spring; take care not to damage nests in compost heaps.

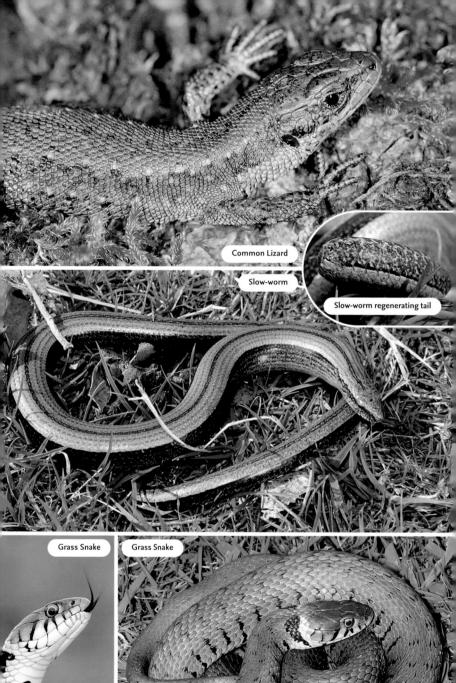

Common Lizard

Slow-worm

Slow-worm regenerating tail

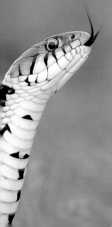

Grass Snake

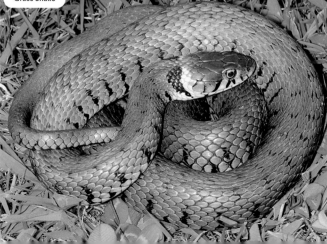

Grass Snake

Smooth Newt *Triturus vulgaris* Length 9–10cm

Widespread newt. Males are striking in spring. **ADULTS** are buffish brown overall; whitish throat is variably marked with dark spots. Females have small black spots across rest of body that sometimes fuse to form lines along body and tail. Male has larger, darker, blotchy

spots on body, most intense in breeding season when body and tail crest is acquired. Belly is orange with dark spots. **JUVENILE** is similar to adult female. **VOICE** Silent. **HABITAT AND STATUS** Returns to water in spring to breed; ditches and fish-free garden ponds are often used. Avoids acid water but summer-drying pools are good. **HABITS** Terrestrial outside the breeding season; usually torpid and hibernating underground Oct–Mar. Feeds mainly on invertebrates. **OBSERVATION TIPS** Easiest to see when courting: visit a breeding pool at dusk and search the shallows with a torch. Terrestrial newts are most active on rainy nights.

egg

Palmate Newt *Triturus helveticus* Length 8–9cm

Our smallest newt. Males are distinctive in spring. Females are similar to female Smooth Newts (above) at all times. **ADULTS** have yellowish belly and unspotted pinkish throat (cf. Smooth Newt). Breeding male has webs between toes on hind feet; tail ends abruptly with thin projecting filament. Body is olive-brown, marbled with dark markings and orange-buff band on side. At other times, webs and tail filament are absent, and body markings are less striking. Adult female is uniformly

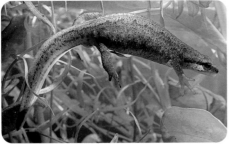

yellowish brown. **JUVENILE** resembles adult female. **VOICE** Silent. **HABITAT AND STATUS** Locally common, favouring more acidic, nutrient-poor waters than Smooth Newt. Found in garden ponds with suitable water conditions. **HABITS** Breeds in ponds Apr–Jun, but otherwise terrestrial; usually torpid Oct–Feb. Eats frog tadpoles in spring. **OBSERVATION TIPS** Easiest to see in breeding ponds; most obvious by torchlight after dark.

female

Great Crested Newt *Triturus cristatus* Length 14–16cm

Our largest newt. Breeding males are unmistakable. **ADULT** is blackish brown with variable dark spots and numerous warts (white-tipped on flanks). From neck to vent, underparts are yellowish with black spots; throat is black with orange-yellow spots. Breeding male has jagged dorsal crest and crest on tail; pale stripe runs along centre of tail. Outside breeding season, male resembles adult female: has a mostly uniform dark body with a yellowish-orange stripe along lower edge of tail. **JUVENILE** resembles adult female. **VOICE** Silent.

HABITAT AND STATUS Favours ponds that do not dry up and will use those in gardens. Scarce, local and protected by law. **HABITS** Found in water mainly Feb–Jul; terrestrial at other times. **OBSERVATION TIPS** Easiest to see in breeding ponds after dark with a torch.

mature larva

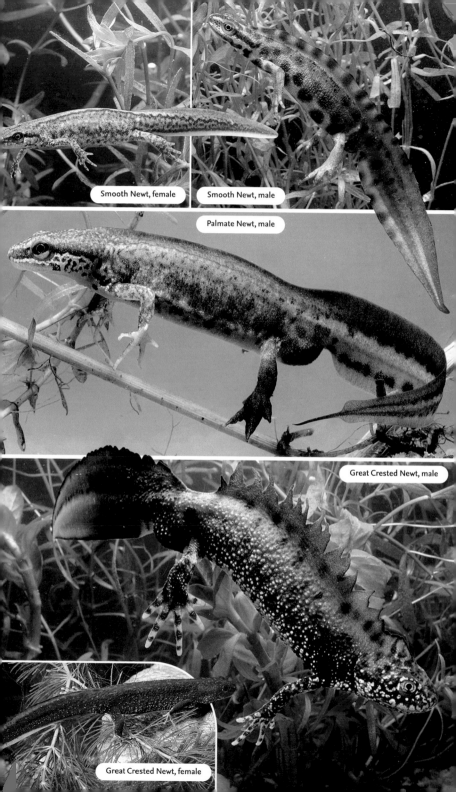

Smooth Newt, female

Smooth Newt, male

Palmate Newt, male

Great Crested Newt, male

Great Crested Newt, female

Common Frog *Rana temporaria* Length 6–10cm

Widespread amphibian and a welcome addition to any garden. Females are larger than males. **ADULT** has smooth, moist skin. Body colour is variable but upperparts are usually olive-yellow or greyish brown with dark blotching and spots. Eye has a dark 'mask' behind it and yellow iris. Underparts are greyish white. Hind feet have webbed toes. In breeding season, male develops swollen nuptial pads behind innermost digits of front feet, and acquires blue throat. Female has more granular texture to skin than male. **JUVENILE** when newly metamorphosed from tadpole resembles a miniature adult. **VOICE** Males utter low-pitched croaking calls when courting in spring. **HABITAT AND STATUS** Common in a range of habitats, including gardens, but tied to areas where suitable breeding ponds are present. Terrestrial outside the breeding season. **HABITS** Courtship and spawning occur Feb–Apr depending on location (earlier in S than N). Females produce spawn (masses of jelly-coated eggs), from which tadpoles emerge; they develop hind legs first, then front legs, then resorb tail and metamorphose into adults. **OBSERVATION TIPS** Easy to observe in spring when courtship is in full swing.

Common Toad *Bufo bufo* Length 5–9cm

Familiar garden amphibian. Females are larger than males. **ADULT** has variable body colour but is usually olive-brown or greenish buff. Skin is covered in toxin-containing warts. Eye has red iris. Hind feet are webbed. In early spring, prior to spawning, females look extremely plump. **JUVENILE** recalls a miniature adult with a relatively large head. **VOICE** Courting males utter soft croaking calls in spring. **HABITAT AND STATUS** Favours a wide range of habitats, including woodland, scrub, grassland and gardens, but seldom strays more than 2km from suitable breeding ponds. Can tolerate the presence of fish because the tadpoles' toxic skin deters predation. **HABITS** More terrestrial than most other amphibians. Courtship and spawning are usually restricted to a few weeks in Feb and Mar. Rough and tumble courtship can involve half a dozen or more males clambering over a single female. Victorious male grips his partner in a posture known as 'amplexus'; rough pads, which develop on the forefingers at this time of year, improve his grip. Spawn comprises long strings of eggs, entwined among aquatic plant stems. Tadpoles are blackish. Their hind legs develop first, then front legs; finally, tail is resorbed and metamorphosis occurs in Jul or Aug, when ponds are vacated. Gait of all animals consists of short hops, much more modest than those of a Common Frog (above). **OBSERVATION TIPS** Easy to observe at the start of the breeding season, during which their antics can be extremely entertaining. Sometimes discovered on rainy autumn nights in the garden with the aid of torchlight.

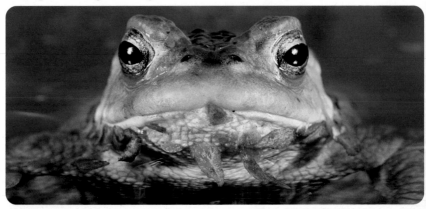

Full of the joys of spring, this male Common Toad is waiting eagerly at the edge of a garden pond for a female to arrive.

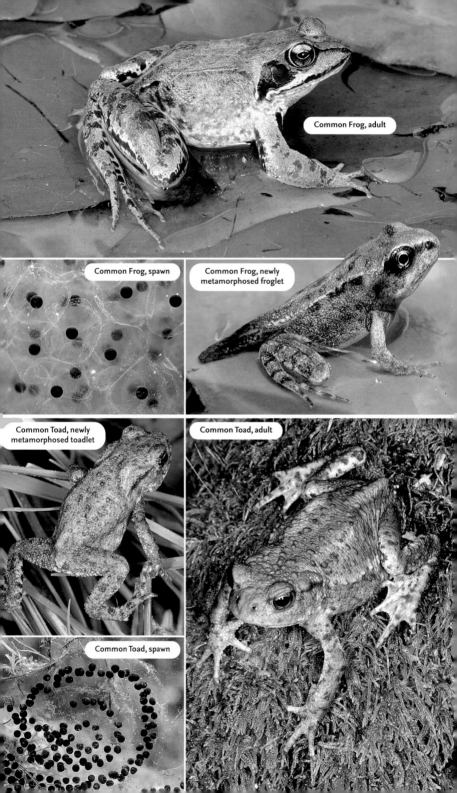

Common Frog, adult

Common Frog, spawn

Common Frog, newly metamorphosed froglet

Common Toad, newly metamorphosed toadlet

Common Toad, adult

Common Toad, spawn

INTRODUCING GARDEN INSECTS

Insects are among the most numerous organisms on the planet and, after birds, probably the most diverse and visible land animals. Anyone with an interest in natural history and a sense of curiosity could devote their entire life solely to the study of insects in their garden and still discover new species on an almost daily basis.

WHAT ARE INSECTS?

In the wider context, insects are invertebrates, this being a division of the animal kingdom comprising animals without backbones. More precisely, they belong to a subdivision of the invertebrate world called arthropods, animals that have an external skeleton and paired, jointed limbs; muscles allowing movement are internal.

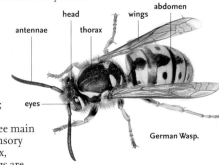

head wings abdomen
antennae thorax
eyes

German Wasp.

An adult insect's body is divided into three main regions: the head, which supports many sensory organs as well as the mouthparts; the thorax, to which three pairs of legs and paired wings are attached (wings are absent in some insects); and the segmented abdomen, within which many of the main body organs are contained.

THE RANGE OF GARDEN INSECTS

The diversity of insect life is truly astonishing and, as with other areas of the natural world, scientists structure and order this diversity by a system called classification. The insect world has a number of broad subdivisions, called orders, members of which have structural features in common. Insect orders whose members are weak-flying and tied to water tend to be poorly represented in the garden. Otherwise, however, the diversity of insect life, literally on your doorstep, is amazing. Below are the important insect orders associated with garden habitats:

Peacock Butterfly.

Hairy Dragonfly.

Green Shield Bug.

Butterflies and moths (order Lepidoptera)

Attractive insects, the adults of which have wings covered in scales, allowing extraordinary colours and patterns to appear. The mouthparts are modified to form a long, sucking proboscis.

Dragonflies and damselflies (order Odonata)

The adults are predatory, mainly clear-winged insects with slender bodies; their nymphs are aquatic and predatory.

True bugs (order Hemiptera)

An extremely varied group of insects (ranging from aphids to shield bugs) with sucking mouthparts; the adults of many species have wings, either folded flat over the body or held tent-wise.

Earwigs (order Dermaptera)

Flattened-bodied insects with pincer-like appendages at the tail end; forewings are modified to form protective plates, while hindwings are either reduced or absent.

Common Earwi

Lacewings and allies (order Neuroptera)
Slender-bodied insects with proportionately large wings as adults, these held in a tent-wise manner when at rest. Both adults and larvae are predatory.

True flies (order Diptera)
A varied and diverse group, the adults of which have one pair of wings (hindwings are reduced to tiny, club-shaped stabilising organs). The adults' mouthparts are mainly adapted for sucking.

Bees, wasps, ants and sawflies (order Hymenoptera)
An extremely variable group, the adults of which have two pairs of membranous wings; some species live communal lives and females of a few species have powerful stings (modified ovipositors).

Beetles (order Coleoptera)
A diverse group, the adults of which have biting mouth-parts and the front pair of wings modified to form protective plates called elytra; hindwings, when present, allow flight and are often folded beneath the elytra at rest.

Lacewing.

A hover-fly
Volucella pelluscens.

Rose Chafer
(a beetle).

Red-tailed
Bumblebee.

ENCOURAGING GARDEN INSECTS

Insects are extraordinarily diverse and abundant in the garden, and their habits and role in garden ecology reflect this. Some are predators of other insects and help maintain a population balance; others are an important source of food for birds. The lives of all garden insects, and indeed all wildlife in the garden, are inextricably linked, and maximising insect diversity and abundance is paramount when it comes to creating a thriving and harmonious ecosystem.

When it comes to encouraging insects, there are plenty of things the gardener can do. Tolerance of perceived pest species is probably the watchword here, and gardeners should also tolerate and encourage as many native plant species as possible (as food for moth larvae, for example). Finally, chemicals should never be used in the garden.

INSECT LIFE CYCLES

Insect life starts with an egg laid by a female. The growing stage (larva) hatches and its rigid skin is moulted several times as it grows, each successive step being called an instar. With some insects (true bugs, for example), the insect becomes more and more adult-like as the life cycle progresses; this is called incomplete metamorphosis. With others, the larva simply gets bigger with each instar and, when fully grown, metamorphoses into a pupa, from which the adult emerges; this is called complete metamorphosis.

BUTTERFLIES IN THE GARDEN

Butterflies are a welcome addition to any garden, and the sight of these delicate, colourful insects fluttering over the herbaceous border is guaranteed to lift the spirits. A knowledge of their habits, life cycles and ecological requirements can help boost their numbers and diversity, benefiting not only the insects themselves but also those who observe them.

WHAT ARE BUTTERFLIES?

Butterflies are day-flying insects that, in classification terms, belong to a group known as the order Lepidoptera; moths are also placed in this order. Butterflies have two pairs of wings that are covered in scales; these often create the colourful or intricate wing patterns so characteristic of many members of the group.

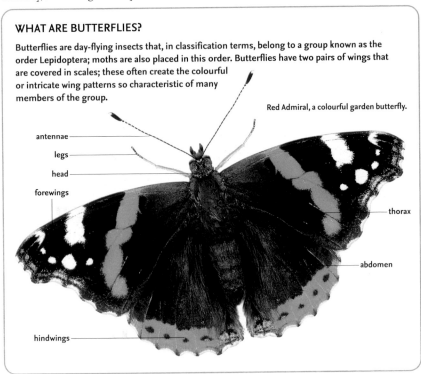

Red Admiral, a colourful garden butterfly.

antennae
legs
head
forewings
thorax
abdomen
hindwings

CATERING FOR THE NEEDS OF GARDEN BUTTERFLIES

The populations of many British butterflies are in sad decline in the countryside at large, and gardens can play a role in helping to conserve some of these species. In order to provide the most effective help, butterflies need more than just food for adults; their whole life cycle needs to be taken into consideration. Take the time to get to know the natural history of the species in your garden and you will be in a much better position to maintain it in a way that benefits butterflies.

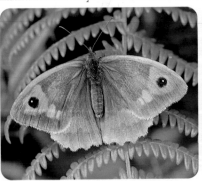

FAR LEFT: Meadow Browns need established grassland for their larvae, and flower-rich hedges for feeding and sunbathing adults. LEFT: Second-brood Holly Blues lay their eggs underneath Ivy flower buds. Cut back your Ivy in summer and early autumn and you will kill their eggs or feeding larvae. Cut the Ivy back in winter and you will deprive Brimstone and Red Admiral butterflies of hibernation spots. Wildlife gardening can be a dilemma!

Of course, food for adult butterflies, in the form of nectar-rich flowers, is important and it is a good idea to plant your borders so that a succession of butterfly-friendly blooms appears from spring to autumn. But food plants for the caterpillars are also important, so refer to the text in the species accounts to familiarise yourself with what is required. Consider also the consequences of gardening methods and timing for larval and pupal butterflies. Without realising it, you may inadvertently kill off a complete life cycle by, for example, pruning shrubs or tidying the herbaceous border at the wrong time.

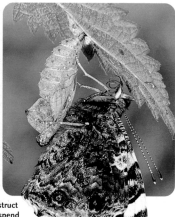

ABOVE: The larvae of the Red Admiral feed on Common Nettles and construct a tent comprising three or four leaves stitched together with silk. They spend their lives inside the tent, protected from the prying eyes of predators.
ABOVE RIGHT: When they reach maturity, Red Admirals pupate inside their larval tent; here, the tent has been teased apart to revel the pupa.
FAR RIGHT: Newly emerged from its pupa, this fresh Red Admiral is drying its wings and flexing its proboscis.

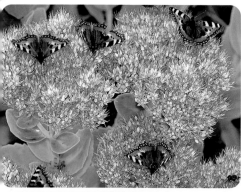

LEFT: Iceplant is fantastic for butterflies in the autumn. These Small Tortoiseshells are taking full advantage of the rich source of nectar.
BELOW: Leaving areas of grass uncut in the garden may encourage meadow butterfly species to breed there, including Gatekeepers.

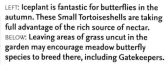
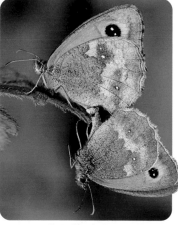

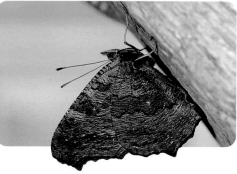

LEFT: For some butterflies, the distinction between garden and home is blurred. A few days earlier, this Peacock butterfly would have been feeding on nectar in the herbaceous border but now it has ventured indoors to find a place to hibernate.

Large White *Pieris brassicae* Wingspan 60mm

Our largest 'white' butterfly. **ADULT** has yellowish underwings. Upperwings are creamy white with a black tip to forewing; female also has 2 spots on forewing. Flies May–Sep. **EGG** is yellow, flask-shaped and laid in clusters on food plant. **LARVA** is black and yellow, and feeds on cabbages, other garden brassicas and Nasturtiums. **PUPA** is attached by harness to stem. **STATUS** Common and widespread; a frequent visitor to gardens.

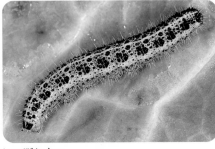
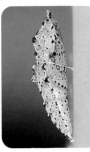

Large White, eggs Large White, larva

Large White, pupa

Small White, egg Small White, larva

Small White *Pieris rapae*
Wingspan 45mm

Smaller than similar Large White (above). **ADULT** has yellowish underwings; upperwings are creamy white with a dark tip to forewing; female has 2 dark spots on forewing. Flies Apr–May and Jul–Aug. **EGG** is yellow, flask-shaped and laid singly on food plant. **LARVA** is green and feeds on cabbages, other brassicas and Nasturtiums. **PUPA** is attached by harness to stem or wall. **STATUS** Common and widespread; a frequent visitor to gardens.

Green-veined White, egg Green-veined White, larva

Green-veined White *Pieris napi*
Wingspan 45–50mm

Wayside butterfly. **ADULT** is similar to Small White (above) but veins are dark on upperwings and greyish green on underwings, particularly hindwing. Double-brooded, flying in spring and midsummer. **EGG** is yellow, flask-shaped and laid singly on food plant. **LARVA** feeds on Garlic Mustard and other wild crucifers. **PUPA** is attached by harness to stem. **STATUS** Locally common in rural gardens.

Orange-tip *Anthocharis cardamines* Wingspan 40mm

Attractive spring butterfly. **ADULT** has rounded wings. Forewing is dark-tipped but only male has an orange patch; hind underwing of both sexes is marbled green and white. Flies Apr–Jun. **EGG** is orange, flask-shaped and laid on flower stem of food plant. **LARVA** is green; feeds on seedpods of Cuckooflower, Dame's Violet and Honesty. **PUPA** is attached by harness to stem. **STATUS** Widespread in S Britain and Ireland, and a frequent visitor to rural gardens.

Green-veined White, pupa, just prior to emergence

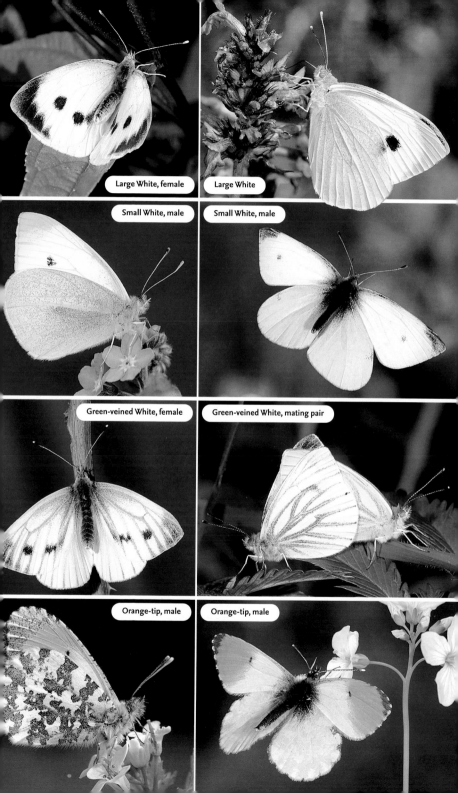

Large White, female

Large White

Small White, male

Small White, male

Green-veined White, female

Green-veined White, mating pair

Orange-tip, male

Orange-tip, male

Brimstone *Gonepteryx rhamni* Wingspan 60mm

Herald of spring and sometimes on the wing as early as Mar. **ADULT** has uniquely shaped wings. Male's brimstone-yellow colour is unmistakable; paler female can be mistaken for Large White (p. 130) in flight. Single-brooded – summer adults hibernate and emerge on sunny spring days. **EGG** is flask-shaped and laid on stems and twigs of food plant. **LARVA** is green and feeds on Buckthorn and Alder Buckthorn. **PUPA** is suspended by harness from underside of leaf. **STATUS** Locally common and often seen in the garden.

Brimstone, eggs

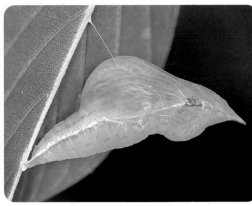

Brimstone, pupa

Clouded Yellow *Colias croceus* Wingspan 50mm

Fast-flying and active butterfly that seldom settles for long. An occasional garden visitor. **ADULT** has dark-bordered upperwings, these yellow in the female and orange-yellow in the male. Both have yellow underwings with few dark markings. **EGG** is pink and narrowly oval; laid on leaves of food plant. **LARVA** is green and feeds on Lucerne. **PUPA** is attached by harness to stem. **STATUS** Summer migrant in varying numbers. Sometimes breeds but does not survive our winters.

Small Tortoiseshell

Nymphalis urticae Wingspan 42mm
Wayside species and a regular garden visitor. Sun-loving and fond of basking. **ADULT** has marbled orange, yellow and black upperwings; underwings are smoky brown. Flies Mar–Oct with 2 or 3 broods; last brood hibernates. **EGG** is green and barrel-shaped; laid in clusters on leaves of food plant. **LARVA** is yellow and black; gregarious and feeds on Common Nettle. **PUPA** is suspended at tail end from stem. **STATUS** Fairly common and widespread, but its fortunes have been mixed; has declined in many areas.

Small Tortoiseshell, hibernating showing underwings

Painted Lady *Vanessa cardui* Wingspan 60mm

Subtly attractive butterfly that is active and fast-flying. **ADULT** has marbled pinkish-buff, white and black upperwings; underwings are buffish with a similar pattern to upperwing. **EGG** is green and ovoid; laid singly on leaves of food plant. **LARVA** is blackish with spiky bristles; feeds on thistles. **PUPA** is suspended within a woven tent of leaves. **STATUS** Summer migrant in variable numbers; most numerous near coasts. Sometimes breeds but does not survive winter.

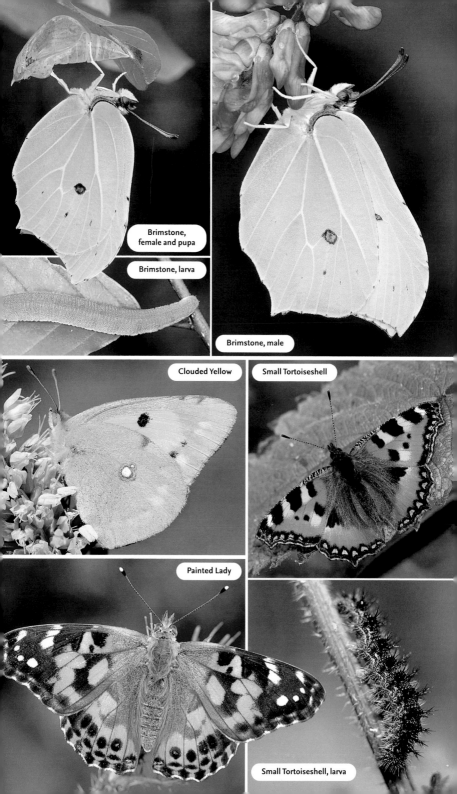

Brimstone,
female and pupa

Brimstone, larva

Brimstone, male

Clouded Yellow

Small Tortoiseshell

Painted Lady

Small Tortoiseshell, larva

Red Admiral *Vanessa atalanta* Wingspan 60mm

Sun-loving wayside butterfly and a frequent visitor to garden flowers. **ADULT** has marbled smoky-grey underwings, and black upperwings with red bands and white spots. Seen in many months but commonest Jul–Aug. **EGG** is green and barrel-shaped; laid singly on leaves of food plant. **LARVA** is blackish with spiky bristles; feeds on Common Nettle and lives within a tent of stitched-together leaves. **PUPA** is suspended within a leaf tent (*see* p. 129). **STATUS** Adults hibernate in small numbers; seen mostly as a summer migrant, often in good numbers.

Peacock *Nymphalis io* Wingspan 60mm

Distinctive and familiar visitor to garden flowers. **ADULT** has smoky-brown underwings, and maroon upperwings with bold eye markings. Flies Jul–Sep and again in spring after hibernation. Sometimes hibernates indoors or in sheds and outbuildings. **EGG** is barrel-shaped; laid in clusters on leaves of food plant. **LARVA** is blackish with spiky bristles; lives in clusters on Common Nettle. **PUPA** is suspended from stem or leaf. **STATUS** Common and widespread except in N.

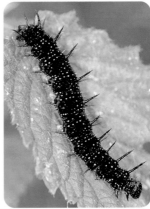

Peacock, larva Peacock, pupa

Comma *Polygonia c-album* Wingspan 45mm

Attractive butterfly with distinctive ragged-edged wings. **ADULT** has smoky-brown underwings with a white 'comma' mark; upperwings are orange-brown with dark markings. Double-brooded: autumn brood hibernates and emerges in spring (seen Sep–May); summer brood flies mainly Jul–Aug. **EGG** is green and barrel-shaped; laid singly on leaves of food plant. **LARVA** is orange-brown with white dorsal band; feeds on Common Nettle and Hop. **PUPA** is suspended from stem. **STATUS** Locally fairly common.

Comma, larva

Speckled Wood *Pararge aegeria* Wingspan 45mm

Favours clearings and sunny corners of the garden, and is fond of sunbathing. Rival males engage in aerial battles. **ADULT** has dark brown upperwings with pale markings; underwings are rufous brown. Double-brooded, flying Apr–Jun and Jul–Sep. **EGG** is pale and ovoid; laid singly on food plant. **LARVA** is green and feeds on grasses. **PUPA** is suspended low on grass stem. **STATUS** Widespread, but common only in S England.

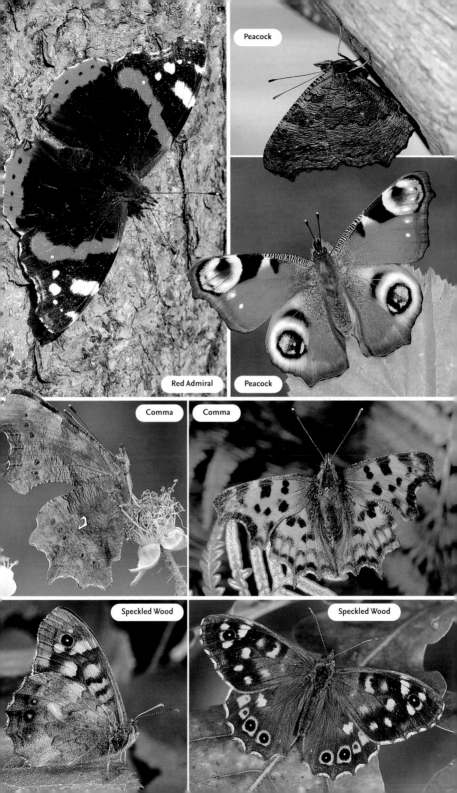

Red Admiral

Peacock

Peacock

Comma

Comma

Speckled Wood

Speckled Wood

Ringlet, larva

Ringlet *Aphantopus hyperantus* Wingspan 48mm
Familiar, dark-looking meadow butterfly. **ADULT** has smoky-brown wings, darker on males than females, with variable numbers of small eye-spots. Flies Jun–Jul. **EGG** is yellowish and semi-ovoid; dropped in flight over grassland. **LARVA** is brown and feeds on grasses. **PUPA** is formed in a cocoon at ground level. **STATUS** Widespread and fairly common within range.

Gatekeeper *Pyronia tithonus* Wingspan 40mm
Wayside and hedgerow butterfly that often feeds on Bramble flowers and visits herbaceous borders in rural gardens. **ADULT** has smoky-brown upperwings with orange markings and a paired eye-spot on forewing. Flies Jul–Aug. **EGG** is whitish, barrel-shaped and dropped among grasses. **LARVA** is pale brown and feeds on grasses. **PUPA** is suspended among low grass stems. **STATUS** Locally common within range.

Meadow Brown *Maniola jurtina* Wingspan 50mm
Classic grassland butterfly. Often visits herbaceous borders in rural gardens. **ADULT** has brown upperwings; male has a small orange patch on forewing containing eye-spot; orange patch is larger in female. Flies Jun–Aug. **EGG** is mottled brown and barrel-shaped; laid or dropped among grasses. **LARVA** is green and feeds on grasses. **PUPA** is suspended from grass stem. **STATUS** Common and widespread.

Small Heath *Coenonympha pamphilus* Wingspan 30mm
Small grassland butterfly. Sometimes visits rural gardens if unimproved grassland is found nearby. **ADULT** seldom reveals upperwings. Underside of forewing is orange with an eye-spot; hindwing is marbled grey, brown and buff. Double-brooded, flying May–Jun and Aug–Sep. **EGG** is beaker-shaped and laid on grass stems. **LARVA** is green and feeds on grasses. **PUPA** is suspended from low grass stem. **STATUS** Widespread but locally common only in S.

Purple Hairstreak *Favonius quercus* Wingspan 38mm
Small, attractive butterfly whose life is linked to mature oaks. **ADULT** male has purple sheen on upperwings; on female, sheen is restricted to

Purple Hairstreak, female

forewing patch. Underwings of both sexes are grey with a hairstreak line. **EGG** is pale and a flattened dome; laid at base of oak bud. **LARVA** is grey-brown and feeds on young oak leaves. **PUPA** is formed on ground. **STATUS** Locally common only in S Britain.

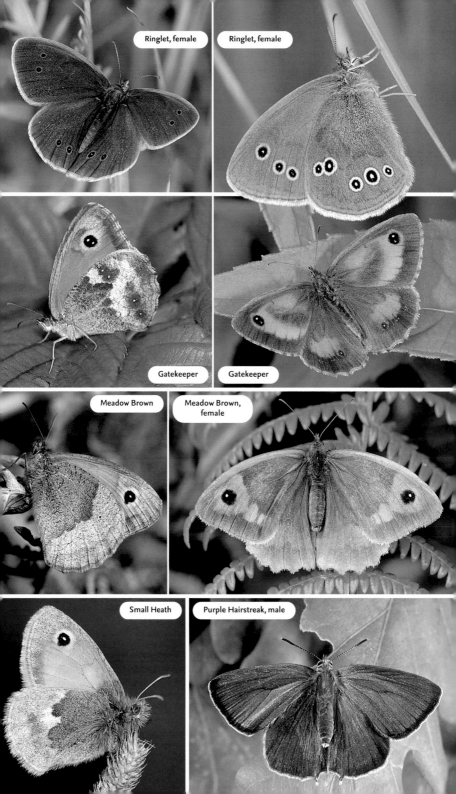

Ringlet, female

Ringlet, female

Gatekeeper

Gatekeeper

Meadow Brown

Meadow Brown, female

Small Heath

Purple Hairstreak, male

Small Copper *Lycaena phlaeas* Wingspan 25mm

Attractive, open country species. Sometimes visits rural gardens. **ADULT** has variable orange and dark brown pattern on upperwings; underwings have a similar pattern to upperwings but dark brown is replaced by grey-buff. Flies May–Sep in 2 or 3 broods. **EGG** is pitted like a miniature golfball; laid on food plant. **LARVA** is green and feeds on Sheep's Sorrel. **PUPA** is formed among leaves on ground. **STATUS** Locally common.

Common Blue, male

Common Blue *Polyommatus icarus* Wingspan 32mm

Our most widespread blue butterfly; sometimes visits rural gardens. **ADULT** male has blue upperwings; female's are usually brown, but sometimes tinged blue in middle. Underside of both sexes is grey-brown with dark spots. Flies Apr–Sep in successive broods. **EGG** is pale and button-shaped; laid on food plant. **LARVA** is green and feeds on trefoils. **PUPA** is dull green and formed on ground. **STATUS** Common in grassy places.

Holly Blue

Holly Blue *Celastrina argiolus* Wingspan 30mm

The most likely blue butterfly to be seen in gardens. Looks silvery in flight. **ADULT** has violet-blue upperwings and black-dotted white underwings. Flies Apr–May and Aug–Sep in 2 broods. **EGG** is pale and button-shaped; laid at base of flower of food plant. **LARVA** is green; feeds on Holly flowers in spring, Ivy flowers in autumn. **PUPA** is brown and formed in bark crevice. **STATUS** Fairly common in S.

Small Skipper *Thymelicus sylvestris* Wingspan 25mm

Has an active, buzzing flight; often visits grassland thistles. Rests with wings held at an angle. **ADULT** has orange-brown upperwings and orange-buff underwings. Brown underside to antennal tip allows separation from similar Essex Skipper (below). Flies Jul–Aug. **EGG** is lozenge-shaped; laid in grass leaf-sheaths. **LARVA** is green; feeds on various grasses. **PUPA** is attached to low grass stems. **STATUS** Common and widespread.

Small Skipper, antenna

Essex Skipper, antenna

Essex Skipper *Thymelicus lineola* Wingspan 25mm

Similar to Small Skipper (above) but underside to antennal tips are black. Has a similar buzzing flight. **ADULT** has orange-brown upperwings and orange-buff underwings. Flies Jun–Jul. **EGG** is lozenge-shaped; laid in grass leaf-sheaths. **LARVA** is green; feeds on various grasses. **PUPA** is attached to low grass stems. **STATUS** Locally common in the S.

Large Skipper *Ochlodes venatus* Wingspan 34mm

Often holds wings at an angle at rest. Visits rural gardens if grassland is nearby. **ADULT** has dark brown upperwings with pale markings. Underwings are buffish orange with paler spots. Flies Jun–Jul. **EGG** is pale and domed; laid on grass leaves. **LARVA** is green; feeds on grasses. **PUPA** is dark and formed in a cocoon. **STATUS** Common and widespread within range.

Large Skipper

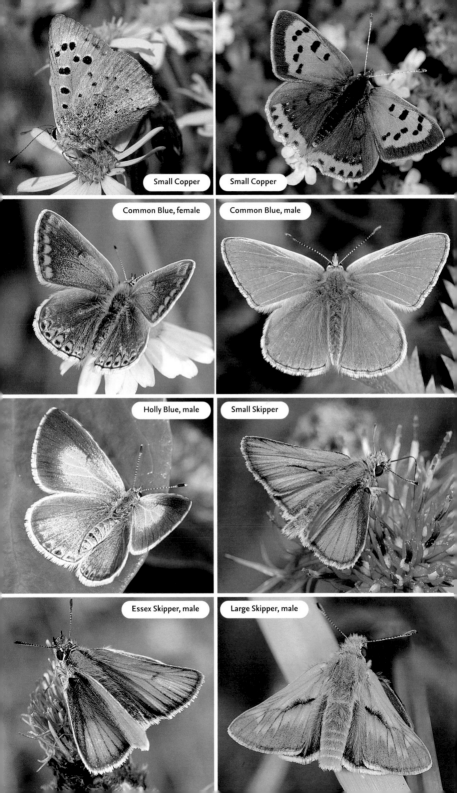

Small Copper

Small Copper

Common Blue, female

Common Blue, male

Holly Blue, male

Small Skipper

Essex Skipper, male

Large Skipper, male

LIFE CYCLES OF BUTTERFLIES AND MOTHS

Butterflies and moths have four stages in their life cycle: the egg, laid by a female of the previous generation; the larva, a growing stage that emerges from the egg; the pupa, an inactive stage inside which adult organs and tissues form; and the adult, which emerges from the pupa. In some moth species the life cycle is repeated two or three times each year, between spring and autumn. But in most, the life cycle is an annual event, adults emerging at the same time each year. If you find some moth eggs or larvae, you might like to try rearing them and following the life cycle all the way through. But before you do so, be sure to identify the species so that you know what to feed it on. Daily supplies of fresh leaves, and the removal of old ones, is vital for the larvae. And at maturity, most need dry soil into which they can burrow before pupating.

THE LIFE CYCLE OF THE COMMA, A TYPICAL GARDEN BUTTERFLY WHOSE LARVAL FOOD PLANT IS THE COMMON NETTLE OR HOP

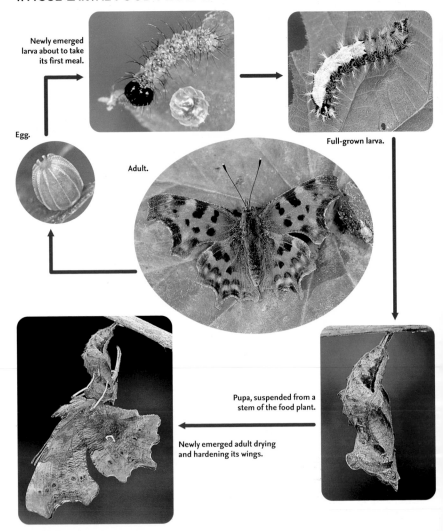

Newly emerged larva about to take its first meal.

Egg.

Adult.

Full-grown larva.

Pupa, suspended from a stem of the food plant.

Newly emerged adult drying and hardening its wings.

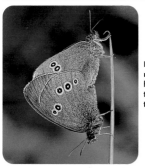

In order to ensure successful fertilisation of the eggs, these mating Ringlet butterflies will remain joined together for nearly half an hour. Although mating butterflies such as these are able to fly short distances, they typically remain static, clinging on to a stem.

THE LIFE CYCLE OF THE POPLAR HAWK-MOTH, A TYPICAL GARDEN MOTH WHOSE LARVAL FOOD PLANTS INCLUDE WILLOW AND POPLAR SPECIES

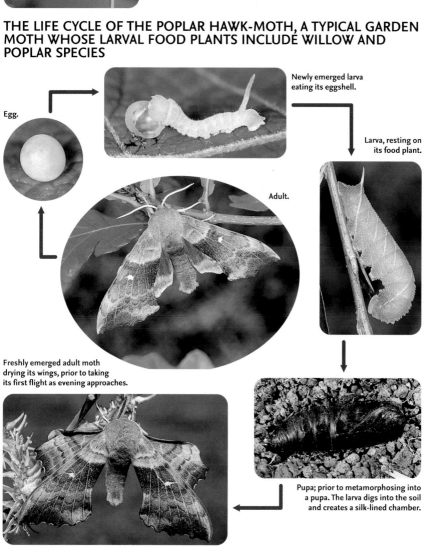

Egg.

Newly emerged larva eating its eggshell.

Larva, resting on its food plant.

Adult.

Freshly emerged adult moth drying its wings, prior to taking its first flight as evening approaches.

Pupa; prior to metamorphosing into a pupa. The larva digs into the soil and creates a silk-lined chamber.

BUTTERFLY AND MOTH LARVAE

Butterfly and moth larvae may lack the sophistication and elegance of their adult counterparts, but many species make up for this by being weird and wonderful to look at. Most have markings and colours that help them avoid being detected by predators, notably birds. But some – those with a form of defence – go out of their way to be conspicuous. Below is a selection of some of the more intriguing garden species.

PEACOCK LARVAE

Right up to the point where they disperse to pupate, the larvae of the Peacock butterfly spend their lives in clustered groups on the leaves of their food plant, Common Nettle.

LARGE WHITE LARVAE

Newly hatched, these young Large White larvae have eaten most of the remains of the eggshells, and are taking their first nibbles of the cabbage leaf on which the eggs were laid.

PUSS MOTH LARVA

This extraordinary, plump-bodied larva has two whiplash tails that help ward off parasitic wasps and a head end that can be swollen when alarmed, exaggerating the false eye-spots; it is presumed these deter small birds.

LOBSTER MOTH LARVA

When full grown, this larva bears a fanciful resemblance to its crustacean namesake. Smaller larvae are rather ant-like; when resting on Beech leaves, they can look rather like the remains of Beech flower bracts.

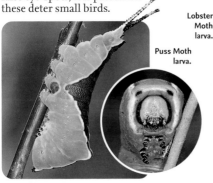

Lobster Moth larva.

Puss Moth larva.

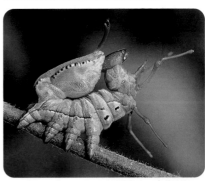

WARNING COLOURS

Relying on the principle of you are what you eat, many larvae are distasteful or poisonous, accumulating chemicals from the leaves they consume. Generally, such larvae often advertise their distasteful natures with warning markings.

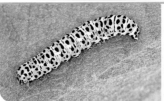

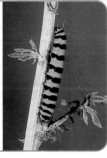

ABOVE: Mullein Moth larva, feeding on Great Mullein.
RIGHT: Cinnabar Moth larva, feeding on Common Ragwort.

LOOPER CATERPILLARS

The larvae of geometer moths (family Geometridae) resemble twigs, and when resting on their food plants they can be hard to spot, such is the accuracy of the deception. They move in a shuffling manner, with arched bodies, and so are often called 'looper' caterpillars.

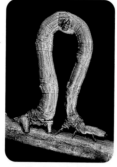

Swallow-tailed Moth larva.

HAIRY CATERPILLARS

Larvae have soft, juicy bodies and make succulent meals for insect-eating birds and other predators. Not surprisingly, many species use camouflage to avoid detection. But the larvae of some are armed with irritating hairs that cause considerable discomfort if ingested. A bird or small mammal may try this once, but soon learns to avoid such hairy caterpillars.

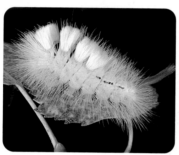

Pale Tussock larva.

HAWK-MOTH LARVAE

Hawk-moth larvae are always impressive, being strikingly marked and often rather large. Most are a shade of green overall and have an oblique stripe on each segment; many species bear the hawk-moth trademark 'horn' at the tail end.

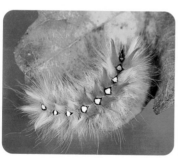

Sycamore Moth larva.

HANGING BY A THREAD

Many moth larvae produce silk, either to help attach themselves to the leaf on which they are feeding, or in some cases to spin a cocoon in which to pupate. But some tiny larvae use it in a more active manner: in order to find new leaves on which to feed, or to reach the ground safely for pupation, they suspend themselves on silken strands and abseil in the breeze.

RIGHT: **Eyed Hawk-moth.**
FAR RIGHT: **Elephant Hawk-moth.**

MOTHS IN THE GARDEN

Moths are among the most diverse and fascinating garden insects. Although most fly at night, and hence are difficult to observe in action, it is relatively easy to find good numbers resting in the daytime. And using a moth trap opens up a new dimension to the study of moths: hundreds of different species that might otherwise remain undetected can be discovered over the course of a year.

WHAT ARE MOTHS?

Moths are closely related to butterflies, both belonging to the order Lepidoptera. So how do you distinguish between the two? All butterflies fly in the daytime but not all moths fly at night – some species are also active in sunshine – so this cannot be used as a rule. British butterflies all have clubbed antennae while in almost all moths the antennae are either feathery (in males of some species) or slender and tapering; there are exceptions to this rule but none that is regularly found in the garden.

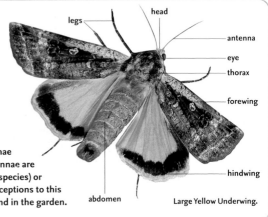

legs, head, antenna, eye, thorax, forewing, hindwing, abdomen

Large Yellow Underwing.

FINDING MOTHS IN THE DAYTIME

Most garden moths take to the wing only after dark and in the daytime remain hidden to avoid predation. Many have remarkably camouflaged wings when resting on substrates that their wing markings and colours have evolved to mimic. Some resemble tree bark or lichens, while others are similar to leaves, either fallen or living. Unsurprisingly, they can be hard to spot at first but, once you've 'got your eye in', finding them becomes easier.

LEFT: **The Buff-tip moth bears an uncanny resemblance to a snapped birch twig.**
RIGHT: **A Peppered Moth's wings are a good match for lichen growing on tree bark.**
LEFT: **The shape, colour and markings of this Pale Prominent create the illusion of frayed wood.**

If you study the leaves of shrubs and trees backlit with sunlight, you may see resting moths in silhouette. Insect-eating birds are also quick to spot a moth that has so inadvisably placed itself as this Mottled Umber.

THE ATTRACTION OF LIGHT

Few people need to be told that moths are attracted to light – leave an outdoor light on after dark in the summer months to demonstrate this for yourself. Taking this a stage further, you can improve your catch by suspending a light over a white sheet. Alternatively, you can buy or make a light trap, whereby the moths are collected in a box beneath the light. The best light source is a bulb that emits ultraviolet light (to which moths are particularly receptive). Captured moths are unharmed by the experience and can be released

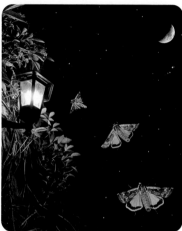

A moth trap in action.

RIGHT: One theory has it that moths use the moon for navigation. By maintaining a constant angle to this fixed reference point in the sky they can fly a straight course; because the moon is so far away, the angle hardly changes even if the moth flies a considerable distance. On overcast nights a man-made light source appears brighter than the moon to a moth's eyes, and if they use it for orientation then they are in trouble: because the light source is so much closer to the moth than the moon, the angle to the light changes dramatically over even a short flying distance. In an attempt to keep a constant angle, the moth flies in a decreasing spiral, ever closer to the bulb, instead of flying in a straight line.

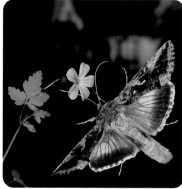

A SWEET TOOTH

Another tried and tested method for attracting certain species of moth is to lure them with food. The classic mixture involves dissolving a bag of sugar and a tin of treacle in a half a litre or so of warmed red wine or brown ale. If the mixture is reduced slowly over heat, it becomes thick and, when cooled, can be painted onto tree trunks and posts. Some moths find the mixture irresistible. 'Sugaring', as the technique is called, is more of an art than a science and catches are extremely variable; warm, muggy nights produce the best results.

Three Svennson's Copper Underwings and a Straw Underwing feasting on a sickly-sweet 'sugaring' mixture.

A Silver Y moth attracted to a flower of Herb-Robert.

ENCOURAGING MOTHS IN THE GARDEN

These days, moths need all the friends they can get and many formerly common garden species are in decline, often because allotment-type gardens are out of favour and hard landscaping tends to take precedence over gardening with plants. To encourage moths, leave wild corners in the garden where 'weeds' can flourish (many of these are food plants for moth larvae), grow as many native species of plants as you can (native plants support far more wildlife than alien ones), and never use chemical sprays.

Horse-chestnut Leaf-miner, larva

Nettle-tap, larva

Skin Moth *Monopis laevigella*
Wingspan 14–20mm
Well-marked moth. **ADULT** has dark, marbled wings fringed with white. Head has a whitish topknot. Flies May–Aug. **LARVA** feeds on organic debris. **STATUS** Widespread and common.

Horse-chestnut Leaf-miner
Cameraria ohridella Wingspan 6–8mm
Recent arrival to Britain. **ADULT** has reddish-brown wings with black and white oblique stripes; head has a white topknot and front. Flies May–Aug. **LARVA** lives in a mine in a Horse-chestnut leaf. **STATUS** Common in the S; range is expanding northwards.

Nettle-tap *Anthophila fabriciana*
Wingspan 10–15mm
Found near nettles. **ADULT** has brown marbled wings with a white cross-stripe; held flat at rest. **LARVA** makes a tent of Common Nettle leaves. Flies May–Aug. **STATUS** Widespread and common.

Bird-cherry Ermine *Yponomeuta evonymella*
Wingspan 17–24mm
One of several similar species. **ADULT** has white wings with 5 rows of black dots on forewing; flies Jul–Aug. **LARVA** feeds on Bird Cherry leaves. **STATUS** Widespread and common.

Brown House Moth *Hofmannophila pseudospretella* Wingspan 15–25mm
Familiar moth. **ADULT** has black-dotted brown wings. Scuttles rather than flies. Found year-round. **LARVA** feeds on organic debris, including stored foods. **STATUS** Widespread and common.

Common Clothes Moth *Tineola bisselliela* Wingspan 10–15mm
Household moth. **ADULT** has shiny brownish wings; tips are pointed. Scuttles rather than flies. Found year-round. **LARVA** Feeds on clothes and carpets. **STATUS** Widespread and common.

Carcina quercana Wingspan 17–22mm
Attractive moth. **ADULT** has brownish wings with a yellow outer margin and spot, and dark red lines. Flies Jul–Aug. **LARVA** feeds on oak and Beech leaves. **STATUS** Widespread and common.

Large Fruit-tree Tortrix *Archips podana* Wingspan 18–25mm
Well-marked moth. **ADULT** has reddish-brown wings with dark marks and lines. Flies Jun–Jul. **LARVA** feeds in fruit-tree flowers and fruits. **STATUS** Widespread and common.

Timothy Tortrix *Aphelia paleana* Wingspan 18–21mm
Nondescript moth. **ADULT** has plain, pale brown wings, suffused yellowish towards base and on head. Flies Jun–Aug. **LARVA** feeds on herbaceous plants. **STATUS** Widespread and common.

Light Brown Apple Moth *Epiphyas postvittana* Wingspan 17–24mm
Distinctive moth. **ADULT** has reddish-brown outer forewings; inner ⅓ of forewings, and head and thorax, are pale. Flies May–Oct. **LARVA** eats almost any plant. **STATUS** Introduced and common.

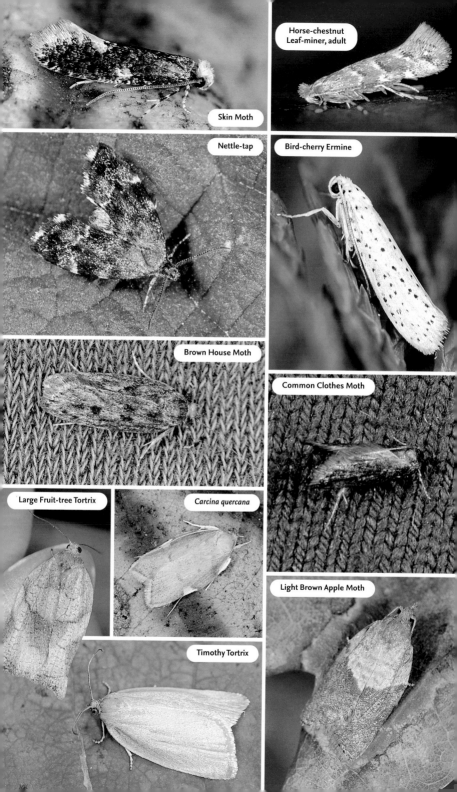

Skin Moth

Horse-chestnut Leaf-miner, adult

Nettle-tap

Bird-cherry Ermine

Brown House Moth

Common Clothes Moth

Large Fruit-tree Tortrix

Carcina quercana

Timothy Tortrix

Light Brown Apple Moth

Red-barred Tortrix *Ditula angustiorana* Wingspan 12–17mm
Well-marked moth. Sometimes flies in daytime. **ADULT** has reddish-brown wings with a pale central band. Flies Jun–Jul. **LARVA** feeds on a range of shrubs. **STATUS** Commonest in the S.

Green Oak Tortrix *Tortrix viridana* Wingspan 18–22mm
Unmistakable moth. **ADULT** has bright green forewings; held flat at rest. Flies May–Jun. **LARVA** feeds in a rolled-up oak leaf. **STATUS** Widespread and common, often abundant.

Acleris forsskaleana Wingspan 18–25mm
Well-marked moth. **ADULT** has creamy-buff wings with a network of fine reddish lines. Flies Jul–Aug. **LARVA** feeds in a folded leaf of Sycamore and maples. **STATUS** Widespread and common.

Acleris ferrugana Wingspan 14–18mm
Variable moth. **ADULT** has buffish-brown wings with a network of darker lines and a dark patch. Flies Jul–Oct in 2 broods. **LARVA** feeds in a rolled oak leaf. **STATUS** Widespread and common.

Acleris emargana Wingspan 19–22mm
Wing shape is distinctive – appears as if a semicircle has been cut from the leading edge. **ADULT** has reddish to whitish forewings with a network of dark lines. Flies Jul–Sep. **LARVA** feeds on sallow and birch leaves. **STATUS** Widespread and common.

Bramble-shoot Moth *Epiblema uddmanniana* Wingspan 15–20mm
Extremely distinctive moth. **ADULT** has grey-buff forewings with a central rich reddish-brown spot. Flies Jun–Jul. **LARVA** feeds on Bramble. **STATUS** Widespread and common.

Bud Moth *Spilonota ocellana* Wingspan 13–17mm
Variable moth. **ADULT** has dark marbled forewings and body, darkest towards head and with blackish dorsal spot. Flies Jul–Aug. **LARVA** feeds on buds of shrubs and trees. **STATUS** Widespread and common.

Cydia splendana Wingspan 12–15mm
Attractive moth. **ADULT** has pale greyish forewings with a dark patch near outer edge. Flies Jul–Aug. **LARVA** feeds in acorns or Sweet Chestnut fruits. **STATUS** Widespread and common.

Codling Moth *Cydia pomonella* Wingspan 14–21mm
Distinctive moth. **ADULT** has greyish forewings, with dark lines and a reddish patch at outer edge. Flies Jul–Aug. **LARVA** feeds inside apples and pears. **STATUS** Widespread and common.

Twenty-plume Moth *Alucita hexadactyla* Wingspan 14–16mm
Unmistakable moth. **ADULT** has pale wings, each divided into 6 feathery 'plumes'. Commonest in summer. **LARVA** feeds on Honeysuckle buds. **STATUS** Widespread and common.

Garden Pebble
Evergestis forficalis
Wingspan 24–27mm
Rests with wings held in tent-like manner. **ADULT** has buff forewings with two diagonal dark stripes and central dark teardrop-shaped mark. Flies May–Jun and Aug–Sep. **LARVA** feeds on cabbages and related plants. **STATUS** Widespread and common.

Garden Pebble

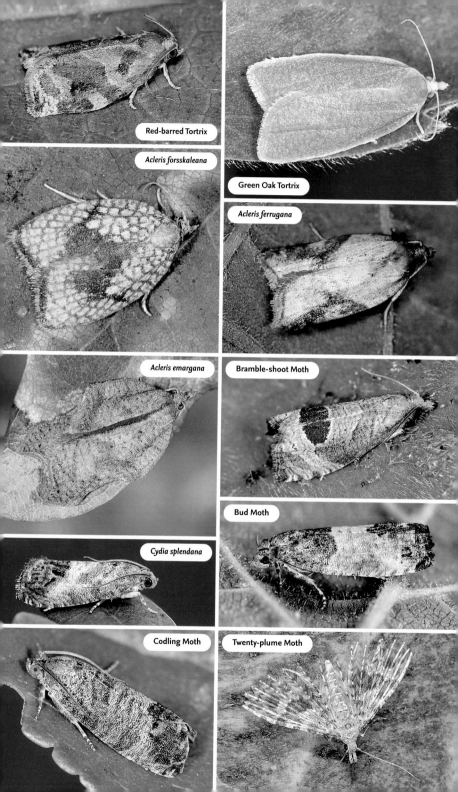

Red-barred Tortrix

Acleris forsskaleana

Green Oak Tortrix

Acleris ferrugana

Acleris emargana

Bramble-shoot Moth

Cydia splendana

Bud Moth

Codling Moth

Twenty-plume Moth

Crambus pascuella Wingspan 21–25mm
Narrow-winged moth, with projecting palps that form a 'snout'. **ADULT** has a white streak on otherwise brownish forewings. Flies Jun–Aug. **LARVA** feeds on grasses. **STATUS** Widespread and common.

Small Magpie *Eurrhypara hortulata*
Wingspan 25–28mm
Distinctive moth. **ADULT** has black and white wings; head, thorax and abdomen tip are yellowish. Flies Jun–Jul. **LARVA** feeds in a rolled leaf of Common Nettle and other plants. **STATUS** Commonest in the S.

Small Magpie

Udea lutealis
Wingspan 24–26mm
Subtly marked moth whose wings are held flat at rest. **ADULT** has creamy-white forewings with brown lines. Flies Jul–Aug. **LARVA** feeds on Bramble and other plants. **STATUS** Widespread and common.

Udea olivalis Wingspan 24–28mm
Wings are held flat at rest. **ADULT** has greyish-brown forewings with white spots. Flies Jun–Jul. **LARVA** feeds on herbaceous plants. **STATUS** Widespread and common.

Mother of Pearl *Pleuroptya ruralis* Wingspan 25–38mm
Distinctive moth. **ADULT** has pale wings with dark lines and veins, and a mother-of-pearl lustre. Flies Jun–Aug. **LARVA** feeds in a rolled Common Nettle leaf. **STATUS** Widespread and common.

Gold Triangle *Hypsopygia costalis* Wingspan 17–23mm
Colourful moth. Rests with wings spread or with forewings covering hindwings. **ADULT** has reddish wings with golden-yellow spots. Flies Jul–Aug. **LARVA** feeds on thatch and other dry plant matter. **STATUS** Widespread and common.

Meal Moth *Pyralis farinalis* Wingspan 20–30mm
Found near stored grain. Rests with its abdomen curved up. **ADULT** has reddish, buff and bluish wings with white lines. Flies Jun–Aug. **LARVA** feeds on grain. **STATUS** Widespread.

Large Tabby *Aglossa pinguinalis* Wingspan 30–40mm
Hides in dark places; runs rather than flies when disturbed. **ADULT** has dark-marbled grey-brown forewings. **LARVA** feeds on organic matter, including straw. **STATUS** Widespread but local.

Bee Moth *Aphomia sociella*
Wingspan 20–40mm
Attractive moth. **ADULT** forewing is pale towards base, with a reddish patch near outer edge. Flies Jun–Aug. **LARVA** feeds on combs in bee and wasp nests. **STATUS** Widespread and common.

Bee Moth

White Plume Moth *Pterophorus pentadactyla* Wingspan 25–35mm
Distinctive plume moth. **ADULT** has narrow white wings whose trailing margins are much divided. Flies Jun–Jul. **LARVA** feeds on bindweeds. **STATUS** Widespread and common.

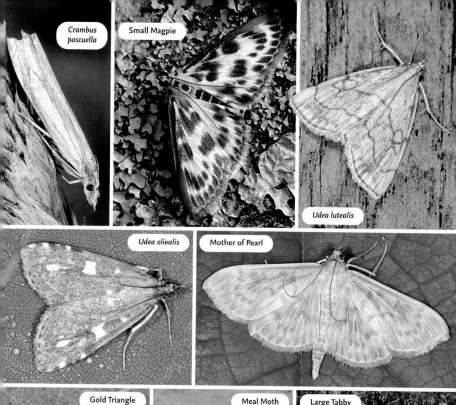

Crambus pascuella

Small Magpie

Udea lutealis

Udea olivalis

Mother of Pearl

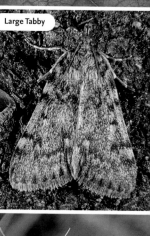

Gold Triangle

Meal Moth

Large Tabby

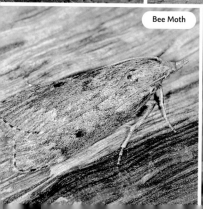

Bee Moth

White Plume Moth

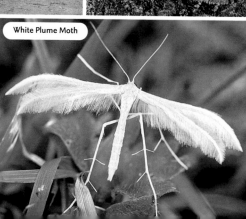

Raspberry Clearwing *Pennisetia hylaeiformis* Length 15–18mm

Wasp-like moth. Flies in daytime. **ADULT** has a blackish body with yellow rings on abdomen, and yellow lines on head and thorax. Wings are mainly clear but with reddish scales on fringe. **LARVA** lives inside Raspberry stems. **STATUS** Recently found in Britain; most records are from central England.

Currant Clearwing *Synanthedon tipuliformis* Length 11mm

Tiny, fly-like moth. Flies in daytime. **ADULT** has a bluish body with 3 yellow bands on abdomen, a yellow 'collar' and yellow lines on side of thorax. Flies Jun–Jul. **LARVA** feeds inside stems of Black and Red currants. **STATUS** Locally common but easily overlooked; within its range, it is common in gardens with mature, neglected currant bushes.

Red-belted Clearwing *Synanthedon myopaeformis* Length 13mm

Easily overlooked fly-like moth. Flies in daytime. **ADULT** has a mainly bluish-black body with a striking red band on abdomen. Wings are black-veined and clear. Flies Jun–Aug. **LARVA** feeds under the bark of apple trees. **STATUS** Locally common in mature gardens and woodlands with neglected apple trees.

Red-tipped Clearwing *Synanthedon formicaeformis* Length 11–14mm

Colourful, fly-like moth. Flies in daytime. **ADULT** has a mainly black body with a red band on abdomen. Wings are mainly clear but red-tipped and with a red leading edge. **LARVA** feeds in stems of sallows and other willows. **STATUS** Widespread and commonest in the S; found in gardens with nearby sallows and willows.

Ghost Moth *Hepialus humili* Length 25–30mm

Distinctive pale moth. **ADULT** male has white wings with subtly darker veins; head, thorax and legs are yellowish. Female has rich yellow wings with orange markings. **LARVA** feeds on roots of grasses and cultivated plants in the garden. **STATUS** Widespread and common.

Orange Swift *Hepialus sylvina* Length 20–24mm

Well-marked moth. **ADULT** male has orange wings with oblique white lines. Female has orange-buff or brown wings with whitish bands. **LARVA** feeds on roots of herbaceous plants. **STATUS** Widespread and common.

Goat Moth *Cossus cossus* Length 5cm

Impressive and distinctive moth. **ADULT** has white, silvery-grey and buff forewings, beautifully patterned to resemble cracked tree bark. Flies Jun–Jul. **LARVA** feeds under the bark of deciduous trees, including willows and poplars; sometimes found wandering in search of a pupation site. **STATUS** Local.

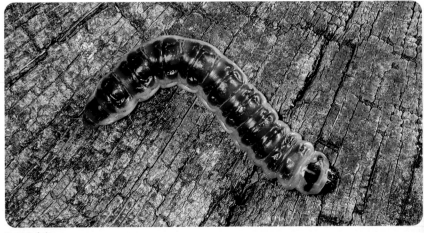

Goat Moth, larva

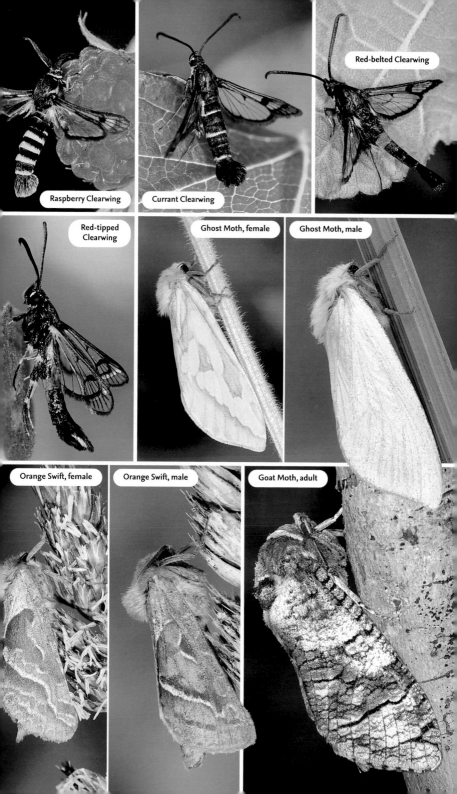

Raspberry Clearwing

Currant Clearwing

Red-belted Clearwing

Red-tipped Clearwing

Ghost Moth, female

Ghost Moth, male

Orange Swift, female

Orange Swift, male

Goat Moth, adult

December Moth *Poecilocampa populi* Length 17–19mm

Dark, hairy-bodied moth. Female is larger than male. **ADULT** has dark brown wings, with buff and reddish outer margins and white cross-lines. Head and thorax are hairy, thorax is blackish, head is whitish at front. Flies mainly Nov–Dec. **LARVA** feeds on various deciduous trees. **STATUS** Widespread and common.

The Drinker *Euthrix potatoria* Length 30–35mm

Striking moth with a pronounced 'snout' when at rest. Female is larger than male. **ADULT** has broad wings with a bold diagonal stripe; ground colour is orange-yellow in male, yellow-buff in female. Flies Jul–Aug. **LARVA** is large and hairy, and feeds on grasses. **STATUS** Widespread and common; found in gardens with nearby suitable grassy habitats.

The Drinker, larva

The Lappet, larva

The Lappet *Gastropacha quercifolia* Length 40mm

Unmistakable moth that is superbly camouflaged when resting among fallen leaves. **ADULT** has reddish wings with scalloped margins; head has a 'snout'. Flies Jun–Aug. **LARVA** is large (up to 10cm long when fully grown); feeds on Common Hawthorn and is well camouflaged when resting lengthwise along a twig. **STATUS** Commonest in the S.

Scalloped Hook-tip *Falcaria lacertinaria* Length 20mm

Well-marked moth. Rests with wings held in a tent-like manner and adopts a posture that enhances its likeness to a dead leaf. **ADULT** has wings whose scalloped edges and dark veins create the appearance of a leaf; wings are reddish grey in male, yellow-brown in female. Flies May–Jun and Aug, in 2 broods. **LARVA** feeds on birch leaves. **STATUS** Widespread and fairly common.

Oak Hook-tip *Watsonalla binaria* Wingspan 25–35mm

Distinctive moth with hook-tipped forewings. Female is larger than male. **ADULT** male has rich brown wings with pale cross-lines and dark spots on forewing. Female has similar markings but buffish forewings and yellow hindwings. **LARVA** feeds on oak leaves. **STATUS** Widespread, commonest in the S.

Pebble Hook-tip *Drepana falcataria* Wingspan 28mm

Attractive moth with hook-tipped forewings. **ADULT** has a variable ground colour, ranging from grey-buff to orange-brown. Forewings have dark transverse line and a small, central eye-spot. Flies May–Jun. **LARVA** feeds mainly on birches. **STATUS** Widespread but locally common only in the S.

Oak Hook-tip, female

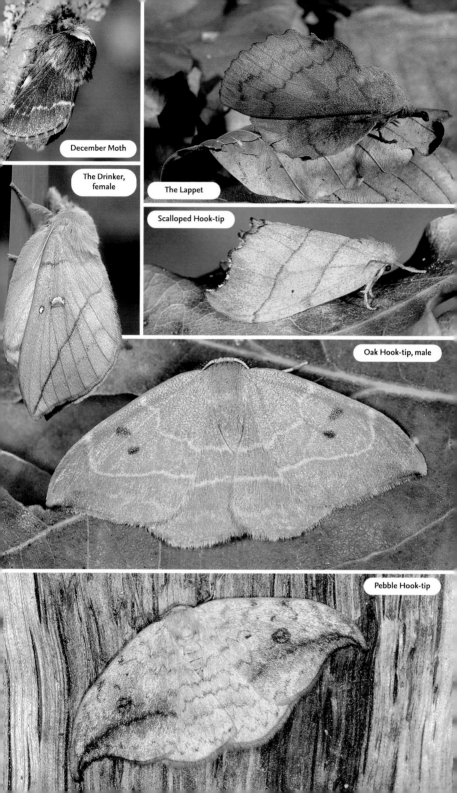

December Moth

The Drinker, female

The Lappet

Scalloped Hook-tip

Oak Hook-tip, male

Pebble Hook-tip

Chinese Character *Cilix glaucata* Length 12–13mm

Intriguing moth whose markings and resting posture create the effect of a bird dropping. **ADULT** has whitish forewings, blotched with brown and purplish blue. Wings are held in a tent-like manner at rest. Flies May–Jun and Aug, in 2 broods. **LARVA** feeds on Common Hawthorn, Blackthorn and Bramble. **STATUS** Widespread and common, except in the N.

Peach Blossom *Thyatira batis* Length 17mm

Beautifully marked moth. **ADULT** has brown forewings with conspicuous pinkish spots and blotches. Flies Jun–Jul; comes readily to light. **LARVA** feeds on Bramble. **STATUS** Widespread and fairly common except in the N; favours hedgerows and gardens where the larval food plant is abundant.

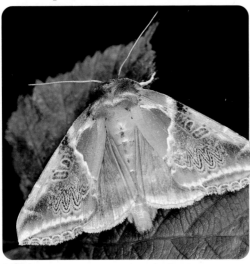

Buff Arches

Buff Arches
Habrosyne pyritoides
Length 20–22mm

Strikingly marked moth. Colours and patterns on forewings recall a cut piece of wood. **ADULT** has an orange-brown patch on forewing, intricately marked like wood grain, and a grey triangle, the colours bounded by white lines. Flies Jul–Aug. **LARVA** feeds on Bramble. **STATUS** Common only in S Britain.

Figure of Eighty
Tethea ocularis Length 24mm

Aptly named moth. Wings are wrapped around body at rest, creating a cylindrical appearance. **ADULT** has distinct white markings that resemble the number 80 on otherwise grey-brown forewing. Flies May–Jul; often comes to light. **LARVA** feeds on Aspen and poplars. **STATUS** Locally common only in the S and in wooded districts.

Oak Lutestring *Cymatophorima diluta* Length 19mm

Well-marked but variable moth. Wings are wrapped around body at rest, creating a cylindrical appearance. **ADULT** has buffish-grey to brown wings with 2 darker bands. Flies Aug–Sep. **LARVA** feeds on oak leaves. **STATUS** Widespread and locally common.

March Moth *Alsophila aescularia* Length 19mm

Only the male has wings, the forewings held overlapping one another when at rest; overall outline is triangular. Female is wingless. **ADULT** male has grey-

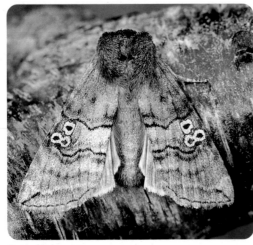

Figure of Eighty

brown forewings with 2 jagged, dark-bordered white lines. Flies Mar–Apr. **LARVA** feeds on oaks, Common Hawthorn and other deciduous trees. **STATUS** Widespread and common.

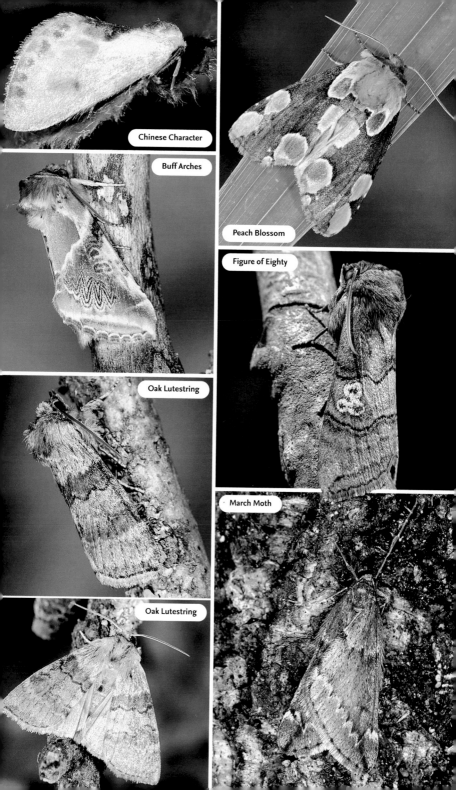

Chinese Character

Buff Arches

Peach Blossom

Figure of Eighty

Oak Lutestring

March Moth

Oak Lutestring

Large Emerald *Geometra papilionaria* Wingspan 42mm
Colourful moth, brightest when newly emerged; fades and wears with age. Wings are spread flat at rest. **ADULT** has green wings with subtle white spots and lines. Flies Jul–Aug and comes to light. **LARVA** feeds mainly on birches but also on Hazel. **STATUS** Locally common in England, Wales and Ireland, in gardens near heaths and woods.

Blotched Emerald *Comibaena bajularia* Wingspan 30mm
Beautifully marked moth. Wings are spread flat at rest. **ADULT** has bright green wings with brown and white blotches on margins. Flies Jun–Jul and comes to light. **LARVA** feeds on oaks and Hazel. **STATUS** Locally common only in S and central England and E Wales, in gardens near mature oak woodland.

Maiden's Blush *Cyclophora punctaria* Wingspan 19–24mm
Beautiful moth that rests with its wings spread flat. Wing margins are angular. **ADULT** has yellow-buff upperwings, flushed with orange towards centre and with 2 rows of dark dots; hindwings are pale yellow-buff. A dark reddish line runs across both pairs of wings. Flies May–Jun and Aug, in 2 broods. **LARVA** feeds on oak leaves. **STATUS** Common only in S England.

Blood-vein *Timandra comae* Wingspan 32mm
Unmistakable and stunning little moth. Rests with wings spread flat at rest. Wing margins are angular. **ADULT** has straw-coloured wings with a dark red transverse line across forewings and red outer margin to both wings. Flies May–Nov in 2 broods. **LARVA** feeds on Common Sorrel, Common Orache and related plants. **STATUS** Locally common in damp waysides.

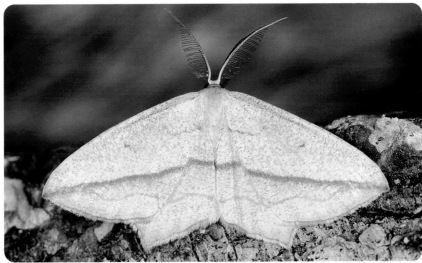

Blood-vein

Riband Wave *Idaea aversata* Wingspan 25–30mm
Well-marked moth that occurs in 2 colour forms. Wings are spread flat at rest. **ADULT** typical form has yellowish wings marked with a broad, dark band. Pale form has yellowish wings marked with 3 concentric dark lines. Flies Jun–Aug. **LARVA** feeds on a variety of low-growing plants such as Common Dandelion and docks. **STATUS** Widespread and common.

Flame Carpet *Xanthorhoe designata* Wingspan 25–27mm
Attractive and well-marked moth. Rests with wings spread flat, forewings covering hind-wings. Forewings have a rounded outer margin. **ADULT** has greyish forewings marked with a bold, broad, dark-edged red band and a dark spot on outer section of leading edge. Head and 'shoulders' are reddish. **LARVA** eats leaves of members of the brassica family, including cabbages and wallflowers. **STATUS** Widespread and common.

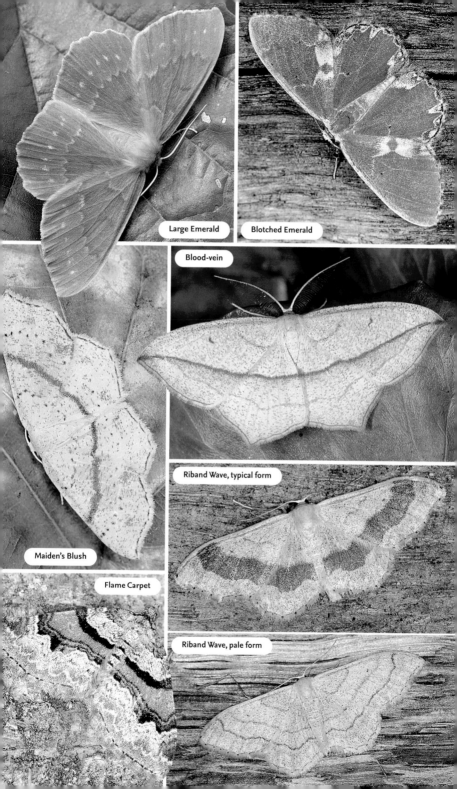

Large Emerald

Blotched Emerald

Blood-vein

Maiden's Blush

Riband Wave, typical form

Flame Carpet

Riband Wave, pale form

Red Twin-spot Carpet *Xanthorhoe spadicearia* Wingspan 20mm
Beautiful little moth. Wings are spread flat at rest. **ADULT** has forewings marked with a broad reddish-brown band and yellow-buff and reddish-brown zones towards head. Has an orange-buff patch on outer margin of leading edge and 2 centrally placed dark spots near outer margin, these sometimes indistinct. Flies mainly May–Jul. **LARVA** feeds on low herbaceous plants. **STATUS** Widespread and common.

Dark-barred Twin-spot Carpet *Xanthorhoe ferrugata* Wingspan 18–22mm
Very similar to Red Twin-spot Carpet (above). Wings are spread flat at rest. **ADULT** has forewings marked with a broad, dark band and 2 dark spots near outer margin. Inner margin of dark band has a distinct notch near wing's leading edge but is otherwise rather straight (in Red Twin-spot, band is usually reddish, not dark, and inner margin is irregularly jagged without obvious single indent). **LARVA** feeds on low herbaceous plants. **STATUS** Widespread and common.

Silver-ground Carpet *Xanthorhoe montanata* Wingspan 23–26mm
Sometimes disturbed from wayside vegetation in daytime. Rests with wings spread flat, forewings mostly covering hindwings. **ADULT** has whitish forewings marked with a darker brown central, transverse band. Flies May–Aug. **LARVA** feeds on bedstraws. **STATUS** Widespread and common in grassy areas.

Garden Carpet *Xanthorhoe fluctuata* Wingspan 19–24mm
Well-marked moth. Rests with wings spread flat, forewings covering hindwings. **ADULT** has whitish forewings with a dark patch halfway along leading edge, a smaller dark spot nearer outer margin, and dark head and 'shoulders'. Flies Apr–Sep as several broods. **LARVA** feeds on leaves of members of the cabbage family and on Nasturtiums. **STATUS** Widespread and common.

Blue-bordered Carpet *Plemyria rubiginata* Wingspan 16–19mm
Distinctive and well-marked moth. Wings are spread flat at rest, forewings mostly covering hindwings. **ADULT** has mostly white forewings with rufous brown patch halfway along leading edge, and at base. Outer margin is blue-grey with a dark tip. Flies Jun–Aug. **LARVA** feeds on Blackthorn, Alder and other deciduous trees and shrubs. **STATUS** Widespread and common.

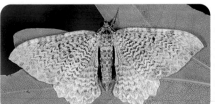

Scallop Shell *Rheumaptera undulata* Wingspan 25–30mm
Well-marked and aptly named moth. Rests with wings spread flat. **ADULT** has pale buff wings that are heavily marked with numerous concentric crosslines that are dark brown, wavy and scalloped. **LARVA** feeds on sallows and Bilberry. Flies Jun–Jul. **STATUS** Widespread but local.

Yellow Shell *Camptogramma bilineata* Wingspan 20–24mm
Colourful moth. Rests with wings spread flat. Often disturbed from vegetation in daytime. **ADULT** wing colour ranges from bright yellow to yellow-brown; wings are intricately marked with several concentric white lines and numerous dark lines, some showing a broad, dark central line. Flies Jun–Aug. **LARVA** feeds on low-growing plants. **STATUS** Widespread and common.

The Mallow *Larentia clavaria* Wingspan 35–40mm
Broad-winged moth that rests with wings spread flat. **ADULT** has brownish wings overall, with pale and dark cross-bands. Flies Sep–Oct. **LARVA** feeds on mallows and hollyhocks. **STATUS** Widespread, but commonest in the S.

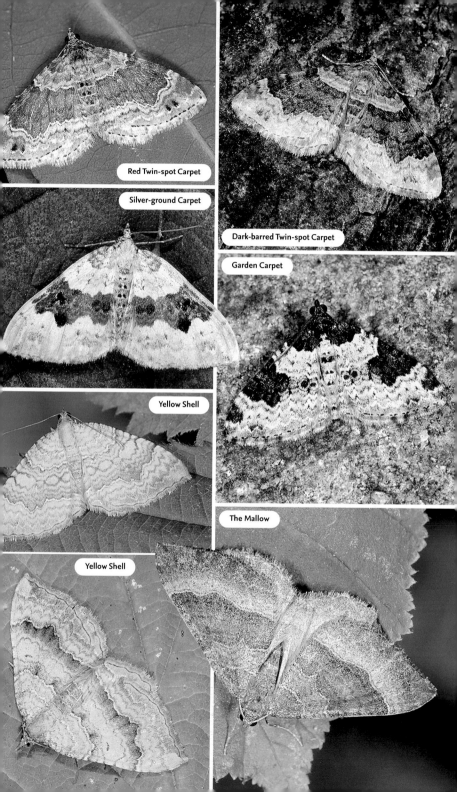

Red Twin-spot Carpet

Silver-ground Carpet

Dark-barred Twin-spot Carpet

Garden Carpet

Yellow Shell

Yellow Shell

The Mallow

The Streamer *Anticlea derivata* Wingspan 30–35mm
Subtly attractive and distinctively marked moth. Wings are spread flat at rest. **ADULT** has pale pinkish-grey forewings with a dark cross-band and a tapering, streamer-like black band running across wing from leading edge. Flies Apr–May. **LARVA** feeds on Dog-rose flowers and leaves. **STATUS** Widespread, but commonest in the S.

The Streamer

Shoulder-stripe *Anticlea badiata*
Wingspan 25–30mm
Well-marked moth whose wings are spread flat at rest. **ADULT** has variable ground colour to wings but constant pattern. Forewings are marked with dark and light bands and lines; has a jagged black stripe at wingtip and a small white 'V' halfway along outer edge. Flies Mar–Apr. **LARVA** feeds on leaves of roses. **STATUS** Widespread, but commonest in the S.

Tawny-barred Angle *Macaria liturata* Wingspan 22–26mm
Rests with wings spread flat, in the manner of a butterfly. Forewings are pointed and slightly hook-tipped; hindwings are angled. **ADULT** has grey or grey-buff, dark-stippled upperwings that are marked with a broad, tawny-orange bar, brightest near leading edge of forewing. Head is also tawny-orange. Flies Jun–Jul; 2nd brood in Aug in south. **LARVA** feeds on Scots Pine and other conifers. **STATUS** Widespread and fairly common.

Purple Bar *Cosmorhoe ocellata* Wingspan 20–25mm
Stunning carpet moth. Wings are held flat at rest. **ADULT** has marbled white forewings with a broad, brown-edged, dark purplish band, and purplish head and 'shoulders'. Flies May–Aug, often as 2 broods. **LARVA** feeds on bedstraws. **STATUS** Widespread and fairly common.

The Phoenix *Eulithis prunata* Wingspan 30–35mm
Intricately marked moth that holds its wings spread flat at rest. **ADULT** has brownish wings overall, strongly marked with jagged dark bands and white lines. Flies Jul–Aug. **LARVA** feeds on leaves of members of the currant family, including cultivated garden varieties, and Gooseberry. **STATUS** Widespread but local.

Barred Straw *Eulithis pyraliata* Wingspan 35mm
Intriguing moth whose forewings are spread wide at rest and obscure the hindwings. This resting posture is unique and diagnostic. **ADULT** has straw-yellow wings marked with dark brown bars. Flies Jul–Sep. **LARVA** feeds on bedstraws and Common Cleavers. **STATUS** Widespread and common.

Small Phoenix *Ecliptopera silaceata* Wingspan 24–26mm
Beautifully patterned moth that holds its wings spread flat at rest. **ADULT** has grey-brown wings overall, marbled darker and with jagged, white-edged, dark bands. Thorax and abdomen are yellowish brown. Flies May–Jun and Aug, in 2 broods in the S. **LARVA** feeds on willowherbs. **STATUS** Widespread, but commonest in the S.

The Streak *Chesias legatella* Length 15–17mm
Distinctive moth that rests with one forewing overlapping the other, in a tent-like manner. **ADULT** has overall buffish-grey wings, subtly marbled with brown and showing a pale streak running from forewing tip, and adjacent, shorter dark and white streaks in middle of wing. Flies Sep–Oct. **LARVA** feeds on Broom. **STATUS** Widespread and locally common.

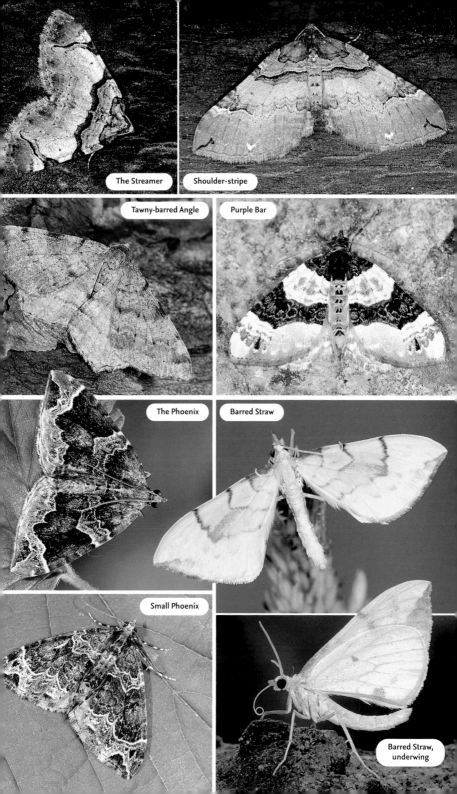

The Streamer

Shoulder-stripe

Tawny-barred Angle

Purple Bar

The Phoenix

Barred Straw

Small Phoenix

Barred Straw, underwing

Dark Marbled Carpet *Chloroclysta citrata* Wingspan 25–30mm

Beautifully patterned but variable moth that holds its wings flat at rest. Very similar to Common Marbled Carpet (below). **ADULT** has variably marbled forewings. One form has a broad white band framed by brown or blackish; another has a broad blackish band framed by pale areas. Central projection on outer edge of this band is more pointed than in Common Marbled. Flies Jul–Aug. **LARVA** feeds on willows and Bilberry. **STATUS** Widespread, but commonest in the N.

Common Marbled Carpet
Chloroclysta truncata Wingspan 25–30mm

Very variable moth. **ADULT** has extremely variably marbled wings. Some forms have a broad, dark band on otherwise brown and white wings; others have a broad chestnut band or patch on otherwise dark wings. Outer edge of central band either lacks central projection or, if present, it is blunt compared to that of Dark Marbled (above). **LARVA** feeds on a wide range of low-growing plants. **STATUS** Widespread and common.

Common Marbled Carpet

Barred Yellow *Cidaria fulvata*
Wingspan 20–25mm

Colourful and distinctive moth. Wings are held flat at rest. **ADULT** has overall yellowish-brown wings with a dark central band and a pale triangle at angle of wingtip. Flies Jun–Jul. **LARVA** feeds on Dog-rose. **STATUS** Widespread but local.

Common Marbled Carpet

Pine Carpet *Thera firmata* Wingspan 30–35mm

Similar to Grey Pine Carpet (below) but separable by studying the wing pattern. Wings are held flat at rest. **ADULT** has a variable forewing colour: buff to grey-buff, with an orange or dull brown central band and head and 'shoulders'; inner edge of central band has sharp indent. Flies Jul–Oct. **LARVA** feeds on Scots Pine. **STATUS** Widespread and locally common.

Grey Pine Carpet *Thera obeliscata* Wingspan 30–34mm

Variable moth that is similar to Pine Carpet (above). Wings are held flat at rest. **ADULT** has forewings that vary from orange-buff to dull grey-brown. All forms have a darker central band, the inner edge of which lacks the sharp, deep indent seen in Pine Carpet. **LARVA** feeds on pines and spruces. **STATUS** Widespread and common wherever its foodplant trees are grown.

Spruce Carpet *Thera britannica* Wingspan 18–24mm

Attractively marked moth. Wings are held flat at rest, and are subtly narrower and more pointed than those of many other carpets. **ADULT** has a variable wing colour, ranging from grey-buff to buffish brown; a subtly darker central band is usually noticeable, and typically has a squarish black dot on wing's trailing margin. Flies May–Jul and Sep–Oct, in 2 broods. **LARVA** feeds on spruces and Douglas Fir. **STATUS** Widespread and fairly common wherever its foodplant trees are grown.

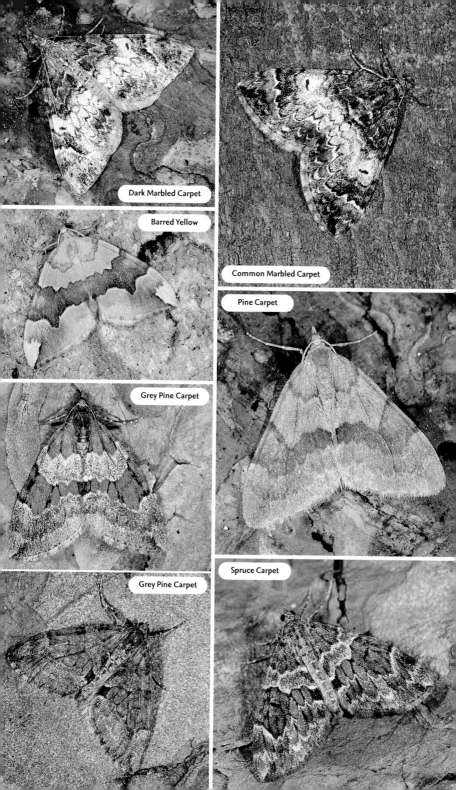

Dark Marbled Carpet

Barred Yellow

Common Marbled Carpet

Pine Carpet

Grey Pine Carpet

Grey Pine Carpet

Spruce Carpet

Cypress Carpet *Thera cupressata* Wingspan 28–32mm

Well-marked moth with relatively narrow, pointed wings by carpet moth standards. Wings are held flat at rest. **ADULT** has mottled grey and grey-buff wings with a striking oblique black line running across them to wingtip. Flies May–Jun. **LARVA** feeds on Leyland Cypress and Monterey Cypress. **STATUS** A recent colonist. First recorded in the 1980s and now fairly widespread in the S.

Red-green Carpet variant

Red-green Carpet

Chloroclysta siterata Wingspan 30–35mm
Attractive, variable moth whose wings are held flat at rest and that has a more narrowly triangular outline than many other carpet moths. **ADULT** has forewings that are marked with variable amounts of red and green. Typical form is green overall with dark cross-bands and red patches or lines; in some forms, the red is absent. Flies Sep–Oct, and again in spring after hibernation. **LARVA** feeds on oaks and Rowan. **STATUS** Widespread and locally common.

Green Carpet *Colostygia pectinataria*

Wingspan 22–25mm
Colourful carpet moth with broadly rounded wings that are held flat at rest. **ADULT** has forewings that are fresh lime-green overall at first, although colour fades to buffish green with time. Has a broad, darker central band that is outlined in white. Flies May–Jul. **LARVA** feeds on bedstraws. **STATUS** Widespread and common.

July Highflyer *Hydriomena furcata* Wingspan 25–30mm

Richly coloured but very variable moth whose broad wings are pointed at the tip and held flat at rest. **ADULT** usually has fairly distinctive bluish-green forewings with 2 narrow, dark cross-bands. Some individuals are yellowish or brown overall. Flies Jul–Aug. **LARVA** feeds on sallows, Hazel, Bilberry and Heather. **STATUS** Widespread and common.

Sharp-angled Carpet *Euphyia unangulata* Wingspan 25–27mm

Colourful and well-marked moth whose broad wings are held flat at rest. **ADULT** has forewings with cross-bands of marbled yellowish brown and off-white; central dark band usually contains a blackish spot. Flies Jun–Jul. **LARVA** feeds on a range of low-growing plants. **STATUS** Widespread, but commonest in the S.

Water Carpet

Water Carpet *Lampropteryx suffumata*

Wingspan 24–26mm
Beautifully patterned moth. Rests with wings spread flat, forewings covering hindwings. **ADULT** has rich brown forewings with several pale, jagged crosslines, and jagged, white streak at tip. Flies Apr–May. **LARVA** feeds on various bedstraws. **STATUS** Widespread and fairly common.

Foxglove Pug *Eupithecia pulchellata*

Wingspan 18–20mm
Attractive, brightly marked little moth whose rather narrow wings are spread flat at rest. **ADULT** has marbled reddish-brown and dark grey forewings. Flies May–Jul. **LARVA** feeds within Foxglove flowers. **STATUS** Widespread and common, particularly in the S and W.

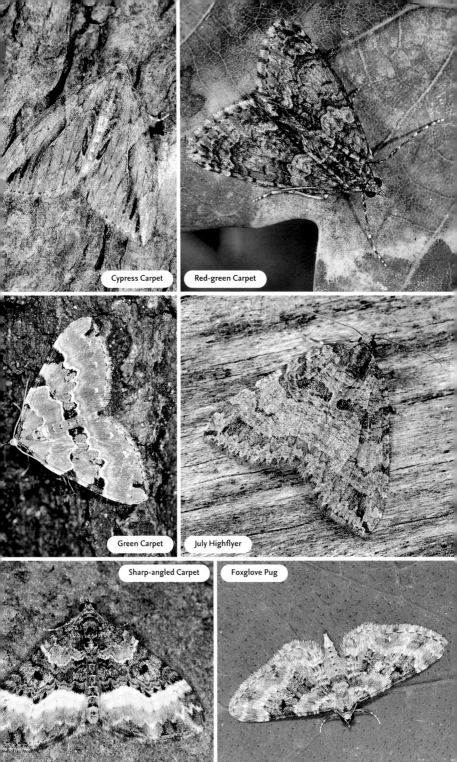

Cypress Carpet

Red-green Carpet

Green Carpet

July Highflyer

Sharp-angled Carpet

Foxglove Pug

Lime-speck Pug *Eupithecia centaureata* Wingspan 16–19mm

Very narrow-winged pug whose wings are spread flat at rest; its markings and colours create the impression of a bird dropping. **ADULT** has whitish forewings overall, with a dark spot on middle of leading edge, a buff band and dark lines. Flies Apr–Aug in 2 broods. **LARVA** feeds on a variety of low-growing plants. **STATUS** Widespread and common.

Cypress Pug *Eupithecia phoeniceata* Wingspan 19–22mm

Distinctive pug with narrow, pointed wings that are spread flat at rest. **ADULT** has grey-buff wings marked with narrow blackish lines. Abdomen has a black line across middle. Flies Aug–Sep. **LARVA** feeds on Monterey Cypress and, possibly, Leyland Cypress. **STATUS** A recent arrival to Britain, known since 1959. Now widespread in S and central England.

The V-pug *Chlorclystis v-ata* Wingspan 15–19mm

Easily recognised by its colour and diagnostic markings. Rests with wings spread flat; outline is triangular. **ADULT** is bright green overall, with a distinct black 'V' mark on forewing. Flies May–Jun, sometimes in Aug as a 2nd brood. **LARVA** feeds on Elder, Common Hawthorn and Bramble. **STATUS** Widespread, but commonest in the S.

Green Pug *Pasiphila rectangulata* Wingspan 15–20mm

Beautifully patterned moth whose rounded wings are spread flat at rest. **ADULT** has wings that are green overall (the precise shade is very variable) and marked with dark bands and lines. Flies Jun–Jul. **LARVA** feeds in flowers of apples and pears. **STATUS** Widespread and common.

Double-striped Pug *Gymnoscelis rufifasciata* Wingspan 16–19mm

Well-marked moth whose narrow wings are spread flat at rest. **ADULT** is usually brownish overall, the wings marked with concentric dark bands and lines, 2 of which are bold and give the species its name. Flies Apr–May and Aug, in 2 broods. **LARVA** feeds on a range of shrubs, including Holly, Ivy, gorses and buddleias. **STATUS** Widespread and fairly common.

Brindled Pug *Eupithecia abbreviata* Wingspan 26–28mm

Attractively patterned, narrow-winged moth that rests with wings spread flat. **ADULT** has overall brown upperwings, beautifully marbled with brown and grey, and with a pale-framed dark, straightish comma mark centrally on forewing. Flies Apr–May. **LARVA** feeds on oaks and Hawthorn. **STATUS** Widespread and common, except in far N.

Early Tooth-striped

Early Tooth-striped *Trichopteryx carpinata* Wingspan 22–24mm

Rather pale-looking moth that rests with wings spread flat, the rather rounded forewings covering the hindwings. **ADULT** has whitish or yellowish-white forewings with numerous, variably dark concentric crosslines; these are often very faint. Flies Apr–May. **LARVA** feeds on Honeysuckle, birches and sallows. **STATUS** Widespread and fairly common.

Yellow-barred Brindle *Acasis viretata* Wingspan 26–29mm

Attractive moth whose rounded wings are spread flat at rest. **ADULT** has yellowish or greenish-yellow wings overall when fresh, although the colours soon fade and wear. Forewings are marked with a blackish band or lines and outer margin is usually pale. Flies May–Jun, sometimes as a 2nd brood in Aug in the S. **LARVA** feeds on range of shrubs, including Holly and Ivy. **STATUS** Widespread but local.

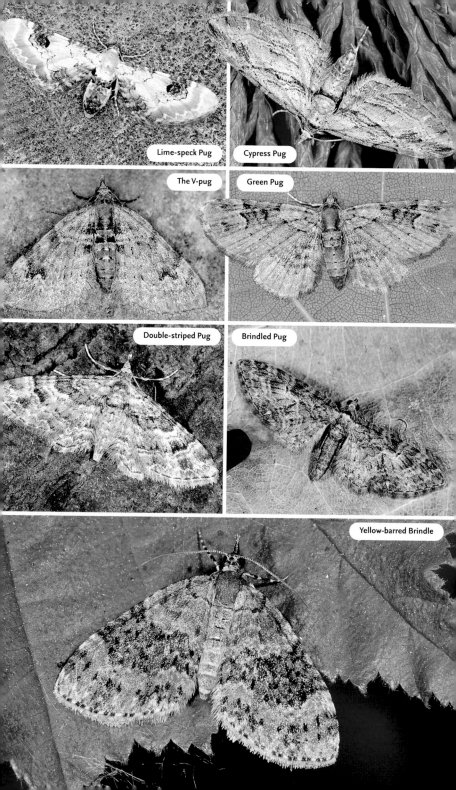

Lime-speck Pug

Cypress Pug

The V-pug

Green Pug

Double-striped Pug

Brindled Pug

Yellow-barred Brindle

Pale November
Moth

November Moth *Epirrita dilutata* Wingspan 20mm

Typical autumn moth, often seen resting near outside lights or caught in car headlights. Its rather rounded wings are spread flat at rest. Extremely hard to distinguish from the Pale November Moth (below). **ADULT** has variably marbled grey and brown wings, usually with jagged cross-lines, these sometimes forming up to 3 subtly darker bands. Some show a central dark spot; if present, this typically lies within the central band. Flies Oct–Nov. **LARVA** feeds on a variety of shrubs and trees. **STATUS** Widespread and common.

Pale November Moth *Epirrita christyi* Wingspan 20mm

Very similar to the November Moth (above) – many individuals are not separable without reference to male genitalia (beyond the scope of this book). **ADULT** has variably marbled grey and brown wings, usually with jagged cross-lines, these sometimes forming up to 3 subtly darker bands. Some show a central dark spot; if present, this typically lies outside the central band. **LARVA** feeds on a variety of shrubs and trees. **STATUS** Widespread and common.

Winter Moth *Operophtera brumata* Wingspan 22–26mm

Winter Moth
male

Small moth with a seasonally appropriate name. Wings are very rounded and held flat at rest. Only males have wings; they are often seen flying in car headlights. To see wingless female, look for mating pairs by torchlight on food plants. **ADULT** has grey-brown wings with concentric cross-lines. Flies Nov–Feb. **LARVA** feeds on most deciduous trees and shrubs. **STATUS** Widespread and common.

The Magpie *Abraxas grossulariata* Wingspan 38mm

Winter Moth female

Unmistakable and easily recognised moth. Rests with wings spread flat. **ADULT** has patterns of black spots and yellow on otherwise white wings. Flies Jul–Aug. **LARVA** feeds on various shrubs, notably currants and Gooseberry. **STATUS** Widespread, but commonest in the S.

Clouded Border *Lomaspilis marginata* Wingspan 32–36mm

Well-marked, delicate moth. Wings are spread flat at rest. **ADULT** has a broad blackish border and spots on otherwise white wings. Flies May–Jul. **LARVA** feeds on Aspen, poplars and sallows. **STATUS** Widespread and fairly common.

Scorched Wing *Plagodis dolabraria* Wingspan 23mm

Intriguingly marked moth. At rest, wings are spread wide and abdomen tip is curved upwards. **ADULT** has buffish wings with close, concentric dark lines; base of wings and tip of abdomen look scorched. Flies May–Jun. **LARVA** feeds on oaks, birches and other deciduous trees. **STATUS** Widespread and fairly common.

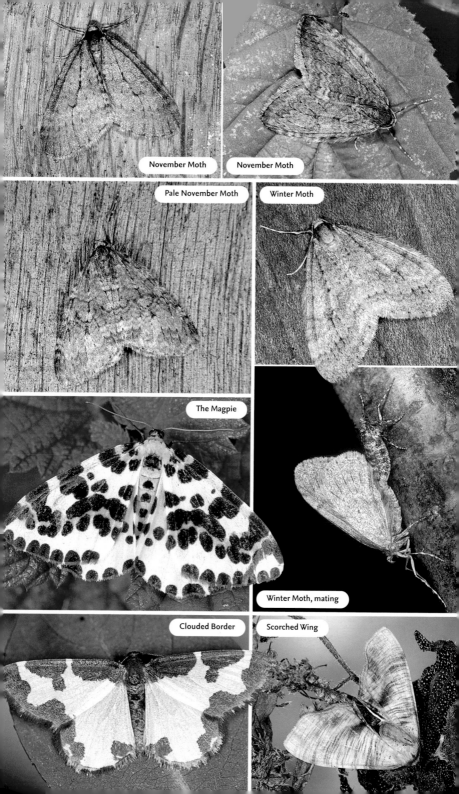

November Moth

November Moth

Pale November Moth

Winter Moth

The Magpie

Winter Moth, mating

Clouded Border

Scorched Wing

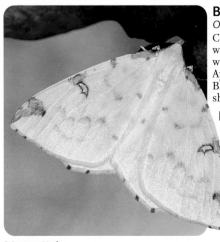

Brimstone Moth
Brimstone Moth

Opisthographis luteolata Wingspan 28mm
Colourful, unmistakable moth. Rests with wings spread flat. **ADULT** has bright yellow wings marked with chestnut blotches. Flies Apr–Oct in several broods. **LARVA** feeds on Blackthorn, Common Hawthorn and other shrubs. **STATUS** Widespread and common.

Lilac Beauty *Apeira syringaria*
Wingspan 38–40mm

Intriguing moth. Wings are spread flat at rest; folded (almost crumpled) leading edge to forewing, combined with wing colour and pattern, create the impression of a dead leaf. **ADULT** has angular wing margins and grey-buff wings with pale patches and dark lines. Flies Jun–Jul. **LARVA** feeds on various shrubs, including privets and Honeysuckle. **STATUS** Widespread, but commonest in the S.

Canary-shouldered Thorn

Ennomos alniaria Wingspan 38–42mm
Colourful and fairly distinctive moth. Wings are held at an acute angle at rest. **ADULT** has angular, jagged margins to wings. Wings are brown with dark lines and marbling; head and thorax are fluffy yellow. Flies Jul–Oct. **LARVA** feeds on a range of deciduous trees and shrubs. **STATUS** Widespread and common.

Dusky Thorn *Ennomos fuscantaria*
Wingspan 36–40mm
Attractive moth with a leaf-like appearance. Rests with wings held at an acute angle. **ADULT** has angular, jagged margins to wings. Forewings are divided into 3 by 2 dark lines; outer ⅓ is dusky brown while inner ⅔ are yellowish brown. Flies Aug–Sep. **LARVA** feeds on Ash. **STATUS** Common only in central and S England and Wales.

September Thorn *Ennomos erosaria*
Wingspan 30–34mm
Well-marked moth with a leaf-like appearance. Rests with wings held at an acute angle. **ADULT** has angular, jagged margins to wings. Forewings are yellowish brown and marked with 2 dark cross-lines; outer ⅓ is dusky

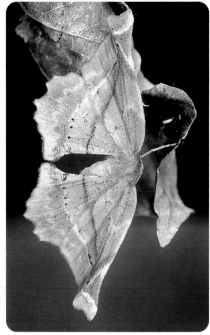

Lilac Beauty

brown while inner ⅔ are yellowish brown. Flies Jul–Oct. **LARVA** feeds mainly on birches and oaks. **STATUS** Widespread, but commonest in the S.

Early Thorn *Selenia dentaria* Wingspan 30–40mm
Well-marked, subtly attractive moth. Rests with wings folded above body. **ADULT** has angular, jagged margins to wings. Undersides of wings (seen at rest) are orange-brown with purplish-grey marbling and dark cross-lines. Flies Aug–Sep. **LARVA** feeds on deciduous trees and shrubs. **STATUS** Widespread and common.

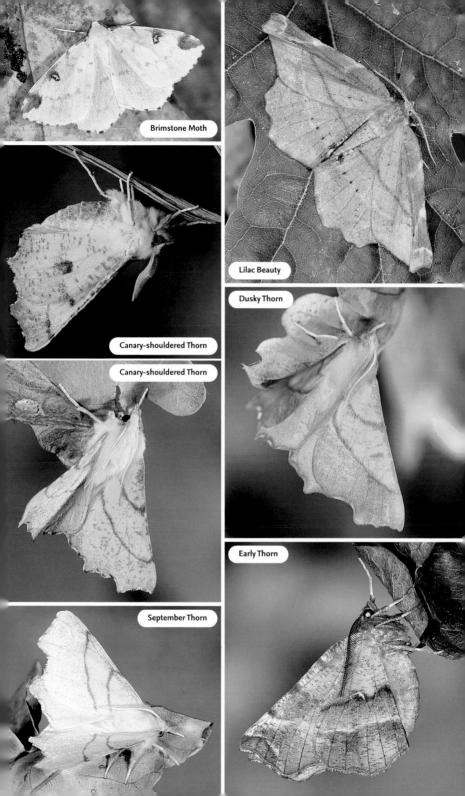

Brimstone Moth

Lilac Beauty

Canary-shouldered Thorn

Canary-shouldered Thorn

Dusky Thorn

September Thorn

Early Thorn

Purple Thorn *Selenia tetralunaria* Wingspan 32–38mm
Richly coloured moth. Wings are held at an acute angle or folded above body at rest. ADULT has angular, jagged margins to wings. Undersides of wings (seen at rest) are purplish brown, flushed orange-brown towards base. Each wing has an angular white crescent-moon mark. Flies Apr–May, and sometimes Aug as a 2nd brood. LARVA feeds on deciduous trees and shrubs. STATUS Widespread and fairly common.

Scalloped Hazel *Odontopera bidentata* Wingspan 32–38mm
Rather plain-looking moth that holds its wings spread flat at rest, creating a triangular outline. ADULT has grey-buff wings with jagged outer margins and dark cross-lines. Flies May–Jun. LARVA feeds mainly on deciduous trees and shrubs. STATUS Widespread and fairly common.

Scalloped Oak *Crocallis elinguaria* Wingspan 17mm
Subtly attractive moth. Wings are spread flat at rest. ADULT has a variably coloured forewing, but in typical form this is buffish yellow with a broad, transverse brown band containing a single dark spot. Flies Jun–Aug. LARVA feeds on most deciduous trees and shrubs. STATUS Widespread and fairly common.

Swallow-tailed Moth, larva

Swallow-tailed Moth
Ourapteryx sambucaria Wingspan 52mm
Distinctive and impressive moth that holds its wings spread flat at rest. Sometimes attracted to outside lights. ADULT has pale yellow wings, the forewing with an angular tip and the hindwing with a short tail streamer. Both wings are marked with brown cross-lines. Flies Jun–Jul. LARVA feeds on Ivy, Common Hawthorn and other shrubs. STATUS Widespread and locally common, except in the N.

Feathered Thorn *Colotois pennaria*
Wingspan 35–45mm
Richly colourful moth that holds its wings spread flat at rest, creating a triangular outline. ADULT has reddish-brown wings, the forewing with a pointed tip and relatively smooth, not jagged, outer margin. Wings are marked with dark cross-lines and note the small white spot near tip. Male has feathery antennae. Flies Sep–Nov. LARVA feeds on deciduous trees and shrubs. STATUS Widespread and generally common, but least so in N Scotland.

Brindled Beauty *Lycia hirtaria* Wingspan 40mm
Well-marked moth with variable colours and markings. Wings have rounded tips and are spread flat at rest. ADULT is usually grey-brown, forewings with black lines and stippling, and yellow-buff suffusion. Flies Mar–Apr. LARVA feeds on deciduous trees. STATUS Widespread, but common only in the S.

Brindled Beauty

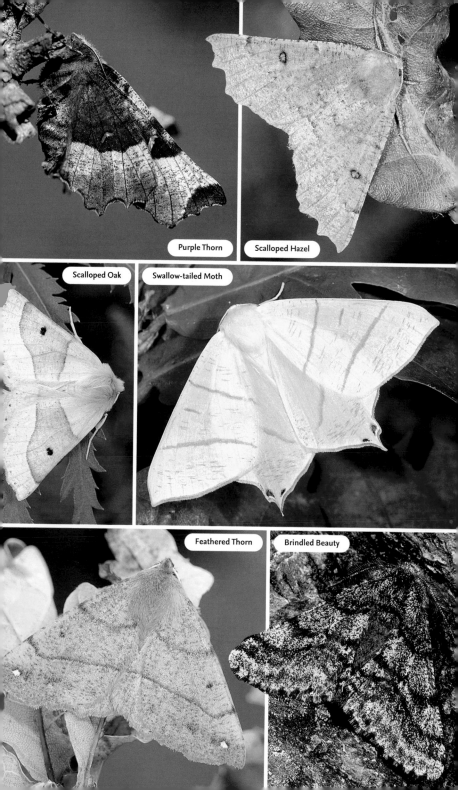

Purple Thorn

Scalloped Hazel

Scalloped Oak

Swallow-tailed Moth

Feathered Thorn

Brindled Beauty

Oak Beauty

Oak Beauty *Biston strataria*
Wingspan 23mm
Attractive moth whose markings provide good camouflage against tree bark. Rests with wings spread flat. **ADULT** has marbled reddish-brown, grey and black wings. Flies Mar–Apr. **LARVA** feeds on various deciduous trees. **STATUS** Widespread and common only in England and Wales.

Peppered Moth *Biston betularia*
Wingspan 35–50mm
Occurs in 2 distinct colour forms. Both are well camouflaged when resting, with wings spread flat, against a suitable section of tree bark. **ADULT** of typical forms either has sooty-black wings or whitish wings peppered with dark spots; intermediate form also occurs. Flies May–Aug. **LARVA** feeds on a range of deciduous trees and shrubs. **STATUS** Widespread and common.

Scarce Umber *Agriopis aurantiaria*
Wingspan 30–35mm
Well-marked late-autumn moth. Only the male has wings, these held flat at rest. Females have vestigial wings and cannot fly. **ADULT** male has yellowish-brown wings with 3 dark cross-lines and dark spots towards outer margin. Adults are seen Oct–Dec. **LARVA** feeds on a range of deciduous trees. **STATUS** Widespread and fairly common.

Scarce Umber

Dotted Border
Agriopis marginaria
Wingspan 28–32mm
Variable moth found in the winter months. Only the male has wings, these held flat at rest. Females have vestigial wings and cannot fly. **ADULT** male of typical form has buffish-brown wings with 3 dark cross-lines; line near outer margin has a distinct kink. Some individuals are a uniform rich brown. Adults are seen Feb–Apr. **LARVA** feeds on a range of deciduous trees. **STATUS** Widespread and fairly common.

Mottled Umber *Erannis defoliaria* Wingspan 40mm
Autumnal moth, the males of which spread their wings flat at rest; females are wingless and cannot fly. **ADULT** male has forewings that vary from pale to dark brown; typical form has a pale central band, bordered by a black line and containing a black dot; other forms are more rufous but all show a black dot. Adults are seen Oct–Dec. **LARVA** feeds on deciduous trees and shrubs. **STATUS** Widespread and common.

Waved Umber *Menophra abruptaria* Wingspan 40mm
Attractive moth whose wing markings recall cut, decaying timber. Wings are spread flat at rest. **ADULT** has buffish wings marked with horizontal dark lines and bands. Flies Apr–Jun. **LARVA** feeds on Lilac and Garden Privet. **STATUS** Widespread, but commonest in S Britain.

Oak Beauty

Scarce Umber

Peppered Moth, dark form

Peppered Moth, pale form

Waved Umber

Dotted Border

Mottled Umber

Willow Beauty *Peribatodes rhomboidaria* Wingspan 30–38mm
Intricately marked moth whose wings are spread flat and wide when at rest, in an almost butterfly-like fashion. Camouflaged against tree bark. ADULT is variable but typical ground colour is greyish buff; most are marked with rows of dark concentric cross-lines, the central one darkest, and thickest towards trailing edge of forewing (often creating a blackish square spot). Flies Jul–Aug. LARVA feeds on deciduous trees and shrubs, including Ivy. STATUS Widespread and common.

Mottled Beauty *Alcis repandata* Wingspan 35–38mm
Variable moth whose wings are spread flat when at rest, in an almost butterfly-like fashion. Well camouflaged on tree bark. ADULT has pale grey-brown or sometimes darker wings with fine black lines and stippling. Usually lacks the dark square spot seen on trailing edge of Willow Beauty's forewing (*see* above). Flies Jun–Jul. LARVA feeds on birches, oaks and Bramble. STATUS Widespread and common.

The Engrailed *Ectropis bistortata* Wingspan 30–40mm
Subtly and intricately marked moth whose rounded wings are spread flat at rest. ADULT has wings that in most forms are pale grey-buff, marked with intricate, dark concentric lines. Flies Mar–Apr and Jul–Aug, in 2 broods. LARVA feeds on deciduous trees and shrubs. STATUS Widespread and common.

Common White Wave *Cabera pusaria* Wingspan 25–28mm
Delicate-looking moth whose wings soon become worn and are spread flat at rest. ADULT has whitish wings marked with 3 darker cross-lines. Flies May–Aug, sometimes in 2 broods. LARVA feeds on deciduous trees and shrubs. STATUS Widespread and fairly common.

Light Emerald *Campaea margaritata* Wingspan 30–40mm
Beautiful moth whose subtle green colour soon fades. Wings are held flat at rest. ADULT has pale green wings with dark-edged white cross-lines and a tiny red tip to pointed forewing. Flies Jun–Aug. LARVA feeds on deciduous trees and shrubs. STATUS Widespread and fairly common.

Barred Red *Hyalea fasciaria* Wingspan 30–40mm
Subtly attractive moth whose wings are held flat at rest. ADULT of typical form has reddish-buff wings with a white-framed central dark band; one form has greenish wings with reddish margins and a reddish border to central band. LARVA feeds on Scots Pine, Norway Spruce and other conifers. STATUS Widespread and common where its food plants grow.

Early Moth *Theria primaria* Length (male) 16–18mm
Rather drab moth that rests with wings spread flat, forewings (in male) covering hindwings. ADULT male has grey-brown to buffish-brown wings with a darker central band containing a dark spot. Female has vestigial wings and cannot fly. Male flies Jan–Feb. LARVA feeds on Blackthorn and hawthorns. STATUS Widespread and mostly common, but scarce in Scotland.

Early Moth, male

Early Moth, female

Willow Beauty

The Engrailed

Mottled Beauty

Common White Wave

Light Emerald

Barred Red

Lime Hawk-moth *Mimas tiliae* Wingspan 65mm

Subtly attractive moth that is well camouflaged when resting among dappled leaves. Wings have jagged outer edges and are held flat at rest. **ADULT** wing colour is variable but usually olive-green with pinkish marbling and darker markings. Flies May–Jun. **LARVA** is pale green with a pale diagonal stripe on each segment, numerous white dots, red spiracles, and a red-tinged 'horn' at tail end; head is rather angular-looking. Feeds mainly on limes. **STATUS** Common only in S England, becoming scarce further N.

Eyed Hawk-moth *Smerinthus ocellatus* Wingspan 80mm

Intriguing moth that has startling markings on hindwings; these are exposed only when moth is disturbed. At rest, forewings afford moth good camouflage among leaves. **ADULT** has marbled grey-brown forewings that obscure hindwings at rest; when alarmed, moth arches its body and wings to expose striking eye-spots on hindwings. Flies May–Aug in 2 broods. **LARVA** is bright green with a pale diagonal stripe on each segment and a 'horn' at tail end. Feeds on willows and apple. **STATUS** Common only in S England.

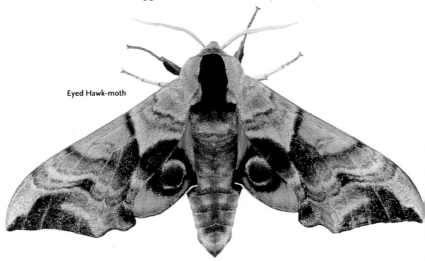

Eyed Hawk-moth

Poplar Hawk-moth *Laothoe populae* Wingspan 70mm

Rests by day among leaves, and easy to overlook because of camouflage afforded by wing patterns and colours. **ADULT** has grey-brown forewings with a darker central band

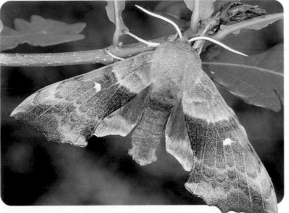

containing a white crescent mark. At rest, hindwings project slightly in front of forewings but reddish mark on hindwing is obscured; this is exposed if moth becomes alarmed. Flies May–Aug in 2 broods. **LARVA** is bright green with a pale diagonal stripe on each segment and a 'horn' at tail end. Feeds on poplars and willows. **STATUS** Common and widespread.

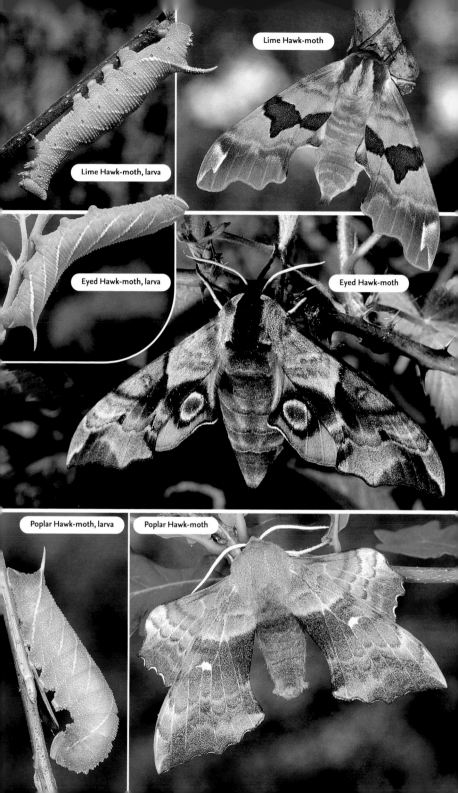

Lime Hawk-moth

Lime Hawk-moth, larva

Eyed Hawk-moth, larva

Eyed Hawk-moth

Poplar Hawk-moth, larva

Poplar Hawk-moth

Privet Hawk-moth *Sphinx ligustri* Wingspan 100mm

Large, impressive moth. Sometimes rests with wings spread, but more typically holds wings in a tent-like manner over body when resting on a tree branch. **ADULT** is well camouflaged when resting with wings covering body. However, if alarmed it exposes pink-striped abdomen and pale pink stripes on hindwing. Flies Jun–Jul. **LARVA** is bright green with purple and white diagonal stripes and a dark-tipped 'horn' at tail end. Head is ringed black. Feeds on privets and Lilac. **STATUS** Widespread and common in central and S Britain.

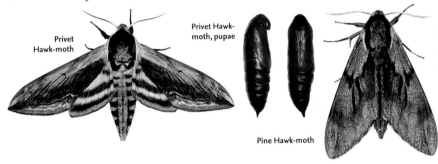

Privet Hawk-moth

Privet Hawk-moth, pupae

Pine Hawk-moth

Pine Hawk-moth *Hyloicus pinastri* Wingspan 80mm

Wing markings and colour create superb camouflage when resting on pine bark. Extremely easy to overlook. **ADULT** has grey-brown forewings with darker streaks and dots. Buffish-orange hindwings are seldom seen at rest but occasionally exposed when moth is alarmed. Flies Jun–Jul. **LARVA** is green with diagonal stripes and a dark 'horn' at tail end. Feeds on conifer needles. **STATUS** Locally common only in S England.

Hummingbird Hawk-moth *Macroglossum stellatarum* Wingspan 45mm

Day-flying species that hovers with an audible hum and collects nectar using long tongue. **ADULT** has brown forewings and an orange patch on hindwings; note the white on sides of abdomen. Flies May–Oct. **LARVA** is pale green with a longitudinal white line, white spots and a relatively small bluish 'horn' at tail end. Feeds on bedstraws. Occasionally seen in Britain, mostly in the S and only in invasion years. **STATUS** Migrant visitor from mainland Europe during the summer months, in variable numbers; in some years it is common in coastal areas.

Elephant Hawk-moth *Dielephila elpenor* Wingspan 70mm

Beautiful moth that visits garden flowers such as Honeysuckle and is sometimes seen feeding at dusk. **ADULT** has pink and olive-green wings and body. Flies May–Jun. **LARVA** is brown or green; head end fancifully resembles an elephant's trunk and eye-spots deter would-be predators. Feeds on willowherbs. **STATUS** Common only in S and central Britain.

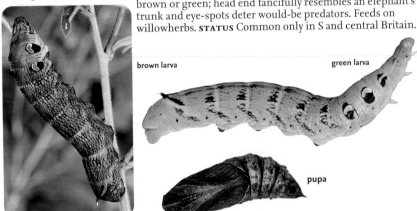

brown larva

green larva

pupa

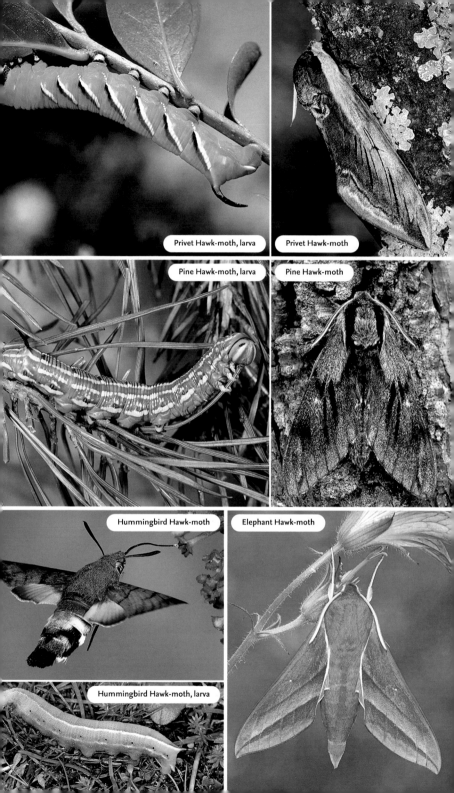

Privet Hawk-moth, larva

Privet Hawk-moth

Pine Hawk-moth, larva

Pine Hawk-moth

Hummingbird Hawk-moth

Elephant Hawk-moth

Hummingbird Hawk-moth, larva

ABOVE: **Buff-tip, larva**
BELOW: **Puss Moth, larva**

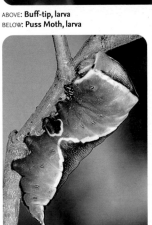

Buff-tip *Phalera bucephala* Length 30mm
Intriguingly marked moth. Rests with wings partly rolled around body, creating an almost cylindrical appearance. ADULT has a buff head and silvery-grey wings with buff tips, giving resting moth the appearance of a broken twig. Flies May–Jul. LARVA is yellow and black, with bristly hairs. Feeds on deciduous trees, including oaks and limes. STATUS Widespread and common.

Puss Moth *Cerura vinula* Length 35mm
Attractive, furry-looking moth. Rests with wings held in a tent-like manner over body. ADULT has pale grey and white wings with darker veins, and dark lines between veins. Abdomen and front legs are particularly hairy. Flies May–Jul. LARVA is squat and green, with a bulbous head and 2 whip-like tail appendages. Feeds on willows and poplars. STATUS Widespread and common.

Sallow Kitten *Furcula furcula* Length 20mm
Charming little moth that recalls a tiny Puss Moth (above). Rests with wings held in a tent-like manner over body. ADULT has an orange-bordered grey band across otherwise white forewing; outer edge of grey band is scalloped. Veins are marked with dark lines. Flies May–Aug in 2 broods. LARVA resembles a miniature Puss Moth larva; also has 2 tail appendages. Feeds mainly on sallows. STATUS Widespread and common.

Poplar Kitten *Furcula bifida* Length 23mm
Similar to, but marginally larger than, Sallow Kitten (above). Rests with wings held in a tent-like manner over body. ADULT has a grey central band and a grey patch near tip of otherwise whitish forewing; outer edge of central band is smoothly curved. Veins are marked with dark lines. Flies Jun–Jul. LARVA resembles a small Puss Moth larva (above); also has 2 tail appendages. Feeds on Aspen and poplars. STATUS Widespread and common.

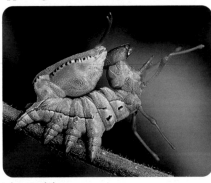

Lobster Moth, larva

Lobster Moth *Stauropus fagi* Length 32mm
Named after its bizarre-looking larva, which is fancifully Lobster-like. ADULT has reddish-grey wings, usually with a pinkish flush; well camouflaged on tree bark, the furry margins to hindwing and legs minimising shadows. Flies May–Jul. LARVA feeds on Beech, oaks and Hazel. STATUS Locally common only in the S.

Iron Prominent
Notodonta dromedarius Length 23mm
Richly coloured moth that rests with wings held in a tent-like manner over body. ADULT has smoky-brown forewings marked with rusty brown and yellow; markings provide good camouflage when resting on tree bark and twigs. Flies May–Aug in 2 broods. LARVA feeds on birches, oaks, Alder and Hazel. STATUS Widespread and locally common.

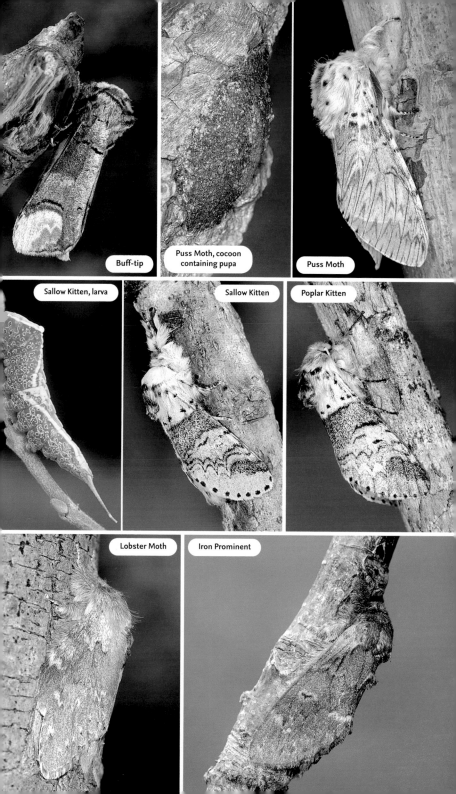

Buff-tip

Puss Moth, cocoon containing pupa

Puss Moth

Sallow Kitten, larva

Sallow Kitten

Poplar Kitten

Lobster Moth

Iron Prominent

Pebble Prominent *Eligmodonta ziczac* Length 25mm

Distinctive moth that rests with wings held in a tent-like manner over body. **ADULT** has buffish-brown forewings with a grey-brown fingernail-like mark near tip and white patch on leading edge. Flies May–Jun, sometimes Aug as a 2nd brood. **LARVA** feeds on willows and Aspen. **STATUS** Widespread and locally common.

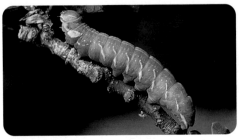

Great Prominent, larva

Great Prominent *Peridea anceps* Length 30mm

Superbly camouflaged moth when resting on oak bark. Rests with wings held in a tent-like manner over body. **ADULT** has marbled brown and grey-brown wings, and hairy legs. Flies May–Jul. **LARVA** is green with diagonal stripes on each segment; feeds on oaks. **STATUS** Widespread and locally common, but only if mature oaks are found nearby.

Lesser Swallow Prominent *Pheosia gnoma* Length 27mm

Well-marked moth that rests with wings held in a tent-like manner over body. **ADULT** has pale grey-buff wings with dark stripes; note the distinct white wedge on outer margin of forewing, which allows separation from similar Swallow Prominent (below). Flies May–Jun and Aug as 2 broods. **LARVA** feeds on birches. **STATUS** Widespread and common.

Swallow Prominent *Pheosia tremula* Length 30mm

Attractive moth that rests with wings held in a tent-like manner over body. **ADULT** has grey-buff and brown wings; distinguished from Lesser Swallow Prominent (above) by the 2 or 3 narrow white stripes running in from outer margin; flies Apr–Aug in 2 broods. **LARVA** feeds on willows and poplars. **STATUS** Widespread and common.

Coxcomb Prominent *Ptilodon capucina* Length 20–22mm

Distinctive little moth. Rests with wings held in a tight tent-like manner over body. Seen in profile, note the coxcomb-like tuft at head end. **ADULT** has brown or reddish-brown forewings with a scalloped outer edge. Coxcomb tuft is paler than rest of body and wings. Flies Apr–May and Aug–Sep in 2 broods. **LARVA** feeds on deciduous trees and shrubs. **STATUS** Widespread and common.

Pale Prominent *Pterostoma palpina* Length 30mm

Well-camouflaged moth that resembles a pale piece of woodchip. **ADULT** has greyish-brown wings; in profile, has prominences along back, palps that project at head end, and tufted tip to abdomen that protrudes beyond wings. Flies May–Aug. **LARVA** feeds on sallows and Aspen. **STATUS** Widespread and fairly common.

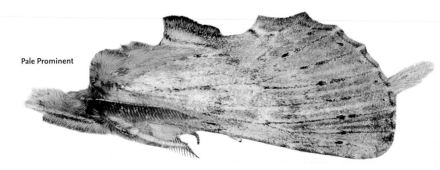

Pale Prominent

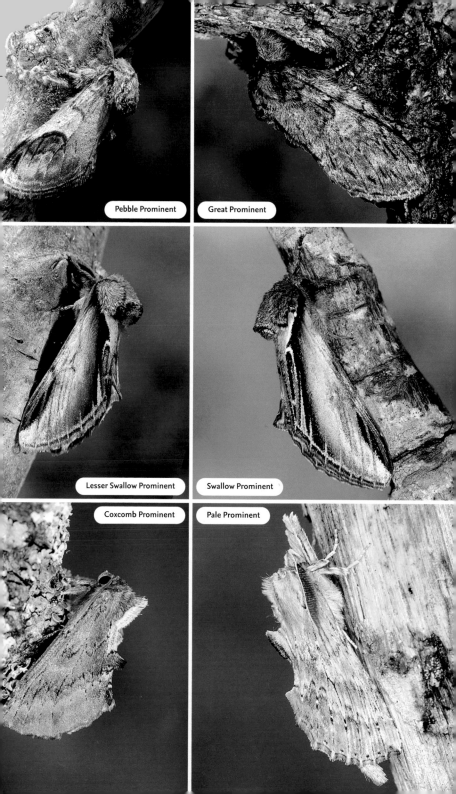

Pebble Prominent

Great Prominent

Lesser Swallow Prominent

Swallow Prominent

Coxcomb Prominent

Pale Prominent

Lunar Marbled Brown *Drymonia ruficornis* Length 22–24mm
Furry-looking moth that rests with wings held in a tent-like manner over body. **ADULT** has brown wings with a white cross-band and white zigzag line. Note the dark crescent-shaped marking in cross-band. Flies Apr–May. **LARVA** feeds on oaks. **STATUS** Widespread and common.

Chocolate-tip *Clostera curtula* Length 17mm
Beautifully marked moth that rests with wings folded in a tight tent-like manner around body. **ADULT** has grey-brown forewings with dark-edged white cross-lines and a chocolate-maroon tip; when alarmed, exposes brown-tipped abdomen. Flies May–Sep in 2 or more broods and comes to light. **LARVA** feeds on Aspen, poplars and willows. **STATUS** Widespread but local.

Figure of Eight *Diloba caeruleocephala* Length 20–22mm
Well-marked autumn species that rests with wings held in a tent-like manner over body. **ADULT** has marbled brown forewings with a white marking that resembles the figure 8. Flies Oct–Nov. **LARVA** feeds on hawthorns, Blackthorn and apples. **STATUS** Widespread and fairly common.

LEFT: **The Vapourer, larva**
ABOVE: **The Vapourer, cocoon**

The Vapourer
Orgyia antiqua Length 16mm
The sexes are dissimilar and only the male has wings; flies mainly in the daytime and sometimes at night. The virtually wingless, slightly downy female is sometimes seen near clusters of eggs laid on tree bark. **ADULT** male has chestnut forewings with a white spot on trailing edge; flies Jul–Sep. **LARVA** has tufts of yellow and black hairs; feeds on deciduous trees. **STATUS** Widespread and common.

Yellow-tail *Euproctis similis*
Length 24mm
A moth to be treated with caution, since both adult and larval hairs cause irritation if handled or inhaled. Wings are usually held folded tightly against body at rest. **ADULT** has white wings and exposes yellow-tipped abdomen when alarmed. Flies Jun–Aug. **LARVA** is hairy with black and red markings; feeds on deciduous shrubs. **STATUS** Widespread and locally common.

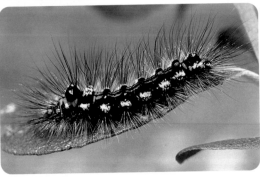
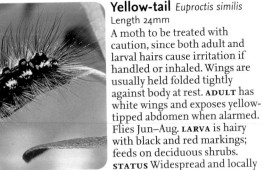

Yellow-tail, larva

Buff Ermine *Spilosoma luteum* Length 28mm
Distinctive moth that rests with wings held in a tent-like manner over body. **ADULT** is pale yellow-buff with variable black spots, many of these aligned in an oblique row. Flies May–Jul. **LARVA** is covered in reddish hairs; feeds on a wide range of herbaceous plants and deciduous trees. **STATUS** Widespread and common.

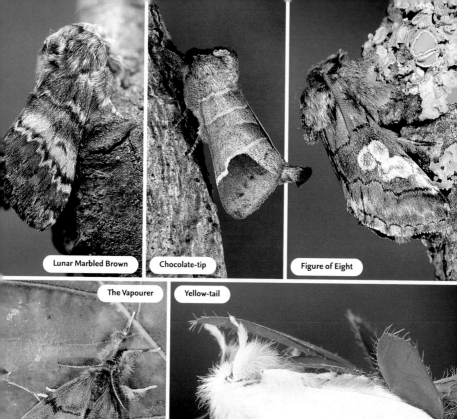

Lunar Marbled Brown

Chocolate-tip

Figure of Eight

The Vapourer

Yellow-tail

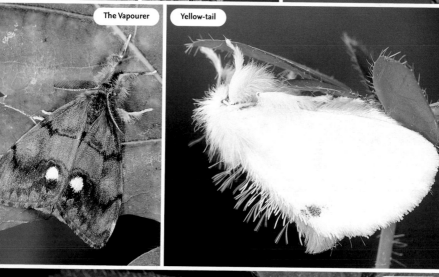

Buff Ermine

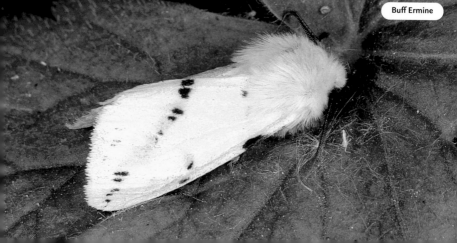

White Ermine *Spilosoma lubricipeda* Length 28mm

A most attractive moth. Its striking white colour means it is fairly frequently discovered resting in the daytime with its wings folded in a tent-like manner over body. **ADULT** has white wings with numerous small black spots; yellow and black abdomen is hidden by wings at rest. Flies May–Jul. **LARVA** feeds on a range of herbaceous plants. **STATUS** Widespread and common.

Muslin Moth *Diaphora mendica* Length 23mm

Adults show a distinct difference between the sexes. Night-flying male comes to light but females are often diurnal. **ADULT** female is superficially similar to White Ermine (above), but wings are translucent and muslin-like, and adorned with very few black spots; males are reddish buff with a few black spots. Flies May–Jun. **LARVA** feeds on low-growing herbaceous plants. **STATUS** Widespread and fairly common.

Rosy Footman *Miltochrista miniata* Length 14mm

Rosy Footman

Attractive little moth that is sometimes discovered in the daytime. Rests with wings spread flat, pressed close to the surface on which it is clinging. **ADULT** has rosy-orange forewings bearing black spots and squiggly lines. Flies Jun–Aug. **LARVA** feeds on lichens growing on tree bark. **STATUS** Common only in S England and Wales.

Dingy Footman *Eilema griseola* Length 32–38mm

Distinctive moth that rests with its rather narrow wings held flat, the forewings overlapping one another. **ADULT** usually has dingy grey forewings with a yellow leading edge; a form with uniformly yellow-buff forewings also occurs. Legs are strikingly black. Flies Jul–Aug. **LARVA** feeds on lichens. **STATUS** Common only in S and central England and Wales.

Scarce Footman *Eilema complana* Length 18–20mm

Well-marked moth that holds its wings in a distinctive manner at rest: they are rolled tightly around body, creating a rather tubular appearance. **ADULT** has grey forewings and thorax, and an orange-yellow head, legs and margin to forewings. **LARVA** feeds on lichens. **STATUS** Widespread and, despite its name, fairly common in S England and Wales.

Common Footman *Eilema lurideola* Length 25mm

Has similar wing colours and markings to Scarce Footman (above), but rests with wings held flat and forewings overlapping one another. **ADULT** has mainly grey forewings with a yellow leading edge; hindwings are yellow. Flies Jul–Aug. **LARVA** feeds on lichens growing on bark of trees and shrubs. **STATUS** Widespread and locally common.

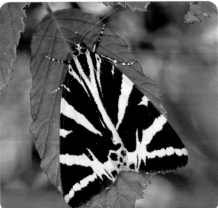

Jersey Tiger *Euplagia quadripunctaria* Length 35–38mm

Well-marked moth that rests with its wings spread flat, forewings concealing hindwings. Flies by day as well as at night. **ADULT** has blackish forewings with bold creamy-white stripes; hindwings (revealed when moth is agitated) are red with black spots. Flies Jul–Sep. **LARVA** feeds on various herbaceous plants. **STATUS** Common in S Devon; also occurs in other southern counties.

Jersey Tiger

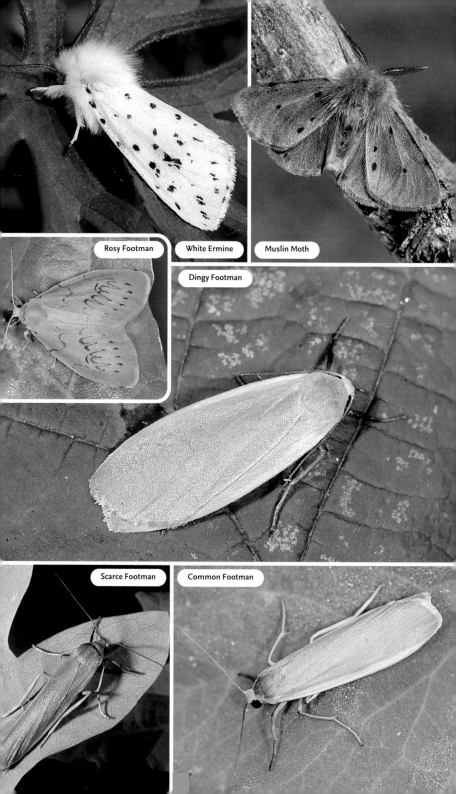

Rosy Footman White Ermine Muslin Moth

Dingy Footman

Scarce Footman Common Footman

Garden Tiger

Arctia caja Wingspan 50–65mm

A once-familiar garden moth that has declined markedly in recent years. Rests with wings spread flat, forewings covering hindwings unless disturbed. **ADULT** has brown and white forewings with variable patterns; the dark-spotted orange hindwings are usually concealed, but revealed (presumably as a shock tactic) when moth is alarmed. Flies Jul–Aug. **LARVA** is hairy and feeds on a wide range of herbaceous plants. **STATUS** Widespread, but a scarce garden species these days.

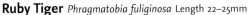

Garden Tiger

Ruby Tiger

Phragmatobia fuliginosa Length 22–25mm

Colourful moth that rests with its wings held in a tent-like manner over body, concealing both its hindwings and colourful abdomen. **ADULT** has reddish forewings; individuals from S of the range are more colourful than their N counterparts. Hindwings are pink or grey. Flies May–Jun. **LARVA** feeds on a range of herbaceous plants. **STATUS** Widespread and common.

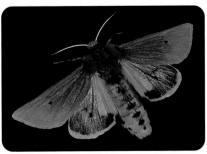

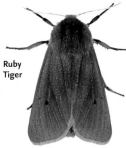

Ruby Tiger

Pale Tussock

Calliteara pudibunda Length 27–30mm

Attractive moth with a hairy abdomen and front legs. Rests with wings held in a shallow tent-like manner over body. **ADULT** has grey or greyish-buff wings, subtly marked with darker lines. Flies May–Jun. **LARVA** is yellow and black and hairy; feeds on birches, oaks, limes and other deciduous trees. **STATUS** Widespread and locally common in S Britain.

Black Arches

Lymantria monacha Length 20–24mm

Beautifully patterned and distinctive moth that rests with its wings spread flat. **ADULT** has white forewings that are boldly patterned with black wavy lines. Flies Jul–Aug. **LARVA** feeds mainly on oaks. **STATUS** Widespread and common.

The Cinnabar

Tyria jacobaeae Length 20–25mm

Well-marked moth whose colours warn potential predators of its distasteful nature. Flies at night but often disturbed from vegetation in daytime. Rests with wings folded or flat. **ADULT** has sooty-black forewings with red stripes and spots. **LARVA** is striped orange and black, and feeds on ragworts. **STATUS** Widespread and common.

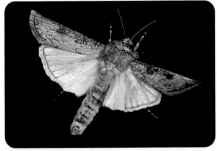

Turnip Moth

Agrotis segetum Length 20–25mm

Variable moth that usually rests with wings held flat, forewings overlapping one another. **ADULT** has brown forewings, usually dark enough to contrast with pale fringe on outer margin; pattern of dark cross-lines, eye-spot-like mark and darkish kidney-shaped mark are distinct. Hindwings are whitish. Flies May–Jun and Aug–Sep, in 2 broods. **LARVA** feeds on herbaceous plants. **STATUS** Widespread and common.

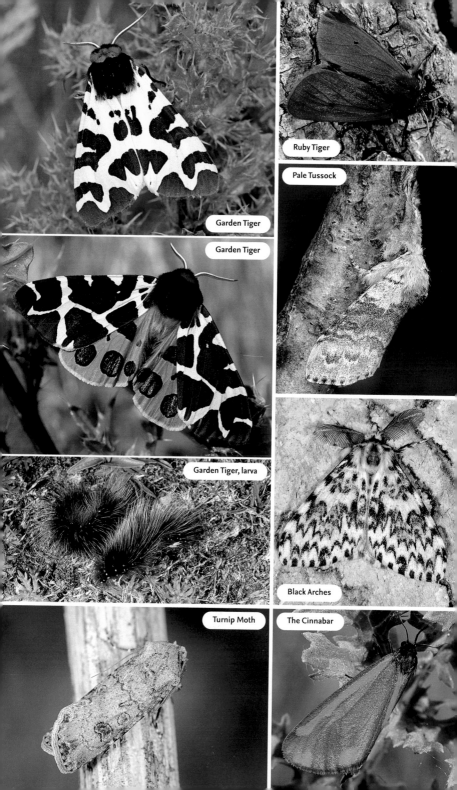

Garden Tiger

Garden Tiger

Garden Tiger, larva

Turnip Moth

Ruby Tiger

Pale Tussock

Black Arches

The Cinnabar

Large Yellow Underwing

Lesser Broad-bordered Yellow Underwing

Lesser Yellow Underwing, Scilly Isles

Lesser Yellow Underwing

Broad-bordered Yellow Underwing, male

Large Yellow Underwing *Noctua pronuba*
Length 25mm

Familiar garden moth. Very flighty and often disturbed from vegetation in daytime. Rests with wings held flat, one forewing overlapping the other. **ADULT** has marbled brown forewings and yellow hindwings that have only a narrow sub-terminal black border. Flies Jun–Sep. **LARVA** eats almost any herbaceous plant. **STATUS** Widespread and extremely common.

Lesser Broad-bordered Yellow Underwing
Noctua janthe Length 20–23mm

Richly marked moth that rests with wings held flat, one forewing overlapping the other. **ADULT** has reddish-brown forewings with subtle purplish-grey banding and a reddish margin to outer leading edge. Note the moth's neatly defined pale front end. Flies Jul–Sep. **LARVA** feeds on a range of herbaceous plants. **STATUS** Widespread, commonest in S Britain.

Lesser Yellow Underwing *Noctua comes*
Length 23–25mm

Forewing markings and colours are variable, but those on hindwings are fairly uniform. Rests with wings held flat, one forewing overlapping the other. **ADULT** has variably buffish-brown forewings, usually with 2 dark spots and faint, pale cross-lines; in some forms (e.g. from the Scilly Isles) the dark lines and spots are extremely bold. Hindwings of all forms are yellow with a narrow black sub-terminal band and dark crescent mark. **LARVA** feeds on a range of herbaceous plants. **STATUS** Widespread and common.

Broad-bordered Yellow Underwing
Noctua fimbriata Length 25mm

Easily disturbed, and needs little encouragement to fly even in daytime. Wings are held flat at rest, one forewing overlapping the other. **ADULT** has forewings that are pale buff in female, richer brown in male; both show a darker brown cross-band and dark mark near tip of leading edge. Hindwings are yellow with a broad black sub-terminal band. Flies Jul–Sep. **LARVA** eats a wide range of herbaceous plants. **STATUS** Widespread and common.

Least Yellow Underwing *Noctua interjecta*
Length 18–20mm

Smallest of the commonly encountered garden yellow underwings. Rests with wings held flat, one forewing overlapping the other. **ADULT** has rich brown forewings with darker lines and narrow bands. Hindwings are yellow with a broad black sub-terminal band and small, dark spot. Flies Jul–Aug. **LARVA** feeds on a range of herbaceous plants. **STATUS** Widespread and fairly common in S Britain.

Broad-bordered Yellow Underwing, underside

Large Yellow Underwing

Large Yellow Underwing

Lesser Broad-bordered Yellow Underwing

Lesser Broad-bordered Yellow Underwing

Lesser Yellow Underwing

Broad-bordered Yellow Underwing

Least Yellow Underwing

Broad-bordered Yellow Underwing

Least Yellow Underwing

Heart and Club *Agrotis clavis* Length 19–22mm

Variably marked moth that rests with wings held flat, one forewing overlapping the other; wings look parallel-sided at rest. **ADULT** usually has buffish-brown to grey-brown forewings marked with a heart-shaped mark, a dark line and a dark spot. Flies Jun–Jul. **LARVA** feeds on a range of low-growing herbaceous plants. **STATUS** Widespread, but common only in S England.

Heart and Dart

Agrotis exclamationis Length 20mm

Well-marked moth whose name derives from its forewing markings. Rests with wings held flat, one forewing overlapping the other. **ADULT** has brown wings with variable dark markings that always include a dark heart-shaped patch and line. Flies May–Jul. **LARVA** eats a wide range of herbaceous plants. **STATUS** Widespread and extremely common.

Heart and Dart

The Flame *Axylia putris*

Length 16–18mm

Wings are sometimes held flat at rest, but often wrapped around the body so that the moth resembles a broken twig. **ADULT** has mottled and speckled, pale buff forewings, marked with a dark spot. Note the dark thorax and pale front of head. Flies Jun–Jul. **LARVA** feeds on low-growing herbaceous plants. **STATUS** Widespread, but common only in central and S Britain.

Dark Sword-grass *Agrotis ipsilon* Length 25mm

Has elongated wings and rests with one forewing overlapping the other. **ADULT** has variably brown forewings with a pale band, and a dark kidney-shaped mark defined by a pale line; dart is dark. Flies May–Nov. **LARVA** feeds on low-growing herbaceous plants. **STATUS** A migrant to Britain from mainland Europe; common in some years and most numerous in S and E Britain.

Autumnal Rustic *Eugnorisma glareosa* Length 18–20mm

Well-marked moth with a variable ground colour to forewings. Rests with wings spread flat, one forewing overlapping the other. **ADULT** usually has grey-buff to grey-brown wings (sometimes much darker) with 3 sets of well-defined black spots. Flies Aug–Sep. **LARVA** feeds on a wide range of plants. **STATUS** Widespread and locally common.

Setaceous Hebrew Character *Xestia c-nigrum* Length 18–20mm

Distinctive moth whose wings are held flat at rest, one forewing overlapping the other. Overall, wings usually look rather parallel-sided. **ADULT** has brown wings with a distinct abutting pale triangle and black mark that bears a passing resemblance to the Hebrew letter 'nun'. Flies May–Aug in 2 broods in the S; single-brooded further N. **LARVA** feeds on a range of herbaceous plants. **STATUS** Widespread and common.

Red Chestnut *Cerastis rubricosa* Length 20–23mm

Colourful, spring-flying moth that rests with its wings flat, one forewing sometimes slightly overlapping the other. **ADULT** has rich maroon-red head, thorax and forewings, the latter with dark and pale spots along leading edge. Flies Mar–Apr. **LARVA** feeds on low-growing herbaceous plants. **STATUS** Widespread and locally fairly common.

Red Chestnut

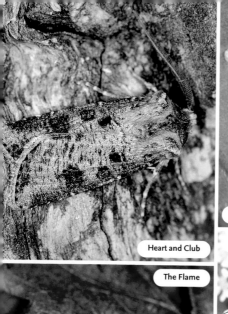

Heart and Club

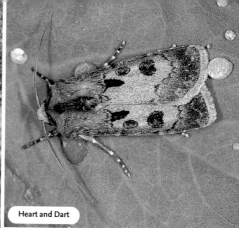

Heart and Dart

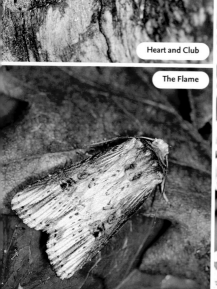

The Flame

Dark Sword-grass

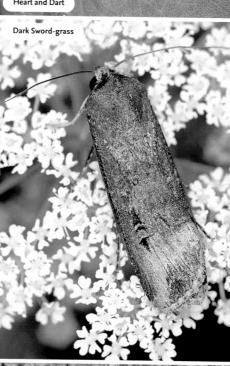

Autumnal Rustic

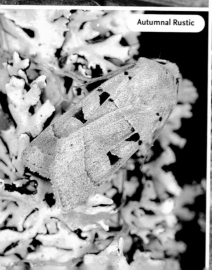

Setaceous Hebrew Character

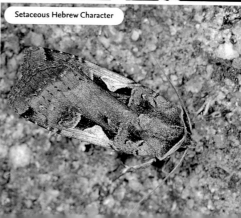

Double Square-spot

Xestia triangulum Length 21–23mm
Recalls Setaceous Hebrew Character (p. 196), but wings are broader and dark spots are usually distinctly square-shaped and separate. Wings are held flat at rest. **ADULT** has brown forewings with 2 blackish square spots and a small blackish wedge near tip of leading edge. Flies Jun–Jul. **LARVA** feeds on deciduous trees and shrubs. **STATUS** Widespread and fairly common.

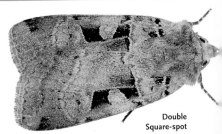

Double Square-spot

Dotted Clay *Xestia baja* Length 20mm

Rather plain-looking moth. Wings are held flat at rest, the forewings slightly overlapping one another. **ADULT** has reddish-brown to buffish-brown forewings with 2 black dots near tip of leading edge; additional black dots are also present in some individuals. Flies Jul–Aug. **LARVA** feeds on a range of deciduous plants. **STATUS** Widespread and common.

Dotted Clay

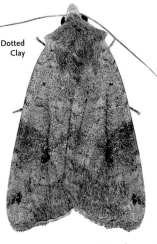

Six-striped Rustic *Xestia sexstrigata* Length 20–22mm

Well-marked and subtly attractive moth. Wings are held flat at rest, the forewings slightly overlapping one another. **ADULT** has reddish-buff wings with a network of dark lines and narrow cross-bands. Flies Jul–Aug. **LARVA** feeds on a range of herbaceous plants. **STATUS** Widespread and fairly common.

Square-spot Rustic *Xestia xanthographa*

Length 17–19mm
Wings are held flat at rest, the forewings slightly overlapping one another. **ADULT** has forewings with a variable ground colour, ranging from grey-brown to reddish brown. Forewing markings are fairly constant, comprising a squarish pale spot and a pale oval with a darker area between them. Flies Aug–Sep. **LARVA** feeds on low-growing plants. **STATUS** Widespread and common.

The Gothic *Naenia typica* Length 22–24mm

Beautifully patterned moth whose wings are spread flat at rest. **ADULT** has grey-brown forewings marked with a network of white lines and white-framed oval patches. Flies Jun–Jul. **LARVA** feeds on a wide range of plants, including many garden species. **STATUS** Widespread and common.

The Nutmeg *Dicestra trifolii* Length 17–19mm

Well-patterned and subtly attractive moth. Wings are spread flat at rest. **ADULT** has marbled grey-brown forewings, with a jagged white line near outer margin and a dark central spot. Flies May–Aug, sometimes as 2 broods. **LARVA** feeds on herbaceous plants, particularly members of the goosefoot family. **STATUS** Widespread, but common only in S England.

Flame Shoulder

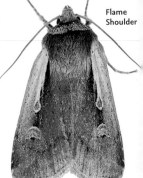

Flame Shoulder *Ochropleura plecta* Length 15–18mm

Well-marked moth that rests with wings spread flat, one forewing slightly overlapping the other. **ADULT** has reddish-brown wings overall; forewings have lengthways white and dark streaks and pale round and kidney-shaped marks. **LARVA** feeds on plantains, docks and other low-growing plants. **STATUS** Widespread and common.

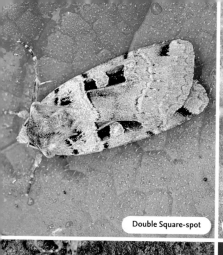

Double Square-spot

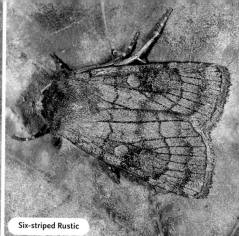

Six-striped Rustic

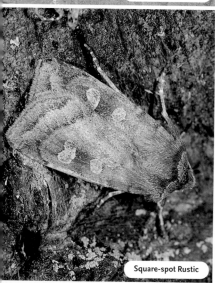

Square-spot Rustic

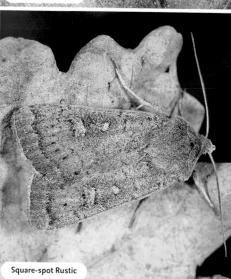

Square-spot Rustic

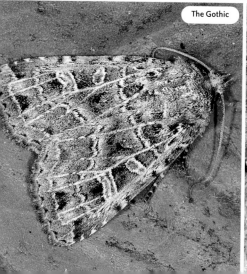

The Gothic

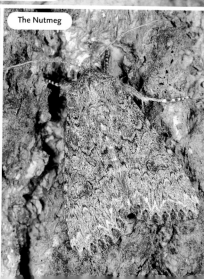

The Nutmeg

Grey Arches *Polia nebulosa* Length 24–26mm

Attractive moth whose wings are held in a tent-like manner over body at rest. **ADULT** usually has grey forewings, although pale brown and dark brown forms also occur. Has a pale central spot and kidney mark near middle of wing, and jagged black marks near outer margin. Flies Jun–Jul. **LARVA** feeds on deciduous trees and shrubs, and Bramble and Honeysuckle. **STATUS** Widespread, but commonest in the S.

Cabbage Moth *Mamestra brassicae* Length 22–24mm

Well-marked but variable moth whose wings are held spread when resting on a flat surface, or in a shallow tent-like manner if resting on a twig. **ADULT** has marbled brown forewings with a white-ringed kidney mark and jagged whitish line towards outer margin. Flies May–Sep in several broods. **LARVA** feeds on cabbages and related plants. **STATUS** Widespread and common.

Dot Moth *Melanchra persicariae* Length 18–20mm

Distinctive moth. Wings are held flat or in a shallow tent-like manner at rest. **ADULT** has blackish forewings with deep blue and brown marbling, and a striking white kidney spot. Flies Jul–Aug. **LARVA** feeds on a wide range of herbaceous plants, including many garden species. **STATUS** Widespread and very common in S and central Britain; scarce elsewhere.

Bright-line Brown-eye *Lacanobia oleracea* Length 19–21mm

Well-marked moth with an aptly descriptive name. Rests with wings held flat. **ADULT** has rich brown forewings marked with a striking white line towards outer margin, indented to form the letter 'W' along its length. Note also the orange-yellow kidney mark and white-ringed circle. Flies May–Jul. **LARVA** feeds on goosefoots and related plants. **STATUS** Widespread and common.

Marbled Coronet *Hadena confusa* Length 17–19mm

Beautifully patterned moth whose wings are held flat when resting on a flat surface. **ADULT** has marbled forewings of varying colour; typical form is grey, black and brown overall, with a white head and 'shoulders', white spots midway along leading edge and a white spot at tip. Flies May–Jun. **LARVA** feeds on Bladder Campion *Silene vulgaris* and related members of the pink family. **STATUS** Widespread but only locally common.

The Lychnis *Hadena bicruris* Length 16–18mm

Attractive little moth that typically rests with wings held flat. **ADULT** has marbled, dark brown forewings overall, with broad cross-bands forming the letter 'Y', outlined in white, and a white line towards outer margin. Flies Jun–Jul. **LARVA** feeds on seedpods of Red Campion and related plants. **STATUS** Widespread and fairly common.

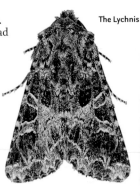

The Lychnis

Powdered Quaker *Orthosia gracilis* Length 19–21mm

Distinctive moth whose wings have a powdery texture. Wings are held in a tent-like manner at rest. **ADULT** has pale grey-buff forewings, stippled with dark dots and with rounded and kidney-shaped dark patches; has row of dark dots alongside submarginal dark band. Flies Apr–May. **LARVA** feeds on sallows. **STATUS** Widespread and common.

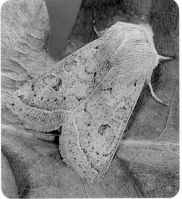

Powdered Quaker

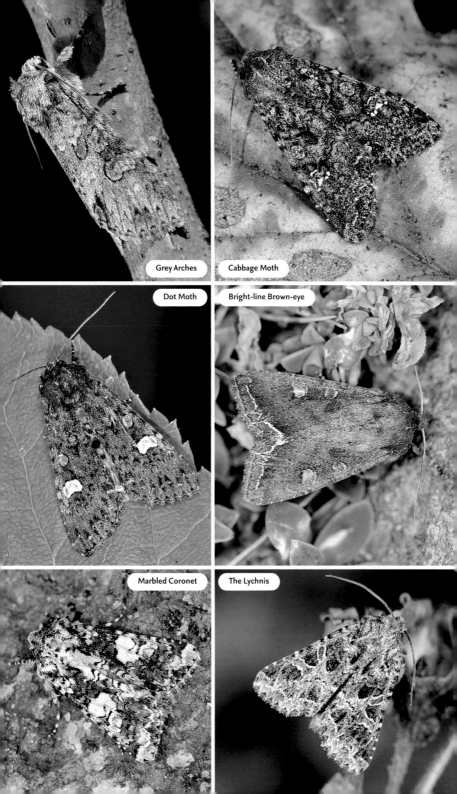

Grey Arches

Cabbage Moth

Dot Moth

Bright-line Brown-eye

Marbled Coronet

The Lychnis

Feathered Gothic *Tholera decimalis*
Length 19–21mm
Well-marked moth. Superficially similar to The Gothic (p. 198) but separable by studying markings and noting male's feathery antennae; also flies later in the year. **ADULT** has grey-brown forewings marked with a network of white lines, mostly along veins. Flies Aug–Sep. **LARVA** feeds on grasses. **STATUS** Widespread but only locally common.

Feathered
Gothic

Pine Beauty *Panolis flammea* Length 16–18mm
Highly attractive and well-marked moth. Usually rests with wings folded in a tight tent-like manner over body. **ADULT** has orange-brown forewings marbled with darker patches, and 2 striking pale spots midway along leading edge. Flies Mar–Apr. **LARVA** feeds on needles of Scots Pine and related trees. **STATUS** Widespread and locally common.

Small Quaker *Orthosia cruda* Length 15–19mm
Plain-looking moth that rests with wings held in a tent-like manner over body. Adults feed on sallow blossoms. **ADULT** has grey-buff to reddish-buff wings speckled with small dots and showing a dark kidney spot. Flies Mar–Apr. **LARVA** feeds on deciduous trees, including willows and oaks. **STATUS** Widespread and fairly common.

Common Quaker *Orthosia cerasi* Length 18–20mm
Variable moth that rests with its wings held flat. **ADULT** has forewings whose colour ranges from grey-buff and buffish brown to dark brown. Typical forms are fairly pale and plain, showing a pale cross-line towards outer margin, and pale-ringed kidney and circular spots. Flies Mar–Apr. **LARVA** feeds on deciduous trees, including oaks and willows. **STATUS** Widespread and common. Sometimes the commonest spring moth to be caught at light traps.

Clouded Drab *Orthosia incerta* Length 21–23mm
This moth's uninspiring name belies the subtle beauty of many of its variable forms. Rests with wings held flat, often with one forewing overlapping the other. **ADULT** of typical forms has grey-buff to reddish-buff forewings, subtly and intricately patterned towards head end, and with a dark central patch and 2 dark spots towards outer margin. **LARVA** feeds on oaks and other deciduous trees. **STATUS** Widespread and common.

Hebrew Character *Orthosia gothica* Length 20mm
Familiar springtime moth. Usually rests with wings spread flat or in a shallow tent-like manner. **ADULT** has marbled brown and grey forewings with a dark mark that looks like a semicircular section has been removed by a hole-punch; this recalls the Hebrew letter 'nun'. Flies Mar–Apr. **LARVA** feeds on variety of herbaceous plants. **STATUS** Common and widespread.

Hebrew Character

Lead-coloured Drab

Lead-coloured Drab *Orthosia populeti* Length 19–21mm
Subtly attractive moth that rests with wings spread flat or in a shallow tent-like manner. Wingtips are more rounded than those of Clouded Drab. **ADULT** has lead-grey forewings, usually with reddish-maroon suffused band across wings and row of dark dots near margins. Flies Apr. **LARVA** feeds on Aspen. **STATUS** Widespread but local.

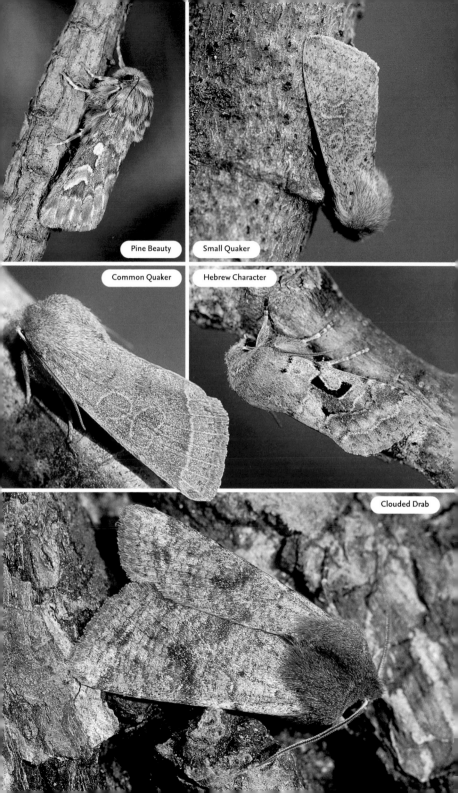

Pine Beauty

Small Quaker

Common Quaker

Hebrew Character

Clouded Drab

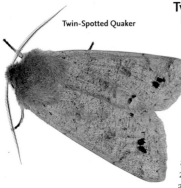

Twin-Spotted Quaker

Twin-spotted Quaker *Orthosia munda*
Length 22–24mm

Distinctive springtime moth that rests with wings held flat. **ADULT** has pale reddish-buff forewings, stippled with dark dots and with a pair of dark spots near outer margin. Flies Mar–Apr. **LARVA** feeds on oaks and sallows. **STATUS** Widespread and fairly common.

Brown-line Bright-eye *Mythimna conigera*
Length 19–21mm

Well-marked, distinctive moth that holds its wings spread flat or in a shallow tent-like manner at rest. **ADULT** has reddish-brown forewings with 2 dark cross-lines, and a whitish spot with 2 adjacent pale buff spots. Flies Jun–Jul. **LARVA** feeds on a range of grasses, notably Common Couch *Elytrigia repens*. **STATUS** Widespread and fairly common.

The Clay *Mythimna ferrago* Length 22–24mm
Superficially rather similar to Brown-line Bright-eye (above), but larger and overall plainer. Wings are held flat at rest. **ADULT** has reddish-buff forewings, subtly marked with a dotted cross-line and a rather indistinct pale spot. Flies Jul–Aug. **LARVA** feeds on a range of low-growing herbaceous plants. **STATUS** Widespread and fairly common.

Common Wainscot *Mythimna pallens* Length 20mm
Rather undistinguished moth that holds its wings in a shallow tent-like manner at rest. **ADULT** has straw-coloured forewings, the veins of which are white; white hindwings are usually hidden at rest. Flies Jun–Oct in 2 broods. **LARVA** feeds on various grass species. **STATUS** Widespread and locally common.

The Shark *Cucullia umbratica* Length 32mm
Unusually shaped moth that is sometimes found resting on frayed wooden surfaces in the daytime. Narrow, pointed wings are held in a tent-like manner at rest; note projection at head end. **ADULT** has grey-brown forewings with darker veins. Flies May–Jul. **LARVA** feeds on sow-thistles. **STATUS** Widespread, but commonest in the S.

The Mullein *Shargacucullia verbasci* Length 25–27mm
Distinctive moth. Narrow, pointed wings are usually held in a tight tent-like manner against body at rest. Note the 'Mohican' fringe when seen in profile, the overall effect created being that of a piece of snapped wood. **ADULT** has buffish-brown wings overall, with dark leading and trailing edges, and a lengthways whitish stripe. Flies Apr–May. **LARVA** is white with yellow bands and black spots. Feeds on mulleins, figworts and Butterfly-bush. **STATUS** Widespread, but commonest in the S.

The Sprawler *Asteroscopus sphinx* Length 22–24mm
Well-marked autumn and early winter species. Rests with wings held in a tent-like manner over body. **ADULT** has grey-buff wings overall with black lengthways streaks and a toothed-edge effect to outer margin. Flies Oct–Dec. **LARVA** feeds on deciduous trees. **STATUS** Widespread, but commonest in central and S Britain.

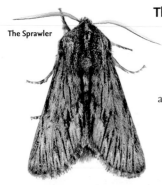

The Sprawler

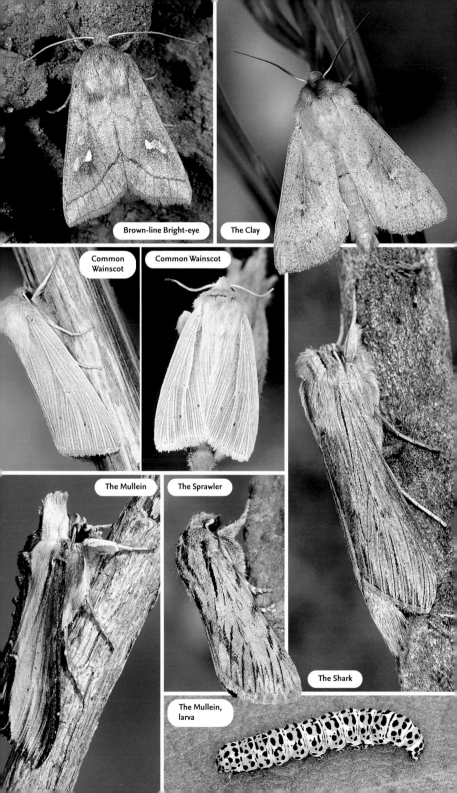

Brown-line Bright-eye

The Clay

Common Wainscot

Common Wainscot

The Mullein

The Sprawler

The Shark

The Mullein, larva

Deep-brown Dart

Aporophyla lutulenta Length 18–20mm

Rather uniform moth, but its deep, rich colour and absence of any striking markings are useful identification pointers. Wings are held in a shallow tent-like manner at rest. **ADULT** has marbled, dark grey-brown forewings, with a subtly darker central band. Flies Sep–Oct. **LARVA** feeds on a variety of shrubs and low-growing plants. **STATUS** Widespread and fairly common.

Deep-brown Dart

Black Rustic *Aporophyla nigra*

Length 22–24mm

Striking and distinctive moth that holds its wings in a shallow tent-like manner at rest. **ADULT** has marbled black to blackish-brown forewings with a central pale comma mark. Flies Aug–Oct. **LARVA** feeds on a range of low-growing plants, including docks and Heather *Calluna vulgaris*. **STATUS** Widespread and locally common.

Black
Rustic

Blair's Shoulder-knot

Lithophane leautieri Length 23–25mm

Elegant moth whose long, narrow, pointed wings are often held in a tent-like manner over body at rest. **ADULT** has pale grey wings overall, with lengthways dark streaks and a central salmon-pink spot bordered by 2 pale spots. Flies Oct–Nov. **LARVA** feeds on Lawson's and Leyland cypresses. **STATUS** A recent arrival to Britain, first recorded in 1951. Now fairly widespread and common.

Early Grey *Xylocampa areola* Length 17–19mm

Intricately marked spring moth. Usually rests with wings held in a tent-like manner over body. **ADULT** has grey forewings overall, with pale kidney-shaped patches, a dark central spot and dark streaks. Flies Mar–May. **LARVA** feeds on Honeysuckle. **STATUS** Widespread, but commonest in S Britain.

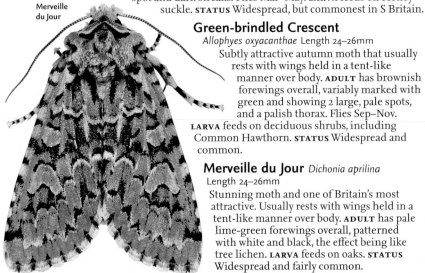

Merveille
du Jour

Green-brindled Crescent

Allophyes oxyacanthae Length 24–26mm

Subtly attractive autumn moth that usually rests with wings held in a tent-like manner over body. **ADULT** has brownish forewings overall, variably marked with green and showing 2 large, pale spots, and a palish thorax. Flies Sep–Nov. **LARVA** feeds on deciduous shrubs, including Common Hawthorn. **STATUS** Widespread and common.

Merveille du Jour *Dichonia aprilina*

Length 24–26mm

Stunning moth and one of Britain's most attractive. Usually rests with wings held in a tent-like manner over body. **ADULT** has pale lime-green forewings overall, patterned with white and black, the effect being like tree lichen. **LARVA** feeds on oaks. **STATUS** Widespread and fairly common.

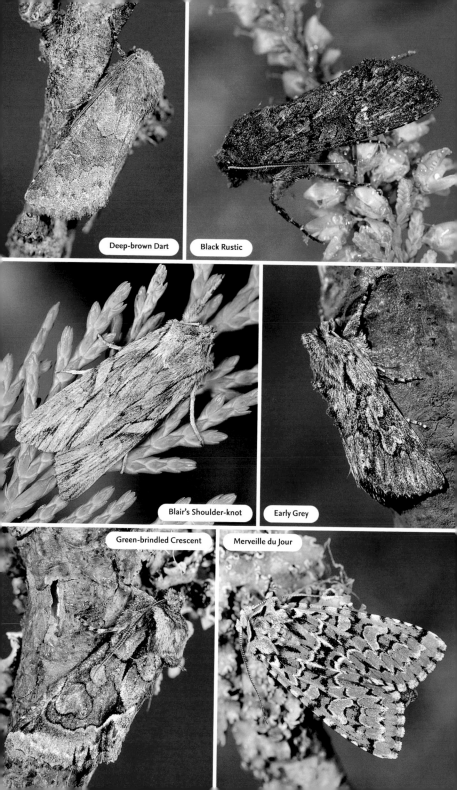

Deep-brown Dart

Black Rustic

Blair's Shoulder-knot

Early Grey

Green-brindled Crescent

Merveille du Jour

Brindled Green *Dryobotodes eremita* Length 16–18mm

Attractive moth that rests with its wings held in a shallow tent-like manner. **ADULT** has variably marbled green and brown forewings, with pale areas around middle of leading edge, and pale band near outer margin. Flies Aug–Sep. **LARVA** feeds on oaks. **STATUS** Widespread; commonest in S Britain.

Large Ranunculus *Polymixis flavicincta* Length 22–25mm

Subtly marked moth whose wings have a slightly dusty look. Wings are held in a flattish tent-like manner at rest. **ADULT** has pale grey-buff wings, marbled with yellowish brown and with a subtle, dark cross-band. Flies Sep–Oct. **LARVA** feeds on a range of herbaceous plants. **STATUS** Widespread, but commonest in central and S England.

The Chestnut

The Satellite *Eupsilia transversa* Length 23–24mm

Distinctive moth that rests with one forewing largely overlapping the other. **ADULT** has orange-brown forewings with a prominent white or orange half-moon mark, around which 2 'satellite' white spots orbit. Flies Oct–Apr. **LARVA** feeds on deciduous shrubs and trees. **STATUS** Widespread and common.

The Chestnut *Conistra vaccinii* Length 17–19mm

Richly coloured moth. One forewing overlaps the other at rest. Forewing has a blunt tip and rounded outer edge. **ADULT** has chestnut-brown forewings with subtle, jagged cross-lines. Flies Sep–May; usually hibernates during cold spells. **LARVA** feeds on deciduous trees. **STATUS** Widespread and common.

Dark Chestnut

Dark Chestnut *Conistra ligula* Length 17–19mm

Similar to The Chestnut (above) but usually darker; forewing has a rather straight outer edge and pointed tip. **ADULT** has rather shiny and uniformly dark brown forewings. **LARVA** feeds on sallow catkins. **STATUS** Widespread, but commonest in the S.

The Brick

The Brick *Agrochola circellaris* Length 22–24mm

Recalls The Satellite (above), but lacks the 'moon' and 'satellite' markings. One forewing partly overlaps the other at rest. **ADULT** has orange-brown forewings with wavy, jagged cross-lines and a central dark spot. Flies Aug–Oct. **LARVA** feeds on poplars and Wych Elm. **STATUS** Widespread and fairly common.

Beaded Chestnut *Agrochola lychnidis* Length 19–21mm

Attractive and well-marked autumn moth. Rests with wings held flat, one forewing slightly overlapping the other. **ADULT** has a variable forewing ground colour, although orange-brown is typical; wings are marked with a row of black dots near outer margin, and scattered black dots elsewhere. **LARVA** feeds on deciduous trees and shrubs. **STATUS** Widespread, but commonest in central and S Britain.

Beaded Chestnut

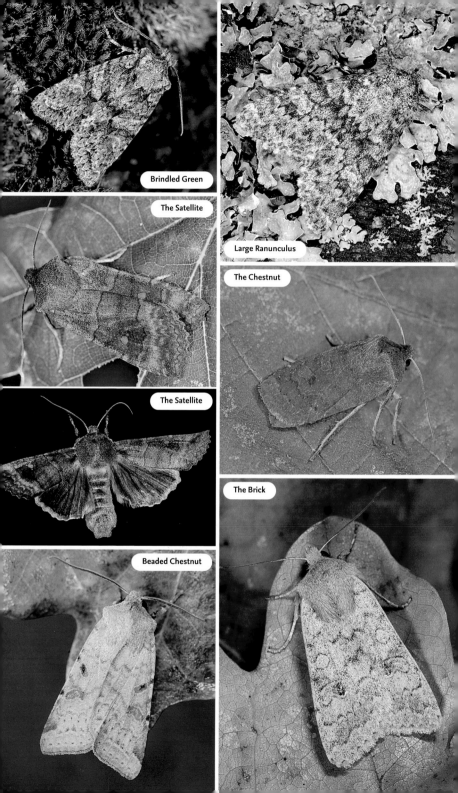

Brindled Green

Large Ranunculus

The Satellite

The Chestnut

The Satellite

The Brick

Beaded Chestnut

Red-line Quaker *Agrochola lota* Length 17–19mm

Well-marked and attractive autumn moth that rests with wings held flat, one forewing partly overlapping the other. **ADULT** has subtly speckled reddish-grey forewings with a dark central spot and a red sub-terminal line towards outer margin. Flies Sep–Oct. **LARVA** feeds on sallow and willow catkins and leaves. **STATUS** Widespread and common in England and Wales.

Yellow-line Quaker *Agrochola macilenta* Length 18–20mm

Recalls a yellower version of Red-line Quaker (above). Rests with wings held flat, one forewing partly overlapping the other. **ADULT** has yellowish-brown forewings with a discrete central dark spot and a dark-edged yellow sub-terminal line towards outer margin. Flies Sep–Nov. **LARVA** feeds on deciduous trees, notably Beech and oaks. **STATUS** Widespread, but commonest in the S.

Centre-barred Sallow *Atethmia centrago* Length 19–21mm

Stunning autumn moth. Rests with wings spread flat. **ADULT** of typical form has mostly orange-yellow forewings with darker brown central bar, inner margin of which has a clean, straight edge; outerwing margin is also brown. Uniformly yellow-buff form occurs, showing neat straight line across forewing. Flies Aug–Sep. **LARVA** feeds on Ash. **STATUS** Widespread but commonest in S and central England.

Barred Sallow *Xanthia aurago* Length 19–21mm

Variable and attractive moth that rests with wings spread flat. **ADULT** of typical form has brownish forewings with a broad yellowish central band, and a yellowish head and 'shoulders'. Another form occurs where the central band is orange-brown. Flies Sep–Oct. **LARVA** feeds on Field Maple and Beech. **STATUS** Widespread and common only in central and S England.

Pink-barred Sallow *Xanthia togata* Length 19–21mm

Beautifully patterned moth that rests with wings spread flat. **ADULT** has yellowish wings overall, speckled with orange-brown, and showing an orange-brown central band, orange-brown spot near base of leading edge, and orange-brown head and 'shoulders'. **LARVA** feeds inside sallow catkins. **STATUS** Widespread and common.

Pink-barred Sallow

The Sallow *Xanthia icteritia* Length 21–23mm

Strikingly colourful autumn moth that rests with wings spread flat. **ADULT** has yellow forewings; one form has wings patterned with orange-brown, and a central band enclosing a dark spot; the other form has minimal orange-brown markings but a dark central spot and dark outer margin. **LARVA** feeds on sallow catkins at first, subsequently on herbaceous plants. **STATUS** Widespread and common.

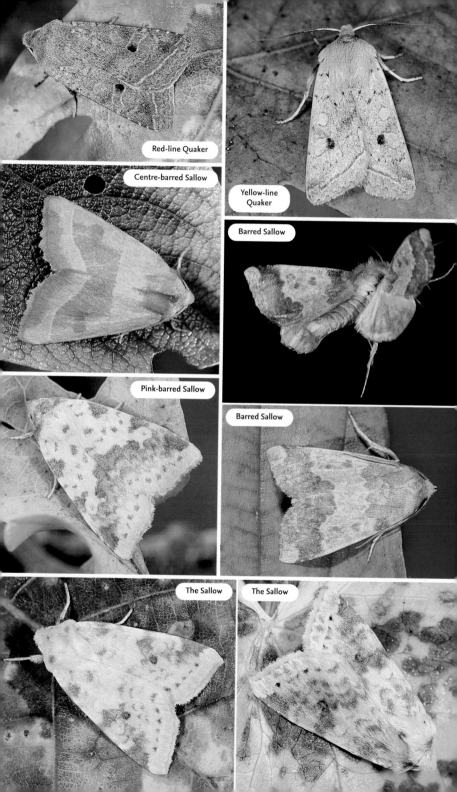

Red-line Quaker

Yellow-line Quaker

Centre-barred Sallow

Barred Sallow

Pink-barred Sallow

Barred Sallow

The Sallow

The Sallow

Lunar Underwing *Omphaloscelis lunosa* Length 18–20mm

Well-marked moth with a variable wing colour. Usually rests with one forewing partly overlapping the other. **ADULT** has forewings whose ground colour varies from buffish brown to dark brown. All individuals show a network of pale veins and cross-lines, and dark bands. Hindwing is pale with a dark half-moon mark. Flies Aug–Oct. **LARVA** feeds on grasses. **STATUS** Widespread; commonest in S.

Poplar Grey *Acronicta megacephala* Length 20mm

Subtly beautiful moth with a slightly 'dusty' look to its wings; at rest, these are held in a shallow tent-like manner. **ADULT** has grey forewings, well marked with darker lines and a well-defined pale circle. Flies May–Aug. **LARVA** eats poplars and willows. **STATUS** Widespread and common.

The Sycamore *Acronicta aceris* Length 24–26mm

Subtly attractive moth whose wings are held in a shallow tent-like manner at rest. **ADULT** has pale grey to sooty-grey forewings, subtly marked with jagged cross-lines. Flies Jun–Aug. **LARVA** is covered in orange and yellow hairs, and is marked with black-ringed white spots. Feeds on Sycamore, Field Maple and Horse-chestnut. **STATUS** Common only in SE England.

The Miller *Acronicta leporina*
Length 20mm

Variable moth that rests with wings held in a shallow tent-like manner. **ADULT** has pale to dark grey forewings, typically with jagged black transverse line from leading edge. Flies Apr–Jun. **LARVA** is covered in long white hairs; feeds on birches and other deciduous trees. **STATUS** Widespread, but commonest in the S.

ABOVE: **The Sycamore, larva**; BELOW: **Grey Dagger, larva**

Grey Dagger *Acronicta psi* Length 23mm

Distinctively patterned moth that rests with wings held in a shallow tent-like manner. **ADULT** has pale grey forewings with distinctive black dagger-like markings. Flies Jun–Aug. **LARVA** is colourful and feeds on deciduous shrubs and trees. **STATUS** Widespread and common. **SIMILAR SPECIES Dark Dagger** *A. tridens* is almost impossible to distinguish from this species in the field; it is widespread but less common than the Grey Dagger.

Knot Grass *Acronicta rumicis*
Length 18–20mm

Well-marked moth that rests with its wings held in a shallow tent-like manner at rest. **ADULT** has powdery greyish wings marked with subtle cross-lines, a central eye-spot and a white comma-like mark on trailing margin. Flies May–Jul, and sometimes Aug–Sep as a 2nd brood. **LARVA** feeds on a range of herbaceous plants. **STATUS** Widespread and common.

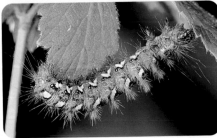

Knot Grass, larva

Lunar Underwing

Lunar Underwing

Poplar Grey

The Sycamore

Poplar Grey

The Miller

Grey Dagger

Knot Grass

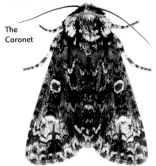

The Coronet

The Coronet *Craniophora ligustri* Length 16–18mm
Beautifully patterned moth whose wing markings and colours resemble lichens. At rest, wings are held in a shallow tent-like manner. **ADULT** has marbled olive-green and purplish-brown forewings, with a pale central spot and a pale patch near tip that recalls a crown. Flies Jun–Jul. **LARVA** feeds on Ash and privets. **STATUS** Widespread but local; commonest in S Britain.

Marbled Beauty *Cryphia domestica* Length 13–14mm
Attractive moth whose wing patterns and colours recall lichens that grow on rocks and walls. Rests with wings spread flat. **ADULT** has forewings that are pale overall, variably marbled and barred with grey or grey-brown. Flies Jul–Aug. **LARVA** feeds on lichens, especially species that grow on rocks and walls. **STATUS** Widespread and fairly common throughout.

Copper Underwing *Amphipyra pyramidea*
Length 24–26mm

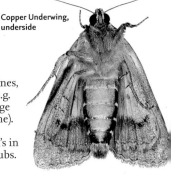

Copper Underwing, underside

Well-marked moth that is very similar to Svensson's Copper Underwing (below). Rests with wings held flat, often one forewing partly overlapping the other. Often roosts communally during daytime. **ADULT** has brown forewings overall, marked with jagged white and dark lines, and showing a pale central eye-spot. Seen from below (e.g. in a clear pot), underside of hindwing has an orange tinge confined to outer margin (beyond sub-terminal dark line). Viewed head on, palps are uniformly pale brown. Flies Aug–Oct, often first appearing 2–3 weeks after Svensson's in any given area. **LARVA** feeds on deciduous trees and shrubs. **STATUS** Widespread; commonest in S Britain.

Svensson's Copper Underwing
Amphipyra berbera
Length 24–26mm

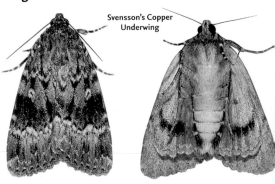

Svensson's Copper Underwing

Well-marked moth that is very similar to Copper Underwing (above). Rests with wings held flat, often one forewing partly overlapping the other. Often roosts communally in day-time. **ADULT** has brown forewings overall, marked with jagged white and dark lines, and showing a pale central eye-spot. Seen from below, orange tinge on under-side of hindwing covers outer margin (beyond sub-terminal dark line) and extends towards base of wing on trailing edge. Viewed head on, palps are dark with whitish tips. Flies Jul–Sep. **LARVA** feeds on deciduous trees and shrubs. **STATUS** Widespread and generally common.

Old Lady *Mormo maura* Length 33–35mm
Rather sombre-looking but subtly well-marked moth. Rests with wings held flat (forming a broad triangle) and has superb camouflage when sitting on wooden fences. Ventures indoors occasionally to roost in daytime. **ADULT** has brown wings overall, marbled and banded with dark brown and lilac-grey. Flies Jul–Aug. **LARVA** feeds on Blackthorn and other deciduous shrubs and trees. **STATUS** Widespread and fairly common.

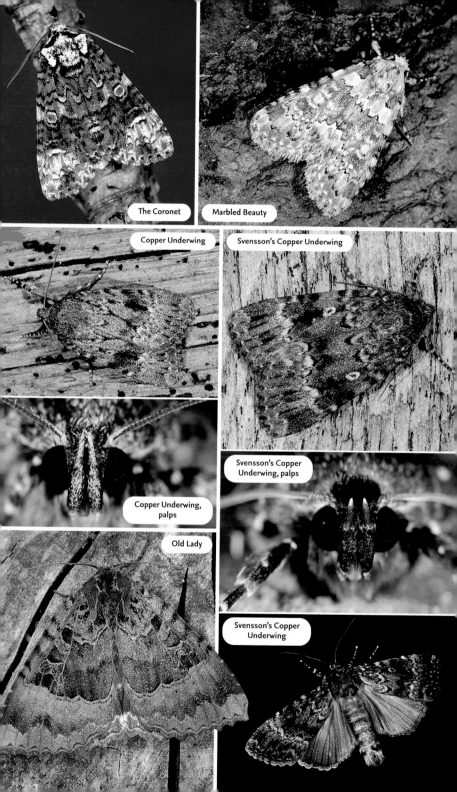

The Coronet

Marbled Beauty

Copper Underwing

Svensson's Copper Underwing

Copper Underwing, palps

Svensson's Copper Underwing, palps

Old Lady

Svensson's Copper Underwing

Brown Rustic *Rusina ferruginea* Length 19–21mm

Rather plain brown moth; a close look reveals subtle and distinct markings. At rest, wings are held in a shallow tent-like manner, or with one forewing overlapping the other. **ADULT** has brown forewings with a dark central band, pale cross-lines and pale spots on leading edge. Male has longer, broader wings than female. Flies Jun–Jul. **LARVA** feeds on various deciduous plants. **STATUS** Widespread and common.

Small Angle Shades *Euplexia lucipara* Length 17–19mm

Small Angle Shades

Well-marked moth. Sometimes rests with wings held flat, but more typically has forewing creased lengthways, creating impression of a dead leaf. **ADULT** has marbled brown wings with a dark central band and outer margin, and pale spot halfway along leading edge. Flies Jun–Jul. **LARVA** feeds on Bracken *Pteridium aquilinum* and other ferns. **STATUS** Widespread and fairly common.

Angle Shades *Phlogophora meticulosa* Length 25–27mm

Unmistakable moth with distinct markings and ragged outer forewing margins. At rest, forewings are usually folded and creased lengthways, creating the impression of a dead leaf. **ADULT** has olive-green and pinkish forewings, with a pale-centred dark triangle on leading edge. Flies mostly May–Oct but can appear in almost any month. **LARVA** feeds on a range of herbaceous plants and many garden varieties, including potted pelargoniums. **STATUS** Widespread and common.

Straw Underwing *Thalpophila matura* Length 19–22mm

Well-marked moth. At rest, forewings are usually held flat, concealing the straw-yellow hindwings. **ADULT** has marbled brown forewings with a pale-ringed eye-spot and pale and dark cross-lines. Flies Jul–Aug. **LARVA** feeds on various grasses. **STATUS** Widespread and fairly common.

Straw Underwing

The Olive *Ipimorpha subtusa* Length 15–17mm

Attractive moth with well-defined wing markings, pointed forewings, and a sharp central 'crest' on head and thorax. Rests with wings held flat. **ADULT** has olive-green to pinkish-brown forewings with narrow, pale cross-lines and a pale-ringed kidney mark and circles. Flies Jul–Aug. **LARVA** feeds on Aspen *Populus tremula* and poplars. **STATUS** Widespread but local; commonest in the S.

The Dun-bar *Cosmia trapezina* Length 15–18mm

The Dun-bar

Extremely variable moth whose pointed, straight-edged forewings are usually held flat at rest. **ADULT** has forewings that usually range from yellow-buff to grey-brown; has 2 dark-edged, pale cross-lines, these defining a central, marginally darker band that contains a dark spot; central band is very dark in one form. Flies Jul–Sep. **LARVA** feeds on deciduous trees. **STATUS** Widespread and common.

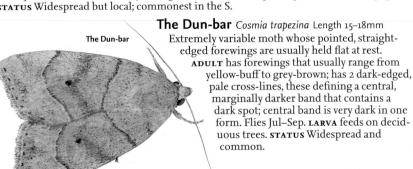

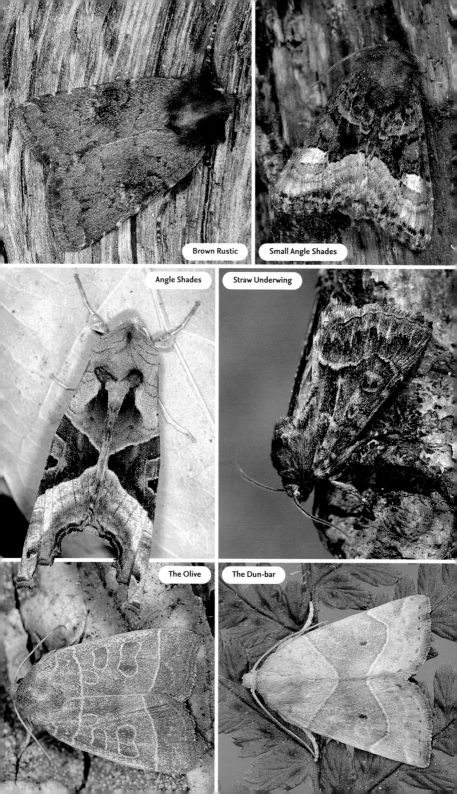

Brown Rustic

Small Angle Shades

Angle Shades

Straw Underwing

The Olive

The Dun-bar

Lunar-spotted Pinion *Cosmia pyralina* Length 15mm
Attractive moth. Holds wings in a flattened, tent-like manner when at rest. ADULT has reddish-brown wings with dark cross-lines and cross-band, and a pale scallop and line on leading edge. Flies Jul–Aug. LARVA feeds on elms and other deciduous shrubs. STATUS Locally common only in S Britain.

Dark Arches *Apamea monoglypha* Length 25–27mm
Variable but usually well-marked moth. Holds its wings in a shallow tent-like manner at rest. ADULT has grey-brown forewings with a pale spot and kidney mark, central black lines, and a jagged black and white line near outer margin. Very dark forms also occur. Flies Jul–Aug. LARVA feeds on various grasses. STATUS Widespread and common.

Light Arches *Apamea lithoxylaea* Length 23–24mm
Distinctive pale moth. Wings are held in a shallow tent-like manner at rest. ADULT has whitish-buff forewings with a rich buff suffusion towards outer margin, and subtle dark lines. Flies Jun–Aug. LARVA feeds on grasses. STATUS Widespread and fairly common.

Clouded-bordered Brindle *Apamea crenata* Length 20–22mm
Variable moth. Holds wings in a shallow tent-like manner at rest. ADULT has usually either pale buff or rich brown forewings; markings usually include pale oval and kidney-shaped marks, and 2 variably darker triangles or wedges on leading edge. LARVA feeds on grasses. STATUS Widespread and common.

Clouded Brindle
Apamea epomidion Length 21–23mm
Well-marked but variable moth. Holds wings in a shallow tent-like manner at rest. ADULT has buffish-brown forewings, sometimes with a prominent dark central band and dark, jagged marks near outer margin; pale oval and kidney marks are usually dark-edged. Flies Jun–Jul. LARVA feeds on grasses. STATUS Widespread and fairly common.

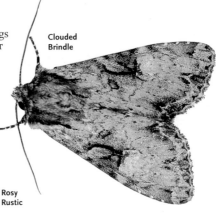

Clouded Brindle

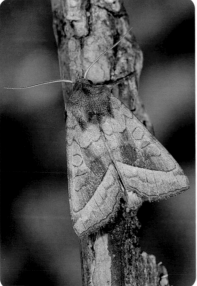

Rosy Rustic

Rosy Rustic
Hydraecia micacea Length 21–23mm
Attractive moth whose pointed wings are held in a shallow tent-like manner at rest. ADULT has reddish-buff forewings, the outer ⅓ palest and defined by a dark, diagonal cross-line. Flies Aug–Oct. LARVA feeds on low-growing plants, especially docks. STATUS Widespread and common.

Ear Moth *Amphipoea oculea* Length 17–19mm
Well-marked moth. Usually rests with wings held flat. ADULT has orange-brown to buffish-brown forewings marked with a fine network of dark lines, a round spot (usually orange) and an ear-shaped mark (white or orange). Flies Jul–Sep. LARVA feeds on grasses. STATUS Widespread and common.

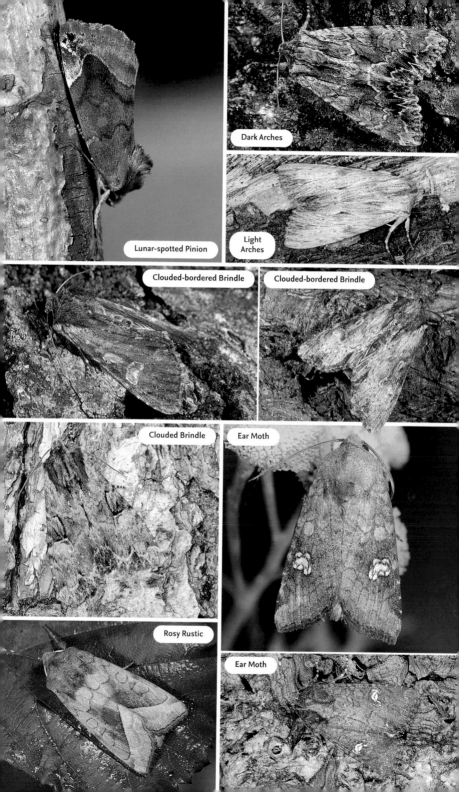

Lunar-spotted Pinion

Dark Arches

Light Arches

Clouded-bordered Brindle

Clouded-bordered Brindle

Clouded Brindle

Ear Moth

Rosy Rustic

Ear Moth

Marbled Minor *Oligia strigilis*, **Rufous Minor** *O. versicolor* and **Tawny Marbled Minor** *O. latruncula* Length 12–15mm

Three variable moths that are hard to distinguish without dissection; here they are treated together. All rest with wings held in a shallow tent-like manner. **ADULTS** have brown forewings, variably marbled with black and greyish white. Some forms of all 3 species have a pale outer edge, and a pale central mark towards base of trailing edge. Other forms are rather uniformly dark but usually show a darker central band. Fly May–Jul. **LARVAE** feed on grasses. **STATUS** All 3 species are widespread and locally common throughout.

Marbled Minor, dark form

Middle-barred Minor *Oligia fasciuncula* Length 12–14mm

Variable, small moth that rests with its wings held in a shallow tent-like manner. **ADULT** has forewings that range from reddish brown to buff; a distinctive feature is a central darker bar bordered on its outer margin by white. Flies Jun–Jul. **LARVA** feeds on grasses. **STATUS** Widespread and common.

Common Rustic *Mesapamea secalis* and **Lesser Common Rustic** *M. didyma* Length 15–20mm

Almost impossible to distinguish without dissection; here they are treated together. Both rest with wings held flat or in a shallow tent-like manner. **ADULTS** have forewings that are variable shades of brown; all have a kidney-shaped mark outlined with white. An individual whose forewings are straw-brown with darker brown margins is likely to be a Common Rustic. Fly Jul–Aug. **LARVAE** feed on grasses. **STATUS** Widespread and common.

Flounced Rustic *Luperina testacea* Length 17–19mm

Variable moth that rests with its wings held flat or in a shallow tent-like manner. **ADULT** has forewings that range from buff to grey-brown; a broad central band is often present, usually containing a broad, dark line and pale-ringed oval and kidney marks. Flies Aug–Sep. **LARVA** feeds on grass stems and roots. **STATUS** Widespread; commonest in central and S Britain.

Frosted Orange *Gortyna flavago* Length 18–20mm

Well-marked and colourful moth that rests with wings held flat or in a tent-like manner. **ADULT** has marbled brown wings with a broad orange-yellow central band and spots at tip and base of wings; pale central circle is usually striking. Flies Aug–Oct. **LARVA** feeds inside stems of plants such as thistles. **STATUS** Widespread; commonest in central and S Britain.

Treble Lines *Charanyca trigrammica* Length 18–20mm

Plain but distinctive moth that rests with wings held flat. **ADULT** has variably brown wings with 3 darker cross-lines. Flies May–Jul. **LARVA** feeds on stems of herbaceous plants. **STATUS** Widespread, but common only in England and Wales.

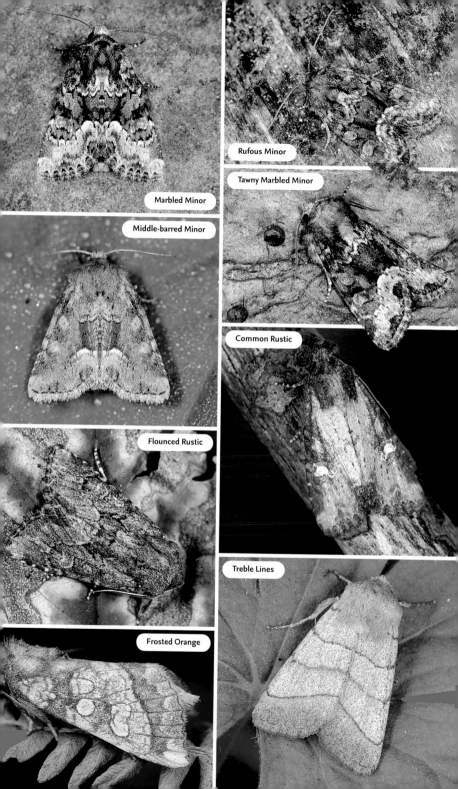

Marbled Minor

Rufous Minor

Tawny Marbled Minor

Middle-barred Minor

Common Rustic

Flounced Rustic

Treble Lines

Frosted Orange

Pale Mottled Willow *Paradrina clavipalpis* Length 14–18mm

Subtly marked moth that rests with one forewing partly overlapping the other. **ADULT** has pale buffish-brown forewings, subtly mottled with orange patches and black lines; a row of black dots is present along outer margin. Flies Jul–Sep. **LARVA** feeds on grass seeds, including those of grain crops. **STATUS** Widespread and fairly common.

The Rustic *Hoplodrina blanda* Length 16–18mm

Very similar to The Uncertain (below). Usually rests with one forewing partly overlapping the other. **ADULT** has reddish-brown to grey-brown forewings, with darker cross-lines (subterminal line often bold) and a central darker spot and kidney mark. Flies Jun–Aug. **LARVA** feeds on low-growing plants. **STATUS** Widespread, but commonest in England and Wales.

The Uncertain *Hoplodrina alsines* Length 16–18mm

Hard to distinguish from The Rustic (above), hence its common name. Usually rests with one forewing partly overlapping the other. **ADULT** has yellowish-brown forewings, with darker cross-lines (central line often bold) and a central darker spot and kidney mark. Flies Jun–Aug. **LARVA** feeds on low-growing plants. **STATUS** Widespread, but commonest in central and S Britain.

The Herald *Scoliopteryx libatrix* Length 19–21mm

Distinctive and unmistakable moth that hibernates in sheds and outbuildings. Usually rests with wings spread flat. **ADULT** has reddish-brown forewings with jagged outer margins, white cross-lines and patches of orange. Flies Aug–Nov, then Mar–Jun after hibernation. **LARVA** feeds on willows and poplars. **STATUS** Widespread and fairly common.

The Herald

Nut-tree Tussock

Colocasia coryli Length 17–19mm

Well-marked and furry-looking moth. Usually rests with wings held in a tent-like manner. **ADULT** has forewings with a variable ground colour but always shows a broad, darker cross-band containing a small eye-like marking outlined in black. Flies May–Jul. **LARVA** feeds on Hazel. **STATUS** Widespread, but locally common only in the S.

Nut-tree Tussock

Silver Y *Autographa gamma* Length 20–22mm

Familiar moth, easily recognised by the distinctive 'Y' mark on its forewings. Flies during the daytime as well as after dark. Rests with wings held in a tent-like manner. **ADULT** has marbled grey-brown forewings with a bold white 'Y' marking. Flies May–Oct. **LARVA** feeds on a wide range of low-growing plants. **STATUS** Widespread and common migrant from S Europe.

Beautiful Golden Y *Autographa pulchrina* Length 21–23mm

Attractive moth that rests with wings held in a tent-like manner; prominent tufts are seen in profile. **ADULT** has marbled reddish-brown wings, with a striking white spot adjacent to a bold white 'V' mark. Flies May–Jun. **LARVA** feeds on a range of low-growing plants. **STATUS** Widespread and fairly common.

Scarce Silver Lines *Bena bicolorana* Length 21–23mm

Attractive moth that rests with wings held in a tent-like manner. **ADULT** has green forewings with 2 transverse white lines. A reddish tinge is sometimes seen on head and cross-lines. Flies Jul–Aug. **LARVA** feeds on oaks. **STATUS** Widespread and fairly common in central and S Britain.

Green Silver Lines
Pseudoips prasinana Length 16–18mm

Stunningly colourful moth that holds its wings in a tent-like manner at rest. **ADULT** has bright green forewings with diagonal white cross-lines; wing margins and legs are often tinged red. Hindwings are white in male and yellowish in female. Flies Jun–Jul. **LARVA** feeds on oaks, Hazel, and other deciduous trees and shrubs. **STATUS** Widespread and fairly common in central and S Britain.

Burnished Brass *Diachrysia chrysitis* Length 20–22mm

Stunning and unmistakable moth. Rests with wings held in a tent-like manner. **ADULT** has golden metallic areas on otherwise brown forewings; head is adorned with orange-brown tufts. Flies Jun–Jul, and Aug–Sep as a 2nd brood in the S. **LARVA** feeds on Common Nettle and other herbaceous plants. **STATUS** Widespread and common.

Gold Spot *Plusia festucae* Length 18–20mm

Beautiful moth that rests with wings held in a tent-like manner, and with prominent tuft seen on thorax. **ADULT** has orange-brown forewings with 2 white spots (sometimes almost fused) and a white streak. Flies Jun–Sep. **LARVA** feeds on a range of low-growing wetland plants. **STATUS** Widespread but local.

The Snout *Hypena proboscidalis* Length 17–19mm

Extremely distinctive moth that rests with its hooked wings spread flat and forming a triangle, and its long palps projecting as a 'snout'. **ADULT** has pale brown to reddish-brown forewings with darker cross-lines. Flies Jun–Aug, and Sep as a 2nd brood. **LARVA** feeds on Common Nettle. **STATUS** Widespread and common.

Beautiful Golden Y

The Snout

Beautiful Golden Y

Scarce Silver Lines

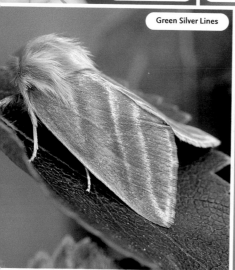

Green Silver Lines

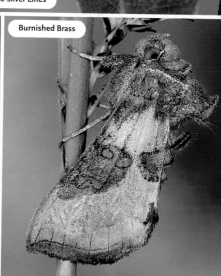

Burnished Brass

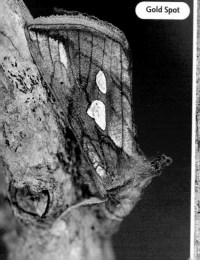

Gold Spot

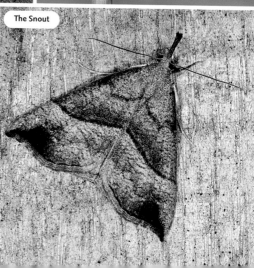

The Snout

The Spectacle *Abrostola tripartita* Length 17–19mm

Well-named moth: when viewed from the front, its head shows distinctive white 'spectacle' markings. Wings are held in a tent-like manner at rest; note tufted projections when seen in profile. **ADULT** has marbled grey forewings with a dark central band. Flies May–Aug. **LARVA** feeds on Common Nettle. **STATUS** Widespread and locally common.

The Spectacle

Dark Spectacle *Abrostola triplasia*
Length 17–19mm

Similar to The Spectacle (above), but overall darker and redder. Wings are held in a tent-like manner at rest. **ADULT** has overall sooty-grey forewings, palest at base (and on head and thorax); the 2 zones of colour are separated by a reddish-brown line. Also has a reddish-brown sub-terminal line defining sooty-grey outer margin of forewing (outer forewing is pale brown in The Spectacle). Flies Jun–Jul. **LARVA** feeds on Common Nettle. **STATUS** Locally common only in S and W Britain.

Red Underwing *Catocala nupta* Length 34–36mm

Impressive moth. Rests with wings spread flat. Its forewings, which afford the moth good camouflage when sitting on wood, usually conceal colourful hindwings; if the moth is disturbed, these are revealed as a shock tactic. **ADULT** has marbled grey and brown forewings and black-barred red underwings. Flies Aug–Sep. **LARVA** feeds on willows and poplars. **STATUS** Common only in S England.

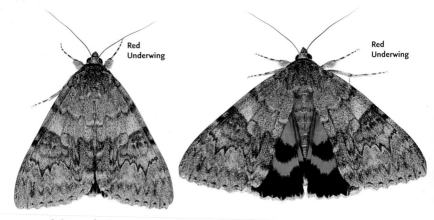

Red Underwing

Red Underwing

Beautiful Hook-tip *Laspeyria flexula* Wingspan 24–26mm

Distinctive moth that rests with its hooked wings spread flat. **ADULT** has hook-tipped, indented purplish-grey forewings, stippled with black dots and with 2 pale cross-lines. Flies Jul–Aug. **LARVA** feeds on various trees and shrubs. **STATUS** Locally common only in S Britain.

Straw Dot *Rivula sericealis* Length 14–16mm

Unmistakable moth that usually rests with wings spread flat. **ADULT** has buffish-yellow forewings with a dark, central kidney-shaped dot and a dark outer margin. Flies Jun–Jul. **LARVA** feeds on grasses, notably Purple Moor-grass *Molinia caeulea*. **STATUS** Locally common only in S Britain; resident numbers are boosted by influxes of migrants.

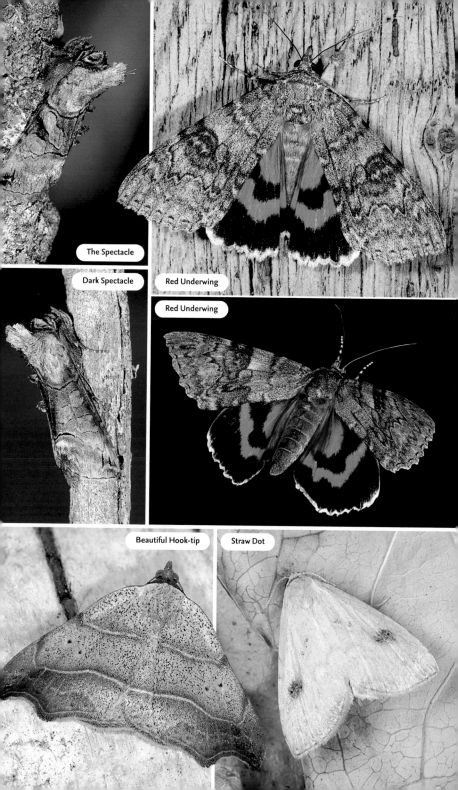

The Spectacle

Dark Spectacle

Red Underwing

Red Underwing

Beautiful Hook-tip

Straw Dot

MINOR INSECT ORDERS

Insects are among the most numerous organisms on the planet and typically the most diverse and abundant group of animals in the garden. While it is understandable that showy groups such as butterflies, beetles and bugs receive the most attention, garden naturalists will find that even the smallest and most insignificant insects have something of interest to commend them.

BRISTLETAILS

These members of the order Thysanura are wingless, scuttling insects with long, strongly segmented bodies covered in scales; they have three long, bristly 'tails'. The Silverfish *Lepisma saccharina* (length 10mm) is a familiar household resident. It favours damp sites and feeds on spilt starchy food.

Silverfish.

PSOCIDS AND BOOKLICE

These tiny insects are members of the order Psocoptera. Some are wingless, but those that can fly hold their wings in a tent-like manner over the body at rest; psocids live on vegetation while booklice occur indoors.

A typical psocid.

FLEAS

These members of the order Siphonaptera are tiny, laterally flattened, wingless insects. They have renowned powers of leaping and blood-sucking feeding habits, and are always associated with warm-blooded hosts.

Ctenophthalmus nobilis, a flea whose hosts include Moles, shrews and rodents.

SPRINGTAILS

These tiny, wingless insects have a forked appendage at their rear end, which they use to spring into the air to escape danger; if you turn over leaf litter or compost you are sure to find some. Tiny they may be, but springtails are among the most abundant animals on the planet.

Tomocerus sp., typical springtails.

COCKROACHES

Alien household cockroach species are a thing of the past, but the Dusky Cockroach *Ectobius lapponicus*, an entirely innocuous native species, sometimes occurs in rural gardens. It is flattened, and has a scuttling gait, long antennae and spiny legs; its head is covered by a protective plate.

Dusky Cockroach.

Members of the insect order Orthoptera include grasshoppers, bush-crickets and ground-hoppers. While most British species are found in grassland and scrub, a few venture into the garden.

Speckled Bush-cricket *Leptophyes punctatissima* Length 14mm

Dainty, plump-bodied insect. **ADULT** is green, speckled with black dots, and has long, spindly legs. Female has a scimitar-shaped ovipositor. **STATUS** Common in the S but scarce elsewhere. Found in herbaceous borders and on Bramble leaves.

ABOVE: **Speckled Bush-cricket female**

Oak Bush-cricket

Meconema thalassinum
Length 15mm
Most active after dark and attracted indoors by lighted windows. **ADULT** has a slender green body and long, spindly legs. Female has a narrow, slightly upcurved ovipositor. **STATUS** Fairly common in the S. Found on leaves of deciduous trees and shrubs.

Oak Bush-cricket

Dark Bush-cricket *Pholidoptera griseoaptera* Length 15–17mm

Familiar wayside insect. Male sings a chirping 'song'. **ADULT** has a marbled dark brown body and thick-'thighed' hindlegs. Female has an upcurved ovipositor. Forewings are vestigial in female and reduced to flaps in male. **STATUS** Common in hedgerows and rough grassland.

Dark Bush-cricket

Common Groundhopper *Tetrix undulata* Length 10mm

Small, well-camouflaged insect; hops well. **ADULT** is variable but usually marbled brown, and has a long pronotum. **STATUS** Common and widespread; favours damp ground with short vegetation.

Common Groundhopper

STICK INSECTS

These slender, slow-moving insects resemble the twigs among which they live. They occur in southwest England but are not native, having been introduced inadvertently with imported plants. The Prickly Stick Insect *Acanthoxyla geisovii* (length 10cm) is the most regularly encountered species, especially on the Isles of Scilly; it is found on Bramble and garden shrubs. The Smooth Stick Insect *Clitarchus hookeri* is another Scilly speciality, while the superficially similar Unarmed Stick Insect *A. inermis* occurs on the Cornish Peninsula.

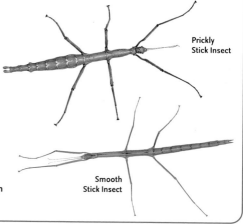

Prickly Stick Insect

Smooth Stick Insect

True bugs (order Hemiptera) are a varied group of insects with sucking mouthparts; adults of many species have wings, these either folded flat over the body or held tent-wise at rest. Garden bug species are described on pp. 230–6.

Common Froghopper *Philaenus spumarius* Length 6mm
Squat, vaguely frog-like bug. Hops well and sucks plant sap. **ADULT** is ovoid and has hardened, marbled brown forewings. **NYMPH** is green and lives in a protective mass of froth ('cuckoo-spit'). **STATUS** Common and widespread (Jun–Aug).

Cercopis vulnerata Length 9mm
Unmistakable species with striking warning markings. Feeds on plant sap and jumps well. **ADULT** has red and black markings; usually found resting on low vegetation. **STATUS** Common in grassy places and margins of rural gardens (May–Aug).

Deraecoris ruber Length 7mm
Well-marked capsid bug with a delicate-looking body and rather long antennae. Feeds on developing fruits and seeds, but also on aphids and other small insects. **ADULT** is variable but usually dark reddish brown; forewings have an orange-red lateral patch near tip. **STATUS** Common in S Britain, in scrub, hedgerows and margins of rural gardens (Jul–Aug).

Campyloneura virgula Length 5mm
Tiny capsid that feeds on aphids and Red Spider Mites. **ADULT** is mainly buff and dark brown, but has orange-yellow on the pronotum and near the forewing tip. **STATUS** Common; usually found on deciduous trees and shrubs (Jul–Oct).

Orthops campestris Length 4mm
Colourful capsid, found on umbellifer flower heads. **ADULT** is usually green but sometimes light brown, with bold, dark markings on pronotum and forewings. Hindwing tips are pale. **STATUS** Common and widespread on flower heads of Hogweed and Wild Parsnip *Pastinaca sativa*. Adults overwinter (seen Jul–Apr).

Common Green Capsid *Lygocoris pabulinus* Length 5–7mm
Familiar green capsid bug with wings held flat over body. Found on a wide range of deciduous shrubs and trees, and often feeds on soft fruits. **ADULT** has a mainly green body but with brown wingtips. Antennae are relatively long. **STATUS** Common and widespread (Jun–Oct).

Rhododendron Leafhopper *Graphocephala coccinea* Length 9mm
Slender, colourful bug with soft forewings. Hops well and feeds on rhododendron sap. **ADULT** has red forewing stripes on an otherwise lime-green body. **STATUS** Introduced from N America but established in S England.

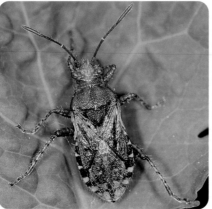

Rhopalus subrufus Length 7–8mm
Colourful bug with membranous forewings. Feeds on a wide range of plants. **ADULT** is reddish overall with black-and-white margins to abdomen. Legs are relatively long and bristly, and antennae tips are cigar-shaped. **STATUS** Widespread and generally common in southern Britain; found in woodland rides and rural gardens (all year, but dormant in winter).

Rhopalus subrufus.

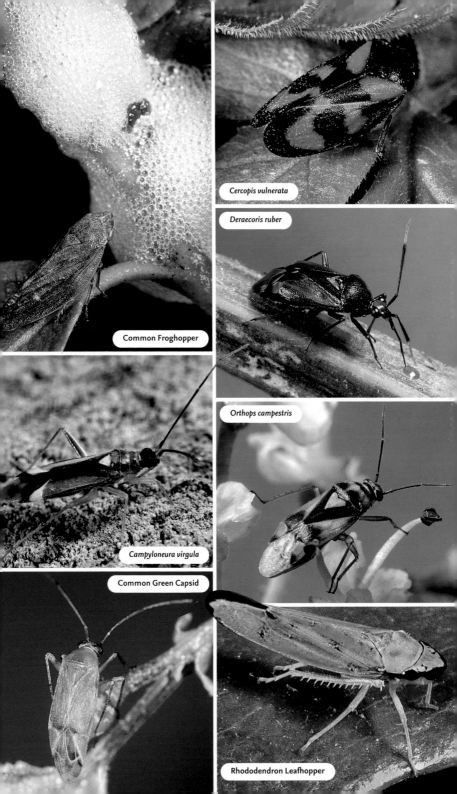

Cercopis vulnerata

Deraecoris ruber

Common Froghopper

Orthops campestris

Campyloneura virgula

Common Green Capsid

Rhododendron Leafhopper

Ledra aurita, nymph

Ledra aurita Length 14mm
Our largest and most bizarre-looking leafhopper. Its camouflaged shape and colours make it hard to spot. **ADULT** is brown and winged, and has thoracic projections. Seen Jun–Aug. **NYMPH** is oval, pale, squat and strangely flattened. Seen Apr–May. **STATUS** Fairly common; found on deciduous trees and shrubs, including oaks and Hazel.

Horned Treehopper *Centrotus cornutus* Length 6mm
Distinctive treehopper whose prontoum extends back along the length of the abdomen. **ADULT** is brown with lateral 'horns' on pronotum; wings are yellowish and membranous. Seen Jun–Jul. **STATUS** Common in meadows and woods, and in mature gardens.

Iassus lanio Length 7–8mm
Well-marked leafhopper with a broad head and rather triangular outline overall. **ADULT** forewings are variable in colour, but often pale green. Head and thorax are usually brown; note bright red eyes. Seen Jul–Oct. **STATUS** Common and widespread, typically associated with oaks.

Dock Bug *Coreus marginatus* Length 15mm
Distinctive bug whose body outline vaguely recalls that of a violin. **ADULT** has a mainly buffish-brown body with red antennal segments and markings on abdomen margins. Hibernates, hence seen in autumn and spring. **STATUS** Found in meadows, hedgerows, and mature gardens, feeding mainly on dock fruits.

Horned Treehopper

Hawthorn Shieldbug
Acanthosoma haemorrhoidale
Length 13mm
Attractive and familiar shield bug that feeds mainly on Common Hawthorn berries (and deciduous leaves generally) and is usually associated with this shrub. **ADULT** is shiny green with black and deep red markings; wings are pale and membranous at tip. Autumn-emerging adults hibernate, reappearing Apr–Jul; nymphs are seen Jun–Aug. **STATUS** Common in hedgerows, woods and mature gardens.

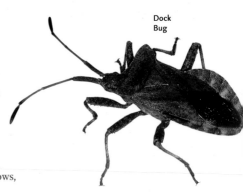

Dock Bug

Birch Shieldbug *Elasmostethus interstinctus* Length 8–10mm
Similar to, but smaller than, Hawthorn Shieldbug (above), and with a strikingly marked scutellum. Usually associated with birches and Hazel. **ADULT** has a greenish body and variably rich reddish suffusion to wings. Front of scutellum is red (green in Hawthorn Shieldbug). Autumn-emerging adults hibernate, reappearing in spring. **STATUS** Common and widespread.

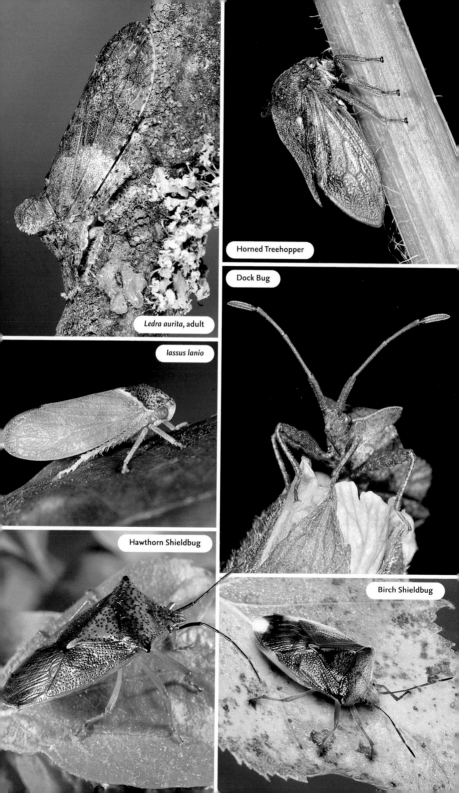

Ledra aurita, adult

Horned Treehopper

Dock Bug

Iassus lanio

Hawthorn Shieldbug

Birch Shieldbug

Green Shieldbug
Palomena prasina Length 13mm
Oval-shaped shield bug. Feeds on Hazel and other shrubs. **ADULT** is mainly green but stippled with tiny black dots; tips of wing are dark. Colours are dull when hibernating but bright green when newly emerged in May. Nymphs are seen in summer and new adults appear in Sep. **STATUS** Common except in N Britain; found in hedgerows and mature gardens.

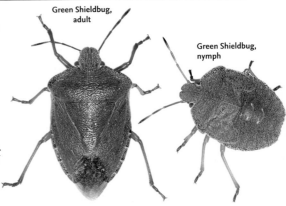

Green Shieldbug, adult

Green Shieldbug, nymph

Forest Bug
Pentatoma rufipes Length 14mm
Shield-shaped bug with lateral processes on pronotum. **ADULT** is reddish brown and shiny, with orange-red legs and body markings; abdomen is banded orange-red and black. Overwintering nymphs appear in Apr; adults are seen Aug–Oct. **STATUS** Associated with mature trees, particularly oaks.

Sloe Bug *Dolycoris baccarum* Length 12mm
Associated with Blackthorn and other shrubs, feeding on sloes and other berries. **ADULT** is dark reddish brown, stippled with black dots; banded reddish-yellow and black abdomen segments are visible beyond outer margin of wings. Pronotum lacks lateral projections seen in some other shield bugs. Seen Jun–Aug. **STATUS** Common except in the N.

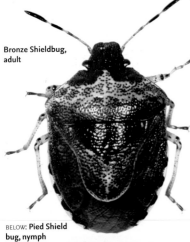

Bronze Shieldbug, adult

BELOW: **Pied Shield bug, nymph**

Bronze Shieldbug *Eysarcoris venustissimus*
Length 6mm
Tiny wayside bug. **ADULT** is grey-brown, with areas of bronze sheen on head and pronotum. Most obvious May–Jul. **STATUS** Locally common in damp hedgerows, waysides and gardens, often on Hedge Woundwort *Stachys sylvatica*.

Pied Shieldbug *Tritomegas bicolor*
Length 7mm
Well-marked hedgerow bug. **ADULT** is oval with black and white markings on wings and abdomen. Emerges in autumn, hibernates, then reappears May–Jul. **NYMPH** Pied like adult but lacks fully formed wings. Seen May–Jul. **STATUS** Widespread in hedgerows, waysides and gardens; often feeds on White Dead-nettle and Black Horehound *Ballota nigra*.

Parent Bug *Elasmucha grisea* Length 7–9mm
Small shield bug, so called because the female often guards eggs and newly hatched nymph against predators. **ADULT** is greyish green overall, variably suffused with bright reddish purple. Note chequered edge to abdomen. Hibernates in winter but otherwise present all year. **STATUS** Common except in Scotland; typically associated with birches.

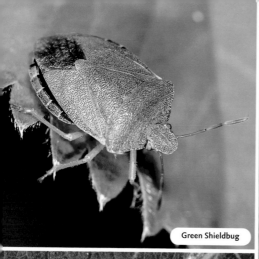

Green Shieldbug

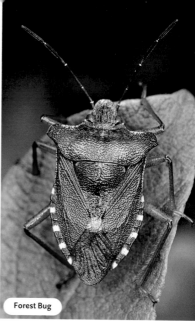

Forest Bug

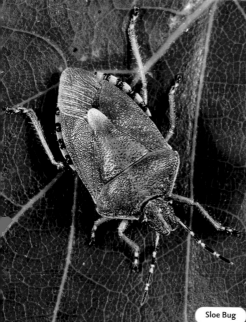

Sloe Bug

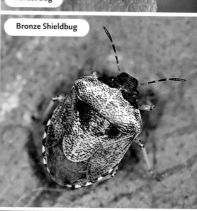

Bronze Shieldbug

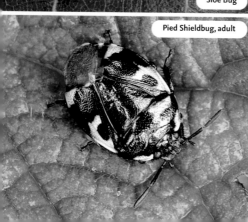

Pied Shieldbug, adult

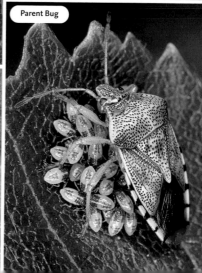

Parent Bug

WHAT ARE APHIDS?

Aphids are tiny sap-suckers with a pear-shaped body and two horn-like projections at the rear end. A different host plant is typically used in spring and summer, and most aphids overwinter as eggs. In spring, aphids are usually wingless and give birth parthenogenetically to live young. Later in the season, winged forms appear to aid dispersal, and egg-laying forms are produced in autumn. Aphids are often considered a nuisance by gardeners, but their ecological importance as food for predatory insects and birds cannot be overstated.

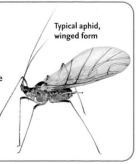

Typical aphid, winged form

Black Bean Aphid *Aphis fabae* Length 2mm

Familiar garden 'blackfly'. Eggs overwinter on Spindle *Euonymus europaeus*. It is eaten by ladybirds but guarded and 'milked' for honeydew by ants. **ADULT** wingless females appear on beans in spring, and huge colonies form by summer, when winged adults appear. **STATUS** Common; at times abundant.

Rose Aphid *Macrosiphum rosae* Length 2mm

Familiar garden 'greenfly'. Forms colonies on roses in spring but moves to other plants, including Wild Teasel, by summer. **ADULT** can be either green or pink with 2 black horn-like projections. **STATUS** Common and widespread.

Woolly Aphid *Eriosoma lanigerum* Length 1–3mm

Best recognised by the waxy cottonwool-like secretions that cover the colony. Found mostly on old apple trees, sometimes on Hawthorn. **ADULT** is squat and purplish brown; winged forms occur in late summer only. **STATUS** Introduced from North America 200 years ago but now widespread here.

Cabbage Whitefly *Aleyrodes proletella* Length 2–3mm

Tiny, white-winged insects that resemble miniature moths. Found on the leaves of garden brassicas. **ADULT** has waxy white rounded wings. **STATUS** Widespread; abundant in spring.

SCALE INSECTS Coccoidea

Hard to recognise as living organisms, let alone insects, this diverse group of sap-sucking bugs (length 2–5mm, depending on the species) is named after the protective scale under which females live. They are found on plant stems in spring, often atop a mass of white fibres containing numerous eggs. Most species reproduce parthenogenetically.

Typical scale insect

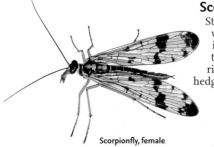

Scorpionfly *Panorpa communis* Length 14mm

Strange-looking insect. **ADULT** has netted wings and a prominent 'beak' used in feeding; scavenges on dead animals, including the contents of spiders' webs, and feeds on ripe fruit. Seen May–Jul. **STATUS** Common in hedgerows and mature gardens.

Scorpionfly, female

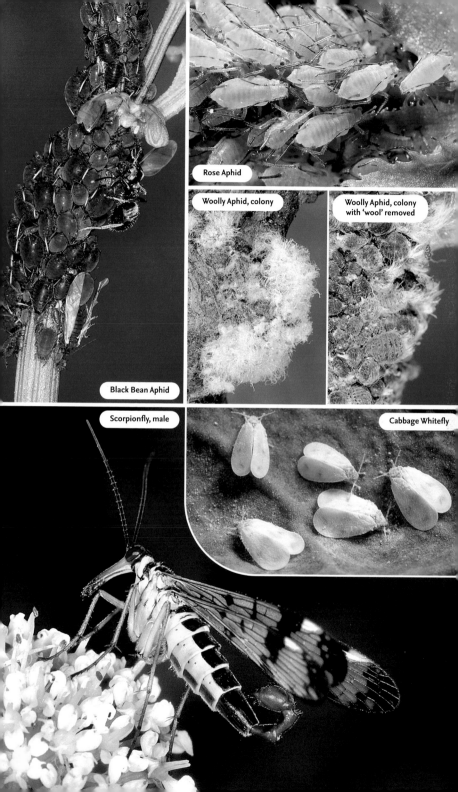

Rose Aphid

Woolly Aphid, colony

Woolly Aphid, colony with 'wool' removed

Black Bean Aphid

Scorpionfly, male

Cabbage Whitefly

Common Lacewing, larva

Common Lacewing *Chrysoperla carnea* Length 15mm

Carnivorous member of the order Neuroptera. **ADULT** has a soft, slender greenish body and delicate, membranous wings. **LARVA** feeds mainly on aphids and creates a camouflaged home from their empty skins. **STATUS** Common and widespread. Found among vegetation in summer and attracted to lighted windows. In autumn, often hibernates indoors, its body turning pinkish.

Common Earwig

Common Earwig

Forficula auricularia Length 13mm

A member of the order Dermaptera, characterised by pincer-like appendages (cerci) at the rear end. Feeds mainly on dead organic matter. **ADULT** is flightless and has a shiny chestnut-brown body. The pincer-like cerci are curved in males but rather straight in females. Hides in leaf litter and under stones or logs during the daytime, and is most active after dark. **STATUS** Common and widespread.

Tipula paludosa Length 16mm

Typical cranefly of garden lawns; also known as 'Daddy-long-legs'. Its flight is erratic, with dangling legs. **ADULT** has a buffish-brown body and transparent wings; commonest Aug–Oct. **LARVA** lives in the soil. **STATUS** Common and widespread.

Tipula maxima Length 30mm

Our largest and most impressive cranefly. Associated with damp grassland and woods. **ADULT** has a brown body and wings marbled with brown patches. Seen mainly May–Jul. **LARVA** lives in damp soil. **STATUS** Widespread and fairly common.

Drone-fly *Eristalis tenax* Length 12mm

Visits flowers to feed on nectar and looks very similar to a Honey Bee drone (p. 246; note its relatively large eyes, and body that is not 'waisted' between thorax and abdomen). **ADULT** has brown markings on dark abdomen. Seen mainly May–Aug. **LARVA** (*see* below) lives in stagnant water. **STATUS** Common and widespread.

Helophilus pendulus Length 10mm

Common hover-fly, often seen on garden flowers. Male hovers over water and both sexes sunbathe. **ADULT** has lengthways yellow lines on dark thorax, and yellow patches on abdomen. Seen May–Sep. **LARVA** lives in stagnant water. **STATUS** Common and widespread; favours damp areas.

FLY LARVAE

Cranefly larva

The larvae of flies are legless and often superficially maggot-like. Yet they are varied in terms of form and function, and are found in a range of habitats. Cranefly (*Tipula*) larvae (known as 'leatherjackets') live in the soil and eat plant roots. Drone-fly larvae (known as 'rat-tailed maggots') live in stagnant water, breathing through a siphon at the tail end. Many hover-fly larvae are active carnivores that eat aphids.

TOP: **Drone-fly larva**; ABOVE: **hoverfly larva**

Common Lacewing

Common Earwig

Tipula paludosa

Tipula maxima

Drone-fly

Helophilus pendulus

Syrphus ribesii Length 12mm
Passable wasp-mimicking hover-fly. Visits flowers to
feed on nectar. **ADULT** has yellow abdominal bands, the
front ones incomplete. Eyes are large and brown. Seen
Apr–Oct. **LARVA** eats aphids. **STATUS** Common and
widespread in gardens.

Syrphus
ribesii

Episyrphus balteatus Length 10–15mm
Slender-bodied hover-fly. **ADULT** has a dull orange
abdomen, the segments defined by broad black bands; also has narrow dark lines mid-
segment. Seen Mar–Nov; swarms on nectar-rich flowers. **LARVA** eats aphids. **STATUS**
Abundant and widespread.

Volucella bombylans Length 14mm
Hairy, bumblebee-mimicking hover-fly. **ADULT** occurs in 2 main forms: mainly black with
a red abdomen tip (a Red-tailed Bumblebee mimic); or brown with buff bands on thorax
and abdomen, and a white or buff abdomen tip (White-tailed or Buff-tailed bumblebee
mimics). Seen May–Sep. **LARVA** scavenges in bumblebee and wasp nests. **STATUS** Common
and widespread.

Volucella pellucens Length 15mm
Well-marked hover-fly. **ADULT** has a mainly black
body with a broad whitish band towards front of
abdomen. Wings have a dark median patch. **LARVA** is
found on leaves and eats aphids. **STATUS** Widespread
and fairly common.

Volucella
pelluscens

Sericomyia silentis Length 16mm
Striking, wasp-like hover-fly. Visits flowers in rural
gardens to feed on nectar. **ADULT** has yellow bands on its
rather broad abdomen. Seen May–Aug. **LARVA** lives in damp
peaty soil. **STATUS** Common and widespread in damp habitats.

LEAF-MINING FLIES

Certain tiny fly larvae live inside
leaves, creating 'mines' as they
eat the tissue between outer
layers (many micro-moth
larvae also do this). In the
garden, look for tell-tale signs
of agromyzid flies *Chromatomyia
periclymeni* in Honeysuckle and
Snowberry *Symphoricarpos albus* leaves,
and *Phytomyza ilicis* in Holly leaves.

Chromatomyia
periclymeni

Holly leaf
miner

Chrysops relictus Length 10mm
Colourful horse-fly. Sometimes the bane of gardeners' lives. Females are blood-suckers,
males feed on nectar. **ADULT** has iridescent green eyes, patterned wings and yellow mark-
ings on abdomen. Seen Jun–Aug. **LARVA** lives in damp soil. **STATUS** Widespread and fairly
common; favours damp acid soils.

Tabanus bromius Length 14mm
Robust horse-fly. Visits rural gardens. **ADULT** has yellowish-brown and black abdominal
markings. Seen Jun–Aug. **LARVA** lives in damp soil and is carnivorous. **STATUS** Locally
common.

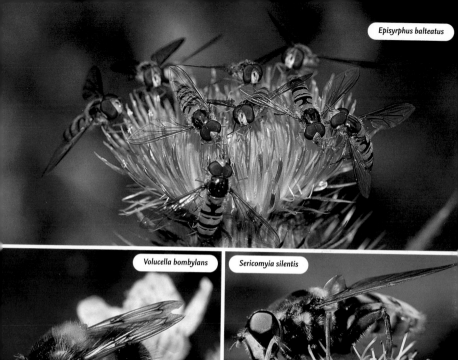
Episyrphus balteatus

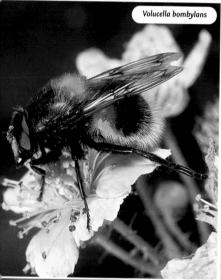
Volucella bombylans

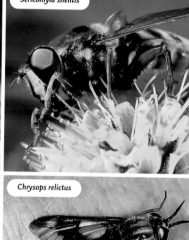
Sericomyia silentis

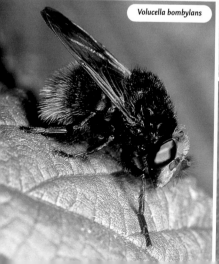
Volucella bombylans

Chrysops relictus

Tabanus bromius

Greenbottle *Lucilia caesar* Length 9mm

Colourful fly, attracted to flowers, dung and carrion. **ADULT** has a shiny green or bronzy-green body and red eyes. **LARVA** lives and feeds in rotting carcasses. **STATUS** Common and widespread.

Flesh-fly *Sarcophaga carnaria* Length 15mm

Attracted to carrion and carcasses. Seldom ventures indoors. **ADULT** has a greyish body but with chequered markings on abdomen; eyes are red and feet are proportionately large. **LARVA** is live-born (eggs are not laid) on decaying flesh. **STATUS** Common and widespread.

Flesh-fly

Common House-fly

Musca domestica Length 8mm

Familiar visitor to houses. Attracted to rubbish, where eggs are laid. **ADULT** has red eyes and a mostly dark body except for orange patches on abdomen. Note sharp bend in 4th long vein of wing. **STATUS** Extremely common and widespread.

Lesser House Fly *Fannia canicularis* Length 5mm

Often found indoors; males fly repetitive circuits beneath ceiling lights and fixtures. **ADULT** is similar to Common House-fly (above) but smaller, and 4th long vein of wing is straight, without sharp bend. **LARVA** lives in putrefying corpses and dung. **STATUS** Common and widespread.

Bluebottle *Calliphora erythrocephala* Length 11mm

Extremely familiar visitor to homes. Found in most months but commonest in summer. Makes a loud buzzing sound in flight. **ADULT** has a shiny blue body, and reddish eyes and jowls. Female is attracted to meat, on which eggs are laid and larvae feed. **STATUS** Common and widespread.

Graphomyia maculata Length 8–10mm

Small house-fly relative. Often seen on garden flowers, especially near damp ground. **ADULT** male has a mostly dark body, but with sides of abdominal segments showing dull orange patches. Female has chequered grey markings on abdomen. Seen May–Oct. **LARVA** is carnivorous and lives in damp ground. **STATUS** Common and widespread.

Tachina fera Length 10mm

Well-marked fly. **ADULT** has a bristly body with orange and black on abdomen and yellow hairs on head; wings are flushed yellow towards base and legs are orange with yellow 'toes'. Seen May–Sep. **LARVA** is a parasite of caterpillars. **STATUS** Common and widespread, favouring damp ground.

Tachina fera

Greenbottle

Flesh-fly

Common House-fly

Lesser House Fly

Bluebottle

Graphomyia maculata

Snipe-fly *Rhagio scolopaceus* Length 12mm
Often sits head-down on tree trunks. Catches other insects in flight. Will sometimes fly straight at observer. **ADULT** has a slender, tapering brown body. Seen May–Jul. **LARVA** lives in leaf litter and is carnivorous. **STATUS** Common and widespread.

St Mark's Fly *Bibio marci* Length 11mm
Often appears around St Mark's Day (25 Apr). Rather sluggish when resting on vegetation. Male flies with dangling legs. **ADULT** has short antennae and a hairy black body. **LARVA** lives in soil. **STATUS** Locally abundant in short grass.

Picture-winged Fly *Urophora cardui* Length 5mm
Typical example of a group of well-marked flies whose larvae induce plant galls. **ADULT** has dark-marbled wings and a slender, tapering abdomen. Seen May–Aug. **LARVA** forms large pear-shaped galls in thistle stems. **STATUS** Fairly common and widespread.

Owl-midge *Pericoma fuliginosa* Length 2–3mm
Peculiar little fly that recalls a tiny moth. **ADULT** has a hairy body and broadly-rounded, hairy wings. Usually rests with wings spread flat. **LARVA** lives in decaying organic matter. **STATUS** Common and widespread.

Owl-midge

Bee-fly *Bombylius major* Length 10mm
Distinctive fly. Looks and behaves like a small bee. Emits a high-pitched hum in flight. **ADULT** has a furry brown body and long proboscis, used for sucking nectar. Seen Apr–May. **LARVA** feeds on the larvae of solitary bees and wasps. **STATUS** Commonest in the S.

Bee-fly

Myopa buccata Length 8–12mm
Distinctive fly with a relatively large head and long legs; abdomen is held curled beneath body. Usually found on or near flowers visited by bumblebees, bees and wasps. **ADULT** has a rich brown body and legs. **LARVA** is an internal parasite of bees and wasps. **STATUS** Fairly common and widespread.

Beris clavipes Length 8–12mm
Distinctive soldier-fly. **ADULT** has a brown head and thorax, and yellow-orange abdomen and legs. Eyes are very hairy and wings are smoky brown. **LARVA** lives in damp ground and feeds on decaying organic matter. **STATUS** Common in the S.

Beris clavipes

Chloromyia formosa Length 8–10mm
Colourful soldier-fly that feeds on nectar and rests on garden flowers. **ADULT** has a green body overall and a hairy head, eyes and thorax. Wings are smoky brown. Iridescent sheen on abdomen is coppery in males, violet in females. **LARVA** lives in damp ground. **STATUS** Common and widespread.

Snipe-fly

St Mark's Fly

Picture-winged Fly

Owl-midge

Bee-fly

Myopa buccata

Chloromyia formosa

Black Garden Ant *Lasius niger* Length 3mm

The familiar, dark garden ant. Forms colonies under slabs and stones. Abundant larvae and pupae are produced in summer. Diet is varied; aphids are 'milked' for honeydew. Cannot sting. **ADULT** worker (female) is blackish brown and wingless; queen is larger (5mm long). Mating swarms of winged males and queens fly on hot summer days. **STATUS** Abundant throughout.

Red Ant, adults and pupae

Red Ant *Myrmica rubra* Length 4mm

The other common garden ant. Favours garden soil and lawns; forms colonies under stones and logs. Diet is varied. Can deliver a painful sting. **ADULT** worker (female) is yellowish red and wingless; queen is larger (5mm long). Winged males and queens swarm in summer. **STATUS** Common and widespread.

Hornet *Vespa crabro* Length 30mm

Our largest wasp. **ADULT** worker (female) is tawny brown on thorax, rear of head and front of abdomen. Front of head is yellow-ish, and abdomen is mostly orange-yellow with black markings. Queen (seen in spring and autumn) is larger (up to 40mm long). Colony is active Jun–Sep. **STATUS** Once scarce; now locally common in the S in rural gardens. Often nests in tree-holes.

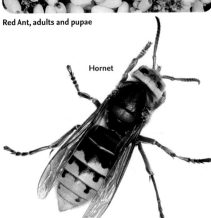

Hornet

German Wasp *Vespula germanica* Length 18mm

Familiar wasp. Like other wasps, its wings are folded lengthways at rest and it makes a buzzing sound in flight. Often nests in loft spaces. **ADULT** has typical wasp colours and body markings, but the face has 3 black dots when seen head on. **STATUS** Common and widespread; often seen in gardens.

Common Wasp *Vespula vulgaris* Length 18mm

Similar to the German Wasp (above) but separable by head markings. Papery nests are built in holes in the ground and in roof spaces. **ADULT** has typical wasp colours and markings; seen head on, face has a black anchor mark. **STATUS** Common and widespread.

Median Wasp *Dolichovespula media* Length 20mm

Recent arrival to Britain. Nests are often suspended in trees. **ADULT** has classic wasp markings but often shows more black than other species; females are usually tinged orange. Head shows a dark median line when seen front on; has 4 yellow spots at rear end of thorax. **STATUS** Locally common in the S; known here only since the 1980s.

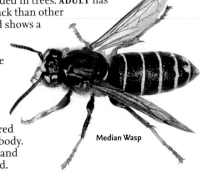

Median Wasp

Honey Bee *Apis mellifera* Length 12mm

Widely kept in hives for honey; wild colonies nest in tree-holes. Inside the colony, a network of wax cells form a 'comb' in which honey is stored and young are raised. **ADULT** has a furry brown body. Workers (females) comprise most of the colony and collect pollen. **STATUS** Common and widespread.

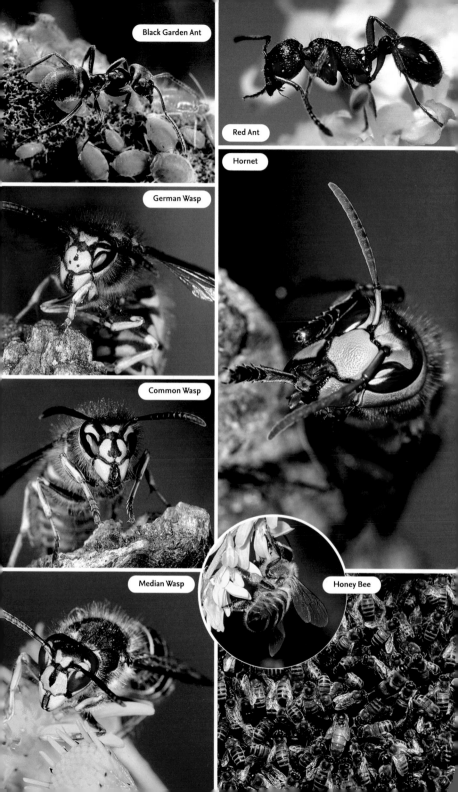

Black Garden Ant

Red Ant

Hornet

German Wasp

Common Wasp

Median Wasp

Honey Bee

Red-tailed Bumblebee *Bombus lapidarius*

Length 14–20mm

Distinctive bumblebee. Nests under stones or in holes in the ground. ADULT worker (female) and queen are black with a red tip to abdomen. Male (seen in late summer) is similar but with a yellow collar. STATUS Common, except in the far N.

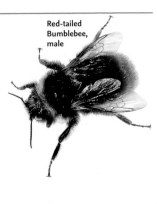

Red-tailed Bumblebee, male

White-tailed Bumblebee *Bombus lucorum*

Length 12–22mm

One of our most familiar bumblebees, and usually common in the garden. Nests in holes in the ground. ADULT has a bright yellow collar and band at front of abdomen. All individuals have a white-tipped abdomen. STATUS Common and widespread.

Buff-tailed Bumblebee *Bombus terrestris* Length 12–24mm

Well-marked and familiar bumblebee. The queen is distinctive but workers and males can be confused with White-tailed (above); note that the orange bands are much duller in Buff-tailed. ADULT has a blackish body with an orange-yellow collar and band at front of abdomen. Queen has a buff-tipped abdomen; this is off-white in workers and males. STATUS Common, except in the far N.

Early Bumblebee *Bombus pratorum* Length 10–16mm

Small, early-appearing bumblebee. Has a rather scruffy-looking coat. Given a poor view, could perhaps be confused with a Buff-tailed or White-tailed (above), but note the distinctive red-tipped abdomen. Nests above ground, sometimes in bird nest boxes. ADULT has a buffish-yellow collar and abdominal band; abdomen is red-tipped. STATUS Common and widespread.

Garden Bumblebee *Bombus hortorum* Length 12–20mm

Shaggy-coated bumblebee. Nests at ground level, or just below. ADULT has a yellow collar, band on rear of thorax and at front of abdomen. Tip of abdomen is extensively white. STATUS Common and widespread, often found in gardens.

Common Carder Bee *Bombus pascuorum* Length 12–17mm

Distinctive tawny-brown bumblebee. Nests at ground level or off the ground, sometimes in bird nest boxes. ADULT has a tawny-brown or ginger thorax, and a dark abdomen with a sparse coat of brown hairs. STATUS Common and widespread.

Tree Bumblebee *Bombus hypnorum* Length 13–18mm

Recent British colonist. Nests in tree-holes. ADULT has a unique combination (among bumblebees) of a ginger thorax and a striking white tip to otherwise black abdomen. STATUS First recorded in Britain in 2001; now fairly widespread in S England.

Hairy-footed Flower Bee *Anthophora plumipes* Length 14–16mm

Resembles a tiny bumblebee. Flight is fast and hoverfly-like. Visits lungwort flowers to feed. Nests in mortar or hole in ground. ADULT female is black with orange-yellow pollen baskets. Male is furry and buffish brown, with long, bristly hairs on middle legs. Both sexes have a long tongue. Active Mar–May. STATUS Common in central and S Britain.

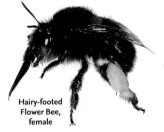

Hairy-footed Flower Bee, female

Hairy-footed Flower Bee, male

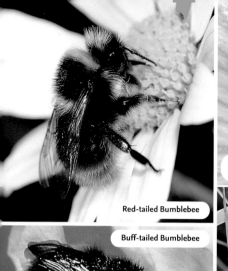

Red-tailed Bumblebee

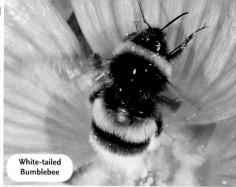

White-tailed Bumblebee

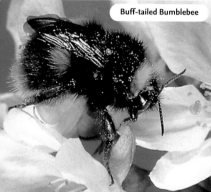

Buff-tailed Bumblebee

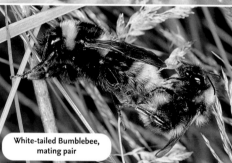

White-tailed Bumblebee, mating pair

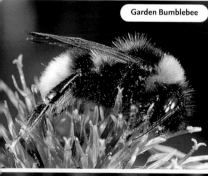

Garden Bumblebee

Early Bumblebee

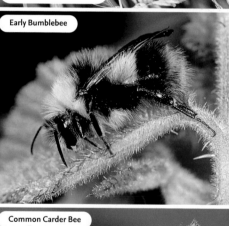

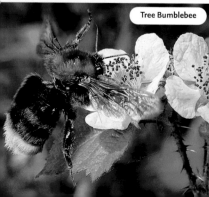

Tree Bumblebee

Common Carder Bee

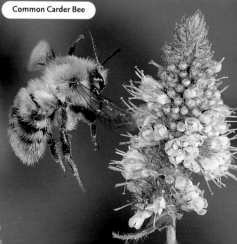

Leaf-cutter Bee *Megachile centuncularis* Length 13mm
Small, furry bee. Cuts semicircular holes in leaf margins of garden roses and other plants. **ADULT** is tawny buff; female has orange pollen baskets. Flies Jun–Aug. **LARVA** lives inside rolled, cut leaf sections. **STATUS** Common and widespread.

Red Mason Bee *Osmia rufa* Length 10mm
Familiar garden insect. Excavates nest in mortar of brick walls. **ADULT** has reddish-orange hairs on abdomen. Flies Apr–Jul. **LARVA** Remains hidden within chamber inside mortar. **STATUS** Common in the S.

Tawny Mining Bee *Andrena fulva* Length 13mm
Distinctive small bee. Nests in excavated burrows in the soil, often in lawns. **ADULT** female has orange-buff hair; flies Apr–Jun. **LARVA** lives in an underground chamber. **STATUS** Common and widespread.

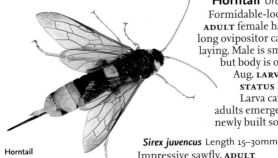

Horntail *Urocerus gigas* Length 20–30mm
Formidable-looking, albeit harmless sawfly. **ADULT** female has black and yellow markings; long ovipositor can penetrate timber for egg-laying. Male is smaller; abdomen is dull orange but body is otherwise blackish. Flies May–Aug. **LARVA** lives inside pine timber. **STATUS** Fairly common in pine forests. Larva can survive in cut wood, and adults emerge from stacked timber and newly built softwood constructions.

Horntail

Sirex juvencus Length 15–30mm
Impressive sawfly. **ADULT** female has a dark body with a metallic blue sheen, and reddish legs. Male is smaller, mostly dark with orange central abdominal segments. **LARVA** lives in pine trunks. **STATUS** Locally common. Larva can survive in cut wood; adults emerge from timber and newly built houses.

Sirex juvencus

Rose Sawfly *Arge pagana* Length 8–10mm
Striking sawfly; could be confused with the soldier-fly *Beris clavipes* (p. 244). **ADULT** has a bright orange-yellow abdomen but otherwise blackish body, and smoky wings. Flies May–Sep. **LARVA** is pale lime-green and yellow, with black dots. **STATUS** Common in the S, often in gardens.

SAWFLY LARVAE

Iris Sawfly larva *Rhadinoceraea micans*

The larvae of sawflies are sometimes found feeding on leaves. At first glance they look like moth and butterfly larvae, but a close inspection reveals that, in addition to the three pairs of true legs near the head that both groups possess, sawfly larvae have six or more pairs of fleshy, suckered 'prolegs' at the rear end; butterfly and moth larvae have five or fewer pairs of prolegs. Sawfly larvae are usually gregarious and, when alarmed, often curl up their tail ends.

Typical sawfly larvae

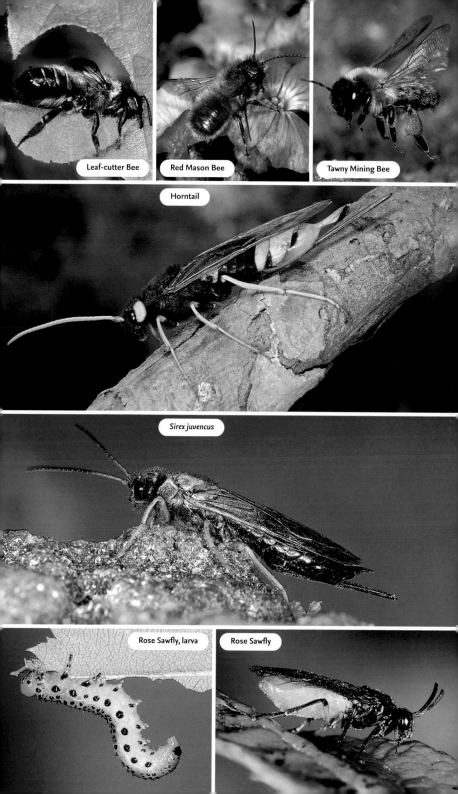

Leaf-cutter Bee

Red Mason Bee

Tawny Mining Bee

Horntail

Sirex juvencus

Rose Sawfly, larva

Rose Sawfly

Figwort Sawfly *Tenthredo scrophulariae* Length 12–15mm
Wasp-like sawfly. **ADULT** has black and yellow bands on abdomen, and orange-yellow antennae and legs. Flies Jun–Aug. **LARVA** is pale bluish green with black dots; feeds on figwort leaves. **STATUS** Common in England and Wales. Similar species occur.

Rhogogaster viridis Length 12mm
Colourful sawfly. Rests on flowers and catches other insects. **ADULT** is usually vivid green, darkest on dorsal surface, and has dark wings. Flies May–Aug. **LARVA** feeds on a range of herbaceous plants. **STATUS** Common and widespread.

Yellow Ophion
Ophion luteus Length 20mm
Familiar parasitic wasp. Comes to lighted windows after dark. **ADULT** has an orange-yellow body and constantly twitching antennae. Flies Jul–Sep. **LARVA** is an internal parasite of moth and butterfly larvae. **STATUS** Common and widespread.

Apanteles sp. Length 3–4mm (adult)
Tiny parasitic wasps, known best in their pupal stage. **ADULT** is a tiny wasp. **LARVA** is an internal parasite of butterfly larvae. **PUPA** is found inside a fluffy yellow cocoon, clusters of which surround the empty skins of its dead hosts, Large White and Small White butterfly larvae. **STATUS** Common and widespread.

Yellow
Ophion

Lissonata sp., male

Pteromalus puparum Length 2mm
Tiny parasitic wasp. **ADULT** has a metallic green body; adults emerge en masse from host pupa. Flies May–Aug, with several broods. **LARVA** is an internal parasite of Large White and Small White butterflies. **STATUS** Common and widespread.

Lissonata sp. Length 25–30mm
Parasitic wasps of wood-boring moth and beetle larvae. **ADULT** female has a blackish body, orange-red legs and a long black ovipositor, used to penetrate wood and parasitise hosts. Flies May–Jun. **LARVA** is an internal parasite of insect larvae. **STATUS** Common and widespread.

Amblyteles armatorius Length 12–15mm
Colourful ichneumon fly. Often sits on flower heads and twitches its antennae. **ADULT** has black and yellow markings on body and legs; wings are smoky brown. **LARVA** is an internal parasite of moth larvae. **STATUS** Common and widespread.

Ruby-tailed Wasp *Chrysis ignita* Length 11mm
Attractive insect. Female searches on walls and banks for mason wasp nests; if owner is absent, she parasitises the larvae. **ADULT** has a shiny green head and thorax, and a ruby-red abdomen. Flies Jun–Aug. **LARVA** is an external parasite of mason wasp larvae. **STATUS** Locally common.

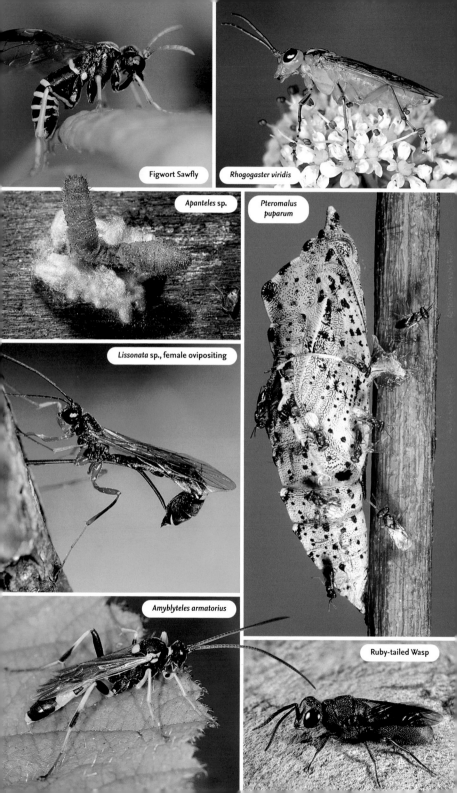

Figwort Sawfly

Rhogogaster viridis

Apanteles sp.

Pteromalus puparum

Lissonata sp., female ovipositing

Amyblyteles armatorius

Ruby-tailed Wasp

Pterostichus madidus Length 14mm
Typical garden ground beetle, usually found
under stones or logs in the daytime. **ADULT** is
shiny black, with finely grooved elytra and
reddish legs. Diet includes fruit and insects.
STATUS Common and widespread, and often
found in gardens. **SIMILAR SPECIES** P. nigrita has
black body and mostly black legs (inner
segment of front legs are reddish in
P. madidus). Widespread and common.

*Pterostichus
nigrita*

Violet Ground Beetle *Carabus violaceus*
Length 28mm
Striking beetle. Hides under stones in the daytime. **ADULT** has a violet sheen on thorax
and elytra margins. **STATUS** Common and widespread; often found in gardens and
hedgerows.

Devil's Coach-horse *Staphylinus olens* Length 24mm
Spectacular rove beetle. If threatened, curls up its abdomen and opens its jaws in a menac-
ing fashion. Hides under stones in the daytime; feeds on invertebrates after dark. Found
year-round. **ADULT** has an all-black elongated body, with a large head and jaws. **STATUS**
Common and widespread; often found in gardens.

Staphylinus caesareus Length 18–20mm
Colourful little rove beetle. Associated with dung and carrion. Mainly nocturnal, so usual-
ly encountered by chance. **ADULT** has a mainly blackish body, but with reddish-orange
elytra and legs. **STATUS** Fairly common and widespread, but easily overlooked. Sometimes
encountered in rural gardens.

Paederus littoralis Length 9mm
Small, strikingly colourful rove beetle. Favours damp, organic-rich debris, including
compost heaps. **ADULT** has a slender red and black body. **STATUS** Common and
widespread.

Stag Beetle *Lucanus cervus* Length 40mm
Impressive beetle. **ADULT** has reddish-brown
elytra, and a black head and thorax.
Male has enlarged, antler-like
jaws, used to battle rivals for right
to mate with antler-less female.
Found May–Jul. **LARVA** lives in buried,
rotting wood. **STATUS** Local in S England;
sometimes found in suburban gardens.

Stag Beetle,
female

Lesser Stag Beetle
Dorcus parallelipipedus Length 28mm
Flat-bodied beetle. **ADULT** recalls a female
Stag Beetle (above) but has an all-black
body and a proportionately large, broad
head and thorax. Found May–Sep. **LARVA**
lives in rotting wood. **STATUS** Widespread but local in S Britain and Ireland.

Rhinoceros Beetle *Sinodendron cylindricum* Length 15mm
Small but distinctive beetle, sometimes found under rotting wood. **ADULT** is black and
rather cylindrical; male has a shiny body with a horn-like projection on head. Found
May–Aug. **LARVA** lives in rotting wood. **STATUS** Widespread but local.

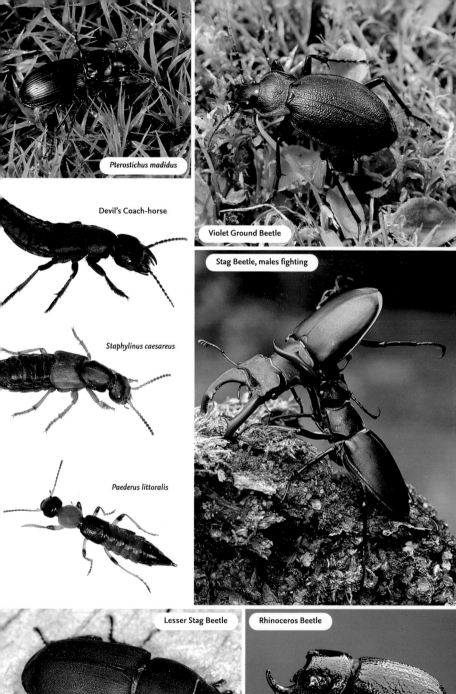

Pterostichus madidus

Devil's Coach-horse

Violet Ground Beetle

Staphylinus caesareus

Paederus littoralis

Stag Beetle, males fighting

Lesser Stag Beetle

Rhinoceros Beetle

Eyed Ladybird *Anatis ocellata* Length 8mm
Large and distinctive ladybird. Associated with conifers. **ADULT** has orange-red elytra marked with white-ringed black spots; head and thorax are black and white. Seen Jun–Jul. **STATUS**. Widespread and locally common.

Seven-spot Ladybird *Coccinella 7-punctata* Length 6–7mm
Formerly our most familiar and abundant ladybird; now ousted in many parts by the Harlequin Ladybird (below). Found in a wide range of habitats, including gardens. **ADULT** has reddish-orange elytra with 7 black spots; head and thorax are black and white. Seen Mar–Oct. **STATUS** Common and widespread.

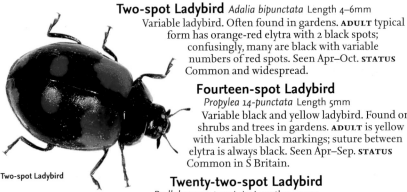

Two-spot Ladybird *Adalia bipunctata* Length 4–6mm
Variable ladybird. Often found in gardens. **ADULT** typical form has orange-red elytra with 2 black spots; confusingly, many are black with variable numbers of red spots. Seen Apr–Oct. **STATUS** Common and widespread.

Fourteen-spot Ladybird
Propylea 14-punctata Length 5mm
Variable black and yellow ladybird. Found on shrubs and trees in gardens. **ADULT** is yellow with variable black markings; suture between elytra is always black. Seen Apr–Sep. **STATUS** Common in S Britain.

Two-spot Ladybird

Twenty-two-spot Ladybird
Psyllobora 22-punctata Length 3–4mm
Small, colourful ladybird. Found in hedgerows and gardens. **ADULT** is bright yellow, each elytra with either 10 or 11 black spots. Seen Apr–Sep. **STATUS** Common in the S.

Cream-spot Ladybird *Calvia 14-guttata* Length 4–6mm
Distinctive little ladybird. **ADULT** is deep orange-red, each elytra with 7 creamy-white spots. Seen Apr–Sep. **STATUS** Widespread and fairly common in gardens and hedgerows.

Harlequin Ladybird *Harmonia axyridis* Length 9mm
Very variable species. Found in gardens and hedgerows. **ADULT** often has yellowish-orange or orange-red elytra with variable numbers of black spots; some have black elytra with red spots (often 1 per elytra). Most have a dark thorax with 2 striking white lateral spots. **STATUS** First recorded here in 2004; range is spreading. A predator of insects, including other ladybirds; now the commonest ladybird in many parts.

LADYBIRD LARVAE

Like adults, ladybird larvae are predators, with aphids featuring in their diets. Identification is hard unless you raise them through to adulthood. A typical larva has an elongated body with bristly projections on each abdominal segment. The body is often bluish or reddish with yellow spots.

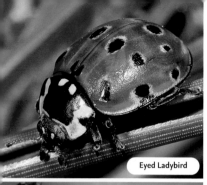

Eyed Ladybird

Two-spot Ladybird

Twenty-two-spot Ladybird

Harlequin Ladybird

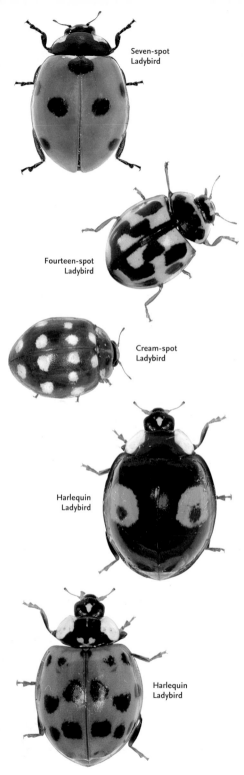

Seven-spot
Ladybird

Fourteen-spot
Ladybird

Cream-spot
Ladybird

Harlequin
Ladybird

Harlequin
Ladybird

Rose Chafer *Cetonia aurata* Length 17mm

Colourful beetle. Often found in flowers, including roses; moves in a cumbersome manner. **ADULT** has a shiny bronzy-green body; the parallel-sided elytra are flecked with white lines and marks. Seen May–Sep. **LARVA** lives in rotting wood. **STATUS** Widespread and locally common, except in Scotland.

Cockchafer

Melolontha melolontha
Length 35mm
Familiar garden beetle. Attracted to outside lights and sometimes swarms around trees at dusk. **ADULT** has hairy rufous-brown elytra and a pointed-tipped abdomen. Seen May–Jun. **LARVA** eats plant roots (*see* photo p. 266). **STATUS** Common, except in Scotland.

Summer Chafer

Amphimallon solstitialis
Length 15–20mm
Compact chafer, recalling a small all-brown Cockchafer (above). Swarms around trees at dusk. **ADULT** is orange-brown; thorax is hairy. Seen Jun–Jul. **LARVA** lives underground, eating plant roots. **STATUS** Locally common only in England and Wales.

Serica brunnea Length 8–10mm
Recalls a small Summer Chafer (above). **ADULT** is mostly orange-brown with a blackish head and eyes. Seen Jul–Aug. **LARVA** feeds on plant roots. **STATUS** Common, except in the far N.

Rhagonycha fulva Length 11mm
Common soldier beetle. Hunts other insects in flowers. Flies well in sunny weather; mating pairs are a common sight. **ADULT** is mainly orange-red with dark-tipped elytra. Seen May–Aug. **STATUS** Common and widespread.

Cantharis rustica Length 14mm
Distinctive soldier beetle. Often seen in flowers, hunting other insects **ADULT** has a reddish abdomen, black elytra and a reddish pronotum marked with a dark spot. Seen May–Sep. **STATUS** Common only in England and Wales.

Glow-worm *Lampyris noctiluca* Length 14mm

Distinctive beetle, located after dark by the greenish light emitted from the underside of wingless female's abdomen tip; this attracts winged males. **ADULT** female has an elongated body; male has a slender body. **LARVA** eats snails and also emits light. **STATUS** Local in S and central Britain, in hedgerows and sometimes in rural gardens.

Lagria hirta Length 10mm
Soft-bodied and rather sluggish beetle. Visits rural gardens, where it is found crawling over flowers and leaves. **ADULT** has an elongated blackish body, the elytra covered in yellowish hairs. Seen May–Aug. **STATUS** Local in S Britain.

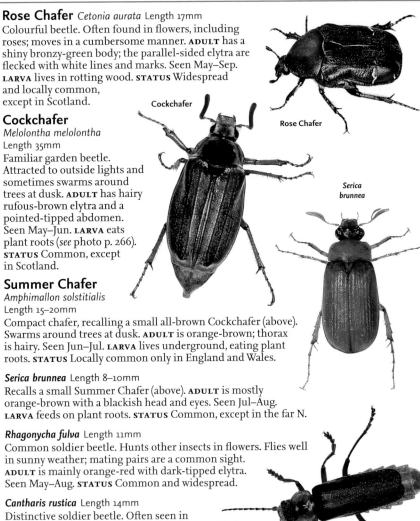

Cockchafer

Rose Chafer

Serica brunnea

Cantharis rustica

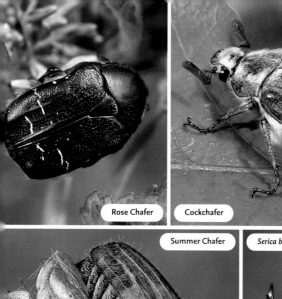

Rose Chafer

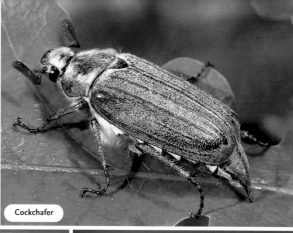

Cockchafer

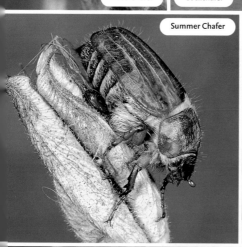

Summer Chafer

Serica brunnea

Rhagonycha fulva

Lagria hirta

Glow-worm

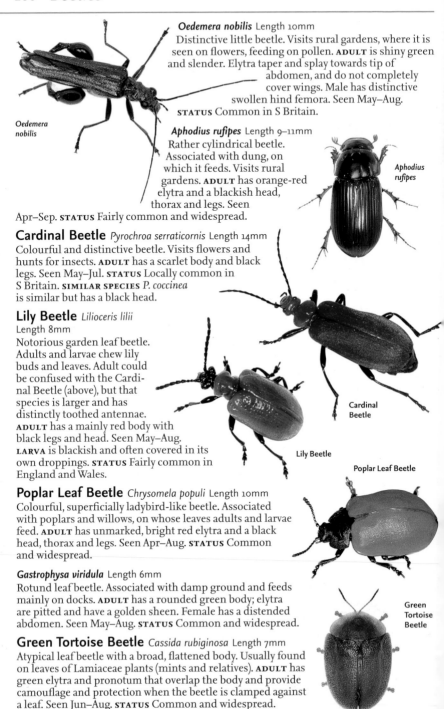

Oedemera nobilis Length 10mm
Distinctive little beetle. Visits rural gardens, where it is seen on flowers, feeding on pollen. **ADULT** is shiny green and slender. Elytra taper and splay towards tip of abdomen, and do not completely cover wings. Male has distinctive swollen hind femora. Seen May–Aug. **STATUS** Common in S Britain.

Oedemera nobilis

Aphodius rufipes Length 9–11mm
Rather cylindrical beetle. Associated with dung, on which it feeds. Visits rural gardens. **ADULT** has orange-red elytra and a blackish head, thorax and legs. Seen Apr–Sep. **STATUS** Fairly common and widespread.

Aphodius rufipes

Cardinal Beetle *Pyrochroa serraticornis* Length 14mm
Colourful and distinctive beetle. Visits flowers and hunts for insects. **ADULT** has a scarlet body and black legs. Seen May–Jul. **STATUS** Locally common in S Britain. **SIMILAR SPECIES** *P. coccinea* is similar but has a black head.

Lily Beetle *Lilioceris lilii*
Length 8mm
Notorious garden leaf beetle. Adults and larvae chew lily buds and leaves. Adult could be confused with the Cardinal Beetle (above), but that species is larger and has distinctly toothed antennae. **ADULT** has a mainly red body with black legs and head. Seen May–Aug. **LARVA** is blackish and often covered in its own droppings. **STATUS** Fairly common in England and Wales.

Cardinal Beetle

Lily Beetle

Poplar Leaf Beetle

Poplar Leaf Beetle *Chrysomela populi* Length 10mm
Colourful, superficially ladybird-like beetle. Associated with poplars and willows, on whose leaves adults and larvae feed. **ADULT** has unmarked, bright red elytra and a black head, thorax and legs. Seen Apr–Aug. **STATUS** Common and widespread.

Gastrophysa viridula Length 6mm
Rotund leaf beetle. Associated with damp ground and feeds mainly on docks. **ADULT** has a rounded green body; elytra are pitted and have a golden sheen. Female has a distended abdomen. Seen May–Aug. **STATUS** Common and widespread.

Green Tortoise Beetle

Green Tortoise Beetle *Cassida rubiginosa* Length 7mm
Atypical leaf beetle with a broad, flattened body. Usually found on leaves of Lamiaceae plants (mints and relatives). **ADULT** has green elytra and pronotum that overlap the body and provide camouflage and protection when the beetle is clamped against a leaf. Seen Jun–Aug. **STATUS** Common and widespread.

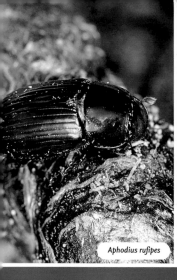
Aphodius rufipes

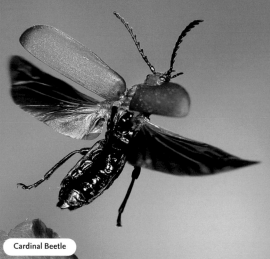
Cardinal Beetle

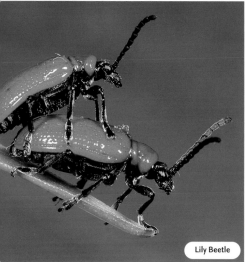
Lily Beetle

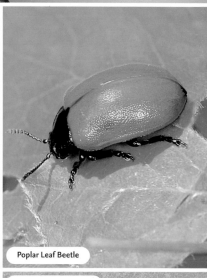
Poplar Leaf Beetle

Gastrophysa viridula

Green Tortoise Beetle

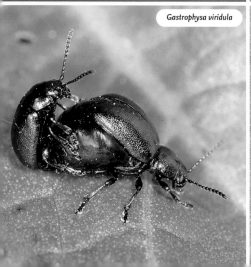

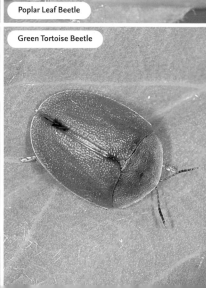

Mint Leaf Beetle *Chrysolina menthastri* Length 9mm
Rounded, extremely shiny leaf beetle. Favours damp ground and usually found on mint leaves, sometimes also on hemp-nettles. ADULT is bronzy green, with a metallic sheen. Seen May–Sep. STATUS Locally common, but absent from Ireland.

Chrysolina polita Length 6–9mm
Beautiful little leaf beetle. Favours damp ground, and found on mints and other Lamiaceae (mint family) plants. ADULT has red or reddish-brown elytra and a metallic green pronotum. Seen Apr–Oct. STATUS Common and widespread.

Rosemary Leaf Beetle *Chrysolina americana* Length 8–10mm
Attractive beetle and a recent arrival to Britain. Found on Rosemary *Rosmarinus officinalis* and lavender plants; eats new shoots and causes them to die. ADULT has a rounded body, with lengthways metallic purple and green stripes on elytra. Seen May–Sep. STATUS First recorded in 1994; now widespread in S England.

Phytodecta viminalis Length 8–9mm
Well-marked leaf beetle whose colours and markings recall a ladybird. Found mainly on willow leaves. ADULT is red or reddish brown with variable black marks on elytra and pronotum. Seen May–Aug. STATUS Widespread and fairly common.

Vine Weevil *Otiorhynchus sulcatus* Length 11mm
Familiar garden weevil whose larvae eat the roots of potted plants. ADULT has a grey-brown body marked variably with patches of yellowish scales; rostrum is short and broad. Seen May–Aug. STATUS Common and widespread.

Phyllobius pomaceus Length 9mm
Small weevil that is often found in the garden; usually associated with Common Nettle. ADULT has a blackish body covered in greenish scales that are easily rubbed off. Seen Apr–Aug. STATUS Common and widespread.

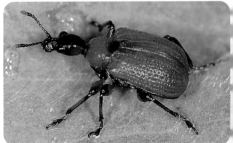

Phyllobius pomaceus

Acorn Weevil *Curculio glandium* Length 5–8mm
Typical weevil. Associated with oak trees; larvae live inside acorns. ADULT has a rather ovoid body covered in brown scales, with subtle marbled patterning. Eyes are dark, and blackish rostrum is extremely long and curved. Seen Apr–Jul. STATUS Common only in S Britain.

Nut Weevil *Curculio nucum* Length 6mm
Similar to the Acorn Weevil (above), but rostrum is proportionately shorter. Always associated with Hazel; larvae live inside nuts. ADULT has an orange-brown body and subtly darker tip to long, curved rostrum. Seen Apr–Jun. STATUS Locally common.

Apoderus coryli Length 5–8mm
Colourful and atypical weevil that lives on Hazel. Reminiscent of a tiny Lily Beetle (*see* p. 260). ADULT has red thorax and elytra and mainly black head. Base of legs are reddish. Seen May–Jul. STATUS Widespread and fairly common.

Apoderus coryli

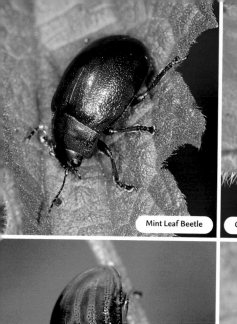

Mint Leaf Beetle

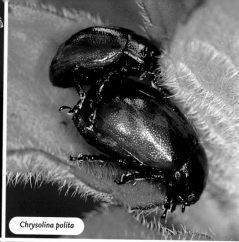

Chrysolina polita

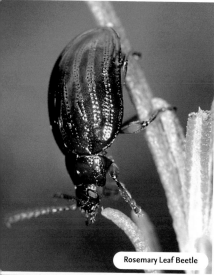

Rosemary Leaf Beetle

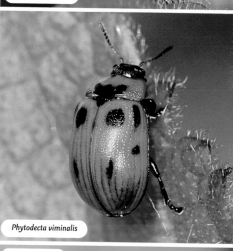

Phytodecta viminalis

Acorn Weevil

Vine Weevil

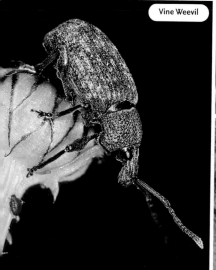

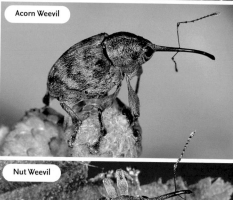

Nut Weevil

BURYING BEETLES

Burying beetles belong to family Silphidae and perform an invaluable service as part of the cycle of life and death. They are sometimes found under animal carcasses or in the act of interring a dead mouse or small bird; they locate these using their keen sense of smell. Having buried the corpse or carrion, the female lays her eggs beside it and the developing larvae use it as a source of food. If you have an enquiring mind and a strong stomach, place a mammal corpse such as a road-kill Rabbit in a wire-mesh cage (to prevent it being dragged away by a Fox or dog). Lift and shake the cage over a white tray every day – burying beetles will drop out. They are often covered in tiny reddish-brown mites (*Gamasus* spp.).

Nicrphorus vespilloides and shrew

Nicrophorus vespillo Length 18–21mm

ADULT has 2 orange bands on elytra and orange-tipped antennae. Hind tibiae are incurved; has yellow hairs at front of thorax. **STATUS** Common and widespread.

Nicrophorus vespilloides Length 18–21mm

ADULT has 2 orange bands on elytra, the posterior band often reduced to 2 spots. Antennae are all dark (in similarly marked species they have orange tips). **STATUS** Common and widespread.

Nicrophorus investigator Length 18–20mm

ADULT has 2 orange bands on elytra, the posterior band often slightly interrupted. Thorax lacks yellow hairs. **STATUS** Widespread and fairly common.

Nicrophorus interruptus Length 18–20mm

ADULT has 2 orange bands on elytra, both broadly interrupted. Thorax lacks yellow hairs. **STATUS** Widespread but local.

Nicrophorus humator Length 24–26mm

ADULT has a black body; clubbed antennae have orange tips. Hind tibiae are straight. **STATUS** Common and widespread.

Necrodes littoralis Length 21–23mm

ADULT has a black body; antennae are not clubbed and are mostly dark, palest towards tip. Hind tibiae are incurved; both elytra bear a 'pimple'. **STATUS** Common and widespread.

Silpha atrata Length 10–12mm
Flattened burying beetle relative. Feeds on snails: its long head can reach deep inside shells. **ADULT** is black, the elytra punctured and ridged. **STATUS** Common and widespread.

Click Beetle
Athous haemorrhoidalis
Length 14mm
Elongated beetle. Can leap into the air if disturbed, accompanied by an audible click. Found on deciduous shrubs, notably Hazel. **ADULT** has hairy reddish-brown elytra and a darker head and thorax. Seen May–Jun. **STATUS** Common and widespread.

Silpha atrata

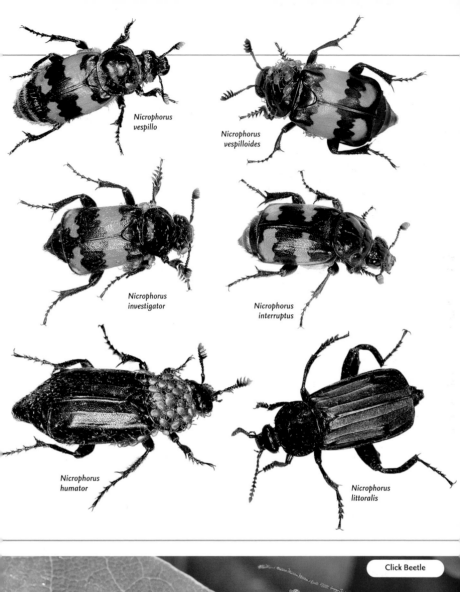

Nicrophorus vespillo

Nicrophorus vespilloides

Nicrophorus investigator

Nicrophorus interruptus

Nicrophorus humator

Nicrophorus littoralis

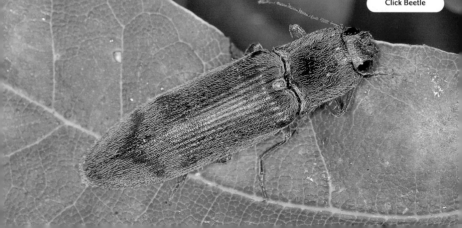

Click Beetle

Furniture Beetle *Anobium punctatum* Length 3–5mm
Small, cylindrical beetle with a hunchbacked appearance:
the head is tucked under the prominent pronotum.
ADULT has a dark brown head and thorax, and rich
brown elytra marked with pitted ridges. Seen mainly
May–Jul. LARVA is the notorious 'Woodworm' that bores
tunnels in timber; exit holes mark the emergence of
adults. STATUS Common and widespread.

' Woodworm' holes

Varied Carpet Beetle *Anthrenus verbasci* Length 1.5–2.5mm
Tiny, rounded beetle that feeds on pollen and is often seen in flowers. ADULT is covered in
grey, yellow and black scales. Seen mainly May–Jul. LARVA is also known as a 'Woolly Bear'
and feeds on dried organic matter, including woollen jumpers and carpets. STATUS
Common and widespread.

Strangalia maculata Length 16mm
Superficially similar to the Wasp Beetle (above), but its elytra are much more yellow. Flies
well and often visits flowers. ADULT has yellow and black elytra, the precise markings
being variable. Legs are black and yellow, but body is otherwise black. Antennae are very
long. Seen Jun–Aug. STATUS Common and widespread.

Wasp Beetle *Clytus arietus* Length 16mm
Extremely wasp-like longhorn beetle, both in terms of markings but also behaviour. Flies
well in sunny weather and often visits flowers. ADULT has striking yellow bands on its
otherwise black body. Seen May–Jul. STATUS Locally common.

Rhagium mordax Length 21mm
Well-marked, downy longhorn beetle. Favours oak woodlands and mature rural gardens.
Sometimes forages in flowers and on foliage. ADULT is buffish brown with darker mark-
ings. Seen May–Jul. LARVA lives in rotting wood. STATUS Locally common.

BEETLE LIFE CYCLES

As with many other insect groups, beetles have a life
cycle that comprises four stages: adults mate and lay
eggs; these hatch into larvae; eventually the larvae
pupate; and from the pupae, new adults emerge.
Beetle larvae are typically rather grub-like, with biting
mouthparts and an unspecialised, segmented body.
Some, such as the Cockchafer larva (p. 258), live in
the soil and eat plant roots; others, including most
longhorn beetle larvae, tunnel in wood; ladybird
larvae are free-living and are predators of aphids
and other small insects. Beetle
pupae are usually rather soft
and vulnerable to damage;
the pupation site is often in
an underground chamber.

Longhorn beetle larva.

Cockchafer
larva.

Summer Chafer
pupa.

Ladybird
larva.

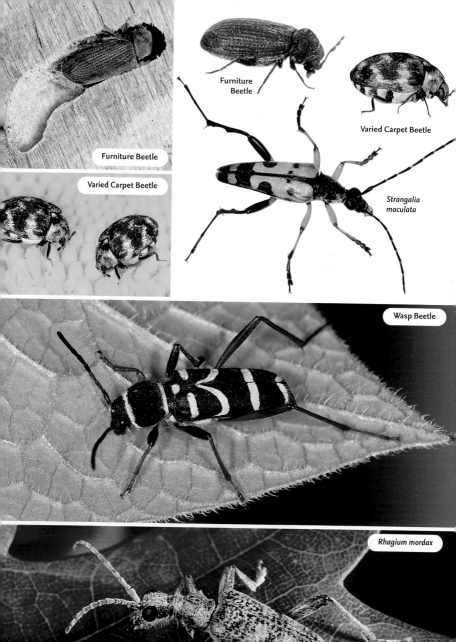

Furniture Beetle

Furniture Beetle

Varied Carpet Beetle

Varied Carpet Beetle

Strangalia maculata

Wasp Beetle

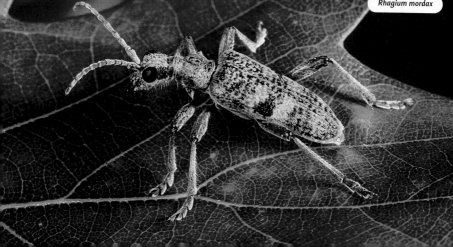

Rhagium mordax

INTRODUCING GARDEN SPIDERS

Spiders inspire mixed emotions in many people, but love or hate them, they are an ever-present part of most homes and gardens. Several species are perpetual house guests.

WHAT ARE SPIDERS?

Spiders are arthropod invertebrates with jointed legs and a hardened outer skin called an exoskeleton. They differ from other arthropods such as insects in having four pairs of legs and a body divided into two parts (a fused head and thorax – the cephalothorax – and an abdomen); a typical adult insect body comprises three parts (head, thorax and abdomen) and there are three pairs of legs. Spiders produce silk, as do many insects. However, spiders have perfected its use, and the webs created by many species are breathtaking architectural structures.

legs

cephalothorax

abdomen

A typical spider.

SILK AND WEBS

Silk is a protein that spiders produce in glands in their abdomen. It is produced in liquid form, but hardens as it is stretched and has incredible tensile strength. Spiders use silk as a lifeline when they move and to protect their eggs, and many species spin webs in which to trap their prey.

As a testament to the strength of silk, this single strand easily supports the weight of this large female Common Cross Spider.

PREDATORY HABITS

All spiders are predators, most eating other invertebrates and insects in particular. They have paired fangs that they plunge into the victim like hypodermic needles, injecting a paralysing venom; in many species the venom also partially digests the prey's internal organs. The ways that spiders feed are varied: some are active hunters, using eyesight and sensitivity to vibrations to catch their prey; others favour the camouflaged ambush approach, lying in wait for passing prey; and many spin silken webs to entrap their victims.

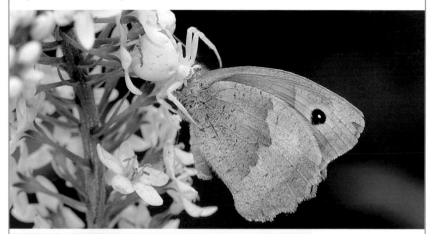

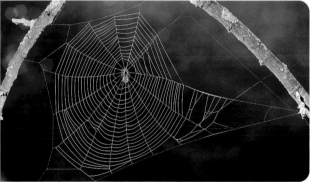

ABOVE: **Crab spiders,** such as *Misumena vatia,* are masters of disguise, their colours and posture a perfect match for the flowers on which they wait in ambush. This one has just caught a Meadow Brown butterfly.

LEFT: A Garden Spider at the centre of its orb web; these marvels of construction are the apogee of silk use among spiders and are often created on a daily basis.

At the centre of an untidy sheet web, this spider has a funnel into which it retreats when danger threatens; it emerges to grab its victim if it senses vibrations on the silk.

Garden Spider *Araneus diadematus* Body length 12mm
Familiar spider, found in gardens and meadows. Its web is a sophisticated orb. **ADULT** varies from grey-brown to reddish brown; abdomen has a central row of white dots and transverse white streaks forming a cross. Female is much larger than male. Seen Jul–Oct. **STATUS** Common and widespread.

Common Cross Spider *Araneus quadratus* Body length 20mm
Well-marked spider of gardens and hedgerows. **ADULT** is similar to Garden Spider (above) but abdomen has 4 large white spots arranged in a square and a white anterior stripe. Abdomen varies from nut-brown to bright red. Female is much larger than male. Seen Jul–Oct. **STATUS** Common and widespread.

Araniella cucurbitina Body length 6mm
Small, attractive spider that spins an untidy orb web among low wayside vegetation. Found in gardens, rough meadows and hedgerows, often among thistles and Bramble. **ADULT** has a lime-green abdomen with yellow bands; cephalothorax and legs are reddish brown. Seen May–Sep. **STATUS** Common and widespread.

Nuctenea umbricata Body length 15–18mm
Strictly nocturnal orb-web spider that hides in the daytime. If disturbed, it retracts its legs and 'plays dead'. Found in gardens, and around houses and sheds. **ADULT** has a yellowish-brown abdomen, marked with a marginal, wavy dark line, a central dark line and dark pits. Female is seen year-round. **STATUS** Common and widespread, but easily overlooked.

Amaurobius similis Body length 12mm
Familiar funnel-web spider, found on walls, behind bark and on fences, in gardens and hedgerows. Builds a tangled bluish-white web leading back to a retreat in a crevice. **ADULT** has a buffish abdomen with paired dark dorsal markings and chevrons towards rear end. Cephalothorax and legs are usually orange-brown. Seen May–Sep. **STATUS** Common and widespread.

Dysdera crocata
Body length 12mm
Attractive and distinctive spider that hides under stones during the daytime. Found in gardens with woodlice. **ADULT** has reddish legs and cephalothorax, and a buffish-brown abdomen. Fangs are relatively huge and opposable, and used to good effect when capturing woodlice. **STATUS** Common and widespread.

House
Spider

House Spider
Tegenaria domestica Body length 10mm
Large, long-legged spider. Spins an untidy web with a tubular retreat in the corner of a room. Females can survive for several years. **ADULT** is rather hairy and varies from pale to dark brown. **STATUS** Common and widespread.

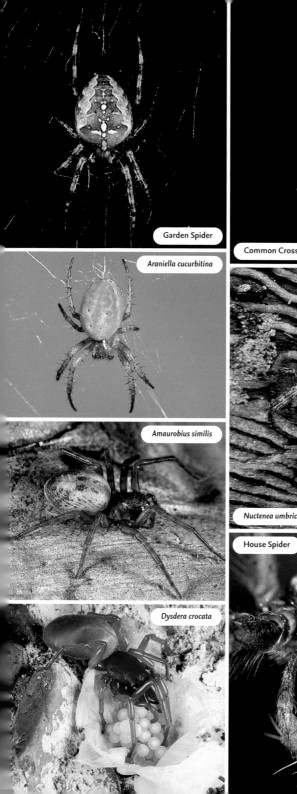

Garden Spider

Common Cross Spider

Araniella cucurbitina

Amaurobius similis

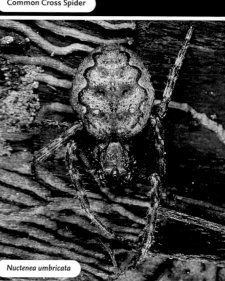

Nuctenea umbricata

House Spider

Dysdera crocata

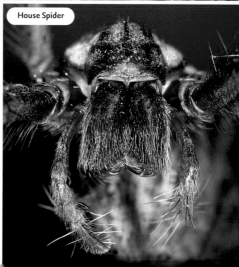

Agelena labyrinthica Body length 16–18mm
Constructs a large sheet web with a central funnel-shaped retreat, along walls and in banks and hedgerows. **ADULT** has a yellowish-brown body, palest on legs and dorsal surface of cephalothorax. **STATUS** Common and widespread.

Misumena vatia Body length 10mm
Widespread crab spider. Ambushes insect prey, resting camouflaged in flowers; changeable colour matches petals. **ADULT** female is typically pure white or pale yellow. Male is tiny with dark legs, and easily overlooked. Seen May–Aug. **STATUS** Common and widespread.

Xysticus cristatus Body length 6mm
Well-marked crab spider. Waits motionless with legs outstretched on a bare stalk or flower. Found in rural gardens, meadows and hedgerows. **ADULT** has patterns of pale and dark brown on abdomen, these forming a series of overlapping triangles. Seen May–Jul. **STATUS** Common and widespread.

Xysticus cristatus

Zebra Spider
Salticus scenicus Body length 7mm
Well-marked and aptly named jumping spider. Moves restlessly up sunny fences and walls. Spots potential prey using its large eyes and then stalks it to within leaping range. **ADULT** has black and white stripes. **STATUS** Common and widespread.

Zebra Spider

Daddy-long-legs Spider *Pholcus phalangioides* Body length 8mm
Household spider usually found hanging upside down from ceilings; spins an untidy web. **ADULT** is narrow-bodied and long-legged. Seen year-round. **STATUS** A relatively recent arrival to Britain, encouraged by the spread of central heating; cannot survive where temperatures dip below 10°C.

Metellina merianae Body length 9mm
Typical cave spider that shuns the light and spends its life in caves and cellars. Particularly common near coasts. **ADULT** has a marbled brown and black abdomen, while its shiny legs are marked with irregular bands of reddish brown and black. Seen May–Jul. **STATUS** Widespread but local.

Pisaura mirabilis Length 14mm
Common hunting spider. Found in mature gardens and hedgerows. Female carries egg sac underneath her body, and builds a nursery tent just before the eggs hatch. **ADULT** has a buffish-brown body with a dark-bordered yellow stripe on carapace. Seen May–Jul. **STATUS** Common and widespread.

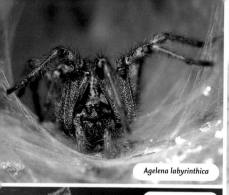

Agelena labyrinthica

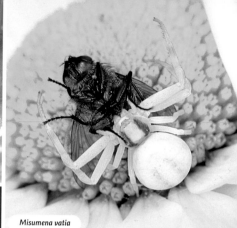

Misumena vatia

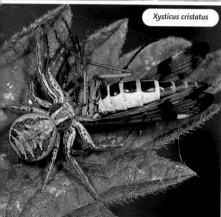

Xysticus cristatus

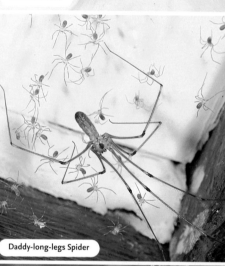

Daddy-long-legs Spider

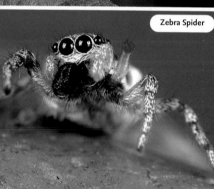

Zebra Spider

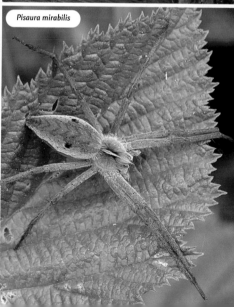

Pisaura mirabilis

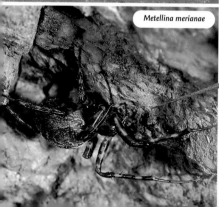

Metellina merianae

Wolf spiders *Pardosa* spp. Body length 6mm
Active hunters, often found in leaf litter. In spring, females carry egg sac attached to the abdomen tip; after the young hatch, they cling to the mother's abdomen. **ADULT** is typically yellow-buff and brown; legs are relatively long. Seen Apr–Jun. **STATUS** Common and widespread.

Enoplognatha elongata Body length 6mm
Colourful little spider with a globular body and translucent legs. Found in flower borders and shrubs. **ADULT** is variable, but typically has a creamy-white abdomen with green and red stripes. Seen May–Jul. **STATUS** Common and widespread.

Tetragnatha extensa Body length 10mm
Long-legged spider with an elongated, sausage-like abdomen. Often aligns itself along a plant stem with legs outstretched. Favours damp ground. **ADULT** has reddish-brown legs and cephalothorax, and a marbled yellow, brown and white abdomen. Seen Jun–Aug. **STATUS** Common and widespread.

> ### MONEY SPIDERS, family Linyphyiidae Body length 2–3mm
> Tiny spiders that create sheet webs, these most obvious at low angles of the sun or when dew-covered on damp mornings. Spider hangs beneath the sheet. There are many species and these are hard to identify. Small examples can 'fly', 'ballooning' on strands of silk, borne by the wind.

> ### HARVESTMEN, order Opiliones
> Spider-like arthropods with 4 pairs of long, gangly legs. Body is undivided (spiders have a separate cephalothorax and abdomen). They do not produce silk and their diet includes a mixture of scavenged dead animals and live prey.

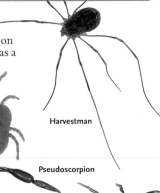

Velvet Mite

Harvestman

Pseudoscorpion

Red Spider Mite
Tetranychus urticae Length 0.5mm
Tiny, fast-moving arachnid that forms sizeable colonies on greenhouse plants. Infestations cause leaf wilt. **ADULT** has a rounded body and 4 pairs of legs. In spring, colour is yellowish green with dark marks, but by summer it becomes bright red. **STATUS** Common and widespread.

Velvet Mite
Trombidium holosericeum Length 5mm
Colourful soil-dwelling arachnid that is a predator of small insects. **ADULT** has a broadly flattened body and 4 pairs of legs, all cloaked in velvety hairs. Seen year-round. **STATUS** Common and widespread.

> ### FALSE SCORPIONS,
> ### order Pseudoscorpiones Length 2–3mm
> Tiny arachnids that are predators with poison claws. Most species live in leaf litter and compost heaps. ADULT resembles a tiny scorpion. STATUS Common and widespread.

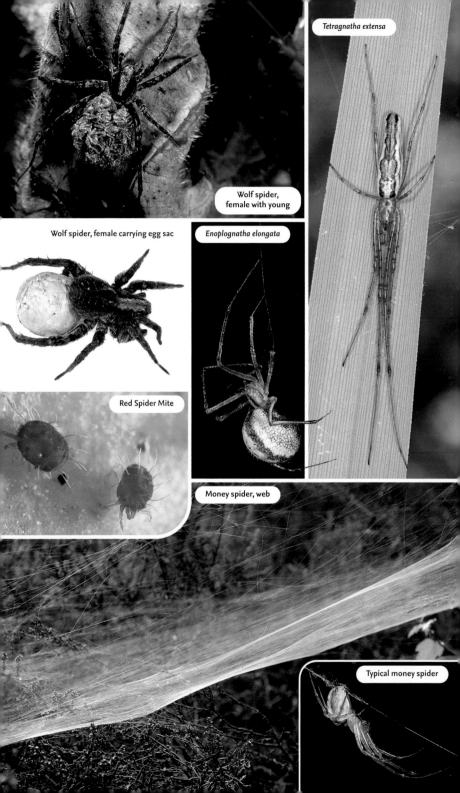

Wolf spider, female with young

Tetragnatha extensa

Wolf spider, female carrying egg sac

Enoplognatha elongata

Red Spider Mite

Money spider, web

Typical money spider

INTRODUCING NON-INSECT GARDEN INVERTEBRATES

In the garden, the most diverse and numerous animals are invertebrates (animals without backbones). Of these, insects and spiders are the most common and obvious, and have already been covered in this book (pp. 126–275). But there are a range of other invertebrates that inhabit the world immediately around us; below is an introduction to the major groups of these creatures.

THE INVERTEBRATE GROUPS

Invertebrates are classified into a number of subdivisions, called phyla (singular phylum), three of which are well represented in the garden. These are: annelid worms; molluscs; and arthropods.

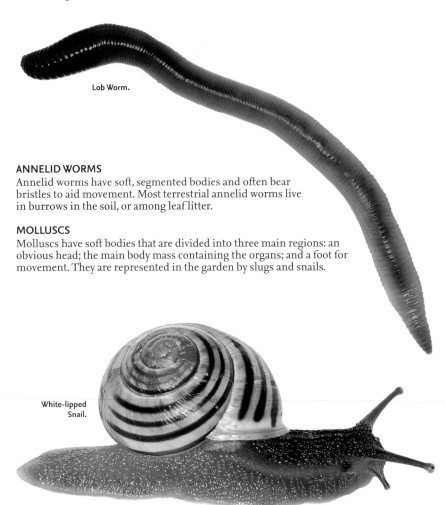

Lob Worm.

ANNELID WORMS

Annelid worms have soft, segmented bodies and often bear bristles to aid movement. Most terrestrial annelid worms live in burrows in the soil, or among leaf litter.

MOLLUSCS

Molluscs have soft bodies that are divided into three main regions: an obvious head; the main body mass containing the organs; and a foot for movement. They are represented in the garden by slugs and snails.

White-lipped Snail.

ARTHROPODS

Arthropods have an external skeleton and paired, jointed limbs. Muscles are internal, attached to the walls of the hardened exoskeleton. This large and complex collection of invertebrates includes the following groups: insects (dealt with on pp. 126–267, and not covered here); spiders and allies (dealt with on pp. 268–75, and not covered here); centipedes; millipedes; and crustaceans.

Centipedes

Centipedes are elongated, segmented arthropods with a pair of legs attached to each body segment. They are predators, as might be guessed from looking at the pair of sharp poison claws at the mouth.

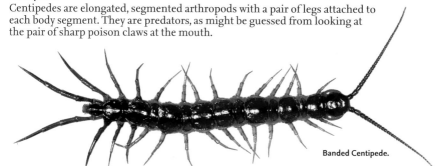

Banded Centipede.

Millipedes

Millipedes are superficially similar to centipedes, but with two pairs of legs per segment. They feed on plant tissue and detritus, and are relatively slow-moving.

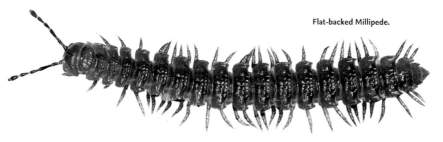

Flat-backed Millipede.

Crustaceans

Most crustaceans live in water – both marine and fresh – but are represented in the garden by woodlice, which are tied to damp environments. They have segmented bodies with a hard dorsal carapace and seven pairs of walking legs.

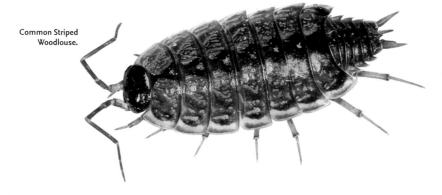

Common Striped Woodlouse.

Common Shiny Woodlouse

Oniscus asellus Length 14mm
One of our commonest woodlice, often numerous in gardens and hedgerows. **ADULT** is shiny and marbled grey and brown, with rows of yellow patches; head has lateral lobes, and jointed end of antennae comprises 3 sections. **STATUS** Common and widespread.

Common Shiny Woodlouse

Common Rough Woodlouse *Porcellio scaber* Length 10mm
Another common woodlouse, often numerous in gardens. **ADULT** is narrower than Common Shiny Woodlouse (above) and greyer, with a rough, not shiny surface; jointed end of antennae comprises 2 sections. **STATUS** Common and widespread.

Common Pygmy Woodlouse

Trichoniscus pusillus Length 5mm
Small woodlouse whose body is elongated and rather rounded in cross-section. In gardens, is found under stones and flowerpots, and among damp leaf litter. **ADULT** is reddish brown and shiny. **STATUS** Widespread and fairly common.

Common Pygmy Woodlouse

Common Striped Woodlouse

Philoscia muscorum Length 11mm
Active woodlouse, found in damp leaf litter and under flowerpots in gardens. **ADULT** is grey-brown with a dark head and dorsal stripe. **STATUS** Very common and widespread.

Rosy Woodlouse

Androniscus dentiger Length 4mm
Distinctive little woodlouse, found under stones and flowerpots on damp ground in gardens. **ADULT** is reddish pink with a yellow dorsal stripe. **STATUS** Common and widespread.

Rosy Woodlouse

Pill Woodlouse *Armadillidium vulgare* Length 11mm
Intriguing woodlouse, recognised by its ability to roll into a ball when disturbed. Found in rural gardens, usually under logs and stones. **ADULT** is slate-grey and rounded in cross-section. **STATUS** Commonest in S England.

Blind Woodlouse

Platyarthrus hoffmannseggi Length 3mm
Tiny, easily recognised woodlouse that always lives in ants' nests, where it is a scavenger – turn paving slabs to find it. **ADULT** is mostly pure white; antennae bases are swollen. **STATUS** Widespread and fairly common.

Landhopper

Arcitalitrus dorrieni Length 8–10mm
Alien, terrestrial relative of coastal

Blind Woodlouse

sandhoppers. Found in leaf litter. **ADULT** has a dark brown to blackish body that is laterally flattened. **STATUS** Native of Australia. Introduced here by accident; first seen on the Isles of Scilly in 1925, now fairly widespread in coastal gardens in SW England.

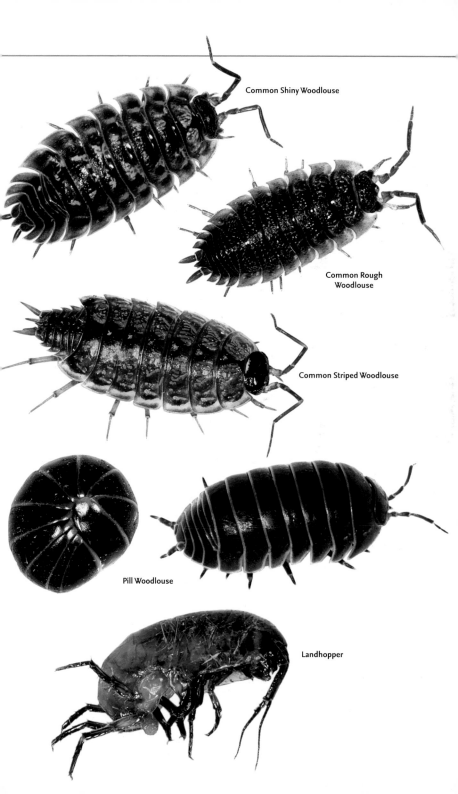

Common Shiny Woodlouse

Common Rough
Woodlouse

Common Striped Woodlouse

Pill Woodlouse

Landhopper

Burrowing Centipede *Stigmatogaster subterranea* Length 35mm
Subterranean centipede that is often common in garden soils and compost heaps. **ADULT** is orange and extremely slender. **STATUS** Common and widespread.

Common Centipede
Lithobius forficatus
Length 30mm
Familiar garden centipede, found under stones and logs in the daytime. **ADULT** has a shiny orange-brown body. **STATUS** Common and widespread. **SIMILAR SPECIES** Banded Centipede *L. variegatus* is similar but has banded legs; it is found in rural gardens and hedgerows.

Banded Centipede

Cylindroiulus punctatus Length 27mm
Common millipede of rural gardens, often found under rotting tree bark or in leaf litter. **ADULT** has a cylindrical, pale reddish-brown body. **STATUS** Common and widespread.

White-legged Millipede *Tachypodoiulus niger* Length 6cm
Familiar millipede of rural gardens and hedgerows, found under flowerpots and logs. Curls into a tight spiral when disturbed. **ADULT** has a cylindrical blackish body and whitish legs. **STATUS** Common and widespread.

Flat-backed Millipede
Polydesmus angustus
Length 24mm
Unusual millipede with a flattened body. Favours organic-rich soils and compost heaps, and creeps under the bark of rotting wood. **ADULT** is grey-brown to yellow-brown with 20 flattened segments to its body. **STATUS** Common and widespread.

Flat-backed Millipede

EARTHWORMS
Charles Darwin rightly pointed out that earthworms were among the most important animals in Britain: the soil's health depends on the aerating effects of their tunnelling, and its fertility is improved by the burying and recycling of organic matter. Of the 25 or so species of earthworm found in Britain, seven are fairly widespread and common in suitable soil types.

Lob Worm
Lumbricus terrestris
Length 14cm.

Redhead Worm
Lumbricus rubellus
Length 6cm.

Green Worm
Allolobophora chlorotica
Length 6cm.

Compost Worm
Eisenia veneta
Length 6cm.

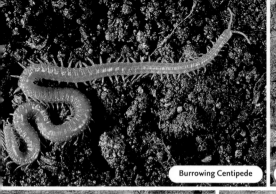

Burrowing Centipede

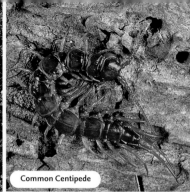

Common Centipede

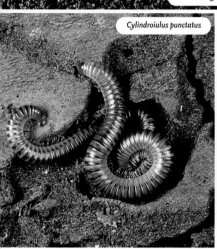

Cylindroiulus punctatus

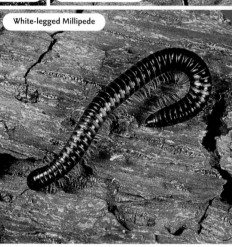

White-legged Millipede

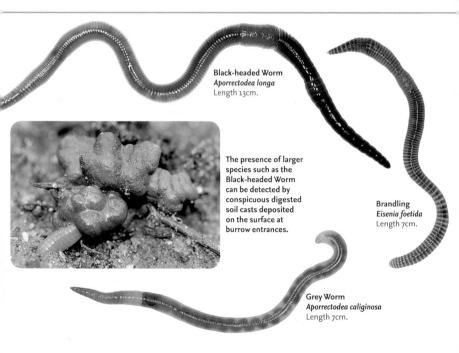

Black-headed Worm
Aporrectodea longa
Length 13cm.

The presence of larger species such as the Black-headed Worm can be detected by conspicuous digested soil casts deposited on the surface at burrow entrances.

Brandling
Eisenia foetida
Length 7cm.

Grey Worm
Aporrectodea caliginosa
Length 7cm.

Garden Snail *Helix aspersa* Shell diameter 4cm

The most familiar large snail in the garden. **ADULT** has a marbled brown and black shell; old specimens become worn. Sometimes hibernates in large numbers. **STATUS** Common and widespread in lowland Britain and Ireland.

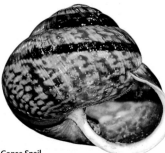

Copse Snail

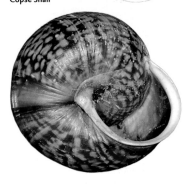

Strawberry Snail *Trichia striolata*
Shell diameter 12mm

Familiar garden snail. **ADULT** has a buffish-brown shell that is rather flattened and ridged; lip is usually pale. Young animals have a hairy shell. **STATUS** Widespread and fairly common, except in Scotland.

Cellar Snail *Oxychilus cellarius*
Shell diameter 12mm

Distinctive garden snail. **ADULT** has a translucent amber-brown shell that is a flattened spiral; body is bluish grey. **STATUS** Widespread and common in lowland areas.

Garlic Snail *Oxychilus alliarius*
Shell diameter 6mm

Similar to, but smaller than, Cellar Snail (above); easily identified by the strong smell of garlic it emits when handled. **ADULT** has a translucent orange-brown shell and blackish body. **STATUS** Common and widespread.

Copse Snail *Arianta arbustorum*
Shell diameter 25mm

Wayside snail, associated with damp ground, sometimes in gardens. **ADULT** has a rather spherical orange-brown shell with a dark spiral band. **STATUS** Widespread but local.

Kentish Snail *Monacha cantiana*
Shell diameter 15mm

Familiar snail, associated with disturbed ground, including gardens. **ADULT** has a mainly pale buff shell, typically flushed darker brown towards mouth (both inside and out). **STATUS** Common and widespread.

Kentish Snail

Rounded Snail *Discus rotundatus*
Shell diameter 7mm

Distinctive garden snail, found under stones and logs in the daytime. **ADULT** has a rather flattened shell with tightly packed whorls; usually shows conspicuous ridges and bands. **STATUS** Common and widespread in lowland areas.

Slippery Snail *Cochlicopa lubrica*
Length 7mm

Distinctive soil-dwelling snail. Can be found by sifting through the fine soil of a molehill. **ADULT** has a slippery brown egg-shaped shell; worn, empty shells look pale. **STATUS** Common and widespread.

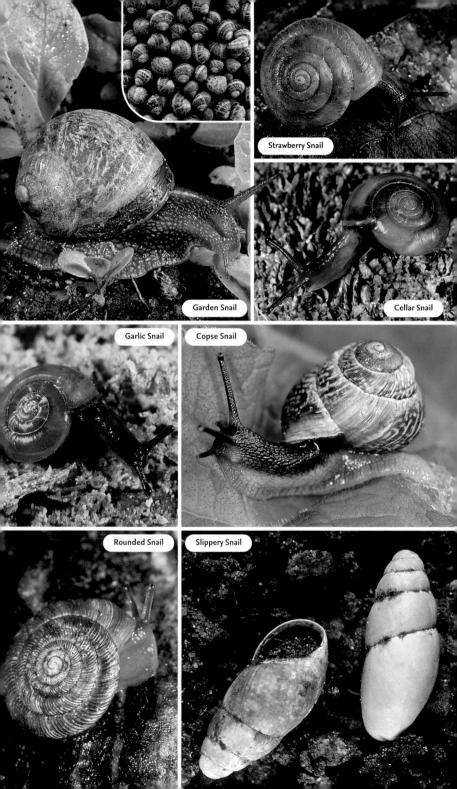

Strawberry Snail

Garden Snail

Cellar Snail

Garlic Snail

Copse Snail

Rounded Snail

Slippery Snail

White-lipped Snail *Cepaea hortensis* Shell diameter 18mm
Extremely variable snail of hedgerows and rural gardens. Often favours damp, shady vegetation. **ADULT** shell is typically either a uniform yellow, or yellow with dark, spiral bands; a diagnostic feature is the shell's white lip. **STATUS** Common and widespread in lowland areas.

Brown-lipped Snail *Cepaea nemoralis* Shell diameter 21mm
Variable species, similar to the White-lipped Snail (above) but told by its shell-lip colour and habitat preferences: favours drier, warmer sites than its cousin. **ADULT** shell is typically either a uniform yellow, or yellow with dark, spiral bands; the shell's dark lip is diagnostic. **STATUS** Common and widespread in lowlands.

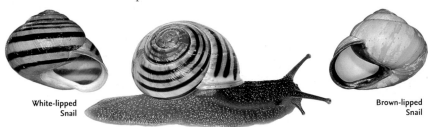

White-lipped
Snail

Brown-lipped
Snail

Large Red Slug *Arion ater* Length 12cm
Large, familiar slug, with a range of colour forms. When alarmed, contracts into a ball and rocks from side to side. Its mucus is colourless and it lays clusters of pale eggs under logs. **ADULT** can be orange-red (commonest in the S and in gardens), black (commonest in the N and in uplands) or grey-brown with an orange sole. **STATUS** Common and widespread.

Common Garden Slug
Arion distinctus
Length 3cm
Small slug of gardens and agricultural land. **ADULT** is usually grey-brown and dark-striped, covered in tiny gold dots. Has orange body mucus and sole is yellowish orange. **STATUS** Commonest in N Britain.

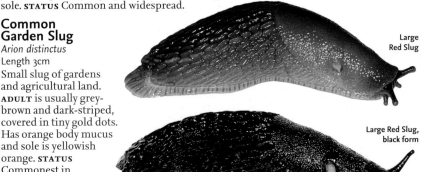

Large
Red Slug

Large Red Slug,
black form

Southern Garden Slug
Arion hortensis Length 3cm
S counterpart of Common Garden Slug (above). Found in gardens and hedgerows. **ADULT** has a grey body with dark longitudinal lines, and is typically palest on flanks; sole is orange and mucus is yellow. **STATUS** Common in S England.

Dusky Slug *Arion subfuscus* Length 7cm
Well-marked slug, found in woods, hedgerows and gardens. **ADULT** has a mainly pale brown body, but has a dark dorsal surface with a single longitudinal dark stripe on each side. Often looks golden due to orange body mucus; sole is yellow but sole mucus is colourless. **STATUS** Widespread and locally common.

Arion circumscriptus Length 4cm
Small, rather pale slug, found in gardens and hedgerows. **ADULT** is overall grey, with dark longitudinal stripes; mantle in particular is speckled with dark dots. **STATUS** Widespread and fairly common.

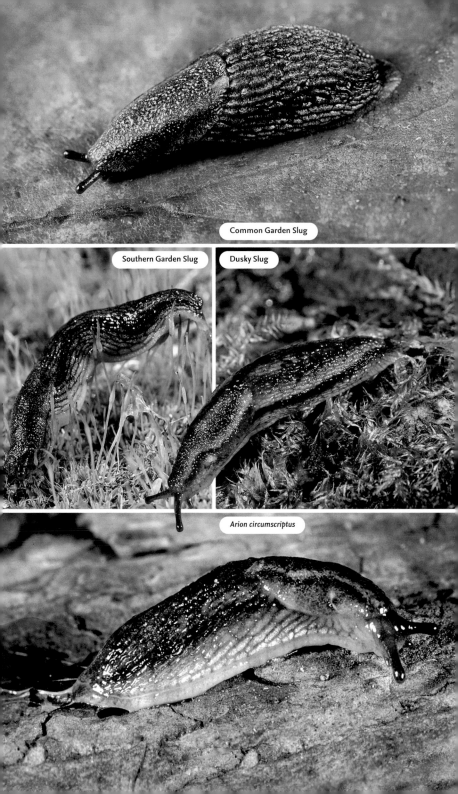

Common Garden Slug

Southern Garden Slug

Dusky Slug

Arion circumscriptus

Yellow Slug *Limax flavus* Length 10cm

Large, colourful slug. Associated with gardens and houses; ventures indoors after dark and into cellars. Feeds on seedlings and vegetables. **ADULT** has a yellowish body marbled and mottled with olive-brown; tentacles are blue and mantle has a thumbprint pattern of concentric rings typical of all *Limax* species. **STATUS** Widespread and locally common.

Leopard Slug *Limax maximus* Length 16cm

Large, well-marked garden slug. **ADULT** is usually mainly pinkish grey but body is covered with numerous dark blotches and spots. Has a pronounced dorsal 'keel' along rear part of body and tail. Mucus is sticky and colourless, and sole is whitish. **STATUS** Common and widespread.

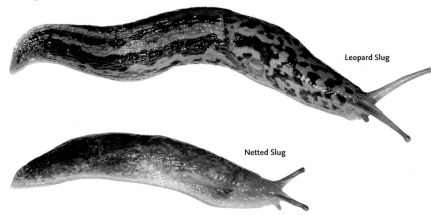

Leopard Slug

Netted Slug

Netted Slug *Deroceras reticulatum* Length 5cm

Destructive garden pest. **ADULT** is variable, but usually buffish brown with a network of darker brown veins and blotches. Body often looks lumpy, keel is truncated at tail end, and it produces large quantities of clear mucus when irritated. **STATUS** Common and widespread.

Brown Field Slug *Deroceras panormitanum* Length 5cm

Problem species in the garden. **ADULT** has a rather translucent greyish body overall, although mantle is usually tinged chestnut. Tail end is abruptly truncated, rising almost vertically. **STATUS** Common and widespread.

Sowerby's Slug *Tandonia sowerbyi* Length 7cm

Familiar garden slug. **ADULT** is usually brown or tan, with a yellowish truncated keel, thick, sticky yellowish mucus, and a pale rim to respiratory pore. **STATUS** Common and widespread.

Budapest Slug *Tandonia budapestensis* Length 6cm

Familiar and troublesome garden slug. **ADULT** is greyish with a yellow keel and colourless mucus; it often contracts into a 'C' shape when disturbed. **STATUS** Common and widespread.

Shelled Slug *Testacella scutulum* Length 10cm

Subterranean slug that eats earthworms and other slugs. Easiest to find in compost heaps. **ADULT** has a yellowish body and a fingernail-like shell covering mantle at rear end. **STATUS** Locally common only in S Britain.

Worm Slug *Boettgerilla pallens* Length 4cm

Slender, mainly subterranean slug. Sometimes seen above ground, after dark in damp weather, but otherwise found while digging soil or compost. **ADULT** has a slender, worm-like body that is pale yellowish brown. **STATUS** Widespread but local.

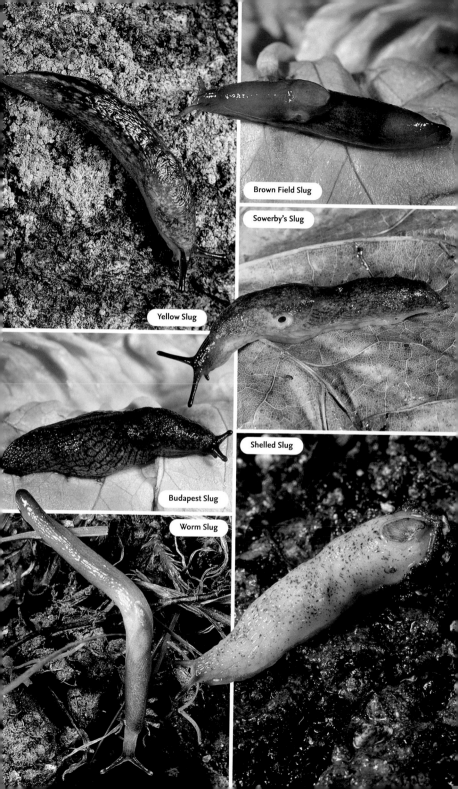

Brown Field Slug

Sowerby's Slug

Yellow Slug

Shelled Slug

Budapest Slug

Worm Slug

INTRODUCING GARDEN TREES AND SHRUBS

Trees and shrubs are an integral part of most gardens. From a design point of view they add a three-dimensional quality to any outdoor space, and a tall or spreading specimen lends an air of maturity to the garden. But most significantly, trees and shrubs are supremely important for wildlife: their leaves and flowers are food for many insects; fruits, berries and nuts are eaten by birds and mammals, as well as invertebrates; and the branches and foliage provide roosting and nesting opportunities for many bird species. Every wildlife garden should have its fair share of trees and shrubs.

TREE OR SHRUB?

How do you tell the difference between a tree and a shrub? A tree is often defined as having a single main stem of 5m or more with a branching crown above this; shrubs typically have numerous stems arising at ground level and normally do not reach the height of a tree. But just to confuse matters, individuals of the same species may become trees or form shrubs, depending on the circumstances in which they grow, or their management. For example, when cut regularly, Hazel forms a multi-stemmed shrub, but in the absence of cutting it may become a medium-sized tree on a single stem.

THE VIRTUE OF NATIVE SPECIES

The ornamental value of many non-native tree species is undeniable: few gardeners can deny the beauty of alien Horse-chestnuts or magnolias in full bloom. But if native garden wildlife is your passion then give preference to native tree and shrub species. The diversity of insects that feed on their leaves is far greater than on alien species; in itself that is a positive thing for wildlife biodiversity, but as an added bonus these insects serve as food for a wide range of predators, including other insects and birds too.

LEAVES

Leaves are thin layers of living tissue containing cells that can trap sunlight energy (in the green pigment chlorophyll) and use this to convert water and carbon dioxide into a simple sugar, glucose. This reaction, known as photosynthesis, is arguably the most important chemical reaction in the world, for it is the basis of all other food production.

Leaves arrange themselves to absorb the maximum amount of sunlight: spreading canopies, or trees growing taller than their neighbours, are both ways in which trees maximise the light-gathering power of their leaves. Evergreen trees do not lose all their leaves at the end of every growing season, but instead retain most through the winter. In contrast, deciduous trees generally shed all their leaves at the end of the growing season, before the onset of winter.

ABOVE: **Backlit Hazel leaf, trapping sunlight energy.**
BELOW: **Hazel is wind-pollinated, its male catkins shedding clouds of pollen that fertilise the tiny, separate female flowers (*inset*).**

REPRODUCTION

Conifer flowers lack petals. The male flowers are short-lived, falling off after they have released clouds of pollen, but the female flowers, often covered with brightly coloured scales, persist after pollination (fertilisation) and develop into cones containing the seeds. They rely on the wind for pollination and also for seed dispersal. A few close relatives of the conifers, such as the yews, produce fleshy fruits instead of cones.

Most flowers of broadleaved trees contain both male and female parts, although there are exceptions. Some flowers use insects to aid pollination, and so often have colourful petals and may also be scented; they usually

open in the summer, when insects are most active. In contrast, wind-pollinated flowers open early in the year before the leaves appear.

RIGHT: **Common Hawthorn blossom is pollinated by insects.**
BELOW: **Common Carder Bee, pollinating Blackthorn blossom.**

TYPES OF FRUIT

The fruits of trees and shrubs vary greatly in appearance. They range from tiny papery seeds with wings (for wind dispersal), through nuts and berries, to large succulent fruits in a variety of shapes and colours. Edible fruits ensure dispersal of the seeds thanks to assistance from animals, which eat the flesh of the fruits but do not digest the seeds.

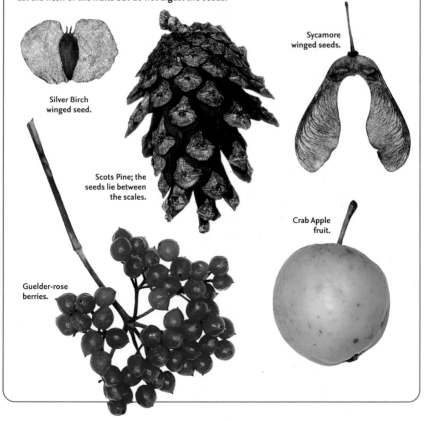

Silver Birch winged seed.

Sycamore winged seeds.

Scots Pine; the seeds lie between the scales.

Crab Apple fruit.

Guelder-rose berries.

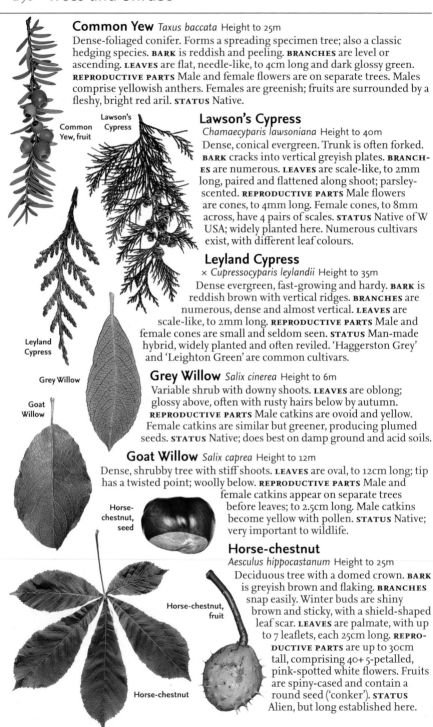

Common Yew *Taxus baccata* Height to 25m

Dense-foliaged conifer. Forms a spreading specimen tree; also a classic hedging species. **BARK** is reddish and peeling. **BRANCHES** are level or ascending. **LEAVES** are flat, needle-like, to 4cm long and dark glossy green. **REPRODUCTIVE PARTS** Male and female flowers are on separate trees. Males comprise yellowish anthers. Females are greenish; fruits are surrounded by a fleshy, bright red aril. **STATUS** Native.

Common Yew, fruit

Lawson's Cypress

Common Yew

Lawson's Cypress

Chamaecyparis lawsoniana Height to 40m
Dense, conical evergreen. Trunk is often forked. **BARK** cracks into vertical greyish plates. **BRANCHES** are numerous. **LEAVES** are scale-like, to 2mm long, paired and flattened along shoot; parsley-scented. **REPRODUCTIVE PARTS** Male flowers are cones, to 4mm long. Female cones, to 8mm across, have 4 pairs of scales. **STATUS** Native of W USA; widely planted here. Numerous cultivars exist, with different leaf colours.

Leyland Cypress

× *Cupressocyparis leylandii* Height to 35m
Dense evergreen, fast-growing and hardy. **BARK** is reddish brown with vertical ridges. **BRANCHES** are numerous, dense and almost vertical. **LEAVES** are scale-like, to 2mm long. **REPRODUCTIVE PARTS** Male and female cones are small and seldom seen. **STATUS** Man-made hybrid, widely planted and often reviled. 'Haggerston Grey' and 'Leighton Green' are common cultivars.

Leyland Cypress

Grey Willow

Goat Willow

Grey Willow *Salix cinerea* Height to 6m

Variable shrub with downy shoots. **LEAVES** are oblong; glossy above, often with rusty hairs below by autumn. **REPRODUCTIVE PARTS** Male catkins are ovoid and yellow. Female catkins are similar but greener, producing plumed seeds. **STATUS** Native; does best on damp ground and acid soils.

Goat Willow *Salix caprea* Height to 12m

Dense, shrubby tree with stiff shoots. **LEAVES** are oval, to 12cm long; tip has a twisted point; woolly below. **REPRODUCTIVE PARTS** Male and female catkins appear on separate trees before leaves; to 2.5cm long. Male catkins become yellow with pollen. **STATUS** Native; very important to wildlife.

Horse-chestnut, seed

Horse-chestnut

Aesculus hippocastanum Height to 25m
Deciduous tree with a domed crown. **BARK** is greyish brown and flaking. **BRANCHES** snap easily. Winter buds are shiny brown and sticky, with a shield-shaped leaf scar. **LEAVES** are palmate, with up to 7 leaflets, each 25cm long. **REPRODUCTIVE PARTS** are up to 30cm tall, comprising 40+ 5-petalled, pink-spotted white flowers. Fruits are spiny-cased and contain a round seed ('conker'). **STATUS** Alien, but long established here.

Horse-chestnut, fruit

Horse-chestnut

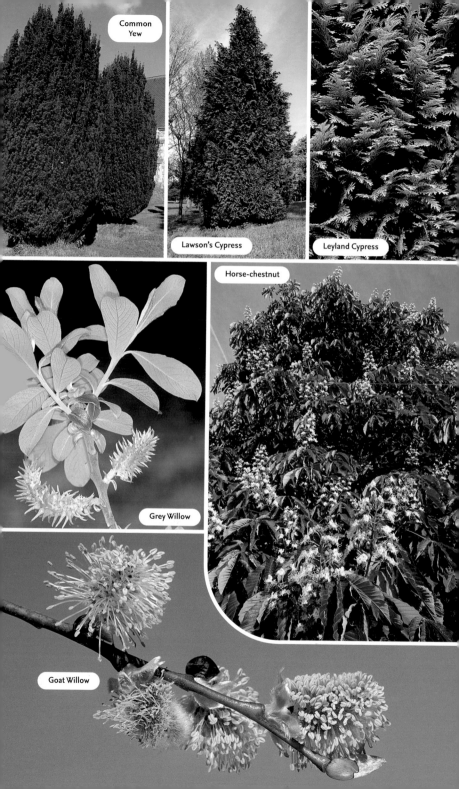

Common Yew

Lawson's Cypress

Leyland Cypress

Horse-chestnut

Grey Willow

Goat Willow

Silver Birch *Betula pendula* Height to 26m

Acquires a weeping habit with age. **BARK** breaks into rectangular plates at base; smooth silvery white higher up trunk. **BRANCHES** are ascending; twigs and shoots are pendulous. **LEAVES** are triangular, toothed, to 7cm long; turn yellow in autumn. **REPRODUCTIVE PARTS** Male catkins are terminal, yellow, pendulous. Female catkins are greenish, in leaf axils; form winged seeds when mature. **STATUS** Native; favours acid soils.

Downy Birch

Silver Birch

Downy Birch *Betula pubescens* Height to 25m

Elegant tree. **BARK** is reddish in young trees; turns thick and grey with age and does not break into basal rectangular plates (cf. Silver Birch, above). **BRANCHES** are mostly erect, never pendulous. Twigs are downy in spring. **LEAVES** are rounded at base, toothed, and have a hairy petiole. **REPRODUCTIVE PARTS** Catkins are similar to those of Silver Birch; seeds have smaller wings. **STATUS** Native; does best in the W and N.

Beech *Fagus sylvatica* Height to 40m

Imposing deciduous tree with a domed crown. **BARK** is smooth and grey. **BRANCHES** are ascending. Buds are reddish, smooth and pointed, to 2cm long. **LEAVES** are oval and pointed, to 10cm long, and have a wavy margin. **REPRODUCTIVE PARTS** Male flowers are pendent and clustered. Female flowers are paired, with brownish bracts. Fruits are shiny 3-sided nuts, to 1.8cm long, enclosed in a prickly case. **STATUS** Native and widely planted; the so-called Copper Beech is a popular form with reddish-brown leaves.

Beech

Pedunculate Oak *Quercus robur* Height to 36m

Spreading deciduous tree with a dense crown. **BARK** is grey, thick and fissured with age. **BRANCHES** Dead branches emerge from canopy of ancient trees. Buds are hairless. **LEAVES** are deeply lobed, with 2 auricles at base; borne on very short stalks (5mm or less). **REPRODUCTIVE PARTS** Flowers are catkins. Acorns, in groups of 1–3, have long stalks and scaly cups. **STATUS** Native and widespread; favours heavier clay soils than the Sessile Oak (below).

Sessile Oak *Quercus petraea* Height to 40m

Sturdy, domed deciduous tree. **BARK** is grey-brown and fissured. **BRANCHES** are rather straight and radiating. Buds have long white hairs. **LEAVES** are lobed and dark green, with hairs below on veins; borne on yellow stalks, 1–2.5cm long, and lacking basal auricles. **REPRODUCTIVE PARTS** Flowers are catkins. Acorns are egg-shaped and stalkless, sitting directly on twig in small clusters. **STATUS** Native; does best in the W and N, on poor soils.

Pedunculate Oak

Sessile Oak

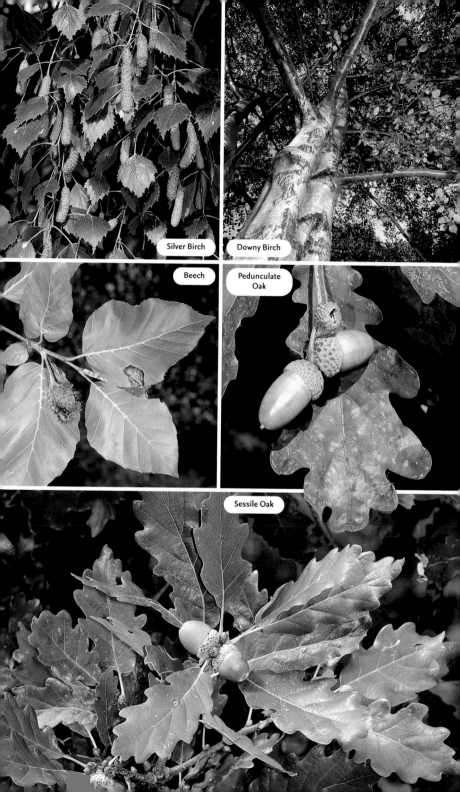

Silver Birch

Downy Birch

Beech

Pedunculate Oak

Sessile Oak

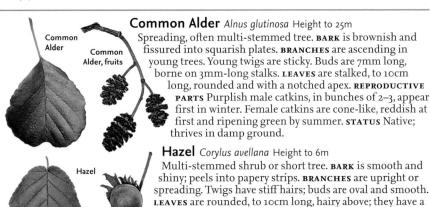

Common Alder *Alnus glutinosa* Height to 25m

Spreading, often multi-stemmed tree. **BARK** is brownish and fissured into squarish plates. **BRANCHES** are ascending in young trees. Young twigs are sticky. Buds are 7mm long, borne on 3mm-long stalks. **LEAVES** are stalked, to 10cm long, rounded and with a notched apex. **REPRODUCTIVE PARTS** Purplish male catkins, in bunches of 2–3, appear first in winter. Female catkins are cone-like, reddish at first and ripening green by summer. **STATUS** Native; thrives in damp ground.

Hazel *Corylus avellana* Height to 6m

Multi-stemmed shrub or short tree. **BARK** is smooth and shiny; peels into papery strips. **BRANCHES** are upright or spreading. Twigs have stiff hairs; buds are oval and smooth. **LEAVES** are rounded, to 10cm long, hairy above; they have a heart-shaped base and pointed tip. Margins are double-toothed. **REPRODUCTIVE PARTS** Male catkins are pendulous and yellow, to 8cm long. Female flowers are red and tiny; produce hard-shelled nuts. **STATUS** Native; an important hedgerow shrub for wildlife.

Hornbeam *Carpinus betulus* Height to 30m

Robust tree; bole is gnarled and twisted. **BARK** is silvery grey and fissured. **BRANCHES** are ascending and twisted; twigs are greyish brown and hairy. **LEAVES** are oval and pointed, with a rounded base, short petiole and double-toothed margin. **REPRODUCTIVE PARTS** Male catkins, to 5cm long, are yellowish green with red scales. Fruits are clusters of winged nutlets. **STATUS** Native; fruits are an important food for Hawfinches (p. 88).

London Plane *Platanus* × *hispanica* Height to 44m

Deciduous tree with a tall trunk and spreading crown. **BARK** is grey-brown and flakes in patches. **BRANCHES** are tangled and twisted. **LEAVES** are 5-lobed, palmate, to 24cm long. **REPRODUCTIVE PARTS** Flowers are rounded and borne in clusters. Greenish, spherical fruits have spiky hairs. **STATUS** Widely planted hybrid.

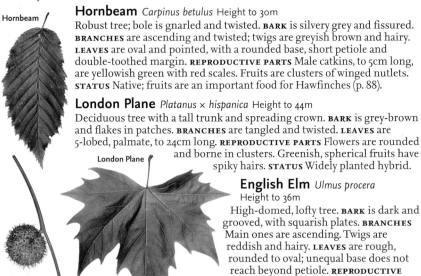

English Elm *Ulmus procera* Height to 36m

High-domed, lofty tree. **BARK** is dark and grooved, with squarish plates. **BRANCHES** Main ones are ascending. Twigs are reddish and hairy. **LEAVES** are rough, rounded to oval; unequal base does not reach beyond petiole. **REPRODUCTIVE PARTS** Fruits are papery, to 1.5cm long, short-stalked. **STATUS** Native; mature trees are seldom seen because of Dutch elm disease.

Wych Elm *Ulmus glabra* Height to 40m

Spreading tree. **BARK** becomes cracked and ridged with age. **BRANCHES** Main ones are spreading. Young twigs have stiff hairs. **LEAVES** are oval, to 18cm long, with a tapering tip. Unequal base extends beyond petiole. **REPRODUCTIVE PARTS** Fruits are papery, to 2cm long. **STATUS** Native; mature trees are seldom seen because of Dutch elm disease.

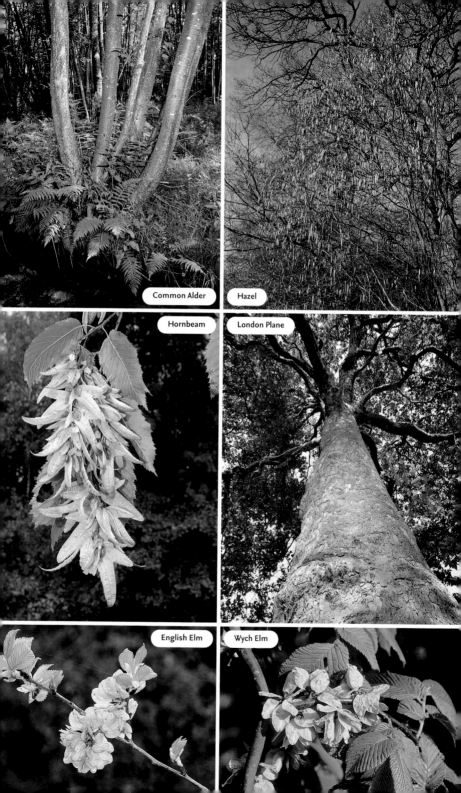

Common Alder

Hazel

Hornbeam

London Plane

English Elm

Wych Elm

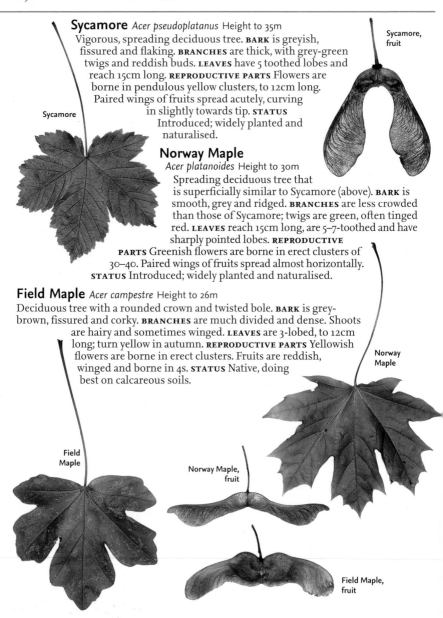

Sycamore *Acer pseudoplatanus* Height to 35m

Vigorous, spreading deciduous tree. **BARK** is greyish, fissured and flaking. **BRANCHES** are thick, with grey-green twigs and reddish buds. **LEAVES** have 5 toothed lobes and reach 15cm long. **REPRODUCTIVE PARTS** Flowers are borne in pendulous yellow clusters, to 12cm long. Paired wings of fruits spread acutely, curving in slightly towards tip. **STATUS** Introduced; widely planted and naturalised.

Sycamore, fruit

Sycamore

Norway Maple

Acer platanoides Height to 30m

Spreading deciduous tree that is superficially similar to Sycamore (above). **BARK** is smooth, grey and ridged. **BRANCHES** are less crowded than those of Sycamore; twigs are green, often tinged red. **LEAVES** reach 15cm long, are 5–7-toothed and have sharply pointed lobes. **REPRODUCTIVE PARTS** Greenish flowers are borne in erect clusters of 30–40. Paired wings of fruits spread almost horizontally. **STATUS** Introduced; widely planted and naturalised.

Field Maple *Acer campestre* Height to 26m

Deciduous tree with a rounded crown and twisted bole. **BARK** is grey-brown, fissured and corky. **BRANCHES** are much divided and dense. Shoots are hairy and sometimes winged. **LEAVES** are 3-lobed, to 12cm long; turn yellow in autumn. **REPRODUCTIVE PARTS** Yellowish flowers are borne in erect clusters. Fruits are reddish, winged and borne in 4s. **STATUS** Native, doing best on calcareous soils.

Norway Maple

Field Maple

Norway Maple, fruit

Field Maple, fruit

Holly *Ilex aquifolium* Height to 15m

Distinctive and familiar evergreen. **BARK** is silver-grey, becoming fissured with age. **BRANCHES** sweep downwards but tips turn up. **LEAVES** are leathery, to 12cm long, and variably wavy with spiny margins. **REPRODUCTIVE PARTS** White flowers, 6mm across and 4-petalled, appear clustered in leaf axils; males and females grow on different trees. Fruits are red berries, borne on female trees only. **STATUS** Native and widely planted. 'Highclere Holly' is a popular cultivar.

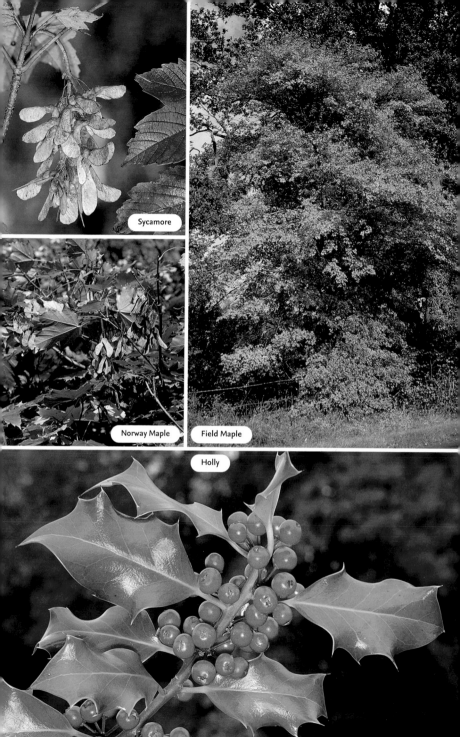

Sycamore

Norway Maple

Field Maple

Holly

Ash *Fraxinus excelsior* Height to 40m

Ash, fruits

Ash

Deciduous tree with an open crown. **BARK** is grey, becoming fissured with age. **BRANCHES** are ascending; grey twigs are flattened at nodes, with conical black buds. **LEAVES** are pinnate, to 35cm long, with 7–13 lanceolate, toothed leaflets. **REPRODUCTIVE PARTS** Flowers are small, purple and clustered. Fruits are single-winged 'keys', borne in bunches. **STATUS** Native, doing best on calcareous or base-rich soils.

Rowan *Sorbus aucuparia* Height to 20m

Open, deciduous tree. **BARK** is grey and smooth. **BRANCHES** are ascending, with purple-tinged twigs and hairy buds. **LEAVES** are pinnate, with 5–8 pairs of ovate, toothed leaflets, each to 6cm long. **REPRODUCTIVE PARTS** Flowers are 1cm across with 5 white petals; borne in dense heads. Fruits are rounded, scarlet and clustered. **STATUS** Native; also widely planted.

Wild Crab, fruit

Common Whitebeam, fruits

Common Whitebeam
Sorbus aria Height to 25m

Deciduous tree or spreading shrub. **BARK** is smooth and grey. **BRANCHES** are spreading; twigs are brown above, green below. Buds are ovoid, green and tipped with hairs. **LEAVES** are oval, to 12cm long, toothed, and very hairy below. **REPRODUCTIVE PARTS** Flowers are white and clustered. Fruits are red and ovoid, to 1.5cm long. **STATUS** Native; also widely planted.

Wild Crab

Wild Crab *Malus sylvestris*
Height to 10m

Wild Cherry

Wild Cherry, fruit

Slender deciduous tree. **BARK** is deep brown, cracking into oblong plates. **BRANCHES** are often spiny; even shoots can be thorny. **LEAVES** are oval, to 11cm long, and toothed. **REPRODUCTIVE PARTS** Flowers are 5-petalled, to 4cm across, white or sometimes pink-tinged. Fruits are rounded, yellowish green, hard and sour, to 4cm across. **STATUS** Native and also planted for ornament; several cultivars exist.

Wild Cherry *Prunus avium* Height to 30m

Deciduous tree with a domed crown. **BARK** is reddish brown, shiny, with circular lines; peels horizontally into papery strips. **BRANCHES** are spreading, with reddish twigs. **LEAVES** are ovate, to 15cm long, and toothed. **REPRODUCTIVE PARTS** Flowers are white, 5-petalled, borne in clusters of 2–6. Fruits are rounded, ripening dark purple or sometimes yellowish, to 2cm long. **STATUS** Native; also widely planted.

Blackthorn, fruit

Blackthorn *Prunus spinosa* Height to 6m

Densely branched shrub. **BARK** is blackish brown. **BRANCHES** are spreading, with spiny twigs. **LEAVES** are ovate, toothed, to 4.5cm long. **REPRODUCTIVE PARTS** Flowers are white, 5-petalled, to 17mm across; produced prolifically (Feb–Mar). Fruits (sloes) are ovoid, to 1.5cm long, blue-black with a bloom. **STATUS** Native; a common hedgerow species. **SIMILAR SPECIES Bullace** *P. domestica* ssp. *institia* is spineless, with larger fruits.

Blackthorn

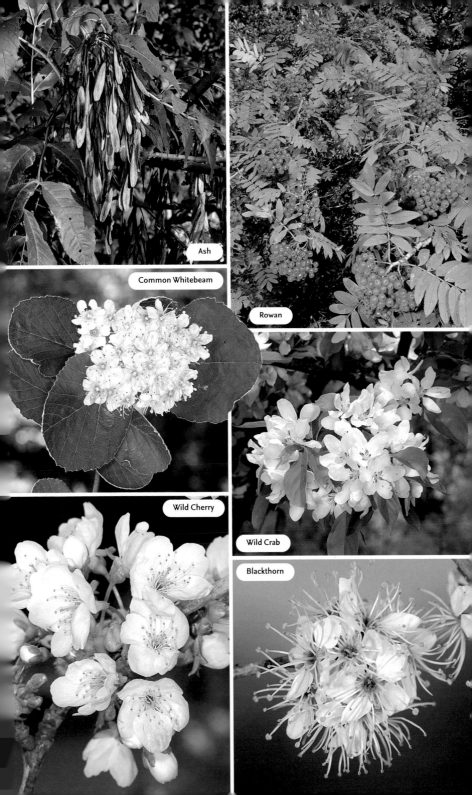

Ash

Rowan

Common Whitebeam

Wild Cherry

Wild Crab

Blackthorn

Cherry Plum *Prunus cerasifera* Height to 8m

Bushy deciduous tree. **BARK** is dark brown and pitted with white lenticels. **BRANCHES** are spiny, with glossy green twigs. **LEAVES** are ovate, to 7cm long and toothed; usually green, but red in some cultivars. **REPRODUCTIVE PARTS** Flowers are stalked and usually white, but pink in some cultivars. Fruits, to 3.5cm long, are rounded and red or yellow. **STATUS** Introduced; widely planted and often naturalised.

Cherry Laurel *Prunus laurocerasus* Height to 8m

Evergreen shrub or small tree. **BARK** is dark grey-brown, pitted with lenticels. **BRANCHES** are dense, with pale green twigs. **LEAVES** are leathery, to 20cm long and oblong. **REPRODUCTIVE PARTS** Flowers are white, fragrant, borne in erect spikes to 13cm long. Fruits are rounded, green, turning red and ripening blackish purple. **STATUS** Introduced; widely planted and sometimes naturalised.

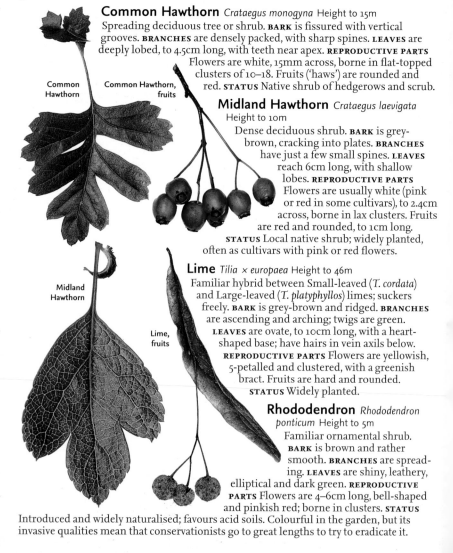

Common Hawthorn

Common Hawthorn, fruits

Midland Hawthorn

Lime, fruits

Common Hawthorn *Crataegus monogyna* Height to 15m

Spreading deciduous tree or shrub. **BARK** is fissured with vertical grooves. **BRANCHES** are densely packed, with sharp spines. **LEAVES** are deeply lobed, to 4.5cm long, with teeth near apex. **REPRODUCTIVE PARTS** Flowers are white, 15mm across, borne in flat-topped clusters of 10–18. Fruits ('haws') are rounded and red. **STATUS** Native shrub of hedgerows and scrub.

Midland Hawthorn *Crataegus laevigata* Height to 10m

Dense deciduous shrub. **BARK** is grey-brown, cracking into plates. **BRANCHES** have just a few small spines. **LEAVES** reach 6cm long, with shallow lobes. **REPRODUCTIVE PARTS** Flowers are usually white (pink or red in some cultivars), to 2.4cm across, borne in lax clusters. Fruits are red and rounded, to 1cm long. **STATUS** Local native shrub; widely planted, often as cultivars with pink or red flowers.

Lime *Tilia × europaea* Height to 46m

Familiar hybrid between Small-leaved (*T. cordata*) and Large-leaved (*T. platyphyllos*) limes; suckers freely. **BARK** is grey-brown and ridged. **BRANCHES** are ascending and arching; twigs are green. **LEAVES** are ovate, to 10cm long, with a heart-shaped base; have hairs in vein axils below. **REPRODUCTIVE PARTS** Flowers are yellowish, 5-petalled and clustered, with a greenish bract. Fruits are hard and rounded. **STATUS** Widely planted.

Rhododendron *Rhododendron ponticum* Height to 5m

Familiar ornamental shrub. **BARK** is brown and rather smooth. **BRANCHES** are spreading. **LEAVES** are shiny, leathery, elliptical and dark green. **REPRODUCTIVE PARTS** Flowers are 4–6cm long, bell-shaped and pinkish red; borne in clusters. **STATUS** Introduced and widely naturalised; favours acid soils. Colourful in the garden, but its invasive qualities mean that conservationists go to great lengths to try to eradicate it.

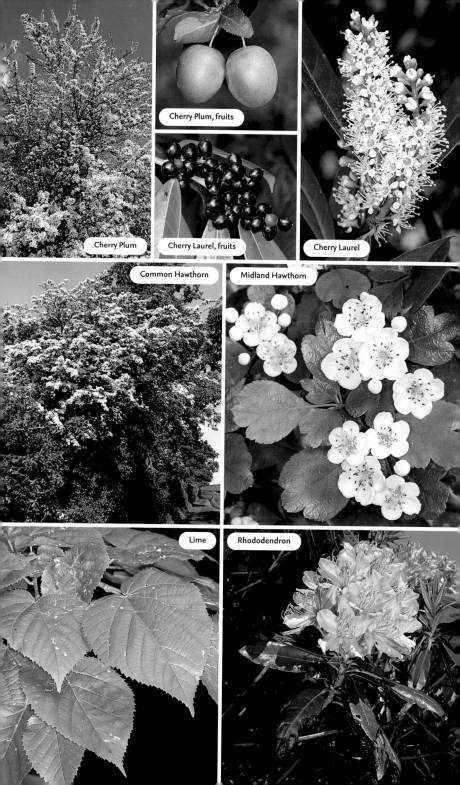

Cherry Plum

Cherry Plum, fruits

Cherry Laurel, fruits

Cherry Laurel

Common Hawthorn

Midland Hawthorn

Lime

Rhododendron

Butterfly-bush *Buddleja davidii* Height to 4m

Dense perennial shrub. **BARK** is grey-brown. **BRANCHES** are dense and arching. **LEAVES** are long and narrow, darker above than below. **REPRODUCTIVE PARTS** Flowers are pinkish purple, 4-lobed, 2–4mm across, and borne in long spikes; they are extremely attractive to butterflies. **STATUS** Naturalised garden escape, sometimes alarmingly invasive and has to be controlled.

Dogwood *Cornus sanguinea* Height to 4m

Shrub or small tree. **BARK** is grey and smooth. **BRANCHES** are straight and slender; twigs are a distinctive dark red in winter. **LEAVES** are opposite and oval, with entire margins and 3–4 pairs of prominent veins. **REPRODUCTIVE PARTS** Flowers are small, white, and borne in large terminal clusters. Fruits are rounded blackish berries; borne in clusters. **STATUS** Native, favouring calcareous soils; also widely planted.

Dogwood, fruits

Wild Privet *Ligustrum vulgare* Height to 5m

Branched semi-evergreen shrub. **BARK** is reddish brown with distinct gashes. **BRANCHES** are dense and much divided; twigs are downy. **LEAVES** are shiny, untoothed, oval and opposite. **REPRODUCTIVE PARTS** Flowers are creamy white, 4–5mm across, fragrant and 4-petalled; borne in terminal spikes. Fruits are shiny, black and clustered. **STATUS** Native on calcareous soils but also widely planted. **SIMILAR SPECIES Garden Privet** *L. ovalifolium* is similar, but its leaves are rounded-oval and more evergreen; it is a popular garden hedging plant.

Wild Privet, fruits

Garden Privet

Guelder-rose, fruits

Elder, fruits

Elder *Sambucus nigra* Height to 10m

Untidy deciduous shrub or small tree. **BARK** is grey-brown, furrowed and corky, becoming lichen-covered with age. **BRANCHES** are spreading and twisted, with a white central pith. **LEAVES** are opposite and compound, with 5–7 pairs of ovate, toothed leaflets, each to 12cm long. **REPRODUCTIVE PARTS** Flowers are white with a sickly sweet scent; borne in flat-topped clusters. Fruits are rounded, shiny black berries, borne in pendulous heads. **STATUS** Native and common.

Guelder-rose *Viburnum opulus* Height to 4m

Spreading deciduous tree. **BARK** is reddish brown. **BRANCHES** are sinuous; twigs are smooth, angular and greyish. **LEAVES** are opposite, to 8cm long, with 3–5 irregularly toothed lobes. **REPRODUCTIVE PARTS** Flowers are white, borne in flat heads with showy outer flowers and smaller inner ones. Fruits are rounded, translucent red berries, borne in clusters. **STATUS** Native; favours calcareous soils.

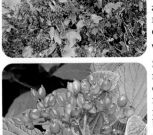

Wayfaring-tree *Viburnum lantana* Height to 6m

Small, spreading deciduous tree. **BARK** is brown. **BRANCHES** have rounded, hairy greyish twigs. **LEAVES** are opposite, to 14cm long, ovate and toothed. **REPRODUCTIVE PARTS** Flowers are white, 5-petalled, to 8mm across, borne in rounded heads about 10cm across. Fruits are oval berries about 8mm long, ripening from red to black. **STATUS** Native, favouring calcareous soils; also planted.

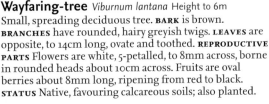

Wayfaring-tree, fruits

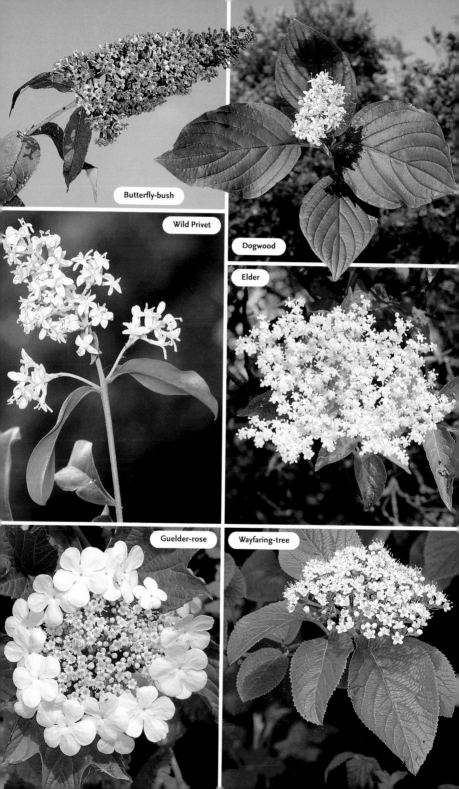

Butterfly-bush

Dogwood

Wild Privet

Elder

Guelder-rose

Wayfaring-tree

INTRODUCING
GARDEN WILDFLOWERS

Native wildflowers have a presence in most British gardens. In some instances they are invited guests, welcomed and even encouraged by garden owners; others are less welcome species whose invasive qualities mean they are present whether the gardener likes it or not. Aside from the attractive appearance of some native wildflowers, almost all species have a significance to other forms of wildlife that cannot be overemphasised.

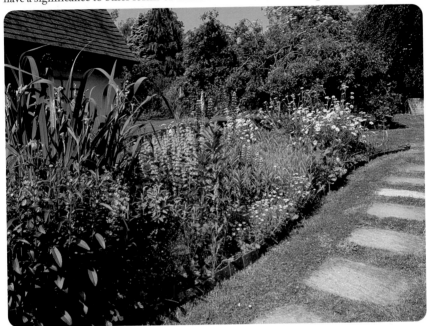

A colourful herbaceous border whose component plants include both native and alien species.

ORNAMENTAL NATIVE WILDFLOWERS

The classic herbaceous border or bed includes a range of plants, mostly exotic in origin, the aim being to produce a harmonious blend of colours and a succession of flowering from late spring to early autumn. Comparatively few native wildflowers feature in the garden designer's palette, which is a pity since there are some truly delightful species that are a match for many tried and tested horticultural favourites.

Below is a selection of some of the more showy native wildflower species that would not look out of place in any herbaceous border. Some are tall and stately, while others are rambling in habit.

Tansy.

Cotton Thistle.

Tufted Vetch.

Foxglove.

Dark Mullein.

FAR LEFT: **Greater Knapweed is an attractive native wildflower that can be grown in the garden and is an important source of nectar for insects such as bumblebees.**

LEFT: **By leaving patches of willowherbs in the garden, you may be graced by the presence of Elephant Hawkmoth larvae, which feed on the leaves.**

NATIVE WILDFLOWER COLONISERS

Compared to natural habitats in Britain, the soil in the garden is considerably more disturbed. Regular digging means the ground is usually loose and aerated, and these conditions suit a range of native wildflowers, some of which are also associated with tilled farmland. Indeed, the seeds of some wildflower species will germinate only when exposed to a degree of disturbance. Many of these plants are the traditional gardener's foes: weeds that in past times would have been eliminated at all costs. While it is certainly true that some native wildflowers really don't have a place in a well-managed garden, modern gardeners who operate with wildlife and biodiversity in mind adopt a more enlightened and tolerant approach to these so-called 'weeds'. Many provide food for a wide range of invertebrates, particularly moth larvae – as the old gardening adage has it, a weed is just a plant growing in the wrong place. So a change in attitude is often all that is needed to see native wildflowers for the delight they are.

To the wildlife gardener, a manicured lawn can seem boring. Instead, set aside areas that can become flowering meadows, studded with the likes of Daisy, Cuckooflower and Yellow Rattle; the latter can be introduced as scattered seed and is a semi-parasite of grasses, helping reduce their vigour and the need for regular mowing.

SETTING ASIDE AN AREA FOR WILDFLOWERS

If your garden space is large enough, one good thing you can do for wildlife is to set aside an area for wildflowers to grow. Teasels, Hogweed, Common Fleabane and Common Nettle are all examples of plants that benefit native wildlife: the first three are nectar sources for insects, and Wild Teasel and Hogweed also provide seeds for birds in winter; Common Nettle is the food plant for the larvae of a select band of butterflies and moths.

RIGHT: **Common Nettle.**
FAR RIGHT: **Wild Teasel.**

Honeysuckle *Lonicera periclymenum* Height to 5m
Familiar woody climber that twines clockwise up other shrubs
and trees. **FLOWERS** are 3–5cm long and scented, the corolla
trumpet-shaped, 2-lipped and creamy yellow to white; borne
in whorled heads (Jun–Aug). **FRUITS** are red berries that appear
in clusters. **LEAVES** are grey-green, oval and borne in opposite
pairs. **STATUS** Widespread and common. Grows in woodland,
hedgerows and scrub, and is a useful and fragrant addition to
any garden hedgerow.

Honeysuckle, fruit

Traveller's-joy *Clematis vitalba* Height to 10m
Scrambling hedgerow perennial. **FLOWERS** are creamy, with
prominent stamens; borne in clusters (Jul–Aug). **FRUITS**
comprise clusters of seeds with
woolly whitish plumes, hence the plant's alternative common
name of Old Man's Beard. **LEAVES** are divided into 3–5 leaflets.
STATUS Locally common in the S, favouring chalky soils.

White Bryony *Bryonia dioica* Height to 4m
Climbing perennial whose progress is aided by long,
unbranched tendrils. **FLOWERS** are greenish, 5-parted and borne
on separate-sex plants; they arise from leaf axils (May–Aug).
FRUITS are shiny red berries. **LEAVES** are 4–7cm across and
divided into 5 lobes. **STATUS** Common only in England; scarce
elsewhere. Grows in hedgerows, providing splendid colour
with its autumn berries.

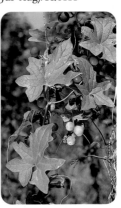

White Bryony, fruits

Black Bryony *Tamus communis*
Height to 3m
Twining perennial. Similar to White
Bryony (above), but note the different
leaf shape and lack of tendrils. **FLOW-**
ERS are tiny, yellowish green and 6-petalled; borne on
separate-sex plants (May–Aug). **FRUITS** are red berries. **LEAVES**
are heart-shaped, glossy and netted. **STATUS** Widespread in
England and Wales. Grows in hedgerows and scrub, and the
berries provide a splash of colour in autumn.

Black Bryony, fruits

Ivy *Hedera helix* Height to 20m
Self-clinging evergreen climber that also carpets
the ground. **FLOWERS** are yellowish green and
4-parted; borne in globular heads (Sep–Nov). **FRUITS** are
berries that ripen to purplish black. **LEAVES** are glossy,
dark green and 3- or 5-lobed with paler veins. **STATUS**
Widespread and common. Grows up trees and also
carpets the ground. Its flowers are a source of
nectar in autumn, its berries are food for birds
in winter, and its foliage provides roosting
and nesting sites for birds.

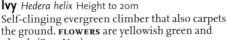

Ivy

Hop *Humulus lupulus* Height to 6m
Twining, hairy hedgerow climber. **FLOW-**
ERS are clustered and greenish yellow (male), or
green and hop-like (female) (Jun–Aug). **FRUITS** are familiar
hops that ripen brown in autumn. **LEAVES** are divided into
3–5 coarse-toothed lobes. **STATUS** Widespread, but locally
common only in the S. Often planted in gardens, or present
in rural locations as a relict of cultivation. Its leaves are food
for Comma butterfly larvae (p. 134).

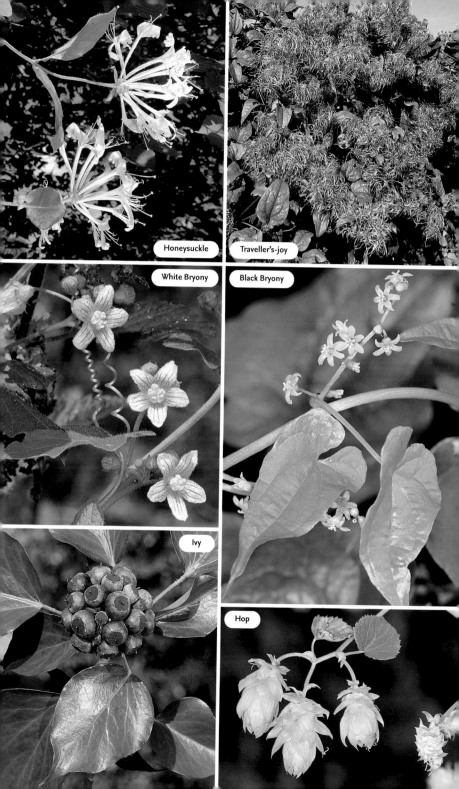

Honeysuckle

Traveller's-joy

White Bryony

Black Bryony

Ivy

Hop

Common Nettle *Urtica dioica* Height to 1m
Familiar stinging nettle. **FLOWERS** are pendulous catkins;
borne on separate-sex plants (Jun–Oct). **FRUITS** resemble
flowers superficially. **LEAVES** are oval, pointed-tipped, toothed
and borne in opposite pairs; 8cm long and longer than stalks.
STATUS Widespread and common, doing best on nitrogen-
enriched and disturbed soils.

Common
Nettle

Redshank *Persicaria maculosa* Height to 60cm
Upright or sprawling hairless annual with
much-branched reddish stems. Found on
disturbed ground and arable field margins.
FLOWERS are pink and borne in terminal
spikes (Jun–Oct). **FRUITS** are nut-like. **LEAVES**
are narrow and oval, and usually show a dark
central mark. **STATUS** Widespread and common
throughout.

Redshank

Black-bindweed

Fallopia convolvulus Height to 1m
Extremely common, clockwise-
twining annual that both trails on the
ground and climbs among garden plants.
FLOWERS are greenish and rather dock-like;
they are borne in loose spikes that arise from
leaf axils (Jul–Oct). **FRUITS** are nut-like
and blackish. **LEAVES** are arrow-shaped
and borne on angular stems. **STATUS**
Widespread and common.

Broad-leaved Dock

Fat-hen

Rumex obtusifolius Height to 1m
Familiar upright perennial of disturbed ground.
FLOWERS are borne in loose spikes that are leafy at
the base (Jun–Aug). **FRUITS** have prominent teeth and
1 tubercle. **LEAVES** are broadly oval, heart-shaped at the
base, and up to 25cm long. **STATUS** Widespread and
extremely common throughout.

Fat-hen *Chenopodium album* Height to 1m
Upright, branched annual of disturbed ground and
waste places. Often has a mealy appearance. **FLOWERS**
are whitish green and borne in leafy spikes (Jun–Oct).
FRUITS are rounded and surrounded by 5 sepals, in
a ring. **LEAVES** are green, and matt-looking owing
to a mealy coating; they vary from oval to diamond-
shaped. **STATUS** Widespread and common, often
appearing in the vegetable patch.

Red
Goosefoot

Red Goosefoot *Chenopodium rubrum* Height to 60cm
Variable upright annual, favouring manure-enriched soils.
Stems often turn red in old or parched specimens. **FLOWERS** are
small and numerous, borne in upright leafy spikes. **FRUITS** are
rounded and enclosed by 2–4 sepals (Jul–Oct). **LEAVES** are shiny,
diamond-shaped and toothed. **STATUS** Widespread and common
in S England; scarce elsewhere.

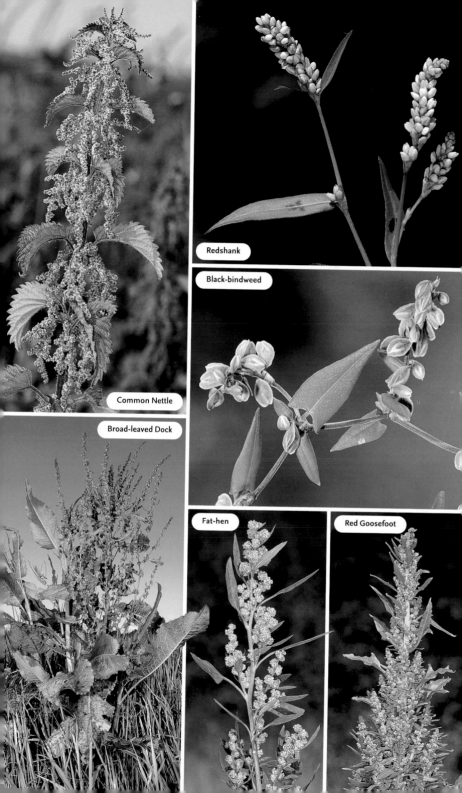

Redshank

Black-bindweed

Common Nettle

Broad-leaved Dock

Fat-hen

Red Goosefoot

Greater Stitchwort *Stellaria holostea* Height to 50cm

Familiar perennial of grassy places. Note the rough-edged stems. FLOWERS are white, with 5 notched petals; borne on slender stems (Apr–Jun). FRUITS are capsules. LEAVES are narrow, fresh green, rough-edged and grass-like; easily overlooked in the absence of flowers. STATUS Widespread and common. Typically a woodland and hedgerow species, it grows around the margins of rural gardens.

Lesser Stitchwort *Stellaria graminea* Height to 50cm

Perennial of grassy places, mainly on acid soils. Note the smooth-edged stems. FLOWERS are white and 5–15mm across, with 5 deeply divided petals (May–Aug). FRUITS are capsules. LEAVES are long, narrow, smooth-edged and grass-like. STATUS Widespread and common throughout. Typically grows in open woodland, meadows and hedgerows, but also found along the grassy margins of rural gardens.

Common Chickweed *Stellaria media* Height to 30cm

Annual of disturbed ground that is sometimes prostrate. Stems are hairy in lines on alternate sides between leaf nodes. FLOWERS are white, 5-petalled and 5–10mm across (Jan–Dec); 3–8 stamens. FRUITS are capsules on long, drooping stalks. LEAVES are oval, fresh green and in opposite pairs; upper ones are unstalked. STATUS Widespread and common, often appearing in the vegetable patch.

Common Mouse-ear *Cerastium fontanum* Height to 30cm

Hairy perennial, found in gardens and grasslands, and on disturbed ground. Flowering and non-flowering shoots occur. FLOWERS are white, 5–7mm across, with 5 deeply notched petals (Apr–Oct). FRUITS are capsules. LEAVES are grey-green and borne in opposite pairs. STATUS Widespread and common throughout.

Red Campion *Silene dioica* Height to 1m

Hairy biennial or perennial of wayside places generally. FLOWERS are reddish pink and 20–30mm across; male flowers are smaller than females and borne on separate plants (Mar–Oct). FRUITS reveal 10 reflexed teeth when ripe. LEAVES are hairy and borne in opposite pairs. STATUS Widespread and common. Typically found in hedgerows and on grassy banks, but also grows around the grassy margins of rural gardens.

Bladder Campion

White Campion *Silene latifolia* Height to 1m

Hairy, branched perennial of disturbed ground and grassy habitats. Sometimes hybridises with Red Campion (above). FLOWERS are white, 5-petalled and 25–30mm across; dioecious, male flowers smaller than females (May–Oct). FRUITS have erect teeth. LEAVES are oval and borne in opposite pairs. STATUS Widespread and common in the countryside at large, sometimes appearing in rural gardens.

Bladder Campion *Silene vulgaris* Height to 80cm

Upright perennial of dry grassland on well-drained soils, especially chalk. FLOWERS are white, drooping, 16–18mm across, with deeply divided petals and swollen, bladder-like calyx (Jun–Aug). FRUITS are capsules. LEAVES are grey-green, oval and in opposite pairs. STATUS Widespread but common only in south. Sometimes grows in 'wild areas' of rural gardens on chalk in southern England.

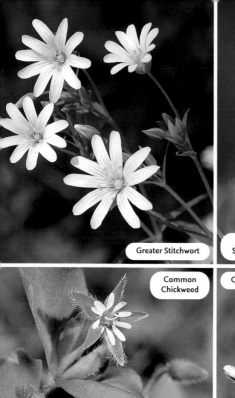

Greater Stitchwort

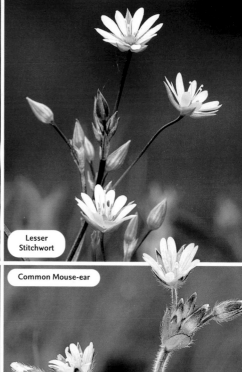

Lesser Stitchwort

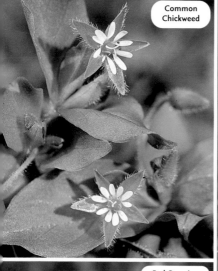

Common Chickweed

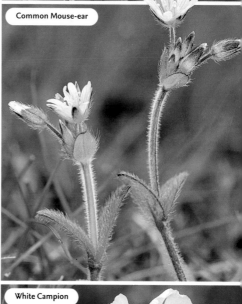

Common Mouse-ear

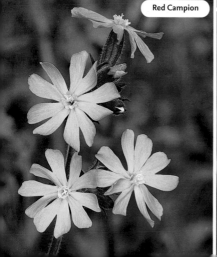

Red Campion

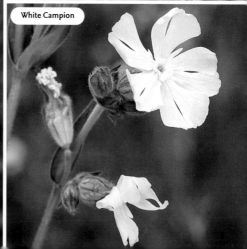

White Campion

Winter Aconite *Eranthis hyemalis* Height to 10cm

Attractive perennial that sometimes forms carpets. **FLOWERS** are 12–15mm across, with 6 yellow sepals; borne on upright stems, above leaves (Jan–Apr). **FRUITS** are dry, many-seeded and splitting. **LEAVES** are spreading (3 per stem) and each divided into 3 lobes. **STATUS** Introduced but widely naturalised, both in woodlands and in mature gardens.

Meadow Buttercup

Meadow Buttercup *Ranunculus acris* Height to 1m

Downy perennial of damp grassland habitats. **FLOWERS** are 18–25mm across and comprise 5 shiny yellow petals with upright sepals; borne on long, unfurrowed stalks (Apr–Oct). **FRUITS** are hook-tipped and borne in a rounded head. **LEAVES** are rounded and divided into 3–7 lobes; upper ones are unstalked. **STATUS** Widespread and common throughout, sometimes growing in areas set aside as grassy wildflower patches in the garden.

Creeping Buttercup *Ranunculus repens* Height to 50cm

Often unwelcome perennial of lawns and other grassy places. Long, rooting runners aid its spread. **FLOWERS** are 20–30mm across with 5 yellow petals and upright sepals; borne on furrowed stalks (May–Aug). **FRUITS** are borne in rounded heads. **LEAVES** are hairy and divided into 3 lobes; middle lobe is stalked. **STATUS** Widespread and common.

Creeping Buttercup

Bulbous Buttercup *Ranunculus bulbosus*
Height to 40cm

Hairy perennial of dry grassland, including chalk downs. Note the swollen stem base. **FLOWERS** are 20–30mm across with 5 bright yellow petals and reflexed sepals; borne on furrowed stalks (Mar–Jul). **FRUITS** are smooth. **LEAVES** are divided into 3 lobes, each of which is stalked. **STATUS** Widespread and often common in suitable habitats; sometimes found in garden areas set aside for wildflowers.

Lesser Spearwort *Ranunculus flammula*
Height to 50cm

Upright or creeping perennial. Often roots where leaf nodes touch the ground. Favours damp ground, often beside streams or ponds. **FLOWERS** are 5–15mm across and usually solitary; borne on furrowed stalks (Jun–Oct). **FRUITS** are beaked but not winged. **LEAVES** are oval at base and narrow up stem. **STATUS** Widespread, commonest in the N. Sometimes found beside large garden ponds or streams.

Bulbous Buttercup

Lesser Spearwort

Lesser Celandine *Ranunculus ficaria* Height to 25cm

Perennial of hedgerows, open woodland and bare ground, sometimes forming clumps or patches. **FLOWERS** are 20–30mm across with 8–12 shiny yellow petals and 3 sepals (Mar–May); open only in sunshine. **FRUITS** are borne in a rounded head. **LEAVES** are heart-shaped, glossy and dark green. **STATUS** Widespread and common. Often found in rural gardens and probably an indication that the site once supported woodland.

Lesser Celandine

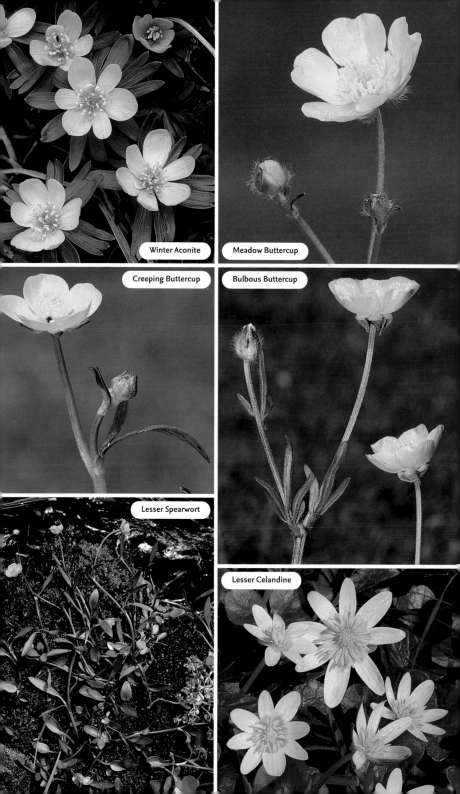

Winter Aconite

Meadow Buttercup

Creeping Buttercup

Bulbous Buttercup

Lesser Spearwort

Lesser Celandine

Hedge Mustard

Hedge Mustard *Sisymbrium officinale* Height to 90cm

Tough, upright annual or biennial of waste ground and disturbed soil. **FLOWERS** are 3mm across with 4 yellow petals; borne in terminal clusters (May–Oct). **FRUITS** are cylindrical, 1–2cm long and pressed close to stem. **LEAVES** are variable: lower leaves are deeply divided while stem leaves are narrow. **STATUS** Widespread and common throughout.

Winter-cress *Barbarea vulgaris* Height to 80cm

Upright, hairless perennial of damp ground. **FLOWERS** are 7–9mm across with 4 yellow petals; borne in terminal heads (May–Aug). **FRUITS** are long, narrow, 4-sided pods. **LEAVES** are dark green and shiny; lower ones are divided, the end lobe large and oval; upper stem leaves are entire. **STATUS** Widespread, but commonest in the S. Sometimes appears in the vegetable patch.

Winter-cress

Hairy Bitter-cress *Cardamine hirsuta* Height to 30cm

Upright annual with hairless stems. Found on damp, disturbed ground. **FLOWERS** are 2–3mm across (petals sometimes absent) and terminal (Feb–Nov). **FRUITS** are curved, up to 2.5cm long and overtop flowers. **LEAVES** are pinnately divided, with rounded lobes; seen mainly as a basal rosette plus 1–4 stem leaves. **STATUS** Widespread and common. Often appears on garden paths and in flowerpots.

Hairy Bitter-cress

Wavy Bitter-cress *Cardamine flexuosa* Height to 50cm

Similar to Hairy Bitter-cress (above), but taller and with wavy, hairy stems. Favours damp and disturbed ground. **FLOWERS** are 3–4mm across with 4 white petals (Mar–Sep). **FRUITS** are curved and barely overtop flowers. **LEAVES** are pinnately divided, with rounded lobes; seen as a basal rosette plus 4–10 stem leaves. **STATUS** Widespread and common. Often appears on garden paths and in flowerpots.

Wavy Bitter-cress

Cuckooflower *Cardamine pratensis* Height to 50cm

Variable perennial of damp, grassy places. Also known as Lady's-smock. **FLOWERS** are 12–20mm across with 4 pale lilac or white flowers (Apr–Jun). **FRUITS** are elongated and beaked. **LEAVES** are seen mainly in a basal rosette of pinnately divided leaves with rounded lobes; narrow stem leaves are also present. **STATUS** Widespread and locally common. Sometimes grows in damp lawns, and is an indication that the lawn in question may have a long history as grassland.

Cuckooflower

Shepherd's-purse *Capsella bursa-pastoris* Height to 35cm

Shepherd's-purse

Distinctive annual of arable fields, tracks, gardens and wayside ground. **FLOWERS** are 2–3mm across with 4 white petals; borne in terminal clusters (Jan–Dec). **FRUITS** are green, triangular and notched. **LEAVES** vary from lobed to entire; upper ones are usually toothed and clasp the stem. **STATUS** Widespread and rather common throughout. Often appears in the vegetable patch and beside paths.

Common Whitlowgrass *Erophila verna* Height to 20cm

Variable, hairy annual of dry, bare places. **FLOWERS** are 3–6mm across and comprise 4 deeply notched whitish petals (Mar–May). **FRUITS** are elliptical pods, borne on long stalks. **LEAVES** are narrow and toothed; they form a basal rosette, from the centre of which the flowering stalk arises. **STATUS** Common and widespread throughout.

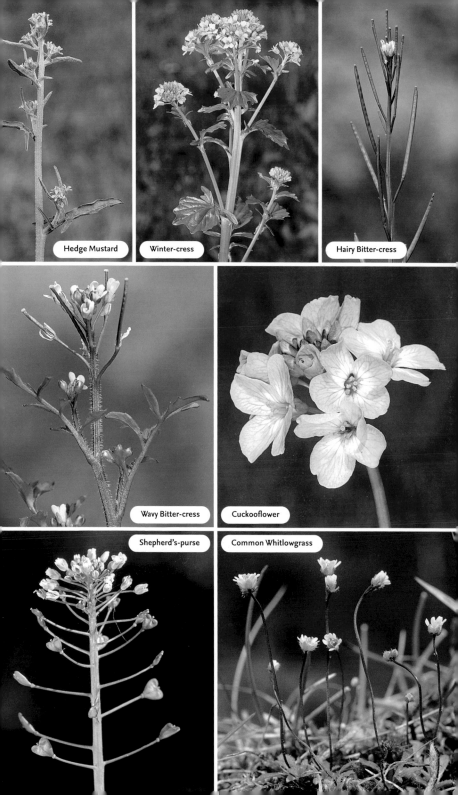

Hedge Mustard

Winter-cress

Hairy Bitter-cress

Wavy Bitter-cress

Cuckooflower

Shepherd's-purse

Common Whitlowgrass

Thale Cress *Arabidopsis thaliana* Height to 50cm
Distinctive annual of dry, sandy soils; often on paths. **FLOWERS** are 3mm across with 4 white petals; borne in terminal clusters (Mar–Oct). **FRUITS** are cylindrical and 20mm long. **LEAVES** are broadly toothed, oval and form a basal rosette; upright flowering stems also bear a few small leaves. **STATUS** Widespread and fairly common in lowland areas.

Garlic Mustard *Alliaria petiolata* Height to 1m
Familiar wayside biennial, often found in hedgerows and on roadside verges. **FLOWERS** are 6mm across with 4 white petals (Apr–Jun). **FRUITS** are cylindrical, ribbed and 4–5cm long. **LEAVES** are heart-shaped, toothed and borne up stem; they smell of garlic when crushed. **STATUS** Widespread and common, but least so in the N and W of the region. Often grows around the margins of rural gardens.

Thale
Cress

Garlic
Mustard

Agrimony *Agrimonia eupatoria* Height to 50cm
Upright perennial of grassy places, hedgerows and verges. **FLOWERS** are 5–8mm across with 5 yellow petals; borne in upright spikes (Jun–Aug). **FRUITS** are bur-like and covered in spines. **LEAVES** comprise 3–6 pairs of oval, toothed leaflets, with smaller leaflets between. **STATUS** Widespread and generally common throughout. Often grows on garden paths and in herbaceous borders.

Dog-rose *Rosa canina* Height to 3m
Scrambling, variable shrub whose long, arching stems bear curved thorns. Associated with hedgerows, woodland margins and scrub. **FLOWERS** are 3–5cm across and fragrant, with 5 pale pink petals and yellow stamens; borne in clusters of up to 4 flowers (Jun–Jul). **FRUITS** are red egg-shaped hips that typically shed their sepals before they ripen. **LEAVES** comprise 5–7 hairless leaflets. **STATUS** Widespread and common throughout.

Dog-rose, fruits

Bramble, flowers

Bramble *Rubus fruticosus* agg. Height to 3m
Scrambling shrub with arching stems that are armed with variably shaped prickles and root when they touch the ground. Found in hedgerows and scrub. **FLOWERS** are 2–3cm across and white or pink (May–Aug). **FRUITS** are familiar blackberries. **LEAVES** have 3–5 toothed leaflets. **STATUS** Widespread and common. Often grows around the margins of rural gardens.

Tormentil *Potentilla erecta* Height to 30cm
Creeping, downy perennial of grassy places, heaths and moors. **FLOWERS** are 7–11mm across with 4 yellow petals; borne on slender stalks (May–Sep). **FRUITS** are dry and papery. **LEAVES** are unstalked and trifoliate, but appear 5-lobed because of 2 large, leaflet-like stipules at the base. **STATUS** Widespread and often common. Sometimes grows in old, mature lawns but typically only where the soil is acid.

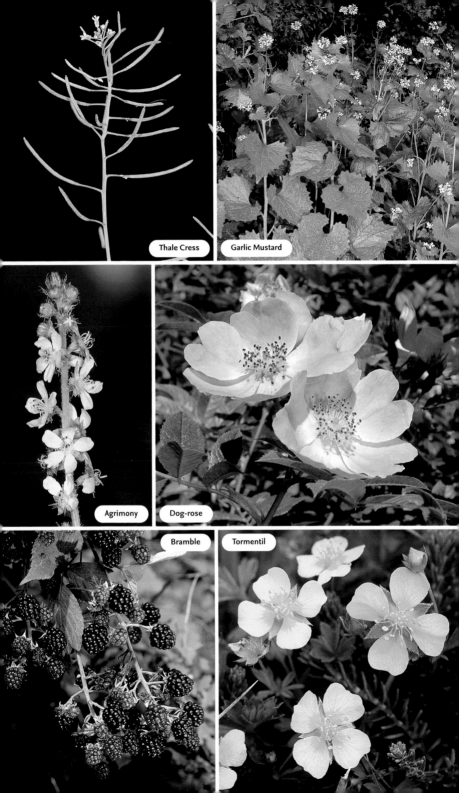

Thale Cress

Garlic Mustard

Agrimony

Dog-rose

Bramble

Tormentil

Silverweed *Potentilla anserina* Creeping

Low-growing perennial with long, creeping stems. **FLOWERS** are 15–20mm across with 5 yellow petals (May–Aug). **FRUITS** are dry and papery. **LEAVES** are divided into up to 12 pairs of leaflets (with tiny ones between them) that are covered in silky silvery hairs. **STATUS** Widespread and common in damp, grassy places and on bare ground.

Wood Avens *Geum urbanum*
Height to 50cm

Wood Avens

Hairy perennial of hedgerows and woodland. **FLOWERS** are 8–15mm across and comprise 5 yellow petals; they are upright in bud but drop when fully open (May–Aug). **FRUITS** are bur-like, with hooked red spines. **LEAVES** are either basal, with 3–6 pairs of side leaflets and a large terminal one, or 3-lobed stem leaves. **STATUS** Widespread and common, often doing well in borders and beside garden paths.

Silverweed

Tufted Vetch *Vicia cracca* Height to 2m

Slightly downy, scrambling perennial. Found in grassy places, hedgerows and scrub. **FLOWERS** are 8–12mm long and bluish purple; borne in 1-sided spikes up to 8cm tall (Jun–Aug). **FRUITS** are hairless pods. **LEAVES** comprise up to 12 pairs of narrow leaflets and end in a branched tendril. **STATUS** Widespread and common throughout; an attractive component of a wildflower herbaceous border.

Ribbed Melilot *Melilotus officinalis* Height to 1.5m

Attractive upright, hairless biennial. **FLOWERS** are bright yellow and borne in spikes up to 7cm long (Jun–Sep). **FRUITS** are wrinkled brown pods. **LEAVES** comprise 3 oblong leaflets. **STATUS** Locally common and possibly native in S England and Wales; introduced elsewhere. Grows in grassy places and on waste ground.

Tufted Vetch

Common Bird's-foot Trefoil

Lotus corniculatus Height to 10cm

Sprawling, solid-stemmed, usually hairless perennial. Found in grassy places. **FLOWERS** are red in bud, but yellow and 15mm long when open; borne in heads on stalks up to 8cm long (May–Sep). **FRUITS** are slender pods, splayed like a bird's foot when ripe. **LEAVES** have 5 leaflets but appear trifoliate (lower pair at stalk base). **STATUS** Common.

Black Medick *Medicago lupulina* Height to 20cm

Downy annual of short grassland and waste places. **FLOWERS** are small and yellow; borne in dense, spherical heads (8–9mm across) of 10–50 flowers (Apr–Oct). **FRUITS** are spirally coiled, spineless and black when ripe. **LEAVES** are trifoliate, each leaflet bearing a point at the centre of its apex. **STATUS** Widespread and rather common, sometimes growing in lawns.

Black Medick, fruits

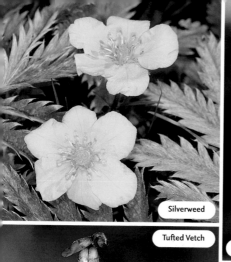

Silverweed

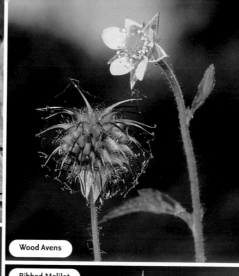

Wood Avens

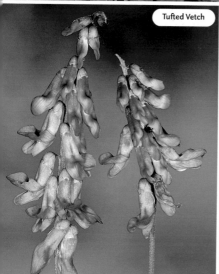

Tufted Vetch

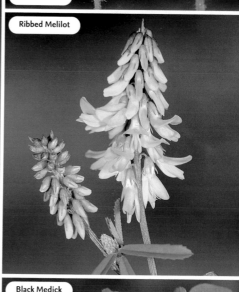

Ribbed Melilot

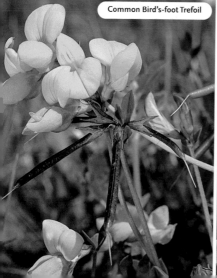

Common Bird's-foot Trefoil

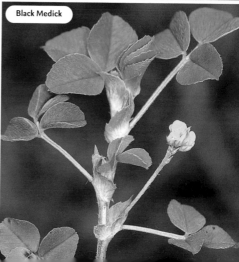

Black Medick

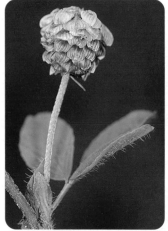

Hop Trefoil *Trifolium campestre* Height to 25cm
Low-growing, hairy annual. Found in dry grassland.
FLOWERS are 4–5mm long and yellow; borne in
compact, rounded heads, 15mm across (May–Oct).
FRUITS are pods, cloaked by brown dead flowers in
hop-like heads. **LEAVES** are trifoliate; terminal leaflet
has longest stalk. **STATUS** Widespread and generally
common; local in N Britain and Ireland.

Red Clover *Trifolium pratense* Height to 40cm
Familiar downy perennial found in grassy places on a
wide range of soil types. **FLOWERS** are pinkish red and
borne in dense, unstalked heads that are 2–3cm across
(May–Oct). **FRUITS** are concealed by calyx. **LEAVES** are
trifoliate, with oval leaflets each bearing a
crescent-shaped white mark; stipules are
triangular and bristle-tipped. **STATUS**
Widespread and often extremely
common throughout the region.

White Clover
Trifolium repens Height to 40cm
Creeping, hairless perennial
that roots at the nodes. Found
in grassy places on a wide range
of soil types. **FLOWERS** are creamy white,
becoming brown with age; borne in long-
stalked, rounded heads, 2cm across (May–Oct).
FRUITS are concealed by calyx. **LEAVES** are
trifoliate, the rounded leaflets often bearing
white marks and translucent lateral veins.
STATUS Widespread and often extremely
common throughout the region.

Hop Trefoil

Red Clover

White Clover

Herb-Robert *Geranium robertianum* Height to 30cm
Straggling, hairy annual of shady hedgerows, rocky banks and woodlands.
FLOWERS are 12–15mm across with pink petals and orange pollen; borne in
loose clusters (Apr–Oct). **FRUITS** have a long, hairy 'beak'. **LEAVES** are hairy
and deeply cut into 3 or 5 pinnately divided lobes; often tinged red. **STATUS**
Common and widespread throughout, often growing on rockeries and
garden paths.

Dove's-foot Crane's-bill *Geranium molle* Height to 20cm
Spreading and branched, extremely hairy annual of dry, grassy places, including verges.
FLOWERS are 5–10mm across with notched pink petals; borne in pairs (Apr–Aug). **FRUITS**
are hairless. **LEAVES** are hairy and rounded, with margins cut into 5–7 lobes. **STATUS**
Common and widespread, especially in the S.

Cut-leaved Crane's-bill *Geranium dissectum* Height to 45cm
Straggly, hairy annual found on disturbed ground and cultivated soils. **FLOWERS** are
8–10mm across with notched pink petals; borne on short stalks (May–Sep). **FRUITS** are
downy. **LEAVES** are deeply dissected to base, the lobes narrow and jagged. **STATUS** Generally
common throughout, although scarce in N Scotland.

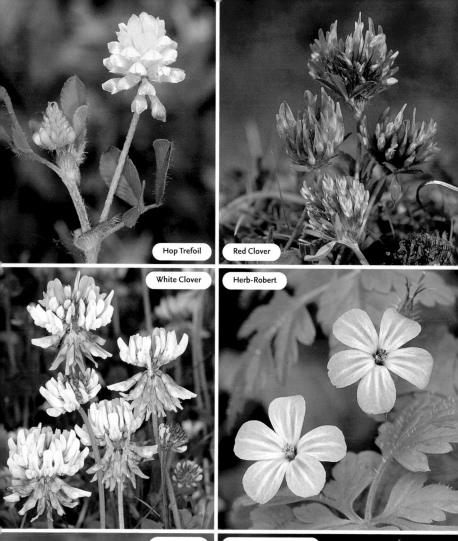

Hop Trefoil

Red Clover

White Clover

Herb-Robert

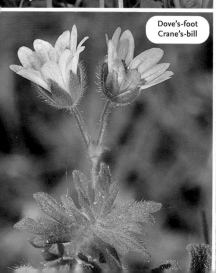

Dove's-foot Crane's-bill

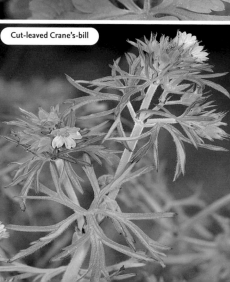

Cut-leaved Crane's-bill

Sun Spurge *Euphorbia helioscopia* Height to 50cm

Upright, hairless yellowish-green annual. Found on disturbed ground and in cultivated soils. **FLOWERS** lack sepals and petals, and are yellow with green lobes; borne in flat-topped umbel-like clusters with 5 leaf-like basal bracts (May–Nov). **FRUITS** are smooth. **LEAVES** are spoon-shaped and toothed. **STATUS** Widespread and common, often appearing in the vegetable patch.

Petty Spurge *Euphorbia peplus* Height to 30cm

Upright, hairless annual that often branches from the base. Found on arable land and cultivated ground. **FLOWERS** are greenish with oval bracts (sepals and petals are absent); borne in flattish umbel-like clusters (Apr–Oct). **FRUITS** are smooth. **LEAVES** are oval, blunt-tipped and stalked. **STATUS** Widespread and common almost throughout; often appears in the vegetable patch.

Dog's Mercury *Mercurialis perennis* Height to 35cm

Hairy, creeping perennial with a fetid smell. Found in woodlands (sometimes forms carpets). **FLOWERS** are yellowish and rather tiny; borne in open spikes on separate-sex plants (Feb–Apr). **FRUITS** are hairy. **LEAVES** are oval, shiny and toothed. **STATUS** Widespread and generally common, but scarce in N Scotland and Ireland. Sometimes found around the margins of rural gardens, its presence an indication that the site was once woodland.

Annual Mercury *Mercurialis annua* Height to 50cm

Hairless, branched and bushy annual. Found on waste ground and in cultivated soils, often near the sea. **FLOWERS** are yellowish green and borne in spikes on separate-sex plants (Jul–Oct). **FRUITS** are bristly. **LEAVES** are narrowly ovate, shiny and toothed. **STATUS** Locally common in the S, where it often appears in the vegetable patch.

Sweet Violet *Viola odorata* Height to 15cm

Fragrant perennial herb of woods and hedgerows, mostly on calcareous soils. **FLOWERS** are 15mm across and violet or white, with blunt sepals (Feb–May). **FRUITS** are egg-shaped. **LEAVES** are long-stalked and rounded in spring; larger and heart-shaped ones appear in autumn. **STATUS** Widespread and locally common in England and Wales. Often planted in gardens, but also a native resident of many rural gardens.

Sweet Violet

Common Dog-violet *Viola riviniana* Height to 12cm

Familiar perennial herb of woodland rides and grassland. **FLOWERS** are 15–25mm across and bluish violet, with a blunt, pale spur that is notched at the tip, and pointed sepals (Mar–May). **FRUITS** are egg-shaped. **LEAVES** are long-stalked, heart-shaped and mainly hairless. **STATUS** Widespread and locally common throughout. Grows around the margins of rural gardens.

Common Dog-violet

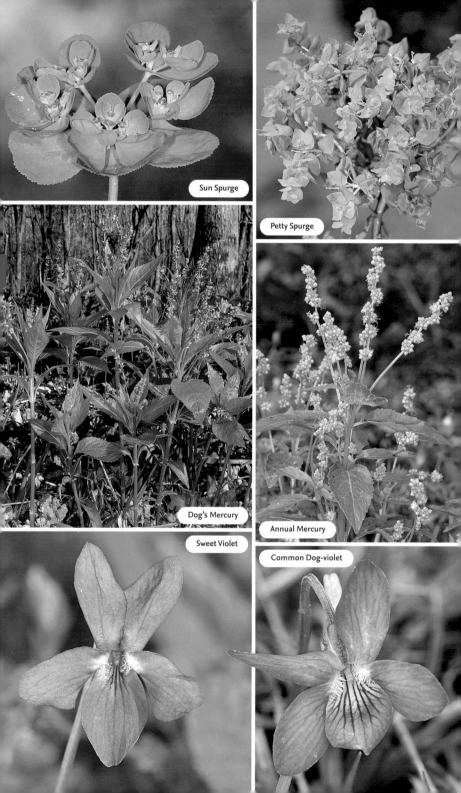

Sun Spurge

Petty Spurge

Dog's Mercury

Annual Mercury

Sweet Violet

Common Dog-violet

Rosebay Willowherb *Chamerion angustifolium* Height to 1.5m
Showy perennial of waste ground, cleared woodland and disturbed
ground, on a wide range of soil types (including old fire sites). FLOWERS
are 2–3cm across with pinkish-purple petals; borne in tall spikes
(Jul–Sep). FRUITS are pods that contain cottony seeds. LEAVES are
lanceolate and arranged spirally up stems. STATUS Widespread
and common throughout.

Hoary Willowherb *Epilobium parviflorum* Height to 75cm
Downy perennial that favours damp and disturbed
ground. FLOWERS are 12mm across with pale pink
notched petals and a 4-lobed stigma (Jul–Sep). FRUITS
are pods that contain cottony seeds. LEAVES are broadly
oval; upper ones are alternate. STATUS Widespread and
common, except in the N; often appears in herbaceous
borders and vegetable patches.

Broad-leaved Willowherb *Epilobium montanum*
Height to 80cm
Upright perennial. Similar to Hoary Willowherb (above)
but almost hairless. Found in woods and hedges. FLOWERS
are 6–10mm across, drooping in bud, with pale pink notched
petals and a 4-lobed stigma (Jun–Aug). FRUITS are pods that contain
cottony seeds. LEAVES are oval, rounded at the base, toothed and
opposite. STATUS Widespread and common; often grows in
herbaceous borders and vegetable patches.

Cow Parsley

American Willowherb *Epilobium ciliatum* Height to 50cm
Upright perennial; stems have 4 raised lines and spreading
glandular hairs. Found on waste ground and damp, shady places.
FLOWERS are 8–10mm across with notched pink petals and a
club-shaped stigma (Jul–Sep). FRUITS are pods that contain
cottony seeds. LEAVES are narrow-oval, toothed and short-
stalked. STATUS Introduced but widely naturalised; often
grows in the compost of flowerpots and beside shady paths.

Cow Parsley *Anthriscus sylvestris* Height to 1m
Downy, herbaceous perennial with hollow, unspotted
stems. Found in meadows and woodland margins, and
on verges. FLOWERS are white and borne in umbels up
to 6cm across; bracts are absent (Apr–Jun). FRUITS are
elongate and ridged. LEAVES are 2- to 3-pinnate, only
slightly hairy and fresh green. STATUS Widespread
and common. Grows around the margins of rural
gardens and is an excellent source of nectar for
insects.

Hogweed *Heracleum sphondylium* Height to 2m
Robust, roughly hairy perennial with hollow, ridged stems. Found
in meadows and open woodlands, and on roadside verges. FLOWERS
are off-white, with unequal petals; borne in umbels with 40 or so rays,
and up to 20cm across (May–Aug). FRUITS are elliptical, hairless and
flattened. LEAVES are up to 60cm long, broad, hairy and pinnate, the
lobes usually rather ovate. STATUS Widespread and common throughout
the region. Grows around the margins of rural gardens and in flowerbeds,
and is an excellent source of nectar for insects.

Hogweed

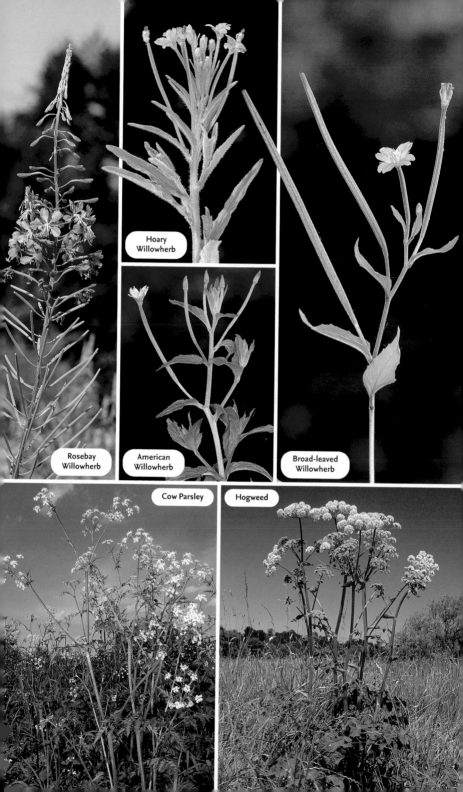

Hoary
Willowherb

Rosebay
Willowherb

American
Willowherb

Broad-leaved
Willowherb

Cow Parsley

Hogweed

Ground-elder

Ground-elder

Aegopodium podagraria Height to 1m

Creeping and patch-forming, hairless perennial. Favours damp and disturbed ground, and is a persistent weed in the garden. **FLOWERS** are white and borne in compact umbels, 2–6cm across with 10–20 rays (May–Jul). **FRUITS** are egg-shaped and ridged. **LEAVES** are fresh green, roughly triangular in outline and twice trifoliate. **STATUS** Doubtfully native; widely introduced and translocated (inadvertently) by gardeners, and now widespread.

Fool's-parsley *Aethusa cynapium* Height to 50cm

Delicate, hairless annual with slender, ribbed stems. Found in gardens and arable fields. **FLOWERS** are white and borne in umbels, 2–3cm across, the secondary umbels with a 'beard' of long upper bracts (Jun–Aug). **FRUITS** are egg-shaped and ridged. **LEAVES** are 2-pinnate, flat and triangular in outline. **STATUS** Commonest in the S, often appearing in the vegetable patch.

Primrose *Primula vulgaris* Height to 20cm

Primrose

Familiar herbaceous perennial, found in hedgerows, woodlands and shady meadows. **FLOWERS** are 2–3cm across, 5-lobed and pale yellow, usually with deep yellow centres; solitary and borne on long, hairy stalks that arise from centre of leaf rosette (Feb–May). **FRUITS** are capsules. **LEAVES** are oval, tapering, crinkly and up to 12cm long; they form a basal rosette. **STATUS** Widespread and common throughout. Often planted or encouraged in shady parts of the garden.

Cowslip *Primula veris* Height to 25cm

Elegant, downy perennial of dry, unimproved grassland, and often associated with calcareous soils. **FLOWERS** are 8–15mm across, fragrant, bell-shaped, stalked and orange-yellow; borne in rather 1-sided umbels of 10–30 flowers (Apr–May). **FRUITS** are capsules. **LEAVES** are tapering, wrinkled and hairy, forming a basal rosette. **STATUS** Widespread and locally common, except in Scotland, where it is rather scarce. Often planted or encouraged in the garden.

Cowslip

Creeping-Jenny *Lysimachia nummularia* Creeping

Low-growing, hairless perennial found on damp, grassy ground. **FLOWERS** are 15–25mm across, yellow and bell-shaped, with 5 pointed lobes; borne on stalks arising from leaf axils (Jun–Aug). **FRUITS** are capsules. **LEAVES** are rounded or heart-shaped; borne in opposite pairs. **STATUS** Locally common in England; scarce or absent elsewhere. Often grows in damp rockeries and beside garden ponds.

Yellow Pimpernel *Lysimachia nemorum* Creeping

Hairless evergreen perennial that is similar to Creeping-Jenny (above) but more delicate. Found in damp, shady places, especially in woodlands. **FLOWERS** are 10–15mm across, yellow and star-shaped, with 5 lobes; borne on slender stalks arising from leaf axils (May–Aug). **FRUITS** are capsules. **LEAVES** are oval or heart-shaped and borne in opposite pairs along creeping stems. **STATUS** Widespread and common throughout the region.

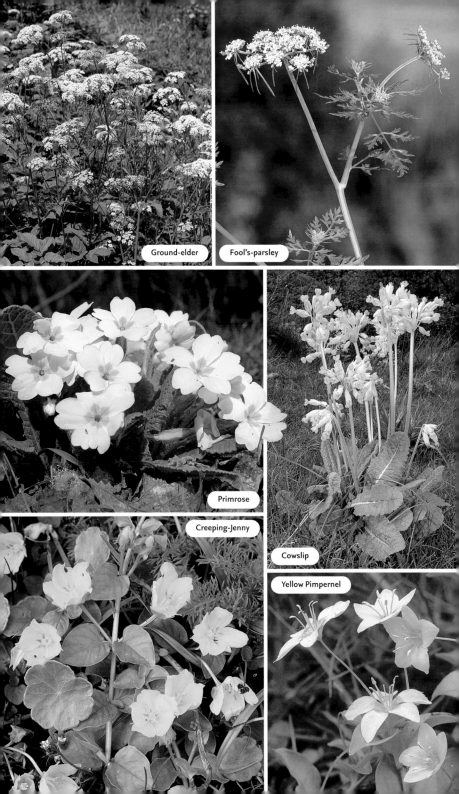

Ground-elder

Fool's-parsley

Primrose

Creeping-Jenny

Cowslip

Yellow Pimpernel

Scarlet Pimpernel *Anagallis arvensis* Creeping

Low-growing, hairless annual of cultivated and disturbed ground. **FLOWERS** are 10–15mm across, with 5 scarlet or pinkish-orange (sometimes blue) petals fringed with hairs; they open wide only in bright sunshine and are borne on slender stalks (Jun–Aug). **FRUITS** are capsules. **LEAVES** are oval and usually in pairs. **STATUS** Widespread and generally common throughout the region, except in Scotland.

Hedge Bindweed *Calystegia sepium* Height to 3m

Vigorous, hairless perennial that twines around other plants to assist its progress. Found in hedgerows, woodland margins and on disturbed ground, often swamping the plants on and through which it grows by late summer. **FLOWERS** are 3–4cm across, white and funnel-shaped (Jun–Sep); the 2 epicalyx bracts, which surround the sepals, do not overlap one another. **FRUITS** are capsules. **LEAVES** are arrow-shaped and up to 12cm long. **STATUS** Widespread and common in the S but scarce in the N.

Field Bindweed *Convolvulus arvensis* Height to 3m

Familiar perennial that grows in disturbed ground and arable land; a persistent weed in the garden. Twines around other plants to assist its progress. **FLOWERS** are 15–30mm across, funnel-shaped, and either white or pink with broad white stripes (Jun–Sep). **FRUITS** are capsules. **LEAVES** are arrow-shaped, 2–5cm long and long-stalked. **STATUS** Widespread and common throughout the region, except in N Scotland.

Cleavers *Galium aparine* Height to 1.5m

Sprawling annual of hedgerows and disturbed ground. Its stems are square and rough, the backward-pointing bristles on their edges helping secure the plant's scrambling progress through vegetation. **FLOWERS** are 2mm across and greenish white, with 4 petals; borne in clusters arising from leaf axils (May–Sep). **FRUITS** are nutlets with hooked bristles. **LEAVES** have backward-pointing marginal bristles. **STATUS** Common and widespread. Often swamps less vigorous plants in the garden unless controlled by cutting.

Cleavers, flower and fruits

Common Comfrey

Common Comfrey *Symphytum officinale* Height to 1m

Roughly hairy perennial with strikingly winged stems. Grows in damp ground beside rivers and ditches. **FLOWERS** are 12–18mm long and tubular to bell-shaped; colour varies but is usually white, pink or purple; borne in curved clusters (May–Jun). **FRUITS** are shiny nutlets. **LEAVES** are oval and hairy, the upper ones clasping, and the stalk running down the main stem. **STATUS** Widespread; common only in central and S England. Often planted or encouraged in the garden.

Early Forget-me-not *Myosotis ramosissima* Height to 10cm

Downy annual of arable fields, bare grassy places and open ground. **FLOWERS** are 2–3mm across, 5-lobed and sky-blue; borne in clusters (Apr–Oct). Corolla tube is shorter than calyx tube. **FRUITS** are nutlets. **LEAVES** are ovate, the basal ones forming a rosette. **STATUS** Widespread and common in most parts, except in the far N. Sometimes grows in bare patches on lawns.

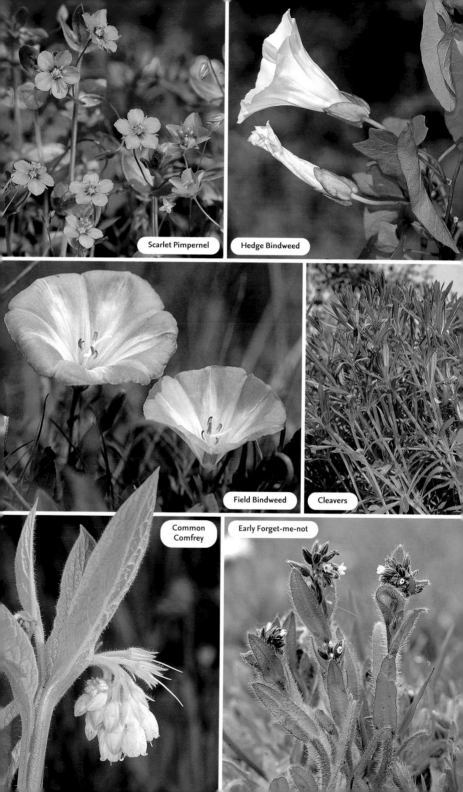

Scarlet Pimpernel

Hedge Bindweed

Field Bindweed

Cleavers

Common Comfrey

Early Forget-me-not

Selfheal *Prunella vulgaris* Height to 20cm

Creeping, downy perennial with leafy runners that root at intervals; flowering stems are upright. Grows in grassy places, hedgerows and woods. FLOWERS are 10–15mm long and bluish violet; borne in dense cylindrical terminal heads adorned with purplish bracts and calyx teeth (Apr–Jun). FRUITS are nutlets. LEAVES are paired and oval. STATUS Widespread, but commonest in the S.

Ground-ivy *Glechoma hederacea* Height to 15cm

Softly hairy and strongly smelling perennial with creeping, rooting stems and upright flowering stems. Grows in woodlands, hedgerows and grassland, and on bare ground. FLOWERS are 15–20mm long and bluish violet; borne in open whorls arising from leaf axils. FRUITS are nutlets. LEAVES are kidney-shaped to rounded, toothed and long-stalked. STATUS Widespread and common, except in the far N.

Ground-ivy

White Dead-nettle *Lamium album* Height to 40cm

Downy, slightly aromatic and patch-forming perennial with square stems. Grows on roadside verges and disturbed ground in hedgerows. FLOWERS are 25–30mm long and white, with a hairy upper lip and toothed lower lip; borne in whorls (Mar–Nov). FRUITS are nutlets. LEAVES are ovate to triangular with a heart-shaped base, toothed and stalked. They are superficially similar to those of the Common Nettle (p. 308) but lack stinging hairs. STATUS Widespread and common throughout, except N Scotland.

Red Dead-nettle *Lamium purpureum* Height to 30cm

Branched and spreading, downy annual. Pungently aromatic when crushed. The whole plant sometimes acquires a purplish tinge. Grows on disturbed ground and cultivated soils. FLOWERS are 12–18mm long and purplish pink, with a hooded upper lip and a lower lip that is toothed at the base and twice the length of the calyx; borne in whorls on upright stems (Mar–Oct). FRUITS are nutlets. LEAVES are heart-shaped to oval, round-toothed and stalked. STATUS Widespread and common.

White Dead-nettle

Henbit Dead-nettle *Lamium amplexicaule* Height to 20cm

Trailing, branched and rather straggly annual. Grows on dry cultivated soil and disturbed ground. FLOWERS are 15–20mm long and pinkish purple, with a hairy lip and a long corolla tube; borne in widely spaced whorls (Mar–Nov). Only a few flowers in a given whorl open at any one time, and some remain small and closed. FRUITS are nutlets. LEAVES are rounded and blunt-toothed, the upper ones almost unstalked. STATUS Widespread but only locally common.

Spear Mint *Mentha spicata* Height to 75cm

Almost hairless perennial that is the most popular cultivated culinary mint. Grows in damp ground; outside the garden context, it is found in meadows and on verges. FLOWERS are 3–4mm long and pinkish lilac; borne in tall, whorled terminal spikes (Jul–Oct). FRUITS are nutlets. LEAVES are narrowly ovate, toothed and almost unstalked. STATUS Popular as a garden plant, but also naturalised locally across the region.

Selfheal

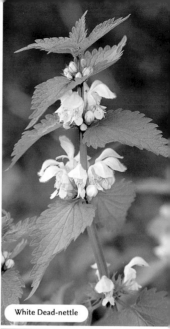

White Dead-nettle

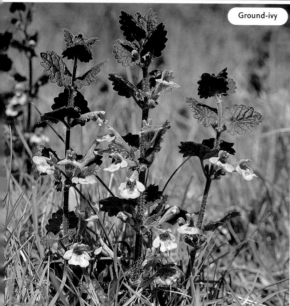

Ground-ivy

Spear Mint

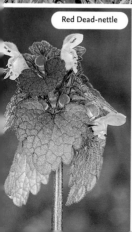

Red Dead-nettle

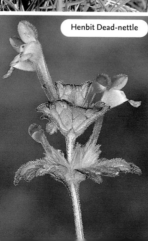

Henbit Dead-nettle

Bittersweet *Solanum dulcamara* Height to 1.5m

Downy, scrambling perennial that is woody at the base, hence its alternative common name of Woody Nightshade. Grows in hedgerows and scrub. FLOWERS are 10–15mm across, with 5 purple petal-like corolla lobes and projecting yellow anthers; borne in hanging clusters of purple stems (May–Sep). FRUITS are poisonous egg-shaped red berries, up to 1cm long. LEAVES are oval and pointed. STATUS Common, except in the N.

Common Figwort

Common Figwort *Scrophularia nodosa* Height to 70cm

Upright, hairless perennial with solid, square stems. Grows in damp, shady places. FLOWERS are 1cm long and greenish with a maroon upper lip, and with narrow white borders to the sepal lobes; borne in open spikes (Jun–Sep). FRUITS are greenish capsules, recalling miniature figs. LEAVES are oval and pointed, with sharp teeth. STATUS Widespread and common, except in N Scotland; grows around margins of rural gardens.

Ivy-leaved Toadflax *Cymbalaria muralis* Trailing

Hairless perennial with trailing purplish stems. Grows on rocks and walls. FLOWERS are 10–12mm across, lilac with yellow and white at the centre, and with a curved spur; borne on long stalks (Apr–Nov). FRUITS are capsules, borne on long stalks that become recurved with maturity, forcing the fruit into nooks and crannies. LEAVES are long-stalked, ivy-shaped, 5-lobed and borne on long stalks. STATUS Originally a garden plant but now widely naturalised.

Germander Speedwell

Veronica chamaedrys Height to 20cm

Delicate and attractive perennial with creeping stems that root at the nodes, and upright flowering stems. Grows in grassy places, in meadows and open woodlands, and on verges. FLOWERS are 10–12mm across, the corolla 4-lobed and blue with a white centre; borne on slender stalks in open terminal spikes (Apr–Jun). FRUITS are flattened, hairy, heart-shaped capsules. LEAVES are oval, toothed, hairy and short-stalked. STATUS Widespread and common throughout.

Slender Speedwell *Veronica filiformis* Prostrate

Mat-forming, downy perennial with creeping stems. Grows in short grassland, sometimes on lawns. FLOWERS are 8–10mm across, the corolla 4-lobed and bluish with a white lip; borne on relatively long, slender stalks arising from leaf axils (Apr–Jul). FRUITS are seldom produced. LEAVES are 5–10mm across, rounded to kidney-shaped, blunt-toothed and short-stalked. STATUS Introduced; now locally common in the S.

Foxglove *Digitalis purpurea* Height to 1.5m

Familiar downy greyish biennial or short-lived perennial. Grows best on acid soils. FLOWERS are 4–5cm long, the corolla pinkish purple (white forms are sometimes found) with darker spots in the throat; borne in tall, elegant terminal spikes (Jun–Sep). FRUITS are green capsules. LEAVES are 20–30cm long, downy, oval and wrinkled; they form a rosette in the 1st year, from which the flowering spike appears in the 2nd. STATUS Widespread and common; often grows and is encouraged in gardens with suitable soils.

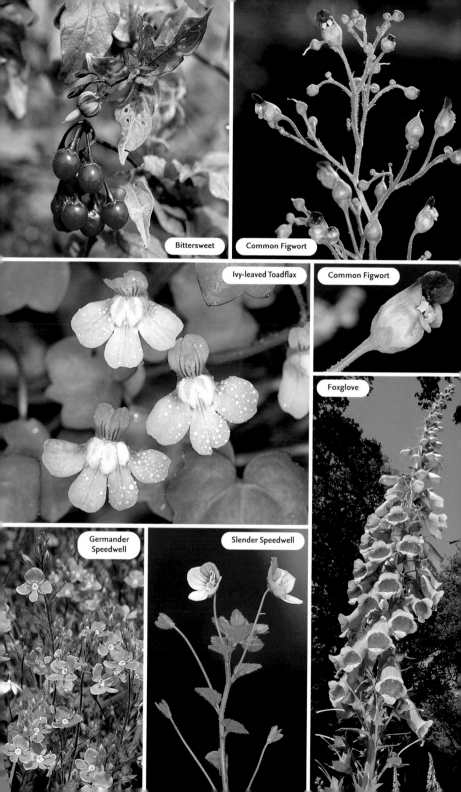

Bittersweet

Common Figwort

Ivy-leaved Toadflax

Common Figwort

Foxglove

Germander
Speedwell

Slender Speedwell

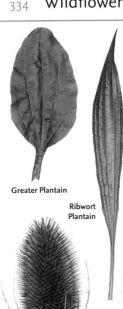

Greater Plantain

Ribwort Plantain

Wild Teasel

Daisy

Oxeye Daisy

Scentless Mayweed

Greater Plantain *Plantago major* Height to 20cm

Persistent and usually hairless perennial of lawns, disturbed grassland and arable land. **FLOWERS** are 3mm across, the corolla pale yellow, and the anthers purple when young and turning yellow later; borne on slender spikes 10–15cm long (Jun–Oct). **FRUITS** are capsules. **LEAVES** are broad, oval and up to 25cm long, with 3–9 veins and a distinct narrow stalk; borne in basal rosettes. **STATUS** Widespread and extremely common.

Ribwort Plantain *Plantago lanceolata* Height to 15cm

Persistent perennial that grows on disturbed grassland, cultivated ground and tracks. **FLOWERS** are 4mm across with a brownish corolla and white stamens; borne in compact heads, 2cm long, on furrowed stalks up to 40cm long (Apr–Oct). **FRUITS** are capsules. **LEAVES** are lanceolate, up to 20cm long with 3–5 distinct veins; borne in spreading basal rosettes. **STATUS** Widespread and common.

Wild Teasel *Dipsacus fullonum* Height to 2m

Biennial of damp and disturbed grassland on heavy soils. Stems are angled, with sharp prickles on the angles. **FLOWERS** are pinkish purple and carried in egg-shaped heads, 6–8cm long, adorned with numerous spiny bracts; borne on tall stems (Jul–Aug). **FRUITS** are dry, papery and borne in the dry flower heads; they are popular with Goldfinches (p. 66). **LEAVES** are spine-coated and appear as rosettes in the 1st year; in the 2nd year these die back and are replaced by opposite stem leaves joined at the base, the resulting cup collecting water. **STATUS** Widespread and common only in the S.

Daisy *Bellis perennis* Height to 10cm

Familiar downy perennial found growing in lawns and other areas of short grass. **FLOWERS** are borne in solitary heads, 15–25mm across, on slender stems; they comprise yellow disc florets and white (often faintly crimson-tipped) ray florets (Mar–Oct). **FRUITS** are achenes. **LEAVES** are spoon-shaped and form prostrate rosettes, from which flower stalks arise. **STATUS** Widespread and common.

Oxeye Daisy *Leucanthemum vulgare* Height to 60cm

Downy or hairless perennial of dry, grassy meadows and verges, often on disturbed ground. **FLOWERS** are borne in solitary heads, 30–50mm across, with yellow disc florets and white ray florets (May–Sep). There are no scales between disc florets. **FRUITS** are achenes. **LEAVES** are dark green and toothed; lower leaves are spoon-shaped, stalked and form a rosette; stem leaves are pinnately lobed. **STATUS** Widespread and common; often grown in the garden.

Scentless Mayweed
Tripleurospermum inodorum Height to 75cm

Scentless, hairless and often rather straggly perennial of disturbed and cultivated ground. **FLOWERS** are borne in clusters of solitary, long-stalked heads, 20–40mm across, comprising yellow disc florets and white ray florets (Apr–Oct). There are no scales between disc florets. Receptacle is domed and solid. **FRUITS** are achenes tipped with black oil glands. **LEAVES** are feathery and much divided. **STATUS** Widespread and common.

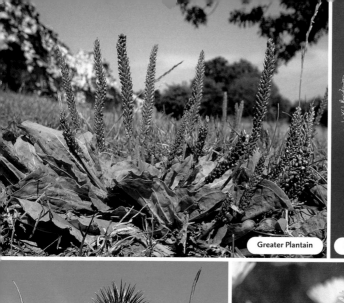

Greater Plantain

Ribwort Plantain

Wild Teasel

Daisy

Oxeye Daisy

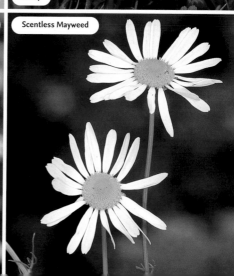

Scentless Mayweed

Pineapple Mayweed *Matricaria discoidea* Height to 12cm

Hairless, bright green perennial that smells strongly of pineapple when crushed. Grows on disturbed ground, paths and tracks. **FLOWERS** comprise yellowish-green disc florets only (no ray florets), which are borne in rounded to conical heads, 8–12mm long, the receptacles of which are hollow (May–Nov). **FRUITS** are achenes. **LEAVES** are finely divided and feathery. **STATUS** Widespread and common.

Common Fleabane *Pulicaria dysenterica* Height to 50cm

Creeping perennial with upright, branched, woolly flowering stems. Grows in damp meadows and ditches on heavy soils. **FLOWERS** are borne in heads, 15–30mm across, with spreading yellow ray florets and deeper yellow central disc florets; heads are arranged in open clusters (Jul–Sep). **FRUITS** are achenes with a hairy pappus. **LEAVES** are heart-shaped and clasp the stem; basal leaves soon wither. **STATUS** Common, except in Scotland.

Yarrow *Achillea millefolium* Height to 50cm

Upright, downy perennial with creeping stems and upright, unbranched, furrowed flowering stalks. The whole plant is strongly aromatic. Grows in meadows, verges and hedgerows, and on waste ground. **FLOWERS** are borne in heads, 4–6mm across, comprising yellowish disc florets and pinkish-white ray florets; heads are arranged in flat-topped clusters (Jun–Nov). **FRUITS** are achenes. **LEAVES** are dark green, finely divided and feathery. **STATUS** Widespread and common.

Common Fleabane

Tansy

Sneezewort *Achillea ptarmica* Height to 60cm

Upright, branched or unbranched perennial with stiff, angular stems, the upper parts of which are downy. Grows in damp situations in meadows, and woodland rides and clearings, almost always on acid soils. **FLOWERS** are borne in heads, 1–2cm across, comprising greenish-yellow disc florets and white ray florets; heads are carried in open clusters (Jul–Sep). **FRUITS** are achenes. **LEAVES** are narrow, undivided, untoothed and stalkless. **STATUS** Locally common.

Tansy *Tanacetum vulgare* Height to 75cm

Robust, upright perennial that is strongly aromatic. Grows on verges and in hedgerows, and on disturbed ground. **FLOWERS** are borne in golden-yellow button-like heads, 7–12mm across, which comprise disc florets only; these appear as flat-topped umbel-like clusters, up to 12cm across, comprising up to 70 heads (Jul–Oct). **FRUITS** are achenes. **LEAVES** are yellowish green and pinnately divided, with deeply cut lobes. **STATUS** Common and widespread; often grown in the garden for its showy flowers.

Feverfew *Tanacetum parthenium* Height to 50cm

Upright, much-branched, downy perennial that is strongly aromatic. Grows on disturbed ground, verges, waysides and old walls. **FLOWERS** are borne in daisy-like heads, 1–2cm across, which comprise yellow disc and white ray florets; heads are arranged in loose clusters (Jul–Aug). **FRUITS** are achenes. **LEAVES** are yellowish green and pinnately divided; lower leaves are stalked, upper ones unstalked. **STATUS** Introduced as a garden plant and widely naturalised.

Feverfew

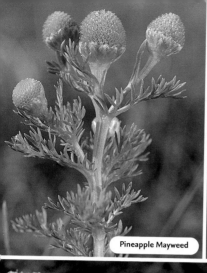

Pineapple Mayweed

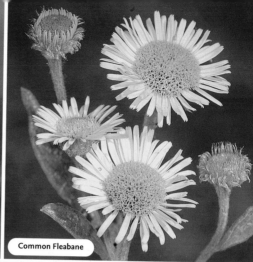

Common Fleabane

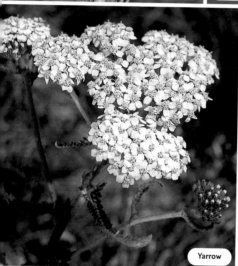

Yarrow

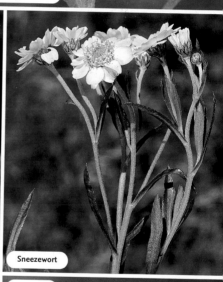

Sneezewort

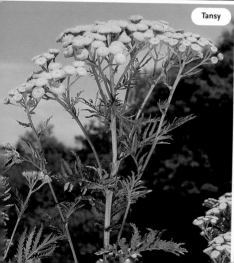

Tansy

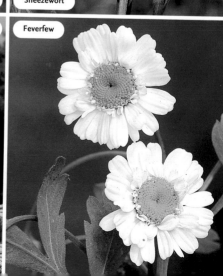

Feverfew

Winter Heliotrope *Petasites fragrans* Height to 20cm
Creeping and patch-forming perennial that grows in damp or shady wayside places and hedgerows. **FLOWERS** are vanilla-scented and borne in pinkish-lilac heads, 10–12mm across; these are carried in spikes, 20–25cm long (Dec–Mar). **FRUITS** are achenes. **LEAVES** are rounded, 20cm across, long-stalked and present all year. **STATUS** Introduced as a garden plant but now widely naturalised.

Colt's-foot

Colt's-foot *Tussilago farfara* Height to 15cm
Creeping perennial with runners and upright, leafless flowering stalks with overlapping, fleshy bracts. Grows in bare and disturbed ground, particularly on clay. **FLOWERS** are borne in heads, 15–35mm across, with orange-yellow disc florets and yellow ray florets; heads are solitary and terminal (Feb–Apr). **FRUITS** comprise a 'clock' of hairy seeds. **LEAVES** are rounded, heart-shaped and 10–20cm across, appearing after flowering. **STATUS** Widespread and common.

Common Ragwort *Senecio jacobaea* Height to 1m
Hairless, poisonous biennial or short-lived perennial. Grows in grassland; thrives in grazed areas (animals avoid eating living plants). **FLOWERS** are yellow and borne in heads, 15–25mm across; these are carried in dense, flat-topped clusters (Jun–Nov). **FRUITS** of disc florets are downy; ray floret fruits are hairless. **LEAVES** are pinnate, with a blunt end lobe. Food plant of Cinnabar moth larvae (p. 192). **STATUS** Common and widespread.

Groundsel *Senecio vulgaris* Height to 40cm
Branched annual plant that is either upright or spreading. Grows in cultivated and disturbed ground, and is familiar as a garden weed. **FLOWERS** comprise cylindrical heads, 10mm long, of yellow disc florets only, with black-tipped greenish bracts; carried in clusters (Jan–Dec). **FRUITS** are very hairy. **LEAVES** are pinnately lobed; lower leaves are stalked, upper ones clasp the stem. **STATUS** Widespread and common.

Common Ragwort

Groundsel

Greater Burdock *Arctium lappa* Height to 1m
Branched and downy biennial of hedgerows and waste ground. **FLOWERS** are borne in egg-shaped heads, 20–40mm across, with purplish florets and greenish-yellow hooked, spiny bracts (Jul–Sep). **FRUITS** have hooked spines that cling to animal fur and aid dispersal. **LEAVES** are heart-shaped with solid stalks; basal leaves are longer than wide. **STATUS** Locally common only in England and Wales. **SIMILAR SPECIES Lesser Burdock** *A. minus* has smaller flowers and leaves with hollow stalks; its basal leaves are wider than long.

Marsh Thistle *Cirsium palustre* Height to 1.5m
Upright, branched biennial that is often tinged reddish. The stems have continuous spiny wings. Grows in damp grassland. **FLOWERS** are borne in heads, 10–15mm across, with dark reddish-purple florets; heads are arranged in clusters (Jul–Sep). **FRUITS** have feathery pappus hairs. **LEAVES** are pinnately lobed and spiny. **STATUS** Widespread and common.

Greater Burdock

Lesser Burdock

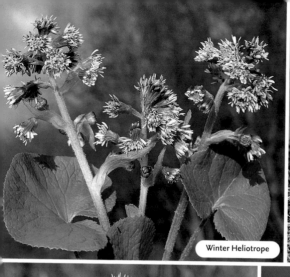
Winter Heliotrope

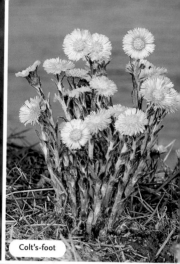
Colt's-foot

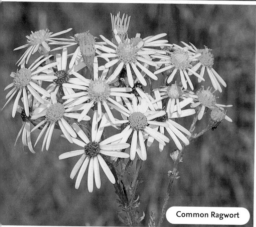
Common Ragwort

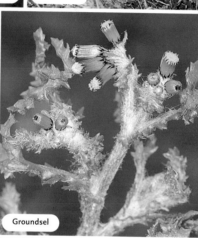
Groundsel

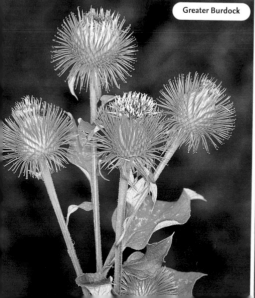
Greater Burdock

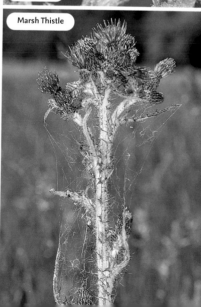
Marsh Thistle

Smooth Sow-thistle *Sonchus oleraceus* Height to 1m

Upright, hairless plant of disturbed ground. Broken stems exude a milky sap. **FLOWERS** are borne in heads, 20–25mm across, with pale yellow florets; heads are carried in umbel-like clusters (May–Oct). **FRUITS** have feathery hairs forming a 'clock'. **LEAVES** are matt and pinnate, with triangular lobes, spiny margins and clasping, pointed auricles at base. **STATUS** Widespread and common.

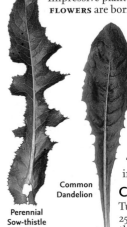

Common Dandelion

Perennial Sow-thistle

Cat's-ear

Perennial Sow-thistle *Sonchus arvensis* Height to 2m

Impressive plant of damp, disturbed ground. Broken stems exude a milky sap. **FLOWERS** are borne in heads, 4–5cm across, with yellow florets; heads are carried in umbel-like clusters (Jul–Sep). **FRUITS** have feathery hairs forming a 'clock'. **LEAVES** are narrow, shiny, dark green above and greyish below, with pinnate lobes and soft marginal spines; they have clasping, rounded auricles at base. **STATUS** Widespread and common.

Common Dandelion *Taraxacum officinale* agg.
Height to 35cm

Variable perennial of grassy places. **FLOWERS** are borne in heads, 3–6cm across, with yellow florets; heads are solitary and borne on hollow stems that yield a milky sap if broken (Mar–Oct). **FRUITS** have a hairy pappus, arranged as a white 'clock'. **LEAVES** are spoon-shaped and sharply lobed; arranged in a basal rosette. **STATUS** Widespread and common.

Cat's-ear *Hypochaeris radicata* Height to 50cm

Tufted perennial of dry grassland. **FLOWERS** are borne in heads, 25–40mm across, with yellow florets that are much longer than the bristly, purple-tipped bracts; flower stalks branch 1–2 times (Jun–Sep). Scales are present between florets. **FRUITS** are beaked, with some feathery hairs. **LEAVES** are oblong, bristly and wavy-edged; they form a basal rosette. **STATUS** Common.

Snowdrop *Galanthus nivalis* Height to 25cm

Familiar spring perennial that grows in damp woodland. **FLOWERS** are 15–25cm long, the 3 outer segments pure white, the inner 3 white with a green patch; solitary and nodding (Jan–Mar). **FRUITS** are capsules. **LEAVES** are grey-green, narrow and all basal. **STATUS** Possibly native in S Britain but widely naturalised.

Yellow Iris *Iris pseudacorus* Height to 1m

Robust perennial of pond margins and damp ground. **FLOWERS** are 8–10cm across and bright yellow with faint purplish veins; borne in clusters of 2–3 flowers (May–Aug). **FRUITS** are oblong and 3-sided. **LEAVES** are grey-green, sword-shaped and often wrinkled. **STATUS** Widespread and common.

Lords-and-ladies *Arum maculatum* Height to 50cm

Perennial of woods and hedges. **FLOWERS** comprise a purple-margined, pale green cowl-shaped spathe, part-shrouding the club-shaped purplish-brown spadix; borne on slender stalks (Apr–May). **FRUITS** are red berries, borne in a spike. **LEAVES** are arrowhead-shaped, stalked, sometimes dark-spotted; appear in spring. **STATUS** Commonest in the S. **SIMILAR SPECIES Italian Lords-and-ladies** *A. italicum* has netted leaves that appear in autumn and, usually, a yellow spadix. Native and widely planted in the garden.

Lords-and-ladies

Lords-and-ladies, fruit

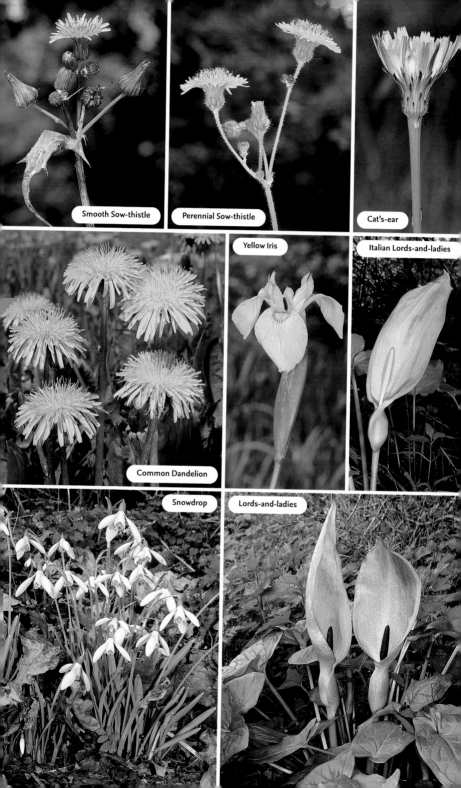

Smooth Sow-thistle

Perennial Sow-thistle

Cat's-ear

Yellow Iris

Italian Lords-and-ladies

Common Dandelion

Snowdrop

Lords-and-ladies

INTRODUCING GARDEN NON-FLOWERING PLANTS

Non-flowering plants lack the impact of their flowering cousins and are often treated as the poor relations. But to the quizzical eye these diverse plants are a fascinating group. Like flowering plants they photosynthesise, but they do not flower and produce seeds.

THE RANGE OF NON-FLOWERING PLANTS IN THE GARDEN

LIVERWORTS

These prostrate plants have a body called a thallus. Some liverworts are flat and almost seaweed-like, while others are leafy. Root-like outgrowths anchor the plant to the substrate on which it grows. Liverworts are prone to desiccation and most are found in damp and humid habitats.

MOSSES

Moss structure is marginally more complex than that of liverworts. Their stems bear scale-like leaves but they lack proper roots, instead being anchored to the substrate by fibrous hairs. Mosses are prone to desiccation and most thrive only in damp settings. Some species carpet the ground, while others grow on branches, fallen logs or rock surfaces.

HORSETAILS

These perennial plants overwinter as underground rhizomes. Jointed aerial stems appear in spring and bear whorls of radiating branches. The spore-producing organs are arranged in cones. If conditions suit them, horsetails can be locally abundant and invasive.

FERNS

Most ferns are large and robust, although garden representatives tend to be smaller. Fern reproduction involves two different, alternating stages or generations. What most people think of as a typical fern is the spore-producing stage in the life cycle.

Crescent-cup Liverwort

Lunularia cruciata Spreading

Fresh-green liverwort with reproductive cups that are crescent- or half-moon-shaped. **STATUS** Common and widespread on damp ground beside streams, but also often abundant in well-watered humus of potted plants and beside paths and tracks.

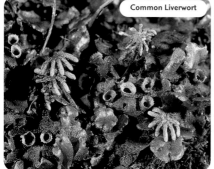

Common Liverwort

Crescent-cup Liverwort

Common Liverwort

Marchantia polymorpha Spreading

Familiar liverwort with a divided, dark green thallus. Lobes overlap, and surface bears shallow cups and umbrella-shaped reproductive structures, these comprising stalked, rayed females and toadstool-like males. **STATUS** Common and widespread on well-watered potted-plant compost.

Pointed Spear-moss

Calliergonella cuspidata
Height 4cm

Distinctive moss that usually appears yellow-green, with pointed tips to the shoots; stems are reddish. Leaves, pressed together when young, can give it a rather bedraggled appearance. **STATUS** Common and widespread on damp ground in garden lawns, and also on chalk downland.

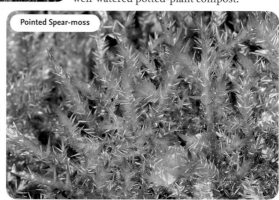

Pointed Spear-moss

Capillary Thread-moss

Capillary Thread-moss

Bryum capillare Height 3cm

Moss whose oval leaves are tipped with a fine point. Elongate-ovoid spore capsules are long-stalked and drooping; green, ripening to brown. **STATUS** Common and widespread; forms compact cushions on roofs and walls.

Rough-stalked Feather-moss *Brachythecium rutabulum* Height 4cm

Moss whose branching stems are covered with shiny, oval, pointed leaves; usually dark green but sometimes tinged yellow. Capsule is curved and long-stalked. **STATUS** Widespread and extremely common in lawns; favours damp ground but also grows in woodland and on banks.

Grey-cushioned Grimmia *Grimmia pulvinata* Height 3cm

Forms compact cushions on walls and roofs. Leaves are narrow and grey-green; the pointed greyish tips can sometimes give whole cushion a silvery appearance, especially in dry weather. **STATUS** Common and widespread, especially in limestone areas.

Silky Wall Feather-moss *Homalothecium sericeum* Height 2cm

Stems are branched and mat-forming, covered with narrow, finely tipped, glossy leaves. In dry weather, plant stems curl and turn brown. **STATUS** Common and widespread in a wide range of sites, including old brick and stone walls and at the base of tree trunks.

Swan-neck mosses *Campylopus* spp. Height 4cm

A group of tufted mosses whose leaves are very narrow and typically taper to a fine, hairlike point. **STATUS** Native species have a mainly westerly range and grow on damp rocks, wet peat or rotting wood. The introduced *C. introflexus* is now widespread and sometimes grows on acid roof tiles.

Wall Screw-moss *Tortula muralis* Height 1cm

Familiar moss with oval, rounded-tipped leaves that end in a fine point. Spore capsules are narrow and held upright on long, slender stalks; yellow when young but ripening brown. **STATUS** Common and widespread. Grows on old brick walls and rocks; forms low, spreading cushions.

Field Horse-tail

Field Horsetail *Equisetum arvense*
Height 75cm

Our commonest horsetail. Sterile shoots with ridged stems carry whorls of unbranched branches, while fertile stems appear in early spring and ripen in May. **STATUS** Common and widespread. Forms spreading patches in damp, grassy places, on waste ground and in herbaceous borders in the garden.

Rustyback *Ceterach officinarum*
Frond length 20cm

Distinctive fern whose dark green fronds are divided simply into rounded lobes and form tufted clumps; lobe undersides are covered in rusty-brown scales. **STATUS** Widespread, but common only in SW England, W Wales and Ireland. Grows on stone walls and rocks.

Wall-rue *Asplenium ruta-muraria* Frond length 12cm

Delicate little fern that often looks densely tufted. Evergreen fronds are dull green and divided simply into oval lobes with spores beneath. **STATUS** Widespread, but commonest in W Britain and Ireland. Grows on stone walls (especially where lime mortar has been used) and on rocks, often in areas of limestone.

Rustyback

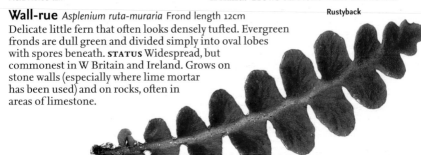

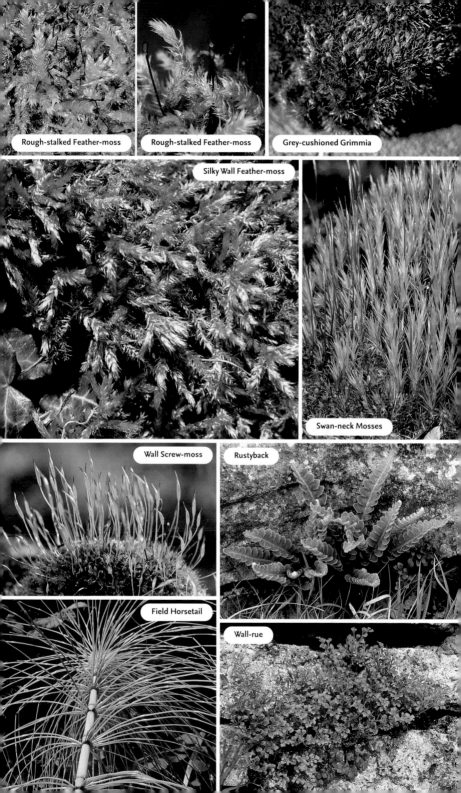

Rough-stalked Feather-moss

Rough-stalked Feather-moss

Grey-cushioned Grimmia

Silky Wall Feather-moss

Swan-neck Mosses

Wall Screw-moss

Rustyback

Field Horsetail

Wall-rue

INTRODUCING LICHENS AND FUNGI

Lichens and fungi are intriguing organisms that have a close relationship with one another. Lichens are present year-round in the garden; fungal fruiting bodies (the structures that most people recognise as fungi) are seasonal in appearance.

LICHENS

Pinning down a strict definition for lichens has always been difficult. These strange organisms are a symbiotic partnership between fungi (which are not plants) and tiny algae or photosynthesising bacteria that live inside the body of the lichen.

FUNGI

Until recently, fungi were thought of as plants, but they are now known to be entirely unrelated. The main body comprises threads called hyphae, which permeate the growing medium (such as rotting wood or leaf litter) and feed the fungus. Collectively, these fungal hyphae are called the mycelium. Toadstools (in all their forms) are just the fruiting bodies of fungi, and their role is to produce and disperse spores.

Spores being liberated by Honey Fungus.

LEFT: The confusingly named Oak Moss (actually a lichen), growing on a twig.

BELOW: Fungal mycelium.

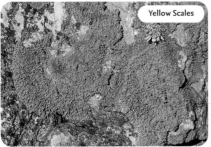

Yellow Scales

Crab's-eye lichens
Ochrolechia spp. Spreading
Encrusting, patch-forming lichens. Surface is greyish with a pale margin. Clusters of raised, rounded and flat-topped spore-producing structures give rise to the genus's common English name. **STATUS** Common in W and N Britain, growing on walls and rocks.

Yellow Scales
Xanthoria parientina Spreading
Forms bright orange-yellow patches whose surface comprises leafy, narrow scales that are rather wrinkled. **STATUS** Common and widespread. Most spectacular on coasts, but also common inland, including in gardens. Grows on rocks, walls and brickwork; also grows on acidic tree bark.

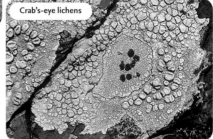

Crab's-eye lichens

Oak Moss *Evernia prunastri* Width 6cm
Lichen comprising repeatedly divided sets of flattened branches that are partly curled and twisted. Upper surface is greenish grey while lower surface is white. **STATUS** Common and widespread. Grows attached to twigs and branches, and found mainly on oaks.

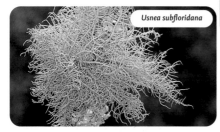
Usnea subfloridana

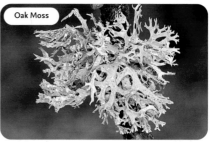
Oak Moss

Usnea subfloridana Length 9cm
Lichen that forms dense, tangled masses of thin threads that 'bounce back' when compressed in the hand. Attached by a hold-fast to twigs, but sometimes grows on rocks. Cup-shaped spore-producing bodies are absent. **STATUS** Common and widespread.

Usnea florida Width 5cm
Forms tangled masses of long, thin threads, attached to twigs with a holdfast. Distinctive cup-shaped spore-producing bodies form at the tips of some branches, the cups fringed by thin hairs. **STATUS** Commonest in W Britain.

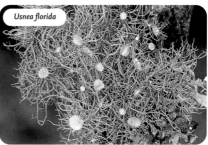
Usnea florida

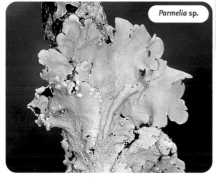
Parmelia sp.

Parmelia sp. Spreading
Encrusting lichen found on the bark of mature deciduous trees. Patches are grey-green and comprise rounded, often overlapping lobes, the surfaces of which have brown flat-topped spore-producing discs. **STATUS** Common and fairly widespread, but intolerant of air pollution.

Hypogymnia physodes Width 25mm
Much-branched but encrusting lichen that forms irregularly rounded patches that are smooth and grey on the upper surface. **STATUS** Widespread and fairly common. Grows on twigs and branches, and also on rocks and walls.

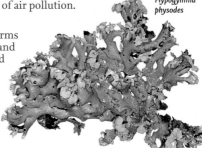
Hypogymnia physodes

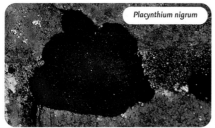
Placynthium nigrum

Placynthium nigrum Spreading
Dark, encrusting lichen that looks rather like a splash of black paint. Associated with limestone rocks but also grows on lime-rich mortar of brick walls. **STATUS** Common and widespread on suitable growing media.

Snowy Waxcap *Hygrocybe virginea* Height to 6cm

Pale, slightly greasy toadstool. **CAP** is whitish, 5cm across, and a flattened dome. **GILLS** are whitish and decurrent. **STEM** is whitish and slightly tapering. **STATUS** Common and widespread in mature garden lawns.

Parrot Waxcap

Hygrocybe psittacina Height to 7cm

Slimy toadstool. Colour is variable (can be orange-red or yellowish green) but always shows a flush of green somewhere on the fruit body. **CAP** is 4cm across and domed, sometimes with an umbo. **GILLS** are same colour as cap. **STEM** sticky and flushed green towards the top, to 7cm long. **STATUS** Common and widespread in grassy places, including mature garden lawns.

Blackening Waxcap

Hygrocybe conica Height to 10cm

Slightly greasy toadstool whose colours, when fresh, can be red, orange or yellow; entire fruit body turns black when ripe. **CAP** is up to 8cm across, conical at first and then expanding. **GILLS** are yellow at first. **STEM** is yellow or orange at first. **STATUS** Common and widespread in grassland.

Blackening
Waxcap

Golden Waxcap *Hygrocybe chlorophana* Height to 9cm

Colourful toadstool. **CAP** is up to 7cm across, greasy, bright yellow, and domed and flattened. **GILLS** are paler than cap. **STEM** reaches 8cm long and is slightly paler than cap. **STATUS** Common and widespread in grassland and mature garden lawns.

Scarlet Waxcap *Hygrocybe coccinea* Height to 7cm

Colourful toadstool. **CAP** is up to 6cm across, scarlet and greasy; bell-shaped at first, maturing flatter. **GILLS** are scarlet and pale-edged. **STEM** is scarlet. **STATUS** Common and widespread in grassland, including mature garden lawns.

Honey Fungus *Armillaria mellea* Height to 14cm

Much-reviled toadstool. **CAP** is up to 12cm across, yellowish brown and scaly towards middle, and flattish with a wavy margin. **GILLS** are yellowish brown and slightly decurrent. **STEM** is up to 12cm long, yellowish, darkening towards base and with a distinct ring. **STATUS** Common and widespread; associated with, and attacks and kills, deciduous trees and shrubs.

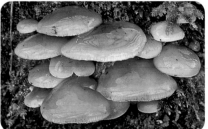

Velvet Shank *Flammulina velutipes*
Height to 11cm

Colourful, clustered toadstool that fruits in late autumn and winter. **CAP** is up to 9cm across, orange-brown, flattish and slightly slimy. **GILLS** are whitish at first, maturing yellowish. **STEM** has a velvety texture. **STATUS** Common and widespread on decaying deciduous timber.

Velvet Shank

Plums and Custard

Tricholomopsis rutilans Height to 11cm

Distinctive toadstool that often occurs in small groups. **CAP** is up to 9cm across, flattish, and rich yellow with maroon scaling. **GILLS** are rich yellow. **STEM** is a similar colour and texture to cap. **STATUS** Common and widespread on decaying conifer timber.

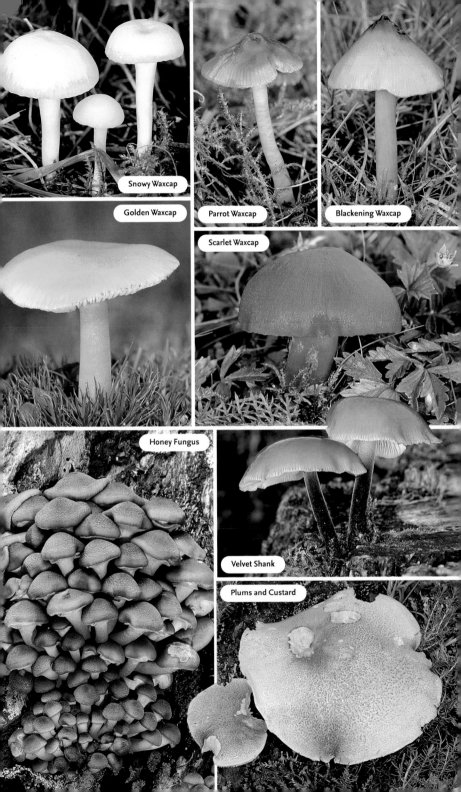

Snowy Waxcap

Parrot Waxcap

Blackening Waxcap

Golden Waxcap

Scarlet Waxcap

Honey Fungus

Velvet Shank

Plums and Custard

Mycena flavescens Height to 7cm
Fragile-looking toadstool that smells of radish. CAP is up to 3cm across, domed to broadly bell-shaped, and buffish-white with a brown tip and brown radial lines. GILLS are pinkish white. STEM is buffish grey and slender. STATUS Widespread and fairly common in lawns and amongst leaf-litter.

Orange Mosscap *Rickenella fibula* Height to 5cm
Colourful and distinctive toadstool. CAP is up to 1cm across, orange-yellow, and convex to funnel-shaped. GILLS are yellowish and decurrent. STEM is yellowish and downy. STATUS Common and widespread in grassland, including mature garden lawns.

Glistening Inkcap *Coprinellus micaceus* Height to 11cm
Colourful toadstool that grows in clusters. When fresh it is colourful, but the fruit bodies blacken and deliquesce as they mature. CAP is up to 3cm across, egg-shaped to bell-shaped and grooved; surface is orange-brown at first, covered in shiny scales that soon wash or rub off. GILLS are white at first. STEM is whitish at first. STATUS Common and widespread on decaying stumps of deciduous trees.

Pleated Inkcap *Parasola plicatilis* Height to 7cm
Delicate toadstool with a fanciful resemblance to an umbrella. CAP is up to 1.5cm across, becoming flattened with a dark centre and radial lines. GILLS are pale brown. STEM is whitish. STATUS Common and widespread in grassland and mature lawns.

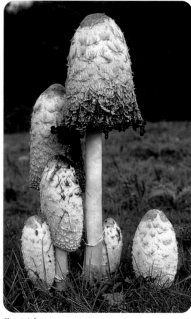

Shaggy Inkcap

Shaggy Inkcap *Coprinus comatus*
Height to 15cm
Impressive and familiar toadstool that often grows in groups. CAP is up to 12cm tall, white with shaggy scales, egg-shaped at first but maturing bell-shaped and turning black and deliquescing. GILLS are white, maturing black and deliquescing. STEM has a fibrous texture. STATUS Common and widespread in grassland and lawns, often on disturbed or compacted ground, including paths.

Stinking Dapperling *Lepiota cristata*
Height to 6cm
Delicate little toadstool with an unpleasant smell. CAP is up to 4cm across, creamy white with reddish-brown scales (most intense towards centre), and domed but flattish. GILLS are creamy white. STEM is whitish, fibrous towards base, and has a ring. STATUS Common and widespread, growing in herbaceous borders and neglected areas of the garden.

St George's Mushroom *Calocybe gambosa*
Height to 9cm
Whitish grassland toadstool with a mealy smell. Typically appears in spring, often around St George's Day (23 Apr). CAP is up to 12cm across, flattish but undulating, and creamy white, flushed with brown. GILLS are creamy white. STEM is whitish and bulbous; seldom tall enough to raise cap above level of grass. STATUS Common and widespread, growing in undisturbed grassland, including mature garden lawns.

Field Mushroom *Agaricus campestris* Height to 9cm
Familiar grassland mushroom. CAP is up to 10cm across, creamy or greyish white, domed at first, expanding and becoming flatter with maturity. GILLS are pink at first, maturing dark brown. STEM is whitish with a slight ring. STATUS Widespread and very locally common in undisturbed grassland, and sometimes on mature garden lawns.

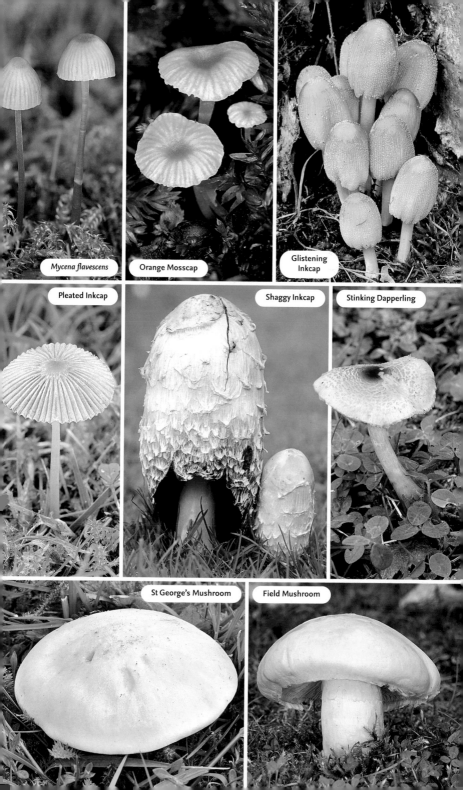

Mycena flavescens

Orange Mosscap

Glistening Inkcap

Pleated Inkcap

Shaggy Inkcap

Stinking Dapperling

St George's Mushroom

Field Mushroom

Brown Rollrim *Paxillus involutus* Height to 9cm
Familiar toadstool that is always associated with birch trees. **CAP** is up to 11cm across, grubby yellowish brown, and convex to funnel-shaped with an inrolled margin. **GILLS** are decurrent and yellowish brown. **STEM** is thick and slightly bulbous, yellowish brown but bruising darker. **STATUS** Widespread and common where birches are present.

Sulphur Tuft *Hypholoma fasciculare* Height to 9cm
Familiar toadstool that grows in large clumps on dead wood. **CAP** is up to 7cm across, orange-yellow but darker towards centre, domed at first but maturing flatter. **GILLS** are yellowish green. **STEM** is orange-yellow with a faint ring; often curved, depending on growing position. **STATUS** Common and widespread on decaying tree stumps.

Agrocybe rivulosa Height to 13cm
Fairly distinctive toadstool that grows only on woodchips. **CAP** is up to 7cm across, pale buff, and undulating and wrinkled. **GILLS** are whitish at first, maturing brown. **STEM** is whitish and fibrous, with a ring. **STATUS** First recorded in Britain in 2004 but now widespread, sometimes occurring on flowerbeds mulched with woodchips.

Earthy Powdercap *Cystoderma amianthinum* Height to 6cm
Distinctive grassland toadstool. **CAP** is up to 5cm across, yellowish brown, with a powdery, granular texture and veil remnants around perimeter. **GILLS** are creamy white. **STEM** is yellowish brown and scaly, with a delicate ring. **STATUS** Common and widespread, sometimes growing in mature garden lawns.

Blue Roundhead *Stropharia caerulea* Height to 10cm
Colourful and distinctive toadstool. **CAP** is up to 8cm across, bluish green and fading to yellowish, domed at first but maturing flatter. **GILLS** are reddish brown at first, maturing dark brown. **STEM** is bluish green with white scales. **STATUS** Common and widespread in organic-rich areas, including well-mulched garden beds.

Redlead Roundhead

Redlead Roundhead
Stropharia aurantiaca Height to 9cm
Colourful toadstool that grows on woodchips. **CAP** is up to 6cm across, domed at first, and orange-red with white velar remains around margins. **GILLS** are buffish brown with a white edge. **STEM** is whitish, sometimes flushed red. **STATUS** Widespread but local; sometimes common in flowerbeds that have been well mulched with woodchips.

Jelly Ear *Auricularia auricula-judae*
Diameter up to 8cm
Unusual fungus that has a convincing resemblance to, and feel of, a human ear. **FRUIT BODY** is orange-brown and slightly translucent, and ear- or cup-shaped with undulating wrinkles. The texture when fresh is elastic and gelatinous; it soon shrivels, darkens and hardens when dry. **STATUS** Common and widespread, growing on dead twigs and branches, typically of Elder (p. 302).

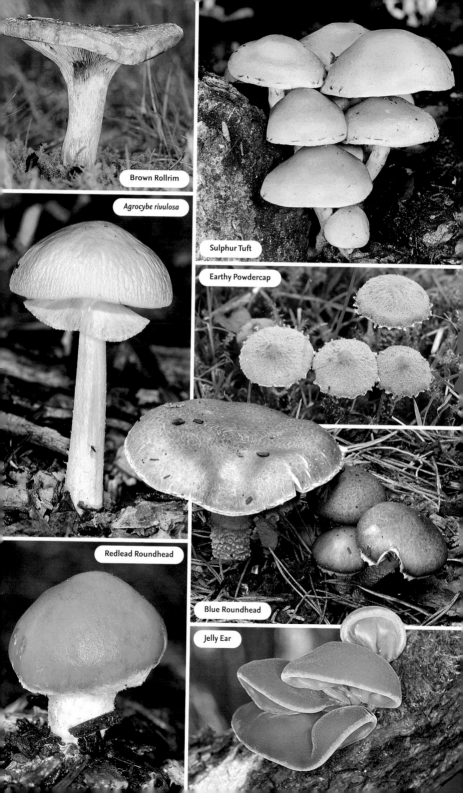

Brown Rollrim

Agrocybe rivulosa

Sulphur Tuft

Earthy Powdercap

Redlead Roundhead

Blue Roundhead

Jelly Ear

Collared Earthstar, releasing spores

Collared Earthstar
Geastrum triplex Diameter to 10cm
Bizarre fungus that is onion-shaped at first, the outer layer splitting into 5–7 segments to reveal a spore sac. **RAYS** are fleshy and creamy buff at first; flesh cracks and browns with age. Fleshy collar usually forms at base of spore sac. **SPORE SAC** is 2–4cm across, unstalked, smooth and creamy buff; the pore is fibrous. **STATUS** Widespread and locally common, growing in humus-rich soils, including well-mulched flowerbeds.

Striated Earthstar
Geastrum striatum Diameter to 6cm
Elegant earthstar that is onion-shaped at first, the outer layer splitting into 6–9 segments to reveal a spore sac. **RAYS** are spreading at first and often become recurved. **SPORE SAC** is 1–2cm across with a powdery layer at first. Diagnostic features of species relate to spore sac: presence of stalk, pleated pore and basal collar. **STATUS** Widespread but scarce, usually found under mature conifers, including Leyland Cypress (p. 290).

White Spindles *Clavaria fragilis* Height to 10cm
Intriguing grassland fungus that grows in clusters. **FRUIT BODIES** are white, worm-like spindles that can be either straight or curled and bent. **STATUS** Common and widespread in undisturbed grassland, including mature garden lawns.

Golden Spindles *Clavulinopsis fusiformis* Height to 12cm
Colourful and distinctive fungus that grows in clusters. **FRUIT BODIES** are bright yellow spindles that taper at both ends. **STATUS** Common and widespread in undisturbed grassland, including mature garden lawns; usually on acid soils.

Turkeytail *Trametes versicolor* Diameter to 10cm
Familiar bracket fungus whose colourful concentric zones give it a fanciful resemblance to the fanned tail of a Turkey. Usually grows in dense tiers. **FRUIT BODY** is thin and semi-circular with a wavy margin. Upper surface is leathery, with concentric zones of colours ranging from buff to reddish brown and black; margin is usually pale. Undersurface is buffish white, with small pores. **STATUS** Common and widespread on deciduous wood.

Silverleaf Fungus *Chondrostereum purpureum* Diameter to 7cm
Colourful fungus that causes 'silverleaf' disease in fruit trees, notably plums. **FRUIT BODY** usually forms undulating, leathery brackets. Upper surface is velvety and purplish brown with a pale margin; lower surface is purplish and wrinkled. **STATUS** Common and widespread.

Coral Spot *Nectria cinnabarina* Diameter 3–4mm
Colourful fungus that appears in clusters on dead and dying twigs of deciduous trees, notably Sycamore (p. 296). **FRUIT BODY** appears in 2 forms, sometimes alongside one another: one is reddish brown, the other pinkish orange. **STATUS** Common and widespread.

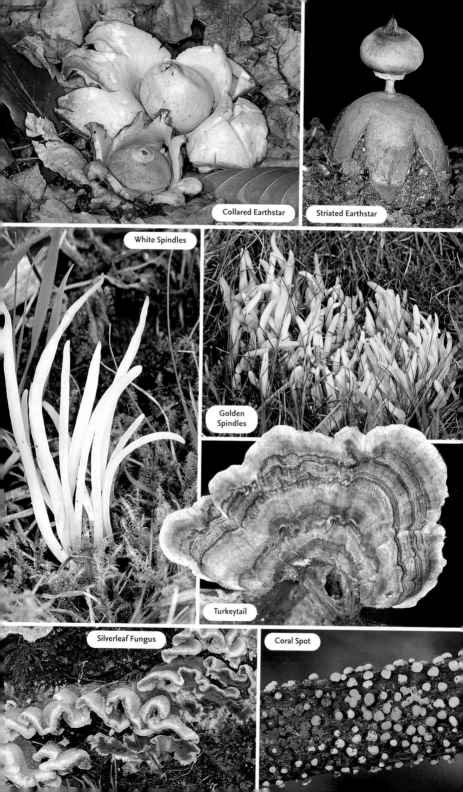

Collared Earthstar

Striated Earthstar

White Spindles

Golden Spindles

Turkeytail

Silverleaf Fungus

Coral Spot

INTRODUCING PONDLIFE INVERTEBRATES

Dip a net into a pond and you will be amazed at what you discover. Even the smallest garden pond is likely to harbour creatures galore, with representatives from most major invertebrate groups. Those that are visible to the naked eye are introduced here.

COELENTERATES
Coelenterates are a mainly marine group that include jellyfish and corals. In fresh water, they are represented by Hydra (*see* p. 370), which resembles a miniature sea anemone.

FLATWORMS
Relatives of parasitic worms, flatworms (or planarians) are free-living with extremely flat bodies and recognisable head and tail ends. Most species are carnivorous (*see* p. 370).

TRUE WORMS
Annelid worms are what most people think of as 'true worms' – animals with segmented bodies (*see* p. 370). There is a distinct head end, with a mouth.

ARTHROPODS
Arthropods are usually the most numerous pond invertebrates. They have an exoskeleton and jointed legs; freshwater representatives include the following:

- **Insects**, most of which have segmented bodies divided into a head, thorax and abdomen. With the exception of bugs and beetles, larval stages are aquatic while adults are terrestrial. The group includes dragonflies, damselflies, stoneflies, mayflies, alderflies, caddis flies, bugs, true flies and beetles (*see* pp. 360–8).

Whirlygig Beetle adult, an insect.

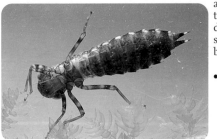

- **Crustaceans**, whose exoskeleton is impregnated with calcium salts. Pond representatives include water fleas, ostracods, copepods, water lice, freshwater shrimps and crayfish (*see* p. 368).

MOLLUSCS
Molluscs (*see* p. 370), a diverse group whose pond representatives include water snails and bivalve molluscs (with paired shells). All molluscs have a muscular foot.

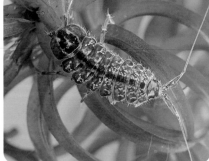

TOP: **Brown Hawker larva, an insect.**
ABOVE: **Freshwater Louse, a crustacean.**

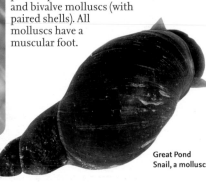

Great Pond Snail, a mollusc

MAKING YOUR OWN GARDEN POND

A pond is a wonderful feature in any garden, creating visual interest and adding greatly to wildlife diversity. Most people are not fortunate enough to have a natural pond in their garden, but creating one is a relatively straightforward matter.

SIZE AND SHAPE

In terms of its value to wildlife, the larger and deeper a pond the better. Such ponds will not only support more wildlife in physical terms, but are also less prone to climatic extremes. With a small, shallow pond there is a risk that it will dry up or overheat in the summer sun, or freeze solid in a bitter winter. The minimum overall size for a pond is 3 × 2m, and ideally it should contain at least two areas that are more than 75cm deep. The profile should also include shallow margins – not only are these needed for the growth of marginal plants, but they also ensure that any terrestrial animals, such as Hedgehogs, have some means of escape should they fall into the pond. Remember that a pond with irregularly curved margins is going to look more natural and harmonious than a straight-sided version.

LOCATION, LOCATION

A pond should be always located in an open part of the garden, but ideally somewhere that receives a degree of shade during the summer months. That said, resist the temptation to site your pond beneath a tree, as falling leaves will inevitably clog it up every autumn and winter.

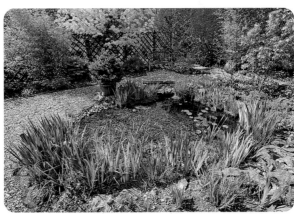

RIGHT: **Surrounded by pebbles and gravel rather than turf, this mature garden pond harbours an abundance of aquatic plants and invertebrates.**

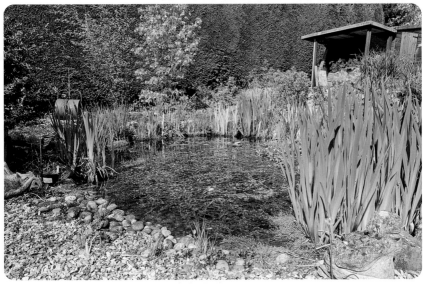

Tall marginal vegetation and the backdrop of a tall hedge ensure there are shady areas in this pond for at least part of the day.

CONSTRUCTION TYPE

There are two sensible options when it comes to making a garden pond. First, a hard moulded shell (made of fibreglass or plastic, for example) can be used – it is simply a matter of buying a suitably sized shell, digging a hole into which it fits reasonably well, and lining the hole with sand to get a snug fit.

The second option, which is the method of choice for most people these days, is to use a flexible butyl liner to create a garden pond. Ask a group of friends to help out to spread the effort involved, and be warned that it is not exactly a cheap operation. The stages involved are as follows:

1. Dig a hole that is at least 3 × 2m across, with a natural-looking margin and with central areas that are at least 75cm deep. Ensure that at least some, if not all, of the margins are gently sloping, and create a shallow submarginal zone, roughly 10–20cm deep; this is where marginal plants will thrive.

2. If the excavated pond has been sited in an existing lawn area, slide a spade under the turf surrounding it to a distance of 50cm or so, and roll it back in strips. After the pond has been filled, the turf can then simply be rolled back over the butyl liner.

3. Remove all obvious stones from the soil surface as these might puncture the pond lining, and spread a generous layer of sand over the whole area – at least 2–3cm deep.

4. Place a layer of underlay on top of the sand. Some people use old carpet, but this tends to deteriorate and disintegrate with time. Instead, consider using proprietary aquatic underlay (sold in specialist shops) or even a layer of thick insulating foam (the sort that is sold for sound insulation). The dimensions of any underlay sheet need to match the area of the pond itself plus twice its maximum depth; this allows for sagging and displacement once the pond has been filled.

5. Lay a layer of thick butyl liner on top of the underlay, covering its margins. The dimensions of the butyl liner need to match those of the underlay sheet. Do not trim the liner until the pond has been filled, as it may sag and stretch as the water is added.

6. If you are feeling extravagant, lay a protective webbing coat on top of the butyl liner to protect it from damaging sunlight. Alternatively, cover the shallow pond margins with gravel or small pebbles.

7. Fill the pond with water. The ideal source is rainwater, but tap-water can be used so long as you leave it standing for a week or so to allow the chlorine to evaporate before adding any animals and plants.

8. Trim the butyl liner, leaving a margin of at least 20cm around the pond edge. Replace the turf if the pond is sited in a lawn, or cover the edge of the liner with stones to give it a natural-looking finish.

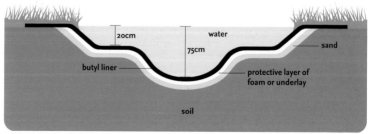

Cross-section through a pond.

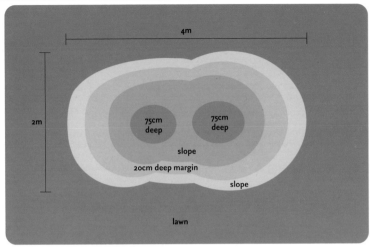

A bird's-eye view of a garden pond.

IMMEDIATE SURROUNDINGS

When you dig a hole for your garden pond you are faced with the problem of what to do with the soil you remove. Unless you have a specific requirement for this soil, two options can be considered: a log pile or a rockery, both of which can be sited near the pond itself. For the log pile, create a layered sandwich of logs, soil, more logs and so on, until you have a pile 40–50cm high; the pile will decompose and sink with time, at which stage more logs can be added. The soil can also be used to create the structural base for an impressive rockery. Both log piles and rockeries provide nooks, crannies and retreats for all manner of creatures, particularly frogs, toads and newts, which spend much of their lives on land and need hideaways during the daytime.

STOCKING THE POND AND COLONISATION

The best source of pond plants is a friend's existing pond – when you collect plants in this way, it is often a good idea to bring back a bucket of water and some sediment at the same time, to kickstart the invertebrate life in your own pond. Although alien, Canadian Waterweed is a good oxygenator, as is the native Water-starwort. Invertebrate life will colonise of its own accord. No plants or animals should be collected from the wild, but it is quite acceptable to translocate frogspawn from a friend's pond in order to establish frogs in your own garden.

ALGAL BLOOMS

Algal blooms are almost unavoidable in a new pond, especially if tap-water (which is often alarmingly nutrient-rich) is used to fill it, and if it is overstocked with plants and animals from the outset. Do not attempt to control the bloom with chemicals. Instead, be patient – the algae are actually doing you a service by using up the dissolved nutrients in the water; once these are exhausted, the bloom will finish, the water will clear and you will have a relatively stable pond environment.

ANNUAL MAINTENANCE

A well-established pond needs little maintenance apart from the removal each autumn of fallen and wind-blown leaves. The removal off excessive growths of pondweed in the summer may sometimes also be required if the pond looks like it might be getting choked.

Southern Hawker, larva

Southern Hawker
Aeshna cyanea Adult length 70mm
Large, active dragonfly. **ADULT** has broad green stripes on thorax and markings of similar coloration on abdomen, except for last 3 segments of the male where the markings are blue. Flies Jun–Oct. **LARVA** is brown and elongate, with a broad, flattened head. **STATUS** Common only in S and central England. Breeds in ponds and lakes, but adults often feed well away from water.

Common Hawker *Aeshna juncea* Adult length 70mm
Active, fast-flying dragonfly. **ADULT** has narrow yellow lines on thorax, blue eyes and blue markings on an otherwise dark brown abdomen; dorsal spots at rear of abdomen are dissected by a dark line. Flies Jun–Oct. **LARVA** is brown and elongate, with a broad, flattened head. **STATUS** Common and widespread, least so in S England. Breeds in ponds, lakes and canals, but adults often feed kilometres away from water.

Brown Hawker *Aeshna grandis* Adult length 74mm
Distinctive dragonfly, easily recognised even in flight by its brown body and bronze wings. **ADULT** male also has blue spots on 2nd and 3rd segments of abdomen. Flies Jul–Sep. **LARVA** is brownish grey with white markings; it is elongate, with a broad, flattened head. **STATUS** Commonest in SE England. Breeds in well-vegetated ponds, lakes and canals, and typically patrols a regular hunting territory around the margins.

Emperor Dragonfly *Anax imperator* Adult length 78mm
Large, active and wary dragonfly, and our most impressive species. **ADULT** is recognised by dark dorsal line running length of abdomen; abdomen ground colour is sky-blue in male, greenish blue in female. Flies Jun–Aug. **LARVA** is brown and elongate, with a broad, flattened head that is almost circular when viewed dorsally. **STATUS** Locally common only in S England. Favours lakes, ponds and canals, and usually hunts over open water. Sometimes visits large garden ponds.

Broad-bodied Chaser
Libellula depressa Adult length 43mm
Attractive dragonfly that actively hawks for insects but also perches for long periods. **ADULT** has a broad, flattened abdomen; this is sky-blue with small yellow spots on sides in mature male, brown with yellow spots on sides in female and immature male. Wings have dark brown bases. Flies May–Aug. **LARVA** is squat and hairy; lives in sediment and detritus at bottom of pond. **STATUS** Common only in S England; often visits, and breeds in, large garden ponds.

Broad-bodied Chaser, larva

Four-spotted Chaser
Libellula quadrimaculata Adult length 40mm
Distinctively marked dragonfly. **ADULT** has a mainly orange-brown body with yellow spots on sides of broad, dark-tipped abdomen. Each wing has a brown patch at base and a dark spot midpoint on the leading edge. Flies May–Aug. **LARVA** is squat and hairy; lives in sediment and detritus at bottom of pond. **STATUS** Locally common in S and central England and Wales; sometimes visits, and breeds in, garden ponds but favours areas with acid water.

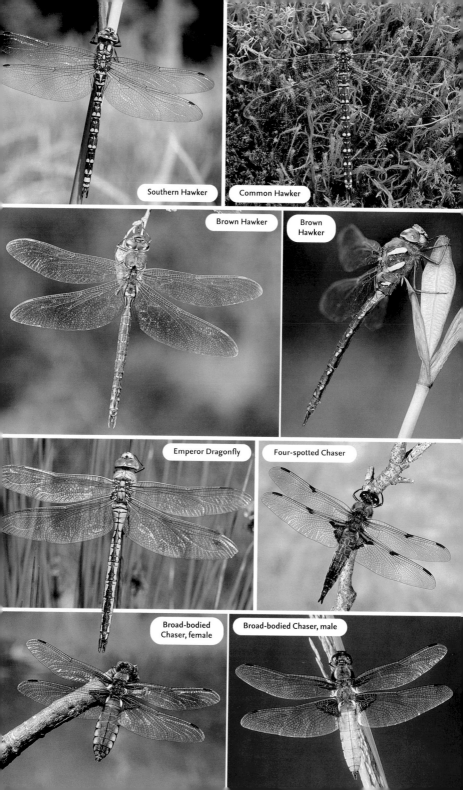

Southern Hawker

Common Hawker

Brown Hawker

Brown Hawker

Emperor Dragonfly

Four-spotted Chaser

Broad-bodied Chaser, female

Broad-bodied Chaser, male

Common Darter *Sympetrum striolatum* Adult length 36mm

Familiar small dragonfly. Often rests on the ground but also uses perches. **ADULT** has a narrow body. Abdomen is deep red in mature male, orange-brown in immature male and female. Flies Jun–Oct. **LARVA** is squat and lives among pondweeds. **STATUS** Widespread, and the commonest dragonfly in many parts. Breeds in still and slow-flowing fresh waters, including larger garden ponds; often feeds well away from water.

DRAGONFLY AND DAMSELFLY LARVAE

Immature stages of dragonflies (larvae) have good eyesight, allowing them to spot their prey; small creatures are caught using a fanged, extensible flap called the 'mask'. Hawker dragonfly larvae are slender, while species such as chasers, which live among debris and silt, are squat and hairy. Empty larval cases (exuviae) can be found on waterside vegetation where adults have recently emerged. Larval damselflies have slim, cylindrical bodies with a 'mask' for catching prey; two antennae project forwards from the head and at the rear are three flattened gills. They live among pondweeds and debris, and are active predators.

RIGHT: Emperor Dragonfly, empty larval case.
BELOW: Common Blue Damselfly larva.

BELOW: Variable Damselfly, segment 2

Azure Damselfly *Coenagrion puella* Adult length 33mm

Colourful damselfly. **ADULT** male is sky-blue with black bands on abdomen and a black 'U' marking on segment 2; female is mostly black, but tip of abdomen is blue. Flies May–Aug. **LARVA** is slender and brown; gills have a pointed tip. **STATUS** Widespread and common except in the N; breeds in mature garden ponds.

Variable Damselfly *Coenagrion pulchellum* Adult length 35mm

Could be confused with Azure Damselfly (above). **ADULT** male is sky-blue with black bands on abdomen; black 'U' marking on segment 2 is linked by a stalk to a black band, and overall the marking is goblet-like; female abdomen is more black than blue. Flies May–Aug. **LARVA** is similar to Azure Damselfly larva but gills have a rounded tip. **STATUS** Common in S Britain and Ireland, and often found in garden ponds.

Variable Damselfly, abdomen

Common Blue Damselfly *Enallagma cyathigerum* Adult length 32mm

Could be confused with *Coenagrion* sp. (above). **ADULT** has a single black line on side of thorax (2 in *Coenagrion* sp.). Male is blue with black bands on abdomen and a mushroom-cloud-shaped dot on segment 2. Green and black female has a diagnostic ventral spine near tip of abdomen. Flies May–Sep. **LARVA** is typically marbled green; gills end at a sharp angle without a projecting point. **STATUS** Common near vegetated still waters, including garden ponds.

Common Blue Damselfly, abdomen

Red-eyed Damselfly *Erythromma najas* Adult length 35mm

Distinctive damselfly. **ADULT** has striking red eyes and a blue-tipped blackish abdomen; thorax of male is black above and blue on sides, while female's is black and yellow. Flies May–Sep. **LARVA** is slender; gills are marked with 3 dark bands. **STATUS** Locally common only in central and S England, favouring ponds and canals.

Common Blue Damselfly, segment 2

Red-eyed Damselfly, tip of abdomen

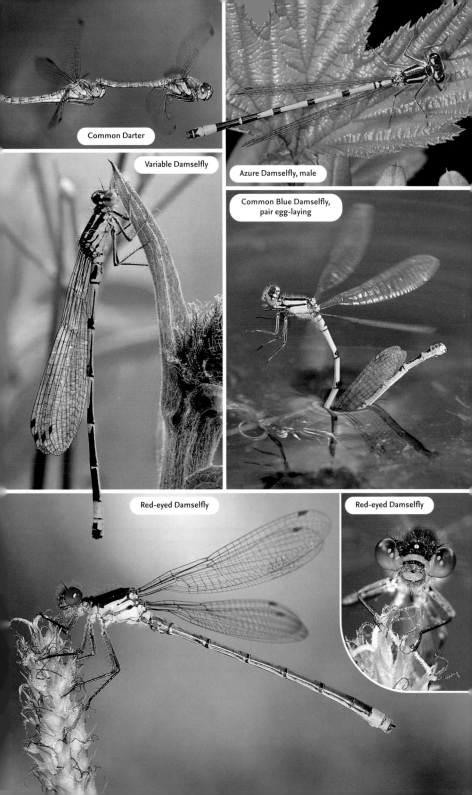

Common Darter

Variable Damselfly

Azure Damselfly, male

Common Blue Damselfly,
pair egg-laying

Red-eyed Damselfly

Red-eyed Damselfly

Blue-tailed Damselfly
Ischnura elegans Adult length 32mm

Distinctive damselfly. **ADULT** is identified by a mainly black body and sky-blue segment 8 of abdomen. Flies May–Aug. **LARVA** is slender; gills are relatively long and narrow, tapering gradually to a sharp point. **STATUS** Common and widespread except in the far N.

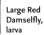
Blue-tailed Damselfly, tip of abdomen

Large Red Damselfly
Pyrrhosoma nymphula
Adult length 35mm

Distinctive damselfly with a rather weak flight. **ADULT** is mainly bright red, but abdomen is marked with black; this is more extensive on female than male. Flies May–Aug. **LARVA** has a stubby, cylindrical body; gills are marked with a dark 'X', and are rather fish-knife-like with a hooked tip. **STATUS** Common and widespread in ponds and canals.

Large Red Damselfly, larva

Water Veneer
Acentria ephemerella Adult length 8mm

Tiny moth, often overlooked because of its size and aquatic habits. **ADULT** is seen only briefly. Male has silvery wings and mates with female (most of which are wingless) at pond surface soon after she emerges from the water, then promptly dies. Flies Jun–Aug. **LARVA** is aquatic and feeds on pondweeds, including Canadian Waterweed (p. 372). **STATUS** Common and widespread.

Mottled Sedge
Glyphotaelius pellucidus Adult length 16mm

Distinctive caddis fly. Lays egg masses on leaves overhanging water. **ADULT** has marbled wings with a neat notch in outer margin. **LARVA** makes a flattened case of leaf fragments. **STATUS** Common and widespread.

Limnephilus sp. Adult length 15–19mm
Diverse group of caddis flies. **ADULTS** mostly have rather uniform buffish-brown wings. **LARVAE** construct cases from plant debris, small stones and snail shells. **STATUS** Common and widespread.

Limnephilus sp., larval case

Grouse Wing
Mystacides longicornis Adult length 11mm

Distinctive caddis fly. **ADULT** has dark-banded wings. **LARVA** constructs a tubular case of sand grains, often with a few slender twigs attached. **STATUS** Common and widespread.

Midge
Chironomus plumosus Adult length 10mm

Non-biting midge. **ADULT** male has wings shorter than abdomen, and plumed antennae; forms large swarms. Female has relatively longer wings and simple antennae. Flies May–Sep. **LARVA** (Bloodworm) is aquatic and red. **STATUS** Common and widespread.

Phantom Midge
Chaoborus crystallinus Adult length 16mm

Non-biting fly associated with standing fresh water. **ADULT** male has plumed antennae and wings that do not reach abdomen tip. **LARVA** (Ghostworm) is transparent and aquatic. **STATUS** Common and widespread.

Mosquitoes
Culex spp., *Anopheles* spp. and *Aedes* spp. Adult length 8–15mm

Several mosquito species are common in Britain; they are hard to tell apart. Only females suck blood while males feed on nectar. **ADULTS** have a 'hunchback' thorax and marbled wings. **LARVAE** live in stagnant water and swim with a wriggling motion, as do pupae to a lesser extent. **STATUS** Common and widespread.

Blue-tailed Damselfly

Large Red Damselfly

Mottled Sedge

Water Veneer

Mottled Sedge, eggs

Grouse Wing

Midge, larva

Mosquitoe, larvae

Phantom Midge, larva

Pond Skater *Gerris lacustris* Length 10mm
Surface-dweller that skates over the water surface on the tips of its legs. Responds to distress movements of insects trapped in the surface film, and feeds on these using its proboscis. **ADULT** has a narrow brown body and slender legs; hibernates away from water. **STATUS** Widespread and common on ponds and lakes.

Lesser Water Boatman *Corixa punctata* Length 10mm
Active bug that swims the right way up using its fringed hind legs as paddles. Feeds on algae and detritus on the bottom of ponds. **ADULT** has a brownish body and well-developed head and eyes. Found year-round in water and occasionally flies in warm weather. **STATUS** Common and widespread in weedy ponds and lakes.

Water Boatman *Notonecta glauca* Length 14mm
Typically hangs at the water surface and swims upside down using its fringed hind legs as paddles. Predator of other aquatic creatures and insects trapped in the surface film. **ADULT** has a tapering greyish body, but looks silvery owing to air bubble trapped on ventral surface. Found year-round and flies in warm weather. **STATUS** Common and widespread.

Saucer Bug *Ilyocoris cimicoides* Length 12mm
Fierce predator of aquatic creatures. Should be handled with caution since it is capable of causing a painful bite. **ADULT** is oval in outline, yellowish brown and stippled with numerous tiny, dark dots. **STATUS** Common and widespread in weedy ponds and lakes.

Water Scorpion *Nepa cinerea* Length 30mm
Predator of tadpoles, small fish and other aquatic insects. Its movements are slow and creeping. **ADULT** is easily recognised by its flattened body and leaf-like outline, long breathing siphon at tail end and pincer-like front legs. **STATUS** Common and widespread in weedy ponds and lakes.

Water Stick
Insect

Water Stick Insect
Ranatra linearis Length 50mm
Distinctive species, easy to overlook in pond samples as it remains motionless and stick-like when out of the water. Adopts a mantis-like pose when submerged and captures passing aquatic creatures. **ADULT** has a slender body, grappling front legs and a breathing siphon at rear end. **STATUS** Fairly common in the S in weedy ponds and lakes.

Whirlygig Beetle *Gyrinus natator*
Length 5mm
Small but distinctive water beetle, seen whirling around on the water surface, often in groups. **ADULT** has a black bead-shaped body and well-developed front legs, these used for swimming; middle and hind legs are small. **STATUS** Common and widespread in ponds, lakes and slow-flowing streams.

Whirlygig
Beetle

Pond Skater

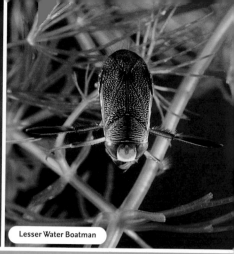

Lesser Water Boatman

Water Boatman

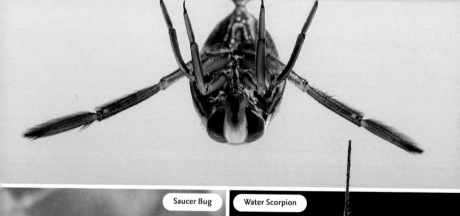

Saucer Bug

Water Scorpion

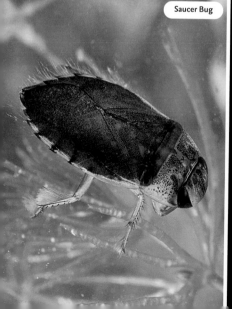

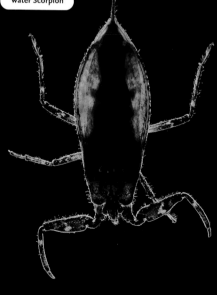

Acilius sulcatus Length 16mm
Active carnivore that swims well using its fringed hind legs as paddles. **ADULT** has an oval body; male has shiny golden elytra that are finely marked; those of female are grooved. **STATUS** Common and widespread in England but local elsewhere. Favours weedy ponds and canals.

Great Diving Beetle *Dytiscus marginalis* Length 30mm

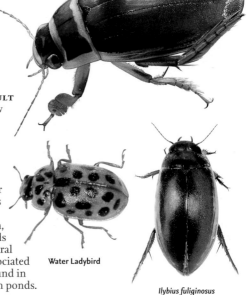

Great Diving Beetle, male

Large, impressive water beetle. Both adults and larvae are fierce predators. **ADULT** has a shiny, mainly black body, with orange-brown legs and margins of elytra and thorax. Male has smooth, shiny elytra; female's are grooved. **LARVA** has an elongate body and piercing jaws; it eats tadpoles and even small newts and fish. Replenishes air supply via tip of abdomen. **STATUS** Widespread and fairly common.

Ilybius fuliginosus Length 10–11mm
Small, streamlined water beetle. Flies after dark and often comes to light. **ADULT** has a blackish body with orange-yellow around margins of thorax and elytra. **STATUS** Common and widespread in ponds and ditches.

Water Ladybird
Anisosticta 19-punctata Length 4mm
Atypical wetland ladybird with a rather elongate and flattened body. **ADULT** has 15–21 dark spots. In summer, ground colour is yellow-buff; after hibernation, colour is reddish in spring. **LARVA** feeds on aphids. **STATUS** Widespread in central and S Britain, but local and always associated with wetland habitats; occasionally found in damp vegetation beside mature garden ponds.

Water Ladybird

Ilybius fuliginosus

Freshwater Louse *Asellus aquaticus* Length 15mm
Rather woodlouse-like aquatic crustacean. Scuttles among water plants and scavenges organic matter from the sediment. **ADULT** has a flattened, segmented body and very long antennae. In spring, female carries whitish eggs in a brood pouch. **STATUS** Widespread, and often extremely common in ponds, lakes and slow-flowing streams.

Water-fleas *Daphnia* spp. Length 1mm
Minute, free-swimming crustaceans that have a single eye and a pinkish body that is so transparent that the internal organs can be seen through the carapace. They swim jerkily, as though hopping, by beating their antennae. **STATUS** Common and widespread. In summer, they can be present in phenomenal numbers.

Copepods *Cyclops* spp. Length 0.5mm
Tiny, free-swimming crustaceans that have a pear-shaped body and a single dark eye-spot; they swim jerkily and often carry paired egg sacs attached to the abdomen. **STATUS** Common and widespread.

Ostracods order Ostracoda Length 0.5–1mm
Tiny, pea-shaped crustaceans whose body is protected by paired shells; they scurry around over the surface of submerged leaves and debris with the aid of protruding antennae and legs. **STATUS** Common and widespread.

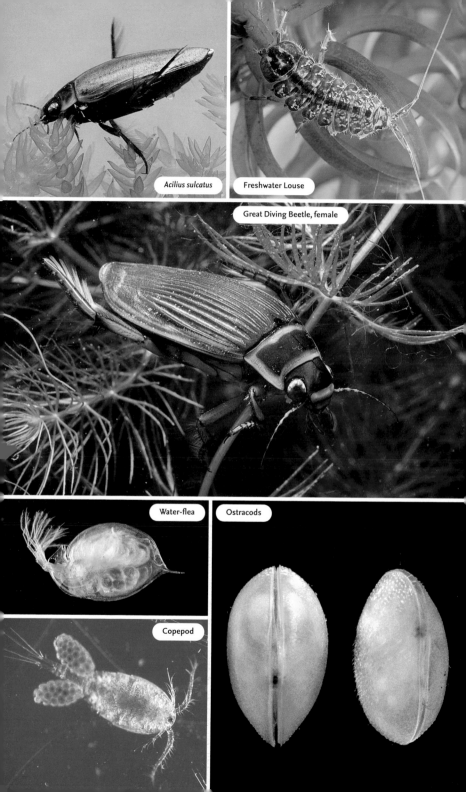

Acilius sulcatus

Freshwater Louse

Great Diving Beetle, female

Water-flea

Ostracods

Copepod

Flatworm *Dugesia lugubris* Length 20mm

One of several flatworm species found in ponds. Glides over submerged leaves. **ADULT** has a thin body and distinct head end; it is dark grey-brown with 2 pale spots at head end next to eyes. **STATUS** Common and widespread. **SIMILAR SPECIES** *Polycelis nigra* (length 1cm) is darker, and lacks white spots at head end.

Dugesia lugubris

Freshwater annelid worms *Lumbriculus* spp. Length 30mm

A group of freshwater worms that bear a striking resemblance to miniature terrestrial earthworms. They live in sediment and silt at the bottom of ponds and lakes, feeding on detritus; their transparent body reveals many of the internal organs. **STATUS** Common and widespread.

Leech

Leech *Erpobdella octoculata* Length 3cm

One of several leeches that are found in ponds. Its very flexible body is brown with yellowish and black markings. It has a sucker at both ends and 8 eyes, although these are hard to spot. Some leeches suck blood, but *E. octoculata* is an active carnivore of small invertebrates. **STATUS** Common and widespread.

Wandering Snail *Lymnaea peregra* Length 10mm

Familiar water snail. **ADULT** has an oval or rounded shell that is pale brown with dark blotches; the last whorl is relatively large and expanded. Tentacles are broad, flattened and ear-like. **STATUS** Common and widespread in lowland ponds and lakes.

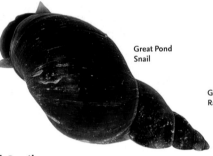

Great Pond
Snail

Great
Ramshorn

Great Pond Snail

Lymnaea stagnalis Length 45mm

Large snail, seen moving among water plants or at the surface, gliding along the underside of the surface film. Visits the surface periodically to replenish its air supply. Feeds on encrusting algae using its rasping tongue. **ADULT** has a conical brown shell. Lays sausage-shaped gelatinous masses of eggs on water plants. **STATUS** Common except in the N.

Great Ramshorn *Planorbis corneus* Diameter 25mm

Large, impressive water snail. **ADULT** has a spirally coiled shell that is dark brown and comprises 5 or so whorls that become ridged with age. **STATUS** Fairly common in ponds and lakes in central and S England.

Ramshorn *Planorbis planorbis* Diameter 12mm

Appreciably smaller than the Great Ramshorn (above). **ADULT** has a brown shell with tightly packed whorls; it is flattened on one side. **STATUS** Common and widespread in lowland Britain.

Hydra *Hydra* sp. Length 5mm

Freshwater relative of sea anemones that is usually found attached to the stems of water plants. **ADULT** has a stalk-like body with a terminal mouth surrounded by tentacles; if disturbed, it contracts into a blob and is difficult to see. Buds new animals in summer. **STATUS** Common and widespread in lowland ponds and lakes.

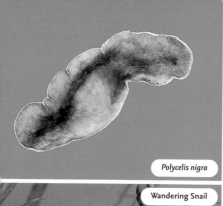

Polycelis nigra

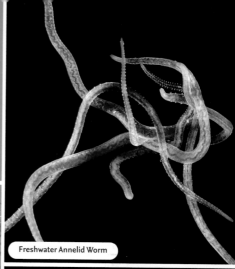

Freshwater Annelid Worm

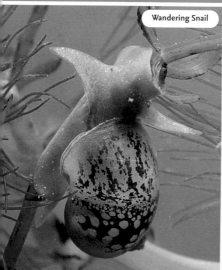

Wandering Snail

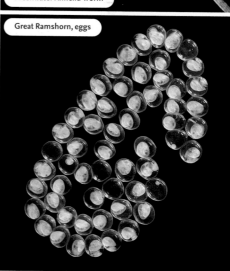

Great Ramshorn, eggs

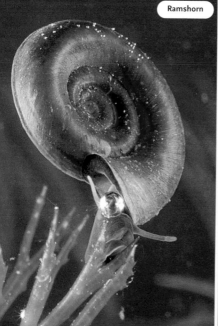

Ramshorn

Hydra

Water-starwort *Callitriche stagnalis* Aquatic

Variable, straggly water plant with slender stems. **FLOWERS** are minute, green, petal-less and borne at base of leaves (May–Aug). **FRUITS** are tiny with 4 segments. **LEAVES** are narrowly oval; those at the water's surface form a floating rosette. **STATUS** Common throughout in still and slow-flowing fresh waters; often does well in garden ponds.

Canadian Waterweed *Elodea canadensis* Aquatic

Submerged perennial with trailing and rather brittle stems. **FLOWERS** are tiny, floating and borne on slender stalks (Jul–Sep); note, however, that plant seldom flowers. **FRUITS** are capsules. **LEAVES** are narrow, back-curved and borne in whorls of 3. **STATUS** Introduced from N America but now widely naturalised. A useful oxygenator in garden ponds.

Mare's-tail *Hippuris vulgaris* Aquatic

Distinctive plant whose upright, emergent stems are produced from the submerged part of the plant more readily in still waters. **FLOWERS** are minute, pink and petal-less; produced at base of leaves (Jun–Jul). **FRUITS** are tiny greenish nuts. **LEAVES** are narrow; borne in whorls of 6–12. **STATUS** Locally common in streams, ponds and lakes, and often introduced to the margins of garden ponds.

Arrowhead *Sagittaria sagittifolia* Height 80cm

Distinctive aquatic perennial. **FLOWERS** are 2cm across, the 3 petals white with a purple basal patch; borne in whorled spikes (Jul–Aug). **FRUITS** are borne in globular heads. **LEAVES** comprise arrow-shaped emergent leaves, oval floating ones and narrow submerged ones. **STATUS** Locally common in the S in still or slow-flowing fresh waters; often introduced to the margins of garden ponds.

Common Duckweed *Lemna minor* Aquatic

Familiar plant that often carpets the surface of ponds by midsummer. **LEAVES** are round and flat, 5mm across with a single dangling root. **STATUS** Widespread and locally common in the wild, but also a frequent plant in garden ponds.

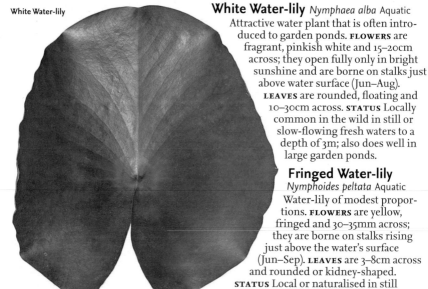

White Water-lily

White Water-lily *Nymphaea alba* Aquatic

Attractive water plant that is often introduced to garden ponds. **FLOWERS** are fragrant, pinkish white and 15–20cm across; they open fully only in bright sunshine and are borne on stalks just above water surface (Jun–Aug). **LEAVES** are rounded, floating and 10–30cm across. **STATUS** Locally common in the wild in still or slow-flowing fresh waters to a depth of 3m; also does well in large garden ponds.

Fringed Water-lily *Nymphoides peltata* Aquatic

Water-lily of modest proportions. **FLOWERS** are yellow, fringed and 30–35mm across; they are borne on stalks rising just above the water's surface (Jun–Sep). **LEAVES** are 3–8cm across and rounded or kidney-shaped. **STATUS** Local or naturalised in still waters; does well in garden ponds.

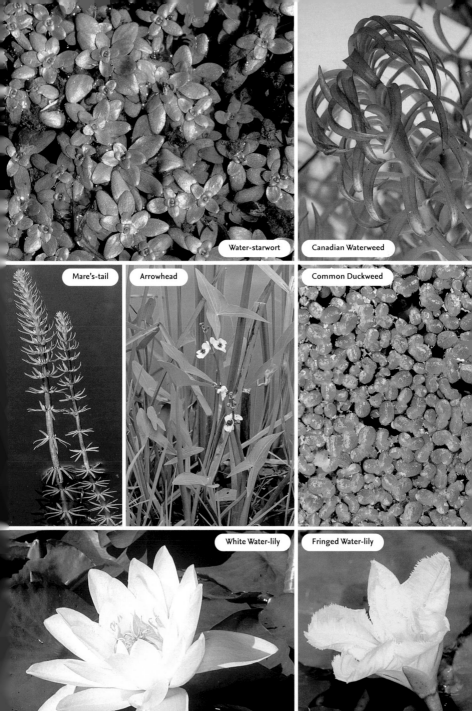

Water-starwort

Canadian Waterweed

Mare's-tail

Arrowhead

Common Duckweed

White Water-lily

Fringed Water-lily

GLOSSARY

Abdomen Hind section on an insect's body; usually appears segmented.

Achene One-seeded dry fruit that does not split.

Acute Sharply pointed.

Alien Introduced by Man from another part of the world.

Alternate Arrangement of leaves that are not opposite.

Amplexus Mating embrace adopted by paired frogs and toads, whereby the male grasps the female with his front legs.

Annelid Segmented worm, belonging to the phylum Annelida.

Annual Plant that germinates, grows and sets seed within a single growing season.

Antennae Slender, paired sensory organs on the head of an insect, or other arthropod.

Anther Pollen-bearing structure seen in flowers.

Aquatic Living in water.

Arboreal Tree-dwelling.

Aril Succulent coating to a seed.

Arthropod Invertebrate belonging to the phylum Arthropoda, characterised by having a hard exoskeleton and jointed legs.

Auricle Ear-like extension seen at the bases of some leaves.

Axil Angle between the upper surface of a leaf, or its stalk, and the stem on which it is carried.

Berry Fleshy, soft-coated fruit containing several seeds.

Biennial Plant that takes two years to complete its life cycle.

Bract Modified, often scale-like leaf found at the base of flower stalks in some species.

Bulb Fleshy, underground structure found in certain plants, comprising leaf bases and next year's buds.

Bulbil Small, bulb-like structure.

Calcareous Soil containing calcium, the source typically being chalk or limestone.

Calyx Outer part of a flower, comprising the sepals.

Cap Structure seen in fungi, under which spore-bearing structures – usually gills or pores – are suspended.

Capsule Fruiting structure within which seeds are formed in flowering plants and that splits to liberate them; also the structure inside which spores develop in mosses and liverworts.

Carapace Hard upper surface of a crustacean's shell.

Carpal Area on a bird's wing corresponding to the 'wrist' joint.

Caterpillar Larval stage of a butterfly or moth.

Catkin Hanging spike of tiny flowers.

Caudal Relating to the tail.

Cephalothorax Fused head and thorax found in spiders.

Cerci Paired appendages at the hind end of an insect's body.

Chlorophyll Green pigment found in plant tissue and essential for photosynthesis.

Clasping Referring to leaf bases with backward-pointing lobes that wrap around the stem.

Compound Leaf that is divided into a number of leaflets.

Compound eye Eye structure typical of insects and some other invertebrates, and comprising numerous cells and lenses, not a single lens.

Cone Structure bearing reproductive structures in conifers.

Conifer Tree that bears its reproductive structures in cones.

Cordate Heart-shaped at the base.

Corolla Collective term for the petals.

Crepusclar Active at dusk.

Cultivar Plant variety created by cultivation.

Deciduous Plant whose leaves fall in autumn.

Decurrent Fungal gills that run down the stem.

Deliquesce Turn to liquid.

Dentate Toothed.

Dioecious Having male and female flowers on separate plants.

Disc florets Small flowers found at the centre of inflorescences of members of the daisy family.

Diurnal Active during daylight.

Dorsal Upper surface.

Ear coverts Feathers that cover the ears in birds.

Echolocation Method by which a bat perceives its surroundings, involving the interpretation of reflected high-frequency sound, the source of the sound being the bat itself.

Elytra Hardened forewings of a beetle.

Entire In the context of a leaf, a margin that is untoothed.

Epicalyx Structures that surround a flower but are not a functioning part of it.

Evergreen Plant that retains its leaves throughout the year.

Eye-stripe Well-marked stripe through the line of the eye of a bird, from the base of the bill to the ear coverts.

Flight feathers Long feathers (primaries, secondaries and tertials) on the trailing half of the wing.

Floret Small flower.

Frond Leaf-like structure found in some lower plants

Fruits Seeds of a plant and their associated structures.

Gall Plant growth induced by another organism, often a gall wasp or fungus.

Glabrous Lacking hairs.

Globose Spherical or globular.

Glume Stiffened bract found in grass flowers.

Herbivore Animal that feeds on plant material.

Hibernation State of winter dormancy in which the animal's activity, body temperature and energy requirements are greatly reduced.

Hybrid Organism derived from the cross-fertilisation of two different species.

Hyphae Thread-like fungal fibres that penetrate the growing medium.

Immature Young bird whose plumage is not adult. Depending on the species, this stage may last months or years.

Inflorescence Flowering structure in its entirety, including bracts.

Insectivore Animal that feeds on insects.

Introduced Not native to the region.

Invertebrate Animal without a backbone.

Juvenile Newly fledged bird with first set of feathers.

Lanceolate Narrow, lance-shaped leaf.

Larva Soft-bodied, pre-adult growing stage in the life cycle of certain insect species.

Leaflet Leaf-like segment or lobe of a leaf.

Lenticel Pore-like structure seen on the leaves, stems and fruits of some plants.

Ligule Membranous leaf-sheath found in grasses.

Linear Slender and parallel-sided.

Lobe Division of a leaf.

Lore Area of feathering between the eye and the base of the upper mandible of a bird.

Malar stripe Narrow stripe of feathers that borders the throat of a bird.

Mantle Area of feathers on the upper back of a bird.

Melanic Showing dark pigmentation.

Midrib Central vein of a leaf.

Migrant Bird that spends the summer and winter in different places.

Moult Process seen in birds during which old feathers are lost and replaced by new ones; also applies to certain invertebrates that shed their skins.

Mucus Slimy, viscous fluid secretion.

Mycelium Mass of fungal hyphae.

Native Occurring naturally in the region and not known to have been introduced.

Needle Narrow leaves found in conifer trees.

Nocturnal Active after dark.

Node Point on the stem from which leaves arise.

Nut Dry, often hard fruit containing a single seed.

Nymph Immature growing stage found in certain insect groups, notably bugs, which has some characters in common with the adult.

Oblong Leaf whose sides are at least partly parallel-sided.

Obtuse Blunt-tipped (usually refers to a leaf).

Operculum Plate found in some molluscs and used to seal off the entrance to the shell.

Opposite Of leaves, arising in opposite pairs on the stem.

Oval Leaf shape.

Ovary Structure containing the ovules, or immature seeds.

Ovate Roughly oval in outline.

Ovipositor Egg-laying structure found at the tail end of some female insects.

Ovoid Egg-shaped.

Palmate Leaf with finger-like lobes arising from the same point.

Palps Sensory appendages found around the mouth in insects and crustaceans.

Parasite Organism that lives in or on another organism, relying on it entirely for its nutrition.

Pedicel Stalk of an individual flower.

Perennial Plant that lives for more than two years.

Perianth Collective name for a flower's petals and sepals.

Petals Inner segments of a flower; often colourful.

Petiole Leaf stalk.

Pinnate Leaf division with opposite pairs of leaflets and a terminal one.

Pod Elongated fruit, often almost cylindrical, seen in pea family members.

Pollen Tiny grains that contain male sex cells, produced by a flower's anthers.

Primaries Outermost flight feathers in birds.

Pronotum Hardened dorsal plate covering the thorax of an insect.

Pubescent With soft, downy hairs.

Pupa Stage in an insect's life cycle between the larva and adult; also called a chrysalis.

Ray florets Small flowers found on the outer fringe of the inflorescence in flowers of the daisy family.

Recurved Curved backwards.

Reflexed Bent back at an angle of more than 90 degrees.

Rhizome Underground stem.

Rosette Radiating arrangement of leaves.

Rostrum Beak-like structure found in insects and used for feeding.

Runner Creeping stem that occurs above ground and may root at nodes or tip.

Scutellum Triangular, posterior part of the dorsal thoracic plate; conspicuous in shield bugs.

Secondaries Middle flight feathers in birds.

Sepal Outer, usually less colourful structures surrounding the reproductive part of a flower.

Sole Underside of the foot in molluscs.

Spadix Upright spike of flowers, found in arums.

Spathe Large bract surrounding the spadix in arums.

Species Unit of classification defining animals or plants that are able to breed with one another and produce viable offspring.

Spike Simple, branched inflorescence.

Spikelet Inflorescence arrangement in grasses, sedges and rushes.

Spore Tiny reproductive body that disperses and gives rise to a new organism.

Stamen Male part of the flower.

Stigma Receptive surface of the female part of a flower, to which pollen adheres.

Stipule Leaf-like or scale-like structure at the base of a leaf stalk.

Style Element of the female part of the flower, sitting on the ovary and supporting the stigma.

Supercilium Typically pale stripe of feathers that runs above the eye in some bird species.

Tarsus What most people refer to as a bird's 'leg'; in strict anatomical terms it is part of the foot.

Tendril Slender, modified leaf or stem structure that assists climbing in some plants.

Terrestrial Living on land.

Tertials Innermost flight feathers in birds.

Thallus Unspecialised vegetative body of a lower plant.

Thorax Middle section of an insect's body.

Tomentose Covered in cottony hairs.

Trifoliate Leaf divided into three sections.

Tubercle Small, rounded swelling.

Umbel Umbrella-like arrangement of flowers.

Umbo Central, raised swelling on the cap of certain fungus species.

Vertebrate Animal with a backbone.

Whorl Several leaves or branches arising from the same point on a stem.

Wing coverts Feathers that cloak the leading half (as seen in flight) of both surfaces of the wings in birds.

Wingbar Striking bar on the wings of some birds.

Wingspan Distance from one wingtip to the other in birds and insects.

FURTHER READING

Chinery, M. (2005). *Complete British Insects*. HarperCollins.
Sterry, P.R. (2004). *Complete British Birds*. HarperCollins.
Sterry, P.R. (2005). *Complete British Animals*. HarperCollins.
Sterry, P.R. (2006). *Complete British Wild Flowers*. HarperCollins.
Sterry, P.R. (2007). *Complete British Trees*. HarperCollins.
Sterry, P.R., and Barry Hughes (2009). *Complete Guide to British Mushrooms and Toadstools*. HarperCollins.

USEFUL WEBSITES

British Trust for Ornithology (BTO) – www.bto.org
Herpetological Conservation Trust – www.herpconstrust.org.uk
Royal Society for the Protection of Birds (RSPB) – www.rspb.org.uk
The Wildlife Trusts – www.wildlifetrusts.org.uk
The Woodland Trust – www.woodland-trust.org.uk

INDEX

PICTURE CREDITS

All the photographs used in this book were taken by **Paul Sterry** with the exception of those listed below; these can be identified using a combination of page number and subject. All images were supplied by **Nature Photographers Ltd**.

S.C. Bisserot: 115 Grey Long-eared Bat, inset; 116 Noctule; 117 Noctule; 121 Great Crested Newt, female; 183 Pine Hawk-moth, larva; 241 *Volucella bombylans*; 249 Buff-tailed Bumblebee; 253 *Apanteles* sp.
Frank Blackburn: 17 Blackcap; 31 Green Woodpecker; 44 Blackcap; 79 Lesser Spotted Woodpecker.
Idris Bowen: 121 Smooth Newt, female. **Robin Bush**: 131 Green-veined White. **Andy Callow**: 228 flea; 231 *Deraecoris ruber*; 231 *Campyloneura virgula*; 231 *Orthops campestris*; 237 Cabbage Whitefly; 247 Black Garden Ant; 247 Red Ant; 251 Red Mason Bee; 257 Two-spot Ladybird; 275 Wolf Spider; 363 Azure Damselfly.
Laurie Campbell: 104 Red Squirrel. **Colin Carver**: 76 Stock Dove; 109 Roe Deer; 111 Fox, right; 113 Stoat, right; 113 Weasel, top. **Hugh Clark**: 97 Hedgehog, middle left; 111 Fox, top left; 111 Badger, top; 114 Brown Long-eared Bat, bottom; 117 Common Pipistrelle, left; 132 Small Tortoiseshells. **Andrew Cleave**: 111 Badger, inset; 297 Norway Maple; 327 Ground Elder; 347 *Placynthium nigrum*. **Ron Croucher**: 27 Little Owl; 344 Field Horsetail. **Geoff du Feu**: 97 Mole; 237 Rose Aphid; 243 Greenbottle; 243 Common House-fly; 243 Lesser House-fly; 243 Bluebottle; 253 *Pteromalus puparum*. **Phil Green**: 273 *Pisaura mirabilis*. **Jean Hall**: 123 Common Toad, spawn; 345 Field Horsetail.
Michael Hammett: 361 Common Hawker; 363 Variable Damselfly. **Ernie Janes**: 13 Great Tits; 16 Redwing; 19 Sparrowhawk, male; 38 Blackbird, female at nest; 71 Lesser Redpoll, top left; 107 Brown Rat; 107 Brown Rat, inset; 109 Muntjac; 109 Muntjac, inset; 115 Brown Long-eared Bat; 283 Garden Snail, colony.
Len Jessup: 372 Arrowhead. **Andrew Merrick**: 8 Robin; 93 Bank Vole; 101 Bank Vole; 141 Ringlets; 144 Mottled Umber; 147 Bird-cherry Ermine; 147 Large Fruit-tree Tortrix; 147 Timothy Tortrix; 149 *Acleris ferrugana*; 149 *Cydia splendana*; 151 *Udea lutealis*; 156 Buff Arches; 156 Figure of Eighty; 158 Blood-vein; 161 Red Twin-spot Carpet; 160 Scallop Shell; 163 Shoulder-stripe; 167 Sharp-angled Carpet; 169 The V-pug; 171 Clouded Border; 175 Scalloped Oak; 175 Swallow-tailed Moth; 178 Early Moth, female; 205 The Clay; 220 Marbled

Minor; 221 Marbled Minor; 221 Middle-barred Minor; 222 The Uncertain; 222 The Rustic; 222 Nut-tree Tussock; 230 *Rhopalus subrufus*; 232 Horned Treehopper; 235 Green Shieldbug; 235 Forest Bug; 235 Bronze Shieldbug; 235 Pied Shieldbug; 239 *Tipula maxima*; 241 *Tabanus bromius*; 243 Flesh-fly; 245 Snipe-fly; 245 Owl-midge; 245 *Chloromyia formosa*; 247 Common Wasp; 249 Early Bumblebee; 253 Figwort Sawfly; 253 *Amblyteles armatorius*; 259 *Rhagonycha fulva*; 261 Poplar Leaf Beetle; 263 *Chrysolina polita*; 263 Rosemary Leaf Beetle; 263 *Phytodecta viminalis*; 271 *Arienella curcurbitina*; 272 Zebra Spider; 281 Worm cast; 283 Copse Snail; 349 Velvet Shank; 351 *Mycena flavescens*; 352 *Agrocybe rivulosa*; 355 Golden Spindles; 355 Silverleaf Fungus. **Lee Morgan**: 115 Grey Long-eared Bat, main; 117 Common Pipistrelle, right; 117 Soprano Pipistrelle; 205 The Mullein.
Owen Newman: 19 Kestrel, male; 97 Hedgehog, top & middle right; 101 House Mouse, top & middle right; 103 Yellow-necked Mouse, left; 113 Weasel, bottom; 114 Brown Long-eared Bat, top. **Philip Newman**: 42 Song Thrush, bottom left; 42 Mistle Thrush, top left. **W.S. Paton**: 33 House martin, top left. **Nicholas Phelps Brown**: 273 Zebra Spider; 275 money spider; 275 Red Spider Mite; 365 midge larva; 365 mosquito larvae; 365 Phantom Midge larva; 369 water-flea; 369 copepod; 371 *Polycelis nigra*; 371 hydra. **Robert Read**: 358 garden pond, top & bottom. **Richard Revels**: 40 Fieldfare; 105 Red Squirrel; 105 Grey Squirrel; 111 Fox, bottom left; 129 Small Tortoiseshells; 133 Small Tortoiseshell; 136 Ringlet; 139 Small Copper; 139 Small Skipper; 139 Essex Skipper; 142 Lobster Moth; 183 Hummingbird Hawk-moth, adult; 184 Lobster Moth; 235 Parent Bug; 239 *Helophilus pendulus*; 241 *Episyrphus balteatus*; 247 German Wasp; 247 Common Wasp; 251 Leaf-cutter Bee; 251 Tawny Mining Bee; 256 ladybird larva; 257 Eyed Ladybird; 257 Twenty-two-spot ladybird; 261Cardinal Beetle; 261 Lily Beetle; 273 *Agelena labyrinthica*; 273 *Xysticus cristatus*; 363 Common Darter; 363 Common Blue Damselfly; 365 Blue-tailed Damselfly; 365 Large Red Damselfly. **Don Smith**: 26 Tawny Owl; 79 Barn Owl, flying. **E.K. Thompson**: 27 Tawny Owl; 361 Four-spotted Chaser. **Roger Tidman**: 18 Kestrel; 22 Feral Pigeon; 25 Swift; 66 Goldfinch, juvenile; 81 Sand Martin; 82 Redstart; 113 Stoat, left; 361 Emperor Dragonfly. **Neil Wilmore**: 369 Ostracods.